S0-AEO-237

THE LIBRARY
OF
ESOTERICA

PLANT MAGICK

FOREWORD BY
Pam Montgomery

DESIGN BY
Thunderwing

WRITTEN & EDITED BY
Jessica Hundley

TASCHEN

PLANT MAGICK

A MIRACLE OF SYMBIOSIS 6
Foreword by Pam Montgomery
NATURE REMAINS. 8
Preface by Jessica Hundley

I *Roots of Connection* 1 0
Plants & People

FROM SOIL TO SKY 1 2
A Brief History of Humans in the Natural World
A SYMBIOTIC PARTNERSHIP 3 2
A Timeline of Humans in Nature

II *The Seeds Are Sown* 3 8
Sacred Symbolism in Nature

FIBONACCI . 4 0
Geometry in Nature
SACRED GARDENS. 4 6
The Art of Nature
RETURN TO EDEN 6 2
Plants in Myth & Spirituality
THE SEPHIROTH 1 0 4
The Enduring Symbolism of Trees

III *Germination and Growth* 154
Plants in Healing & Ceremony

PLANTCRAFT 156
Botanical Spells & Green Witchery

HEALING BOTANICALS 166
The Use of Plants as Medicine

MYCELLIAL MAGICK 202
The Power of Mushrooms

RITES OF PASSAGE 210
Symbolic Plants of Birth, Love, Victory, & Death

PISTIL AND STAMEN 246
Sensuality & The Botanical Realm

IV *The Blossom Opens* 268
Plants & Higher States

RITUAL ELATION 270
Stimulating Plants

THE BACCHANAL 292
Plants & Intoxication

SOMA Plants & The Expansion of Consciousness 328

CANNABIS 330 CACTI 366
MAGIC FUNGHI 342 DATURA 386
OPIUM 354 AYAHUASCA 394

UNDER THE INFLUENCE 406
Art & Psychedelics

V *Pollinating Consciousness* 424
Plants & Culture

THE BEANSTALK 426
Plants in Literature, Plays & Poetry

PLANTS AS MUSE 450
Plants & Contemporary Culture

FOR THE SEEKERS 512
A Final Note on the Library of Esoterica

BIBLIOGRAPHY, IMAGE CREDITS, ACKNOWLEDGMENTS, & RESOURCES 514

Foreword by
PAM MONTGOMERY

A MIRACLE OF SYMBIOSIS

(frontispiece)
Samuel Colman
Parnassia · United
States · 1971 A study
from *Nature's Harmonic
Unity*, by American
painter, interior designer,
and writer, who is best
remembered for his
paintings of the Hudson
River and, in more
recent years, for two
books on geometry in
art and architecture and
its relation to natural
form, number, rhythm
and proportion.

Our breath consists of an inhalation of oxygen and an exhalation of carbon dioxide. All the oxygen on the planet comes from trees and plants both of the land and sea. All the oxygen we breathe is directly from the green world of trees and plants. What a miracle of symbiosis exists between plants and people through this exchange of breath! Symbiotically speaking, we're more related to plants than we are to other animals. Plants and trees make up 99% of all living organisms on the planet. We're a part of nature, but we've forgotten this. We've fallen into a deep amnesia. Our separation from nature began perhaps most dramatically during the Industrial Revolution of the late 1800s. Our relationship with nature, with plants, has since become perverted. Now nature is a commodity. And we've forgotten what it means to be a good steward.

Yet we remain in this co-existent, symbiotic relationship with the green world. We breathe, so therefore, we are in relationship with plants. We need them. And we can learn from them. Plants know how to adapt and evolve. And this moment in time is about adapting. Right now, we must look to plants for guidance, as we are forced to adapt ourselves. We must learn how to adapt to a changing climate, a changing culture. Everything's changing right now. Plants have been here adapting, changing, for millions of years – in order to continue to thrive. They have wisdom and they can teach us – if we're willing to listen.

The work that I do as a writer and teacher is focused on nurturing our partnership with plants, bringing into conscious awareness that we are in relationship with the plants, and then from there – helping to build a co-creative partnership. We're in it together. One of the things we must shift, is the belief that we can't really make a change. We have help. Our role is to work alongside nature, to take our rightful place as good stewards of the plants, of the land and sea. That is our birthright. I believe we can achieve a dynamic where the plants and mushrooms and trees and people – all work together to create a partnership where all life, including human life – thrives on this beautiful planet.

– Pam Montgomery
Scholar, Ecologist & Author
Danby, Vermont, 2022

Ariana Papademetropoulos · *The Poets Flower*
United States · 2021 The California-born painter
creates large format, vibrant paintings that allow
entry into an imaginary realm. As the artist explains,
"I try to use beauty as a portal to get somewhere
else. It's all about balance. And I try to find that
balance between femininity, masculinity, dark, light,
and magic."

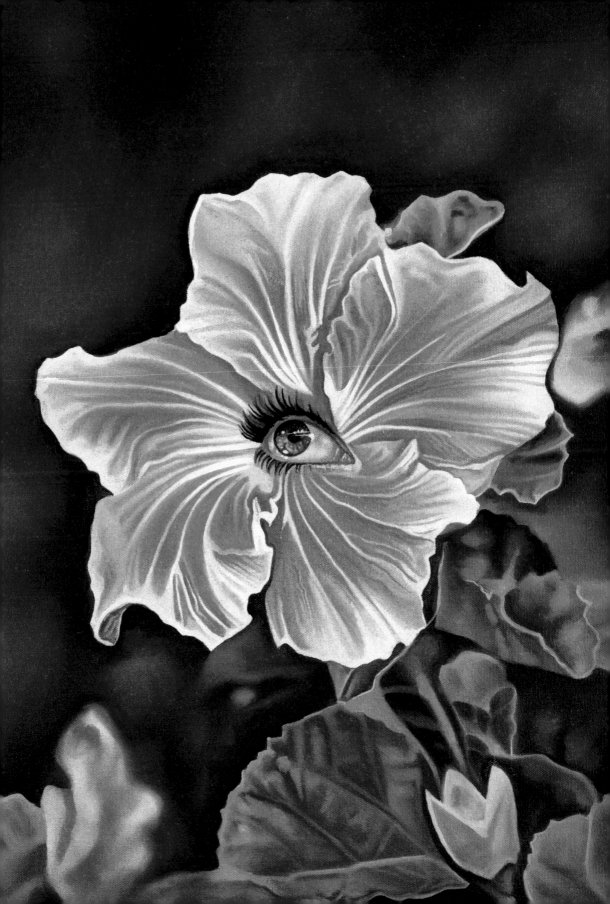

Preface by
JESSICA HUNDLEY
Series Editor

NATURE REMAINS

After you have exhausted what there is in business, politics, conviviality, love, and so on — have found that none of these finally satisfy, or permanently wear — what remains? Nature remains; to bring out from their torpid recesses, the affinities of a man or woman with the open air, the trees, fields, the changes of seasons — the sun by day and the stars of heaven by night.

— WALT WHITMAN, *Specimen Days,* 1892

We live in an era of isolation and disconnection, our screens a surrogate for bodily experience, a two-dimensional world slowly replacing our immersion in the living, breathing, material realm. Our time online replaces our time in nature — our hands in warm soil, or tracing the rough edges of tree bark, our feet sunk into soft grass or stepping through a pine-needle path, above us, bright sun streaming through a stained-glass canopy of green. We have become separated, by industrial and technological revolutions, from the wild and growing things, cast out from Eden, not through an act of original sin, but of our own volition.

Look around, eyes open and one soon realizes that we remain in the Garden. The earthly delights are not hidden beyond high walls, but instead, wait just outside our door. With this volume of *The Library of Esoterica*, we hope to plant this seed of awakening, providing a reminder to open ourselves up, once again, to the natural realm, to the plants, cacti, fungi, flowers and trees that heal and sustain us. We explore the symbolism, ceremony and our ritual relationships with the botanical world. We trace the historical roots of plants and fungi in myth, religion, and magickal practices around the globe. And we celebrate botanicals as muse, both in popular culture and in the visionary art inspired by psychoactive plants, cacti and mushrooms.

Nature, in her generosity, offers us potent medicines and nourishing foods and restorative spiritual, mental and emotional sustenance. By exploring the history of our relationship with natural world, we find traces of our lost selves, our own stories threaded through the myths of the ancient deities once worshiped by our ancestors. And as we begin again to comprehend our deep and symbiotic connection with Mother Earth, the hope is that we will listen to and learn from her, becoming better and more gentle stewards, nurturing the environment that in turn — nurtures all life on this planet.

— Jessica Hundley
Los Angeles, California, 2022

Lieke Romeijn · *Portrait of Marlotte* · **Netherlands 2020** The multimedia artist Romeijn works with materials culled from nature in both her culinary and fabric art creations. In her photography explorations she often poises her subjects amid natural landscapes, using only sunlight to capture raw and intimate portraits of friends and family.

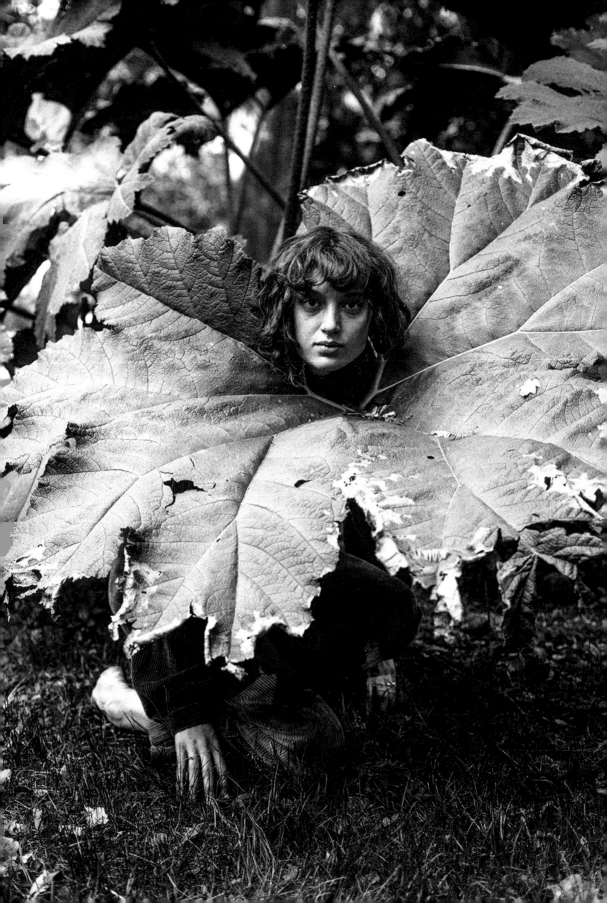

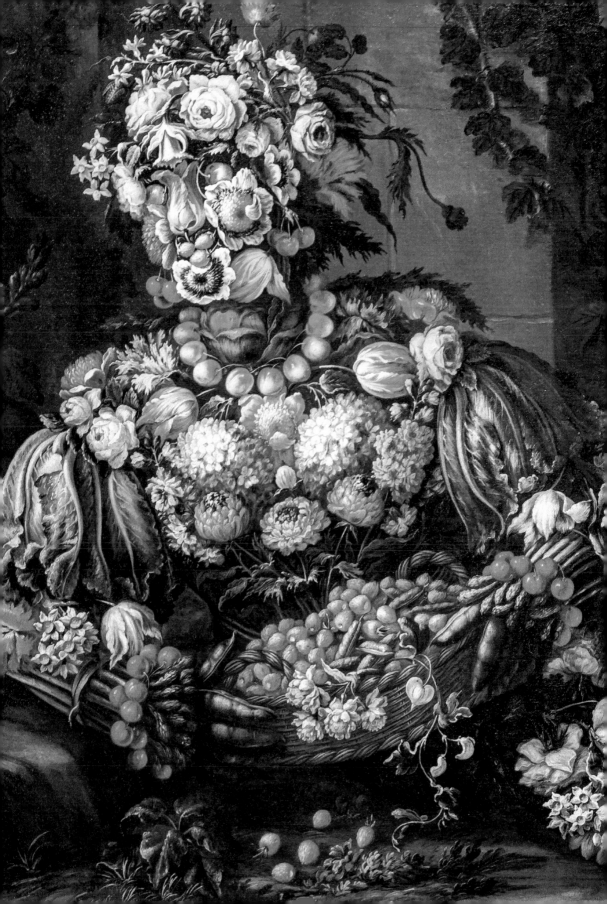

PART I

—

*Roots of
Connection*

PLANTS &
PEOPLE

FROM SOIL TO SKY

A Brief History of Humans in the Natural World

There is nothing lovelier on this planet than a flower, nor more essential than a plant. The true matrix of human life is the greensward covering Mother Earth. Without green plants we would neither breathe nor eat. On the undersurface of every leaf a million movable lips are engaged in devouring carbon dioxide and expelling oxygen. All together, 25 million square miles of leaf surface are daily engaged in this miracle of photosynthesis.

— PETER TOMPKINS & CHRISTOPHER BIRD, from *The Secret Life of Plants*, 1973

The spiraling form of a flower painted by prehistoric hand on cave rock wall, the distinctive shape of a mushroom, carved carefully into ancient stone — the history of people and the natural world is a symbiotic one, a vast and intertwining evolution. Plants and other species, such as mushrooms and fungi, were some of the very first living beings on Earth, with terrestrial growth thought to have first appeared at least 430 million years ago. The first land plant is considered to be the leafless Cooksonia, whose fossilized remains have been found dating back to what is known as the Silurian era, an early geological period on our planet. Evolving out of water, birthed by algae, and making their way to dry soil, plants, mushrooms, trees, and flowers were the essential elements in the formation of our own human existence, forming the air we breathe, the foods we eat to grow, survive, and thrive.

For prehistoric humans, nature was thought to provide not only healing and sustenance, but spiritual guidance as well, the Earth itself a goddess, its plants, and botanicals offerings from a pantheon of primeval deities. Trees, mushrooms, and flowers held potent symbolic meanings and provided a conduit, a passage into the realms of the gods. For the Egyptians, the blue lotus or water lily was considered a sacred plant, representing the sun, resurrection, and rebirth in their complex mythologies. The Druidic religions of the British Isles saw their gods and goddesses embodied in the enduring strength of the oak tree. For the Greeks and Romans, the pomegranate, crimson dark and blood-hued, was a potent symbol of the afterlife. For the Aztec and Maya of Mesoamerica, mushrooms were thought to be consciousness-expanding, "food of the gods." Across cultures, depictions of trees, plants and flowers found their way onto tombs, temples, and totems — nature the altar at which the early world held worship.

(previous pages) **Giuseppe Arcimboldo** · *Spring* **Italy** · **1563** An influence to many surrealist artists, the Italian painter is known for imaginative human figures made entirely of fruits, vegetables, flowers, fish and books.

Dante Gabriel Rossetti · *The Day Dream* · **England** **1880** Sitting in the branches of a sycamore tree is the artist's wife holding a sprig of honeysuckle, a sweet-smelling vine that symbolizes the bonds of love.

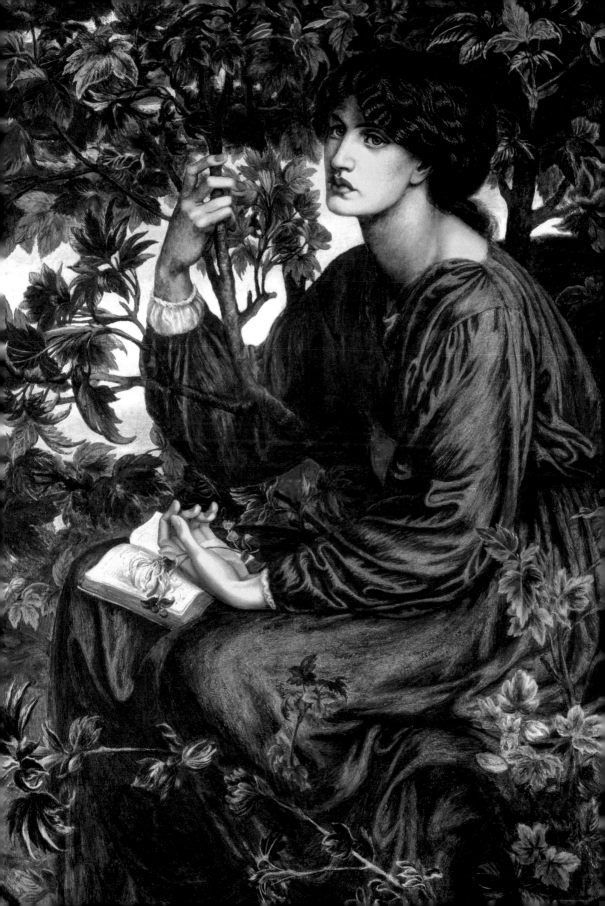

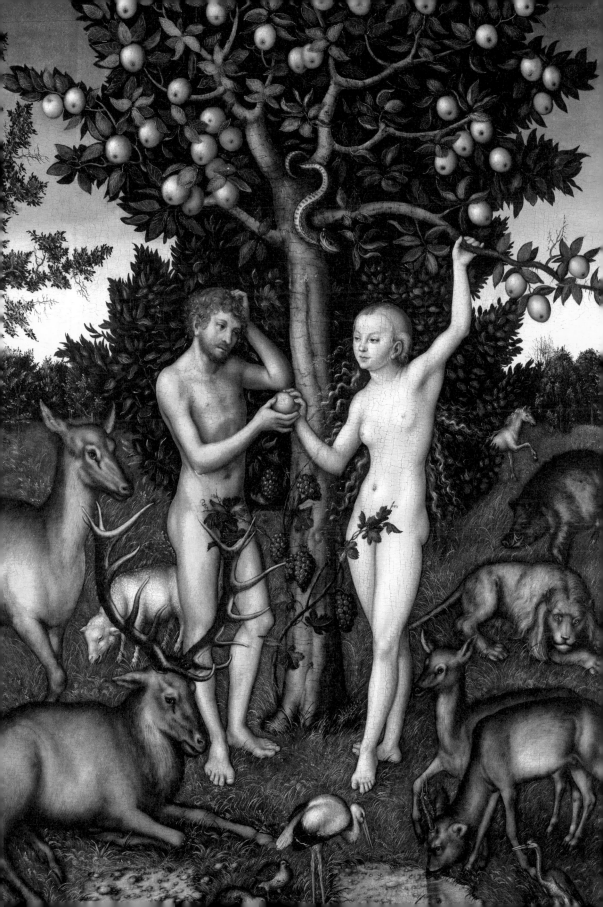

GERMINATION AND FIRST GROWTH

It was not until the Neolithic era, however, over 10,000 years ago, that humans first began to settle plots of land, planting, and domesticating botanicals, and documenting their experiences into carved clay tablets, or penning their evolving knowledge onto scrolls made of the pressed papyrus plant. Agriculture is thought to have originated in Western Asia, eventually spreading across the globe, and forming the first expansive civilizations. In Babylon, the Assyrians would first cultivate the date palm. The Egyptians used the flood waters of the Nile for irrigating plots, growing plants for not only food and medicine, but for ornamentation as well, creating elaborate gardens and public parks. These early agricultural cultures carefully documented the use of plants for medicine and nutrition and passed down this knowledge through the language of storytelling and eventually, into early forms of writing.

The oldest known written documentation of plants is thought to date back to Sumerian culture nearly 5000 years ago. One of the first known medical texts, documenting the use of herbs and plants, was compiled by Egyptians in approximately 1550 BCE. Known as the *Ebers Papyrus*, this scroll consists of writings on botanicals utilized to cure an array of conditions. Early Egyptian healers recommended curatives we still use today, such as aloe vera for skin ailments and Spiraea ulmaria, or meadowsweet, a flowering plant in the rose family whose chemical make-up is used in modern aspirin.

In India, the origins of what is now known as Ayurvedic medicine were first documented in the *Atharva Veda*, Hindu scriptures written in approximately 1200 BCE. In China, a deified figure known as Shennong, thought to have lived in approximately 2800 BCE, is considered the forefather of modern Chinese Medicine. His famous *Materia medica*, is considered one of the oldest books on the use of plants for healing. According to lore, Shennong himself tasted hundreds of botanicals, many poisonous, in order to best record their qualities.

The great scholars and philosophers of early Greece would expand on this plant knowledge, their works providing the core foundation for Western botanical and medical studies for centuries to come. The renowned physician Hippocrates, who lived between 460 and 370 BCE would study and expand upon existing botanical and herbal documentations in his teachings. The scholar Theophrastus, a follower of Aristotle, penned the expansive ten volume work titled *Enquiry into Plants* or *Historia Plantarum*. Written sometime between 350 and 287 BCE Theophrastus documented numerous plant varieties and their uses. Considered to be one of the first "herbals" or books of plant medicines, the *Historia* describes a wide array of medicinal uses, and instructions on how best to gather and extract potent resins and juices. The Roman philosopher and naturalist Gaius Plinius Secundus, also known as Pliny the Elder was another key contributor to our modern knowledge of botany. His *Natural History*, a multi-volume series first published in the

Lucas Cranach the Elder · *Adam and Eve* · Germany 1526 The peaceful moment before the fated fall from grace is depicted in the Garden of Eden. The apple is embraced by both Adan and Eve as they make their doomed decision.

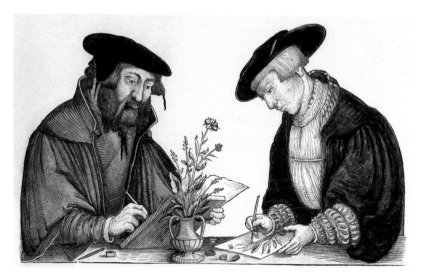

year 77, offers not only texts on agriculture and horticulture but also includes an extensive overview of plants and their uses, both medicinally and in religious and spiritual ceremony. In one major section of the series, Pliny lists over 900 plant medicines and their uses. In another, he discusses the importance of various trees and plants in pagan ritual and ceremony. But perhaps the most important early writings on the natural world are contained within the five volumes of *De materia medica*. Written between the years 50 and 70 by the Greek physician Pedanius Dioscorides, these books became a precursor to nearly all botany texts to come. Throughout the Middle Ages and into the Renaissance, *De materia medica* would be translated into several languages and carefully copied and illustrated by hand into countless editions that would find their way around the globe, and inform generations of scientists, scholars, and enthusiasts.

SEED INTO SAPLING

Another scholar whose contributions to botanical knowledge and the medical use of plants are considered indispensable is the visionary Benedictine Abbess, Hildegard of Bingen. Born in 1098, in Germany, Bingen would live an extraordinary life for a woman of her era. Within the confines of the convent walls, she would immerse herself in art, music, books, and horticulture, developing a passionate conviction that God existed, not only above, but below, as well. "Gaze at the beauty of the green earth," she would famously write, "the truly holy person welcomes all that is earthly. The earth should not be injured. The earth should not be destroyed. There is the music of Heaven in all things. The Word is living, being, spirit, all verdant greening, all creativity." In addition to her writings and her duties as Abbess and spiritual leader, Bingen would also create countless works of

Leonhart Fuchs · *Portraits of Albrecht Meyer and Heinrich Füllmaurer* · Switzerland · 1542 From the Taschen edition of *Fuchs Herbal*, the famous 1543 herb manual by botanical pioneer Leonhart Fuchs. In this image Fuchs captured his collaborators on the book, illustrator Meyer and engraver Füllmaurer.

Unknown · *Krishna and Radha* · India · Unknown The mythological couple symbolizing God and the human soul, court under a tree surrounded by lotus blossoms of which pure petals emerge from muddy depths.

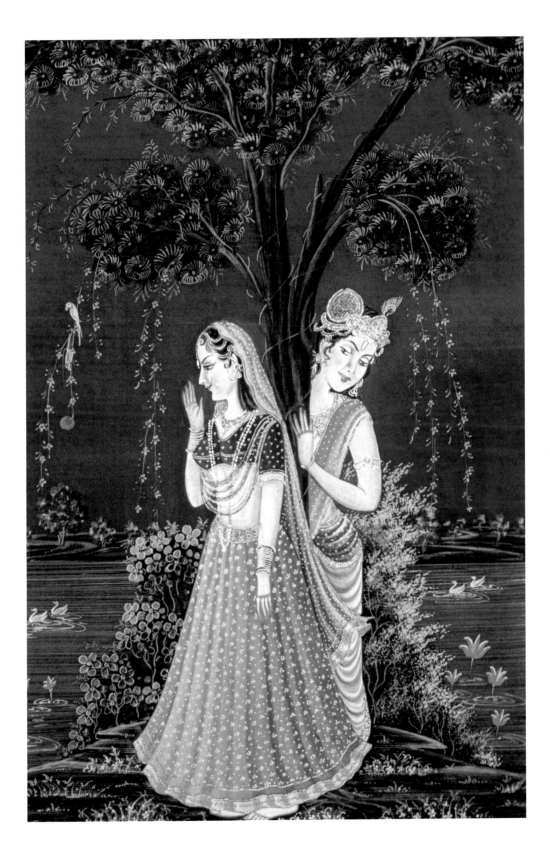

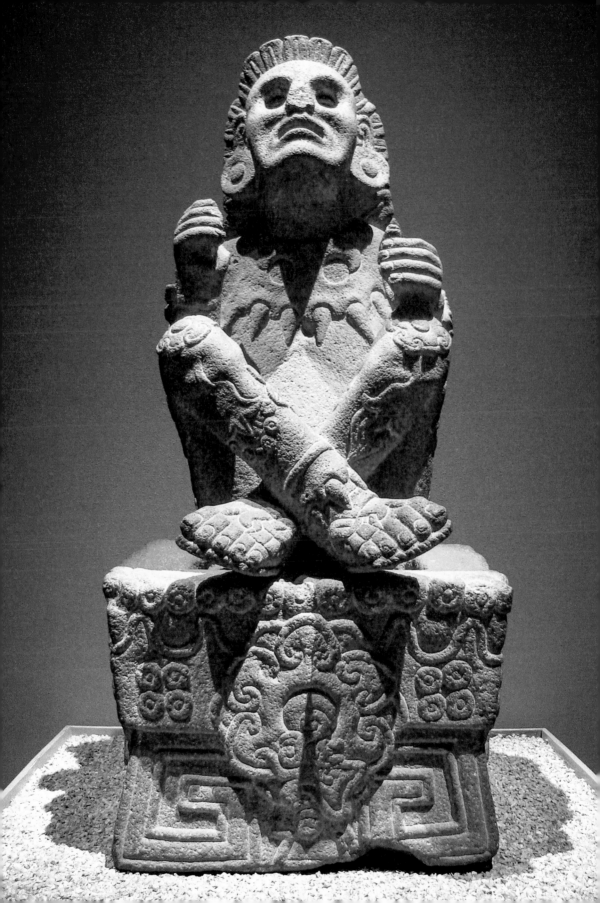

transcendent art, compose music and pen two immense publications on botany, medicinal plants, and healing practices. The first is a nine-volume natural history documenting animals, minerals, as well as plants and their uses, titled *Physica*. The second, *Causae et Curae*, explores Bingen's revolutionary philosophy on the human body and its connection to the natural world. Bingen believed that our health is reliant on the planet's health, and that plants and herbs were powerful allies in healing the

body holistically, but in return, they needed nurturing and stewardship themselves. Bingen's practical education came in the form of experience. Renowned for her medical knowledge, the garden at her abbey was planted with medicinal herbs and botanicals. She and her sister nuns actively treated patients with much success. Her writings, recorded in Latin, remain some of the sole documentation of the vast medical and herbal knowledge of predominantly female healers of the Middle

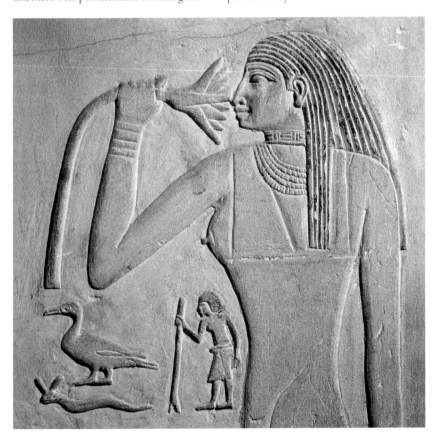

Unknown · *Xochipilli* · Mexico · Unknown Seated at the base of a temple, the God of love, flowers, art, and dance is painted in bold colors from the Borgia Codex, a pictorial manuscript from Central Mexico. His association with the flower symbolizes the blossoming of the human soul.

Unknown · *A Relief of the Wife of Nikaure* · Egypt · 5th Dynasty Found in the sun-temple of King Neferirkare, the relief of the wife of Hathor priest, Nikaure, holds and smells a single lotus flower, sacred to Egyptians.

Ages, as most women of the era were illiterate, passing down traditions verbally and through mentorship, from one generation to the next. Writings on botany and herbal medicines were reserved primarily for men, but specifically for the libraries of royalty and for the wealthy, as these hand-crafted, hand-illustrated tomes were rare and extremely expensive. It was not until the advent of woodblock printing processes, first used in China in the 9th century and later with Johannes Gutenberg's invention of the printing press in 1436, that botanical knowledge was finally disseminated around the world. Books on botany became extremely popular during the Renaissance, as well as the use of plant symbolism in paintings, sculpture, and illustrations of the era. Vast gardens were planted as a show of status at palaces and in cities across Europe, Asia, and the Middle East. Plants became muse, medicine, and commodity, most notably in the late 1500s, when the tulip was first imported to Holland from the Ottoman Empire. An all-out craze for the flower ensued and for a moment, during a phase appropriately named "tulip mania," the multi-hued flowering plants were worth more than gold.

FULL BLOOM

In the 17th and 18th centuries, the Age of Enlightenment would usher in an intellectual and philosophical movement that would result in a groundswell of botanical and medicinal studies. One of the most renowned botanists of this period was the Swedish physician Carl Linnaeus, whose prolific writings resulted in the study and categorization of thousands of plant species. His book, *Systema Naturae*, printed in 1735, identified over 7000 thousand botanicals. 1751's *Philosophia Botanica* expanded upon Linnaeus' philosophies regarding the plant world. His *Species Plantarum*, released in 1753, established a plant-naming system that is still used today. Like Abbess Bingen before him, Linnaeus saw God's work in the beauty of the natural world. In his preface to *Systema Naturae* he states, "The Earth's Creation is the glory of God, as seen from the works of Nature by Man alone." His vast and in-depth writings would have a profound effect on the modern study of botany, horticulture, and ecology. Linnaeus was also greatly admired during his lifetime, respected, and celebrated by his contemporaries. His fellow Swede, the author August Strindberg once wrote of him, "Linnaeus was in reality a poet who happened to become a naturalist."

Meanwhile, in the arts, the genre of botanical illustrations was thriving, with new editions of herbal texts being published the world over. In 1675, with the release of her *New Book of Flowers* the Swiss naturalist and talented illustrator Maria Sibylla Merian would provide the aesthetic groundwork for generations to come. Her ornate, highly detailed drawings of plants were an inspiration, particularly to female artists, including the Scottish illustrator Elizabeth Blackwell, best known as the author and engraver for the immensely popular tome *A Curious Herbal*, published between 1737 and 1739. Painting specimens from the Chelsea Physic Garden in London, a four-acre plot established in 1673 to grow medicinal botanicals, Blackwell elegantly documented nearly 500 plants and their uses. With the success of *A Curious Herbal*, Blackwell was able to support

Robert John Thornton · *Nymphaea Coerulea* England · 1812 From the *The Temple of Flora*, a book by Robert John Thornton considered by many to be the greatest of all flower books. The plate portrays the blue lotus, known for its psychoactive properties used by Egyptians to attain higher levels of consciousness.

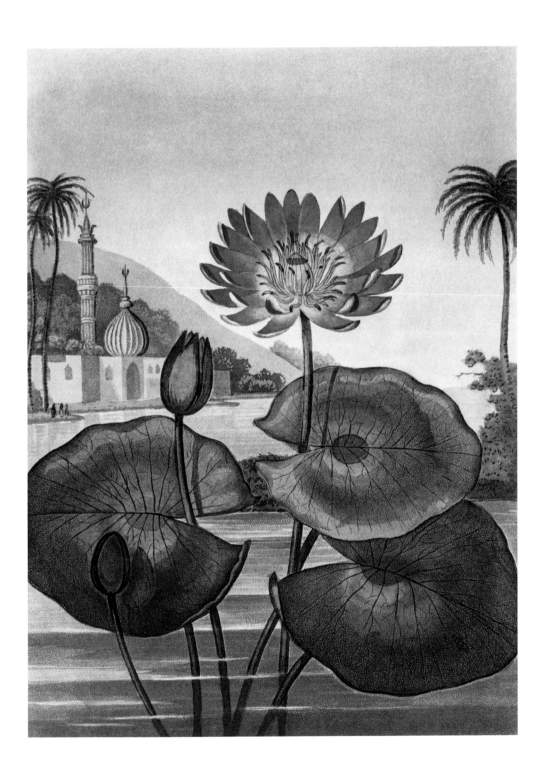

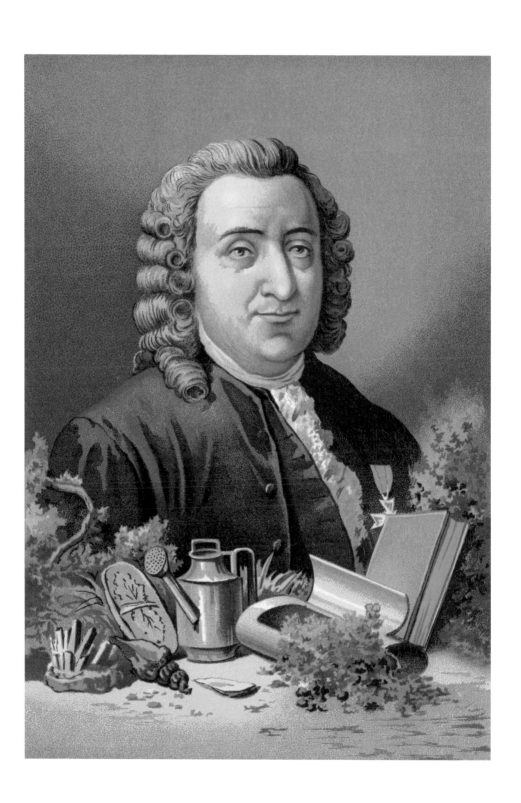

her child and raise funds to ensure her husband's release from a debtor's prison. While her work was disregarded by many male botanists of the era as "amateur," Blackwell is now considered to be one of the most important cultural figures in herbalism and plant medicine. Over the next few centuries, long before the invention of photography, Blackwell and other artists would offer vibrantly realistic renderings of rare botanicals and exotic mushrooms, trees, flowers, and herbs, ultimately helping to share with the public the remarkable beauty and diversity of the natural realm. The talents of artists such as Pierre-Joseph Redouté, one of France's premiere botanical illustrators of the early 1800s and later, the works of English artist Marianne North, would earn accolades not just from the science community but by the art world as well. Redouté's work would be hung in the Louvre, while North has her own gallery at Kew Gardens in England. One of the preeminent botanical illustrators of the Victorian era, North was also an avid plant-hunter as well, documenting botanicals discovered during her extensive travels to Europe, North and South America, Australia, Asia, and Africa.

The scientific study of nature in the 19th century would culminate with the 1859 release of Charles Darwin's *The Origin of Species*. Darwin's thesis — that humans, animals and plants are interrelated and thereby defined as co-dependent — would inspire a new era of ecology and environmentalism. And our perception of the natural world would be irrevocably transformed. Through the late 19th century, the Romantic Movement in English literature, and the Transcendental philosophies of American authors such as Ralph Waldo Emerson and Henry David Thoreau embraced a return to nature for both spiritual sustenance and creative inspiration. "The happiest man," exclaimed Emerson in his best-selling book of essays, *Nature*, first published in 1836, "is he who learns from nature the lesson of worship." Later amid the throes of the Industrial Revolution, many began to seek solace in the natural world, our innate connection to the Earth and its bounty severed by smokestack and assembly line.

POLLINATION AND PROPAGATION

Over the next century, advances in science and technology would allow for the synthetization and manufacture of fungi and plant-based compounds into a wide array of medicines and materials. Perhaps the most revolutionary of these was the isolation of compounds found in ergot, a fungus that grows on grains, by Albert Hofmann. Lysergic acid diethylamide was first synthesized by Hofmann in the late 1930s, but it was not until 1943 that he would discover L.S.D.'s psychedelic qualities after ingesting a trace amount in his laboratory. He wrote of the experience, "In a dream-like state… I perceived an uninterrupted stream of fantastic pictures, extraordinary shapes with intense, kaleidoscopic play of colors." Hofmann's discovery would allow the modern Western world entry into a rite long considered sacred to ancient and indigenous cultures — the use of plant medicines for shamanic transformation and enlightenment. Over the next few decades, the study and use of the psychoactive plants and mushrooms would definitively alter the state of culture and consciousness.

José Armet Portanell · *Carl Linnaeus* · Spain 1878 Carl Linnaeus was a Swedish botanist who created the system we use for classifying plants. His work was hugely influential in the modern study and categorization of various botanicals and fungi. The illustration is from the book *La Ciencia Y Sus Hombres* by Luis Figuier.

A contemporary of Hofmann's, the Harvard scholar Richard Evans Schultes, was one of the first Westerners to study the use of plants in indigenous ceremony, writing his undergraduate thesis on Native American peyote rituals in 1937. In 1941, Schultes received his PhD. in Botany, penning his doctoral dissertation on the use of hallucinogenic mushrooms and morning glory in indigenous Mexican cultures. Schultes' early work would have a huge influence on key figures in what was to become known as the field of ethnobotany. Inspired by Schultes' study of psychoactive mushrooms, the American businessman Robert Gordon Wasson and his wife, Dr. Valentina Pavlovna Guercken, a pediatrician, scientist, and experienced mycologist, traveled to Mexico in the hopes of participating in a traditional ritual of the indigenous Mazatec peoples. The couple were welcomed by the shaman Maria Sabina, who graciously allowed them access to a healing ceremony involving the ingestion of psychoactive mushrooms. A photo essay of this experience, published by the Wassons in *Life* magazine in 1957, would expose what had once been a secret, sacrosanct medicinal rite – to the world at large. The floodgates of consciousness, or what the English writer Aldous Huxley would term, "the doors of perception" – had suddenly been flung open. Throngs of eager scientists, artists and seekers began studying and experimenting with mushrooms and other plant medicines such as peyote and ayahuasca. At Harvard, in 1960 the young psychologists Timothy Leary and Richard Alpert began their infamous Harvard Psilocybin Project, using Hofmann's synthesized versions of psilocybin and L.S.D. in various experimental trials. In 1970, ethnobotanist Terence McKenna and his brother Dennis would travel to the Amazon, publishing their experiences with the area's hallucinogenic plants in their 1975 book, *The Invisible Landscape: Mind, Hallucinogens, and the I Ching*. Later, in the 1992 book *Food of the Gods*, Terence McKenna would expound upon his "Stoned Ape Theory," which proposed that human consciousness evolved in part due to our primitive ancestor's accidental ingestion of psilocybin mushrooms.

Today, psychedelic plant medicines have experienced a renewed interest within the scientific and psychiatric community and have been embraced by a young generation of spiritual seekers. Journalist Michael Pollan's best-selling book *How to Change your Mind* and *This is Your Mind on Plants*, explore the effects of plant medicine through intimate and in-depth research. The mycologist Paul Stamets, in his book *Mycelium Running*, makes the claim that mushrooms may in fact be a key factor in helping to save the planet. With the environment in crisis, we continue to look for solutions, both in nature herself and within the ancient traditions of plant stewardship long practiced by cultures around the globe. In *Braiding Sweetgrass: Indigenous Wisdom, Scientific Knowledge, and the Teaching of Plants*, written by the Potawatomi scientist and scholar Robin Wall Kimmerer, the author offers insight into the ways that nature, if respected, can be our nurturer and guide. "It is not enough to weep for our lost landscapes," she writes, "we have to put our hands in the earth to make ourselves whole again. Even a wounded world is feeding us. Even a wounded world holds us, giving us moments of wonder and joy."

Mikhail Dmitrievich Ezuchevsky · *Charles Darwin in the Langdon-Down greenhouse* · Russia · 1920
In addition to being the father of evolution theory, Darwin was a botanist and engaged in plant experimentation in his private hothouse.

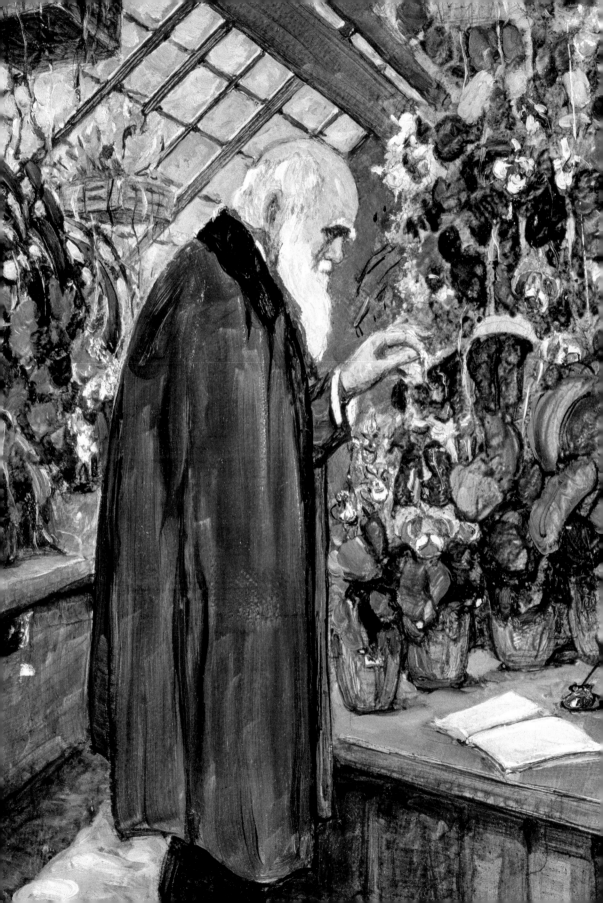

The teachings of the plant world also have an immense impact and influence over my work and practice in the arts. From them I learn about intentional collaboration and interdependence, the necessity of care and nourishment in our pursuit of growth and evolution, and the true blessing of existing in this world. Plants and plant medicine have always been constants in my life. As a child, I didn't know our traditional Afro Caribbean and Afro Dominican healing practices as "plant medicine," but the universe made sure to bring me full circle to my starting point. I came to my formal study of plant medicine about 8 years ago, when my wife was suffering from debilitating, paralyzing migraines. Western doctors prescribed her a series of seizure medications. I started searching for another way. I've been on this journey ever since, learning and growing, sharing, and receiving, dreaming, and deepening my practice alongside my community, my family, and brilliant, visionary collaborators. There is a role for the plants in everything we do. I have been privileged enough to practice alongside other organizers and herbalists operating at small scales to affect change within our neighborhoods and across our interconnected spheres of influence. When I reflect on the enormous efficiency and impact of neighborhood-based mutual aid networks across New York City alone, just from 2020 to the present moment, it restores my faith in what can happen when we approach transformative change from block-by-block model, versus starting with the world. I have witnessed many ways in which movement work has leaned into biomimicry, taking a page from nature's book, emulating systems of nature to address the complex issues of the human condition. The natural world around us continues to be our greatest teacher: the cosmos, the ocean, the plants. They are, at all times, revealing everything we need to know and understand about living in more synchronous coordination with our planet.

— SUHALY BAUTISTA-CAROLINA
Artist, Herbalist, Activist & Founder of Moon Mother Apothecary, 2022

(page 28)
Albrecht Dürer
Portrait of the Artist Holding a Thistle
Germany · 1493
Thought to be one of the first-self-portraits ever painted by a Northern European artist, Dürer poses here with a thistle species known as known as, 'Mannstreu' considered to symbolize fidelity. He may have created this piece as an engagement present for Agnes Frey, whom he would wed in 1494.

(pages 30–31)
Sandro Botticelli
Spring · Italy · 1477–78
An abundance of symbology bursts from the scene in the orange grove, with Venus, Mercury, The Three Graces, all present for the marriage of Zephyr and Chloris. After being wed, Chloris becomes Flora, the Goddess of springtime.

Unknown · *Ikebana* · Japan · 1900s The ancient Japanese art of flower arranging known as "ikebana," translates roughly to "making flowers come alive." The practice originated as botanical altar offerings and has evolved into a complex and symbolic language of shape, color, and form.

Bernie Boston · *Flower Power* · United States · 1967 Peaceful Vietnam protester and LSD spiritualist George Edgerly Harris, who later changed his name to Hibiscus and started the band and collective The Cockettes, boldly pokes a flower into the barrel of a gun being pointed at his face.

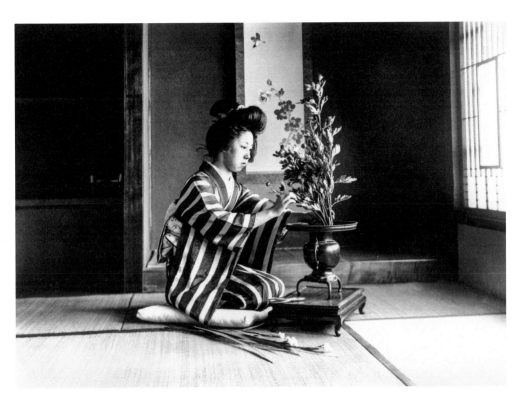
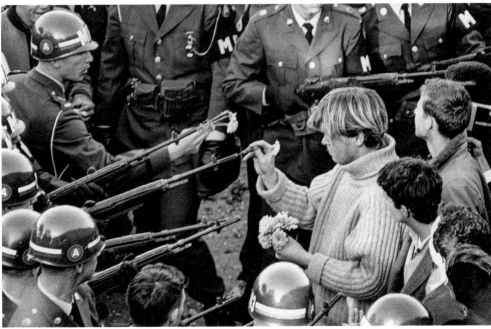

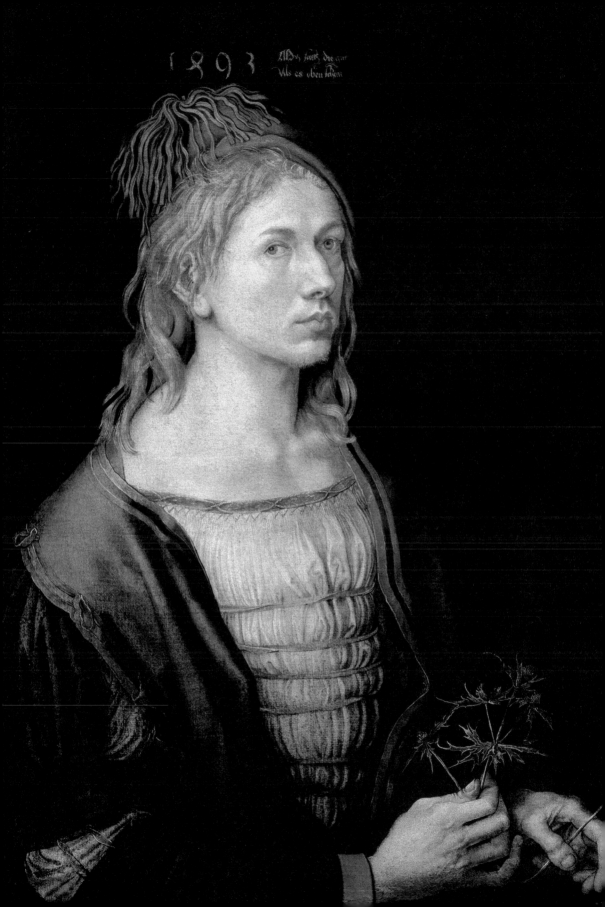

Unknown · *Miss Anne Pratt, The Famous Botanist* · England 19th Century Anne Pratt was a botanical and ornithological illustrator and one of the best-known English botanical illustrators of the Victorian age.

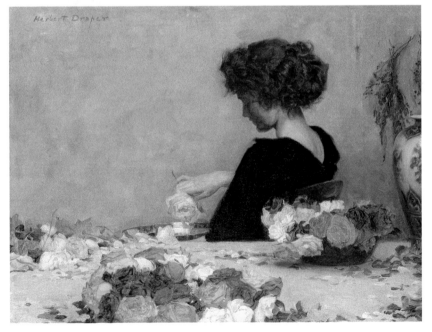

Herbert James Draper *Pot Pourri* · England 1897 Pot-pourri, translated from French to 'putrid pot,' dates to the 12th century when a lack of plumbing required the use of dried flowers, herbs, and spices, yet it is suspected to have been used as early as the time of cave-dwellers.

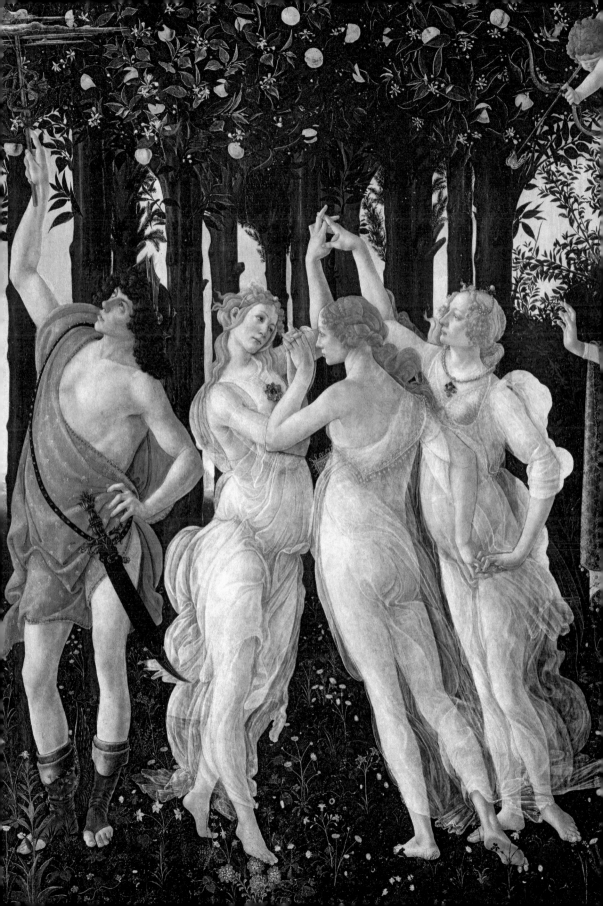

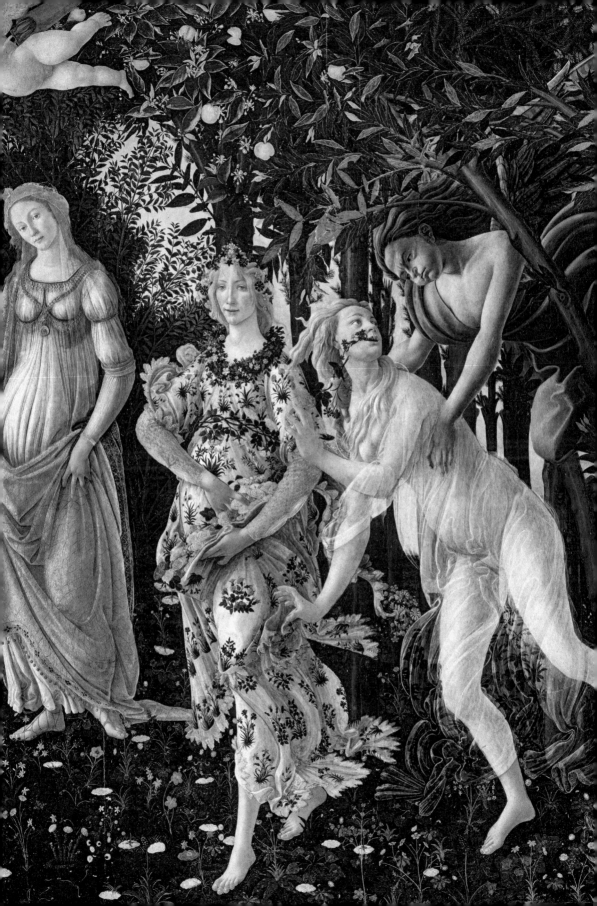

A SYMBIOTIC PARTNERSHIP

A Timeline of Humans in Nature

The Cambrian Period · The first plants are thought to have evolved on Earth nearly 500 million years ago.

The Neanderthal Period · The first species of archaic humans evolved. Archeological discoveries during this era trace the first use of plants for healing to as far back 60,000 years ago.

10,000–4,500 BCE · The Neolithic Revolution. This is a period when humans first began to settle plots of land, planting, and domesticating botanicals. Agriculture is thought to have originated in Mesopotamia and West Asia as traditional hunter/gatherer societies formed permanent communities and began to farm.

10,000 BCE · The earliest evidence of ritualistic use of plants can be traced to rock paintings depicting mushroom species discovered in Australia. Psilocybin mushrooms have been used by indigenous cultures around the globe.

4000 BCE · Archeologists uncovered ancient, preserved peyote effigies in the Shumla caves

Lucas Cranach
Adam and Eve in the
Garden of Eden
Germany · 1534
A cosmic perspective of the most well-known garden, illustrated in the German bible, translated, and made accessible by theologian and reformer, Martin Luther.

along the Rio Grande on the border between Mexico and the United States, suggesting the ritualistic use of sacred cactus.

3350–3105 BCE · One of the oldest existing mummies, discovered in the Alps and named Ötzi the Iceman by archeologists, is thought to have lived in Europe between 3350 and 3105 BCE. Among the Iceman's belongings were intricate birch bark baskets, and a pouch containing berries and various mushroom species, the latter most likely used for medicinal purposes as well as for tinder in lighting fires.

3000 BCE · The use of plants in healing is a practice that goes at least as far back as to ancient Sumer. Archeologists have discovered written documentation of medicinal botanicals, carved by Sumerians long ago onto clay tablets dating to this era.

2800 BCE · Shennong, considered the forefather of modern Chinese Medicine is thought to have penned what became known as *Materia medica*, considered one of the oldest books on the use of plants for healing.

2100–1200 BCE · *Epic of Gilgamesh*, the ancient Sumerian poem, is one of the oldest known pieces of written literature in the world. *Gilgamesh* tells of a hero's quest for immortality through his search for a life-giving plant.

1550 BCE · *Ebers Papyrus* is written, one of the first medicinal texts, a scroll found in Egypt consisting of documentation of botanicals utilized to cure an array of ailments.

1450–392 BCE · An ancient celebration of the Goddess Demeter celebrated outside Athens, Greece, The Mysteries at Eleusis, as they were known, were secret ceremonial rituals that may have involved the ingestion of psychoactive plants or mushrooms.

1200–200 BCE · Archeologists uncover ancient carvings of a figure holding a San Pedro cactus, thought to have been created by the Chavin artisans who flourished in Péru during this era.

1200 BCE · The *Atharva Veda*, is written, the ancient Hindu scriptures which outline the tenets of Ayurvedic Medicine. One of the

— PALEOZOIC — 3000 BCE —

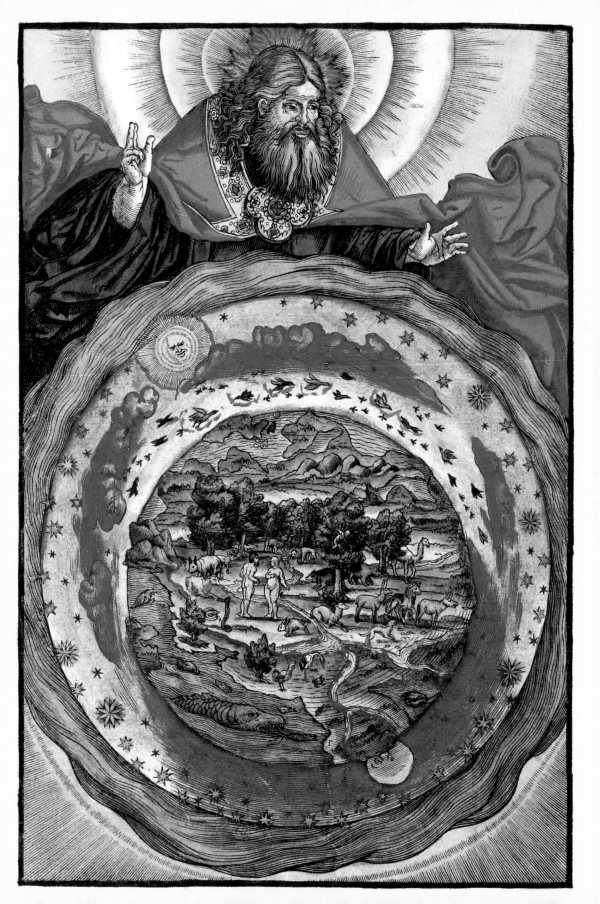

world's oldest healing systems, Ayurvedic modalities use plants and other botanicals to cure a host of illnesses.

800–200 BCE · The *Upanishads*, a Sanskrit texts outline Hindu philosophy mention a cosmic tree called "Asvattha." It is said to grow upside down, its roots deep in the heavens, its branches reaching down toward Earth.

563–483 BCE · The historical Buddha, Prince Siddhartha Gautama, is born and at age 29, while meditating under the Bodhi or sacred fig tree, achieves enlightenment.

460–370 BCE · Hippocrates, the Father of Medicine, studies and expands upon existing botanical knowledge in his teachings.

350–287 BCE · *Enquiry into Plants* or *Historia Plantarum* by the Greek scholar Theophrastus is written documenting numerous plant varieties and their uses.

200 BCE · In early Mesoamerica, statues of mushroom deities have been uncovered by archeologists that may have been carved during this era.

50–70 CE · *De materia medica* penned by Greek physician Pedanius Dioscorides, becomes a precursor to nearly all botanical texts to come. The book would be translated into several languages, copied and illustrated by hand into countless editions.

77 · Pliny the Elder publishes *Natural History*, a multi-volume series on agriculture and horticulture that would become another key contribution to our modern knowledge of botany. *Natural History* also includes an extensive overview of plants and their uses, both medicinally and in religious and spiritual ceremony.

200s · In China, a process of pressing the pulp of certain trees and plant materials is developed, eventually evolving into the paper we know today, now most often manufactured using the cellulose fibers processed from a variety of tree wood as well as grasses and plants such as cotton and hemp.

600 · *Tipiṭaka (Verses of the Elder Monks)*, a series of sacred Buddhist verses is penned, mentioning the use of plants. The volumes are written over a three-hundred-year period, with some verses dated as early as the late 6th century BCE.

1025–1027 · The gifted Persian philosopher Ibn Sina pens two important volumes of plant medicine with his *Canon of Medicine,* and *The Book of Healing*.

1001–1064 · Islamic scholar and physician Ibn Buṭlān compiles the vast encyclopedia known as *Historia Plantarum*.

1098 · Benedictine Abbess, Hildegard von Bingen is born. Bingen would pen nine-volume natural history documenting animals,

minerals, as well plants and their uses, titled *Physica*. Her second book, *Causae et Curae*, explores Bingen's revolutionary philosophy on the human body and its connection to the natural world.

1436 · Johannes Gutenberg's invention of the printing press allows botanical knowledge to be disseminated in printed publications around the world.

1554 · *Cruydeboeck*, a book of herbal medicine, is written by the Dutch physician and botanist Rembert Dodoens.

1500s · The naturalist, herbalist, and physician Li Shizhen, compiles his *Compendium of Materia Medica*, which lists hundreds of plants and herbs key to Chinese Medicine modalities.

1500s · The tulip is first imported to Holland from the Ottoman Empire and "tulip mania" seduces all of Europe.

1552 · The *Badianus Manuscript* is penned, a detailed overview of ancient Aztec plant medicines, written by the physician, Martinus de la Cruz, and translated into Latin by Juannes Badianus. Both authors were of Aztec descent and students at College of Santa Cruz.

1560 · Spanish priest Bernardino de Sahagún writes his expansive tome *The General History of the Things of New Spain,* documenting Aztec peyote and plant medicine ceremonies.

500 BCE —— **1000 CE** —— **1500**

1597 · John Gerard publishes *Herball, or Generall Historie of Plantes*, an illustrated overview of herbs and plants.

1655 · Dioscorides' famous *De materia medica* is translated into English for the first time by the botanist John Goodyer.

1661 · Under King Louis XIV, the first designs were created for what will become the expansive Gardens of Versailles.

1675 · The *New Book of Flowers* is published by Swiss illustrator Maria Sibylla Merian.

1707 · Swedish physician Carl Linnaeus was born. Linnaeus' prolific writings resulted in the study and categorization of thousands of plant species. He penned numerous important botanical books including *Systema Naturae*, *Philosophia Botanica*, and *Species Plantarum*. Linnaeus would develop our modern system of plant categorization and identify over 7000 thousand species of botanicals in his lifetime.

1739 · Artist and author Elizabeth Blackwell publishes the immensely popular illustrated botanical tome, *A Curious Herbal*.

1822 · The American journalist and landscape architect Frederick Law Olmsted is born. In 1858 Olmsted is awarded his first commission, the design of New York City's Central Park. The result was a space that expressed Olmsted's

belief that the concept of the "public" park meant that it should be accessible to all.

1836 · Ralph Waldo Emerson publishes his book of essays, *Nature*, in which he defines the philosophies of the burgeoning Transcendentalist Movement.

1838 · The author, botanist, ecologist, and conservationist John Muir is born. His writings documenting nature in the American West helped to advocate for the initial formation of the National Park system in the United States.

1854 · Transcendentalist and author Henry David Thoreau publishes his memoir of his time spent living in nature in his book, *Walden, or Life in the Woods*.

1855 · Walt Whitman publishes *Leaves of Grass*, a cathartic book of poetry celebrating humans' relationship to each other and to the natural world.

1859 · Charles Darwin's *The Origin of Species* is published, inspiring a new era of ecology and environmentalism.

1864 · The pioneering inventor George Washington Carver is born into slavery to become one of most important scientists in American history. Carver's vast legacy of work would result in huge advances in the fields of agriculture, ecology, and environmentalism.

1898 · The use of psychoactive cacti is documented by a Western author in *Mescal: A New Artificial Paradise* by the physician Havelock Ellis. The essay details his research into indigenous ceremonies and his own personal experience ingesting peyote.

1943 · On April 19, on what would later become known internationally as "Bicycle Day" the Swiss chemist Albert Hofmann intentionally ingests L.S.D. a compound he had successfully synthesized from ergot fungi nearly a decade prior.

1953–1954 · The English author and philosopher Aldous Huxley documents his personal psychedelic experience with mescaline, a compound found in the peyote and San Pedro cacti, in his book, *The Doors of Perception*.

1957 · The researcher Humphry Osmond, who, in the late 1950s, conducted some of the first experiments with hallucinogens as potential therapy for mental illness, coins the term "psychedelic" at the New York Academy of Sciences.

1957 · *Life* magazine publishes the photo essay "Seeking the Magic Mushroom" documenting the experiences of R. Gordon Wasson and his wife, Dr. Valentina Pavlovna Guercken with the Mazatec shaman Maria Sabina. As a result, the ritual use of psychoactive mushrooms is introduced for the first time widely and to a Western audience.

1700 ——————— 1800 ——————— 1900 —————

1960 · Dr. Timothy Leary and Dr. Richard Alpert, psychology professors at Harvard, initiate the first sessions of the "Harvard Psilocybin Project," studying the use of psychoactive mushrooms on mental health.

1962 · The conservationist and marine biologist Rachel Carson publishes *Silent Spring*, warning of the dangers of chemicals and pollution on the natural world, igniting the international environmental movement.

1970 · Ethnobotanist Terence McKenna and his brother Dennis travel to the Amazon to study hallucinogenic plants, the first of many trips which informed their various books on the subjects of psychoactive plants and fungi.

1973 · *The Secret Life of Plants*, a book by Peter Tompkins and Christopher Bird is published. Based on the experiments of biologists Sir Jagadish Chandra Bose and Corentin Louis Kervran, the book makes the claims that plants have sentience and are capable of communication.

1976 · *Mother Earth's Plantasia*, an album by electronic music pioneer Mort Garson, is first released. The tracks on the record were composed specifically to be listened to by plants.

1979 · A documentary based on the 1973 book *The Secret Life of Plants*, is released, featuring a soundtrack by Stevie Wonder.

1979 · In their book, *Plants of the Gods*, scholars Albert Hofmann, Richard Evans Schultes, Christian Rätsch, PhD describe the sacred peyote rituals of Native American tribes and the enduring importance of the plant in both medicinal and spiritual healing.

1980 · Paul Stamets founds his company Fungi Perfecti with the mission to "research, study and preserve and spread knowledge about the use of fungi for helping people and the planet."

1986 · The Multidisciplinary Association for Psychedelic Studies (MAPS) is founded. MAPS specializes in research on the uses of psychedelics and marijuana for mental and spiritual healing.

1992 · Ethnobotanist and organic psychoactive researcher Terence McKenna releases his book, *Food of the Gods, The Search for the Original Tree of Life: A Radical History of Plants, Drugs, and Human Evolution.*

1994 ·American author and herbalist Rosemary Gladstar founds the non-profit United Plant Savers, whose mission is to "protect native medicinal plants, fungi, and their habitats while ensuring renewable populations for use by generations to come."

1998 · *The Encyclopedia of Psychoactive Plants* is published by German anthropologist Christian Rätsch. One of the most comprehensive publications ever written

on the subject, the book details the botany, history, distribution, cultivation, and preparation and dosage of more than 400 psychoactive plants.

2009 · American journalist and documentarian Hamilton Morris debuts his monthly column on psychoactive drugs for *Vice* magazine titled, "Hamilton's Pharmacopeia." The column would eventually evolve into the documentary series of the same name, produced, written, directed, and starring Morris.

2013 · Biologist and scholar Robin Wall Kimmerer, releases her book, *Braiding Sweetgrass: Indigenous Wisdom, Scientific Knowledge, and the Teachings of Plants.*

2000s–Present · Authors such as Michael Pollan and Paul Stamets release influential books on the study of fungi and psychoactive plants for both planetary health and spiritual and mental well-being. Meanwhile, a new generation of ecologists, botanists, farmers, and environmentalists such as Alexis Nikole Nelson and Marcus Bridgewater, explore and celebrate the natural world through publishing, film, social media, and activism.

Maurice Harris
Shades of Blackness, Vol. 2
#untouched #nofilter
#naturalopulence
United States · 2018
A Los Angeles-based florist, performer and artist, Harris utilizes flowers and other natural elements in portraits celebrating their community. In a photographic series titled, "Shades of Blackness" the artist captures the model Gracie Cartier framed in vivid florals.

1960 ———— 1980 ———— 2000

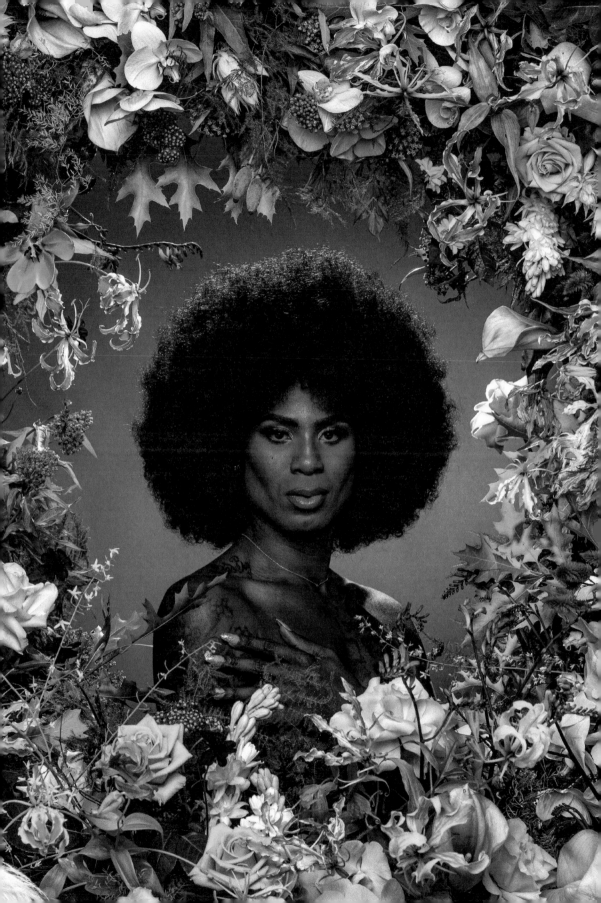

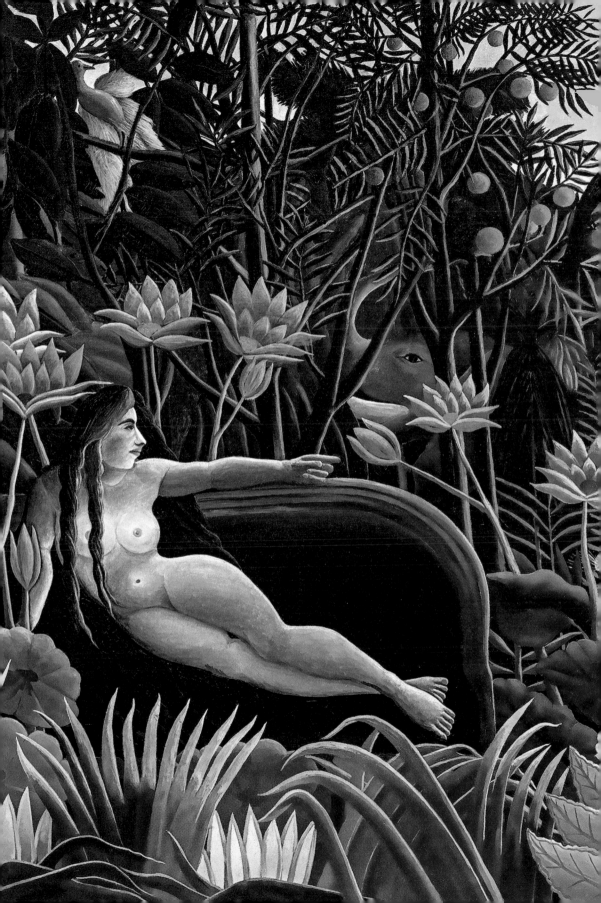

PART II

—

*The Seeds
Are Sown*

SACRED SYMBOLISM
IN NATURE

FIBONACCI

Geometry in Nature

Where there is matter, there is geometry.

— JOHANNES KEPLER

Mathematician, Astronomer, and Natural Philosopher

The Golden Ratio, represented by the Greek letter Phi, can be seen in many aspects of the natural world, an unexpected mathematical universality which blurs the already hazy boundaries between physics and mysticism. Sacred geometry is an underlying presence in almost all natural forms, but the beauty of the Golden Ratio, also known as the Fibonacci Sequence, is perhaps most elegantly expressed in the growth of plants, flowers, fruits and trees. Named for the 13th century Italian mathematician, Leonardo Fibonacci, this mathematical sequence can be best understood as a law of accumulation, created by adding a number to the number prior, beginning with 0 and 1. This formula governs how many botanicals develop — petal and leaf multiplying in a slow accumulation of growth, a process ultimately reflected in elegant geometric forms.

Pinecones and cacti, pineapples, and Sunflowers, for instance all display delicate double sets of spirals, each set adding up to their adjacent Fibonacci numbers. The gentle whorl of Rose blossoms and vegetables such as cabbages also showcase a Golden Ratio arrangement, each petal or leaf circling gracefully around a center stem. Even the Strawberry and the Cauliflower follow the geometric patterns of the Fibonacci sequence. The formula is also on display in the petal count of many flowers. From Daisies to Lilies to Buttercups, florals often reflect a Fibonacci number evolved to allow for space for each petal to best access water and sunlight.

The miraculous mathematics of nature are also often referred to as Divine Proportion, a phenomenon that has been studied for centuries by philosophers, scientists and artists, an endlessly intriguing code embedded in the shapes and growth patterns of plants, trees, and flowers. This sacred geometry seems to appear everywhere one looks, from the closed curve of a Lily about to bloom, in the circular labyrinth housing the seeds of the Sunflower and the Fiddlehead Fern, slowly unfurling its leaves to the sky.

(previous pages) Henri Rousseau · *The Dream* France · 1910 Rousseau is especially celebrated for his dream-like and imaginative paintings that often feature lush renderings of plants and other botanicals. In this work, intricate detail is given to each leaf and frond amid a verdant tropical landscape.

Valero Doval · *Dark Illusion* · Spain · 2016 As part of their series "Visual Arrangements" the artist created mixed-media collages exploring elements of shape, form, and sacred geometry.

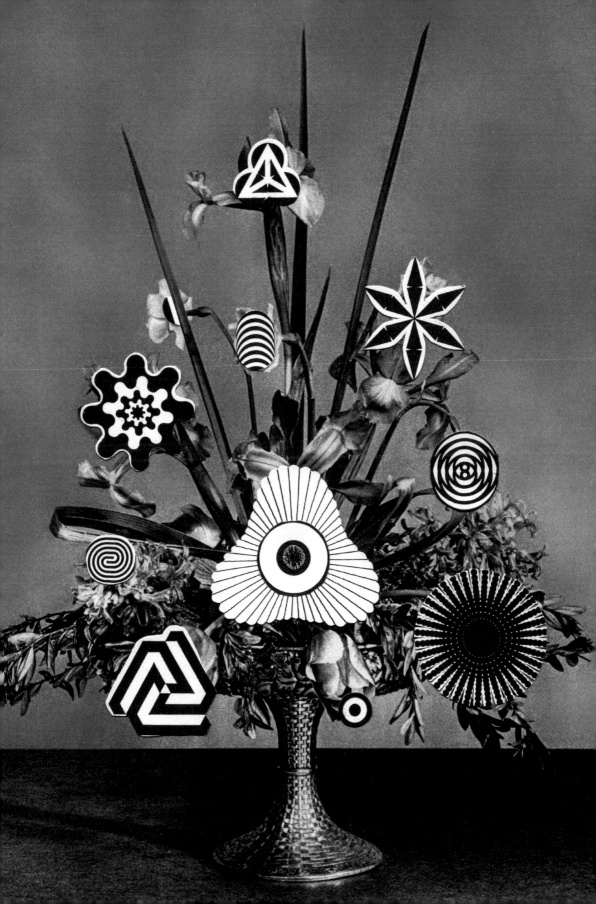

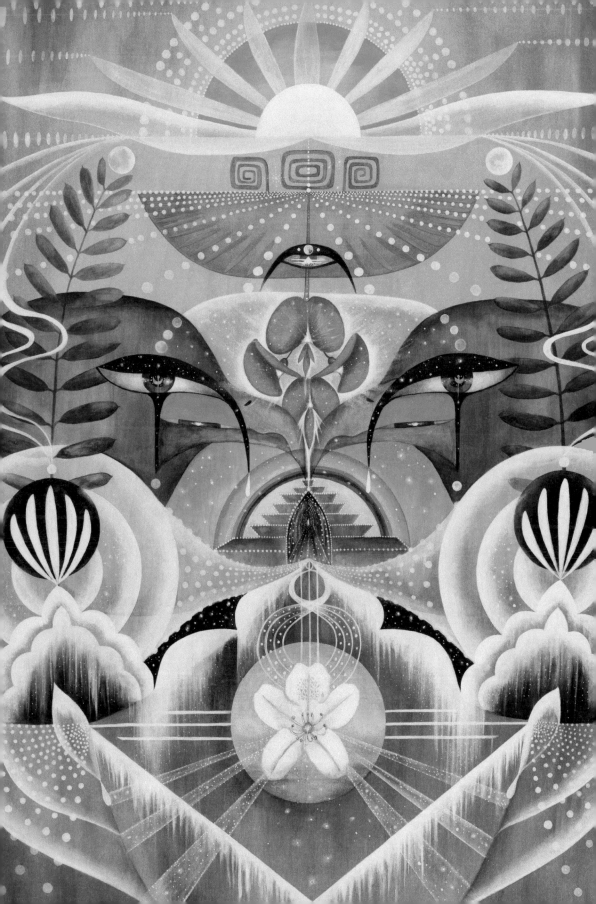

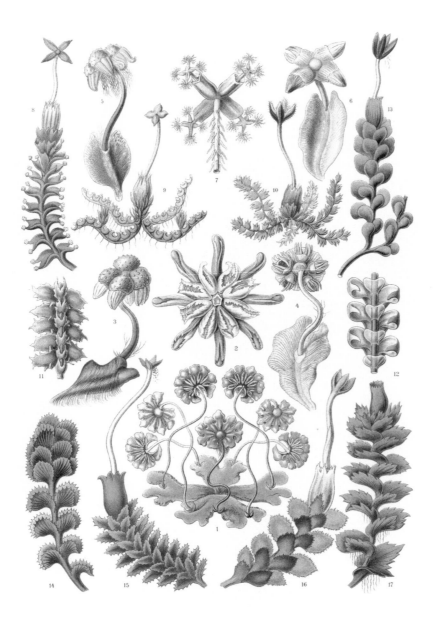

Sarah Stewart · *Hierophant* · United States · 2016
A painter and muralist, Stewart created the
Hierophant as part of a series of 78 Tarot-inspired
images, each of Stewart's illustrations reflects her
primary inspiration – the natural world.

Ernst Haeckel · *Hepaticae* · Germany · 1899–1904
The German zoologist, naturalist, and marine
biologist was also a talented artist, much of his
work documenting the natural world he so passion-
ately studied. This illustration is from his series,
Art Forms in Nature.

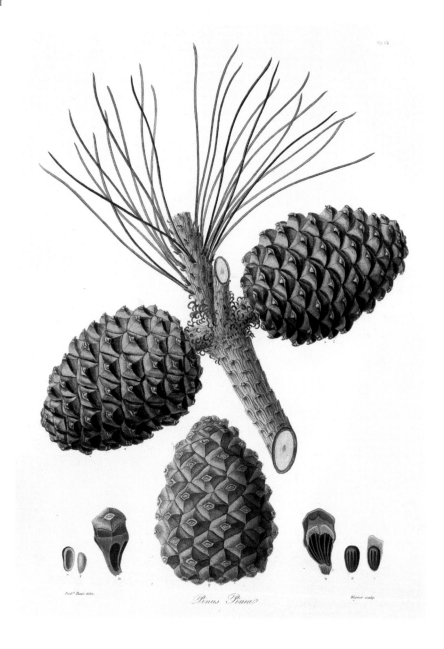

Pinus Pinea

Leonhart Fuchs · *Stone Pinecone* · Switzerland · 1542
An elegant example of the Fibonacci sequence in nature, the pinecone is seen as a symbol of fertility and power. Resembling a pinecone, the mysterious pineal gland, located deep in the brain, produces melatonin, which regulates sleep and human rhythm.

Carl Blossfeldt · *Passiflora* · Germany · 1929
Known for his close-up photos of plants, the artist believed 'the plant must be valued as a totally artistic and architectural structure,' as is the detailed lotus, symbol of purity.

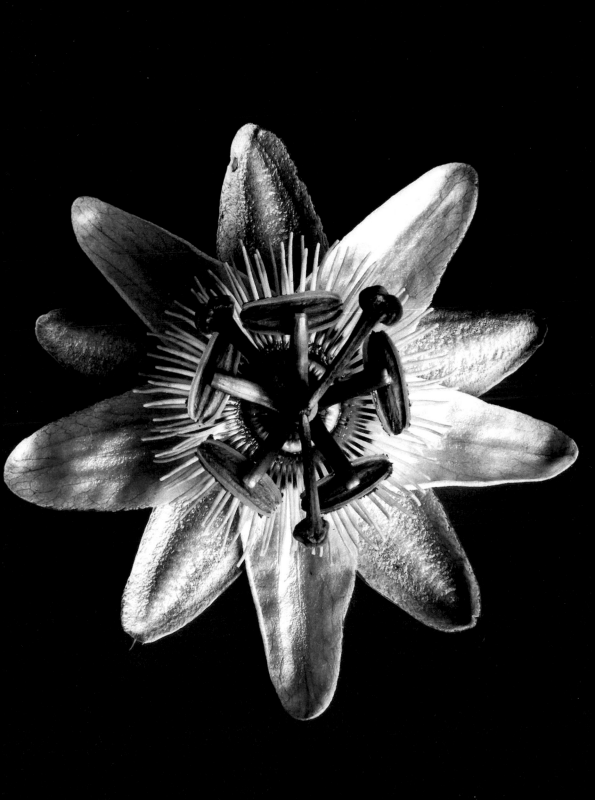

SACRED GARDENS

The Art of Nature

The gardener digs in another time, without past or future, beginning or end...As you walk in the garden you pass into this time — the moment of entering can never be remembered. Around you the landscape lies transfigured. Here is the Amen beyond the prayer.

— DEREK JARMAN, Filmmaker, artist, and writer – excerpt from *Modern Nature*, 1992

From the lush and ordered gardens depicted in early Egyptian and Roman murals, to ancient renderings of the great Hanging Gardens at Babylon, civilizations have long been transforming natural spaces into respites for both contemplation and celebration. The intentional, meditative planting of botanicals can be traced back to the earliest agriculture, to the very first humans placing seed into soil. In cultures around the world, simple farming methods eventually evolved into ornate and elaborate landscaping, with many of these gardens, some planted hundreds of years ago, still growing and blooming today. An existing example of classic Chinese garden design, first planted in the 11th century, remains a celebrated feature in the historic city of Suzhou. In the 16th century, the architect Niccolò Pericoli began building his masterpiece, the Boboli Gardens in Italy, which still flourish today. Construction on the famous gardens at the Palace at Versailles in France first began in

1661. Today, the historic land hosts thousands of tourists each year. In Tokyo, the centuries-old Shinjuku Gyoen still entrances visitors with its bounty of cherry trees, blossoming into beauty each spring.

The garden has evolved as a private respite as well; the landscaped plots of artists, poets, and philosophers are places for both contemplation and inspiration. In 1907, the Swiss psychiatrist and psychoanalyst Carl Gustav Jung, commissioned garden architects Walter and Oskar Mertens — working closely with them to create a home garden that would offer him space for study and meditation. A few decades later, the British writer Vita Sackville-West began building her now famous gardens at Sissinghurst Castle, captivating the public by publishing a series of poetic essays describing her progress on the land. In 1986, following his AIDS diagnosis, the filmmaker, artist, and

Alphachanneling · *Flowers of Life* · United States 2021 Exploring the sensuality through vibrant artworks incorporating floral and botanical elements, the artist known as Alphachanneling offers viewers, "an invitation to indulge in the erotic exaltation of the sublime."

(following pages)
Édouard Manet
*The Monet Family
in Their Garden at
Argenteuil* · France
1884 Along the banks
of the Seine River
fellow artist Claude
Monet with wife Camille
and son Jean are
captured at their
Argenteuil home under
a lovely shade tree.

activist Derek Jarman retreated to Prospect Cottage, his property on the bleak coast of Dungeness, England. The journals he penned there, collected into the 1992 book, *Modern Nature*, document his time at the home, much of it spent building and planting his exquisitely eccentric artist garden, an unexpected mix of plants, flowers, and sculptural elements. For Jarman, this cottage garden offered much needed peace, a sanctuary of calm as he slowly succumbed to his illness.

A century prior, the French painter Claude Monet spent two decades creating his garden in Giverny, a place built for artistic inspiration, which later provided solace amid the First World War. In 1914, he wrote of his gardening progress, "Yesterday I resumed work. It's the best way to avoid thinking of these sad times." Today visitors arrive from all over the world. Monet's garden is still a powerful reminder that nature, creativity, and work – can help to heal us all.

John Gay · *The Rose Garden at Sissinghurst Castle*
England · 1967 From castle to prison, to an
acclaimed garden, Sissinghurst brims with roses
and hedge work to rival any English garden.

Jacques-Ernest Bulloz · *Claude Monet, Giverny*
France · 1905 The French impressionist painter
photographed in his charming garden where he
lived and created.

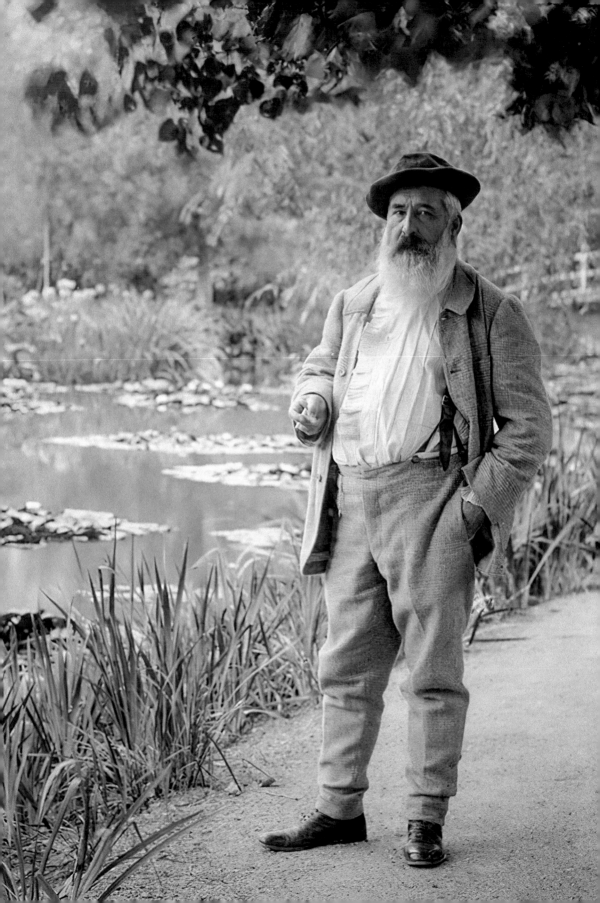

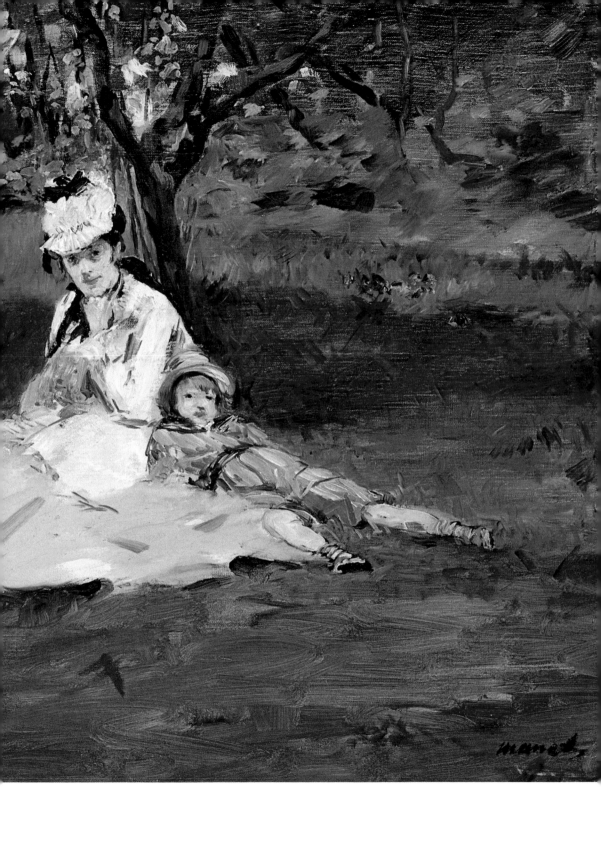

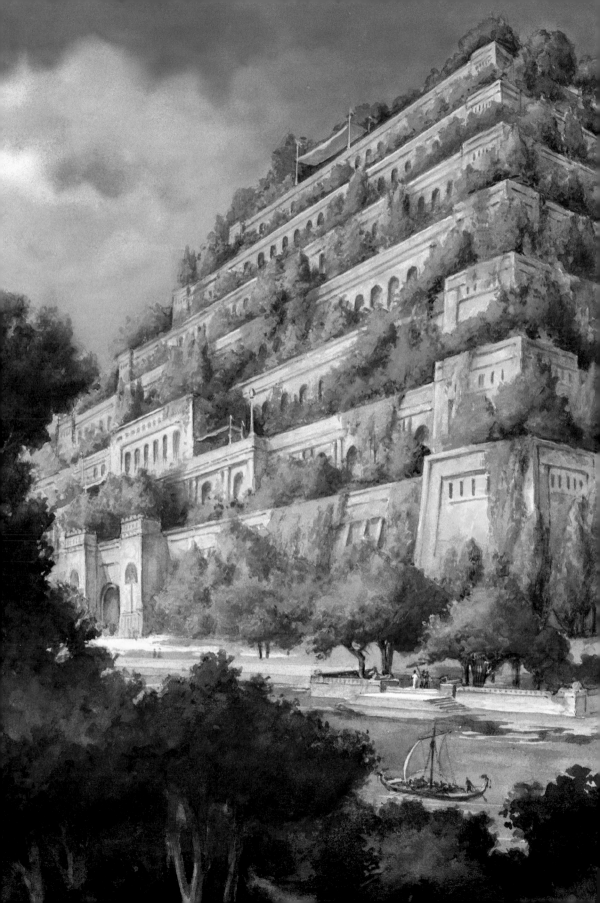

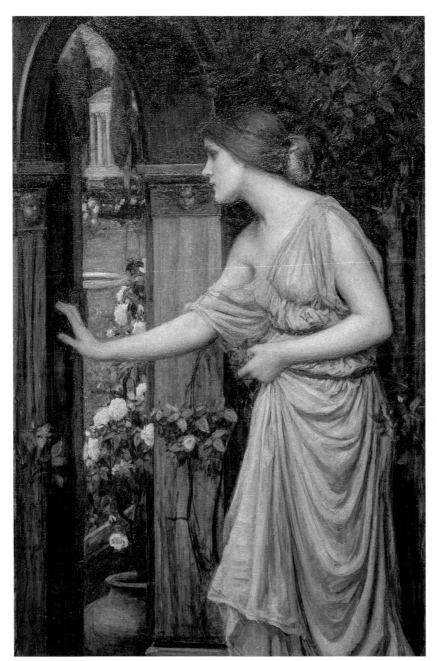

Felix Gardon · *Hanging Gardens of Babylon* France · 20th Century Whether they were mythological, poetic or factually existent, the most elusive of the seven wonders of the ancient world, which beautified the capital of the Babylonian Empire, are the subject of many artworks.

John William Waterhouse · *Psyche Opening the Door into Cupid's Garden* England · 1903 Psyche is trying to catch a glimpse of her secret lover in daylight. Sometimes called 'the last Pre-Raphaelite', Waterhouse used his lush, romantic style in this mythological scene.

53

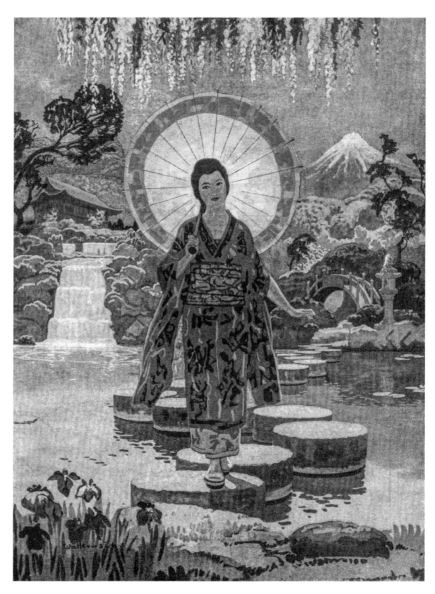

(following pages)
Claude Monet
Springtime · France
1872 The artist's first
wife, Camille Doncieux,
sits in their home
garden of Maison Aubry
in Argenteuil, France.

Unknown · *Japanese lady wearing a kimono* · England
1921 Japanese gardens, renowned for their
peaceful beauty and meditative vibration, are
shown with hanging cherry blossoms on the cover
of *My Magazine*.

Valero Doval · *Silent Spring* · Spain · 2012 Named
for the book by Rachel Carson that warned of the
threat of global warming. In much of his work, as
the artist explains, "my tendency to look for beauty
in contrast; in the combination of opposing con-
cepts that mirror the diversity of man and nature."

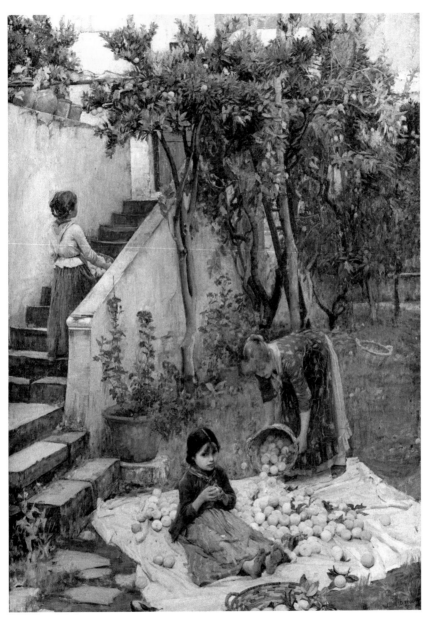

(following pages)
Tuco Amalfi · *Garden of Peace III* · Brazil · 2004
In his prolific series of vividly rendered works, Amalfi envisions an idyllic world. As the artist explains, "Visionary art is not surrealism or fantasy. It is a mission where the artist...allows for divine inspiration so the work can awaken in people the infinite within themselves."

Jeaneen Lund · *Mystic Illusion* · United States · 2021
As part of a series photographed at Claude Monet's home at Giverny, France, Lund's detailed photograph of plant species known as "Mystic Illusion," captures the late painter's intentional use of color and form within the plantings at his famous garden.

John William Waterhouse · *The Orange Gatherers*
England · 1890 The orange tree is considered a symbol of prosperity and was believed to suggest wealth and abundance. Waterhouse enhances the presentation with a bounty of ripened fruit.

RETURN TO EDEN

Plants in Myth & Spirituality

As the flower of a lotus,
Arisen in water, blossoms,
Pure-scented and pleasing the mind,
Yet is not drenched by the water,
In the same way, born in the world,
The Buddha abides in the world;
And like the lotus by water,
He does not get drenched by the world.

— UDAYIN, Buddhist disciple – from the *Tipiṭaka (Verses of the Elder Monks)*, a series of verses
written in a three-hundred-year period, with some dated as early as the late 6th century BCE

The deeply rooted symbolism of plants found within the mythologies and religions of the world, poetically conveys our enduring spiritual connection with the natural realm. Flowers, fruits, trees, and herbs all play integral roles in the foundational narratives of nearly every global culture. In the ancient Mesopotamian epic of *Gilgamesh*, the young hero seeks the secret of immortality, diving to the bottom of sea in search of a healing plant said to possess the power of resurrection. According to the myth, *Gilgamesh* is successful in finding the plant, but it is ultimately stolen by a serpent, who uses it to molt and thus, be reborn. Water plants, particularly the lily and lotus, reoccur frequently in the spiritual and mythological symbolism of various cultures. The Maya of the Central Americas feature numerous depictions of the water lilies in much of their art, the plant seen as representation of sex, fertility, and birth. In fact, the name of the water lily in Mayan, "nikte'ha'" translates roughly to mean, "vulva of the water."

Halfway across the world and along the ancient river Nile, thought to be the birthplace of the earliest civilizations, grows the papyrus and blue lily, both sacred plants to the Egyptian peoples. Emerging gracefully from the muddy shores of the great river, the lotus mirrored the Egyptian myths of creation, death, rebirth, and the rising of the Sun God Ra from primeval waters. Ancient Egyptians integrated flowers and plants into many of their rites and rituals, from the delicate floral weavings that ornamented their dead, to symbolic artworks that depicted

Vasko Taskovski · *Gemini* · Macedonia · 1999
The visionary work of Taskovski transforms ordinary realms into surrealistic fantasy worlds, rich with plant and animal symbolism. Here the zodiac sun sign of Gemini is rendered as tree-like forms emerging from a cosmic egg.

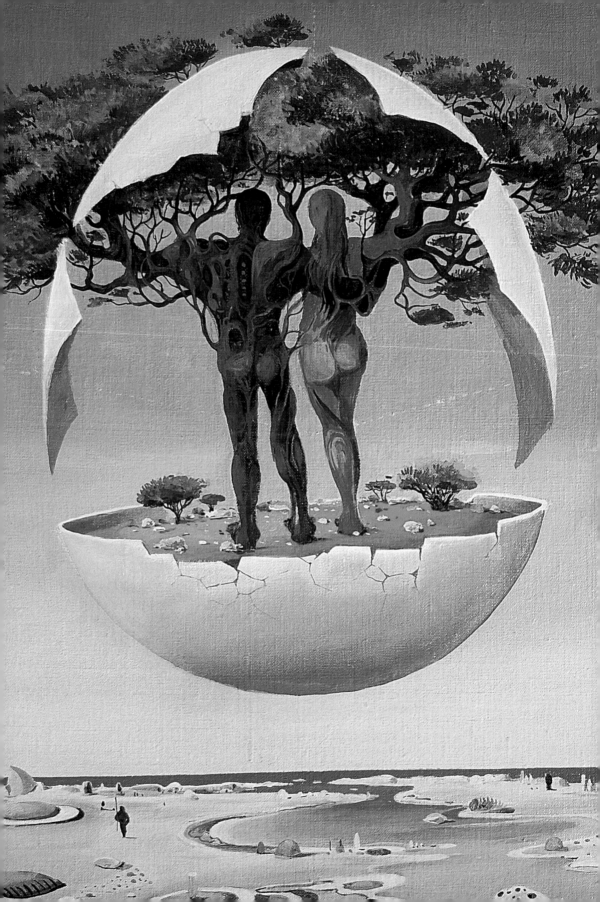

plants as a connection between earthly life and the realm of the gods. The date palm appears often in Egyptian murals and scrolls and is thought to symbolize Ra, while other species of palm trees were often linked to the moon God Thoth. For the Egyptians and many other early pagan and pre-Christian cultures, deities reside among the living, alive symbolically within root and stalk, leaf, and bloom.

In Hindu and Buddhist teachings, the lotus figures prominently, its roots deep in the muddy water emerging into many-petaled flower a symbol of the rising up from our lower depths toward higher enlightenment. The ancient Buddhist scroll, the *Lotus Sūtra*, tells the legend of lotus flowers blooming beneath each step of the infant Buddha. In Hinduism, the goddess Lakshmi is often depicted standing astride a lotus, a symbol of purity and divinity and the god Vishnu is often depicted holding a lotus blossom in his hands. Lotus and other flowers are often offered at Hindu altars, along with other sacred plants and herbs such as Tulsi. The latter is a sacred plant in India, venerated for not only its medicinal qualities, but as a protection against evil and misfortune.

Within the mythologies of the ancient Romans, even the Latin word "flora" itself is aligned with a deity, the goddess of flowers, worshiped in the festivals of the "Floralia" which welcomed in the rebirth and renewal of the spring season. The delicately beautiful Narcissus or Daffodil flower, growing often along streams or riverbanks, is associated with the myth of the vain, doomed Narcissus, worshiping his own reflection in the water. The

pomegranate fruit, red and rich with seeds, was believed in Greek mythology to represent fertility and the underworld, the plant originally thought to have emerged from the blood of the young Adonis, wounded by a boar, and revived by the love of the Goddess Aphrodite.

The fruit figures most prominently in the myth of Persephone, the maiden kidnapped and forced to marry Hades, God of the dead and reside forever in the Underworld. Persephone's mother, Demeter, Goddess of the harvest, was so enraged by the disappearance of her daughter she allowed the soil to go barren and the crops to wither and die. At this, Zeus demanded that Hades return Persephone to her mother in the world of the living. Hades, reluctant, but obedient, fed his wife six seeds from the pomegranate fruit, ensuring she would be forced to return to him and reside in the underworld six months out of every year. The myth explained the natural cycle of the seasons, the abundant blossoming and rebirth of spring, said to mark the joy of Demeter as her daughter emerged from the darkness. And the cold dark of winter represents Demeter's grief as Persephone makes her return to Hades.

For the ancient Druids of the British Isles, trees were objects of worship, particularly the oak, which was considered sacred, a representation of their most powerful deities. In China, the peach tree figured prominently in early Taoist writings, thought to represent longevity. Peach blossoms are still often carried by Chinese brides to represent prosperity and a long marriage. In many Asia cultures, bamboo also plays a key role in legend and folklore and

Unknown · *Radha and Krishna* · India · Unknown
Nidhivan, or 'forest of Tulsi' was a dense and lush garden of mystery where the God Krishna would visit Radha at night. A sacred and medicinal basil plant to the Hindus, Tulsi is said to grow in pairs here, symbolizing their union.

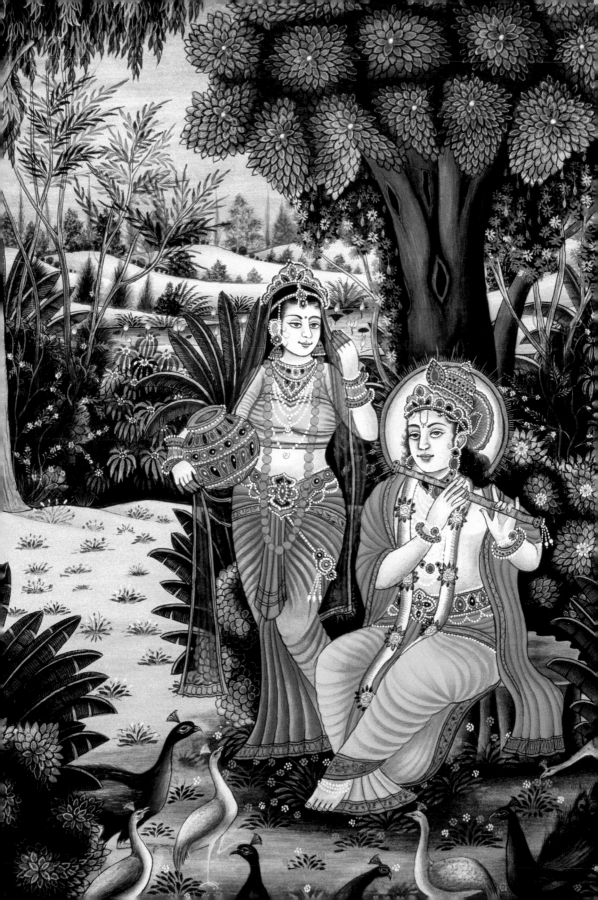

is often associated with strength and longevity. In Norse mythology, the goddess of spring, Idun, is said to be the keeper of magickal apples which impart immortality. In the Greek myth of the Garden of Hesperides, golden apples were said to have grown, a wedding gift from the Earth goddess Gaia to Zeus's wife, Hera, the goddess of women and childbirth. These sacred apple trees were tended by the nymphs known as the Hesperides and protected by a great serpent. In a now-lost epic poem concerning the labors of Hercules, thought to have been penned in 600 BCE, Hercules, the greatest of Greek heroes, is charged with challenging the serpent to retrieve three golden apples for King Eurystheus.

In Christian faiths, the apple is perhaps the most well-known and enduring example of plants as spiritual symbols. Plucked off the branch by Eve in the Garden of Eden, the apple represents forbidden knowledge of sin committed at the bidding of the snake, itself a symbol of evil.

Later, the apple is said to have been held in the hands of Christ, and thus its meaning was transformed. The apple, held by Jesus in many artistic depictions, is thought to represent not condemnation, but rebirth, a second chance for humanity's redemption. Roses also figure prominently in Christian myth, with meanings often linked to color and shape. The five petals represent the wounds of Christ at crucifixion, the red rose associated with his blood and martyrdom. White roses are thought to represent the purity of the Virgin Mary. In many artistic depictions of the Virgin and the infant Christ, roses and other flowers encircle them, garlands or wreaths representing fertility and joy. Lilies are another flower often symbolically linked to Christian teachings, which tell of lilies springing up in each spot where the blood of the condemned Christ touched soil.

Unknown · *Copy of tomb painting of Sebkhotpe* Egypt · 1902–2000 Sebkhotpe and his wife in the garden, are painted on a private tomb. Egyptian art is communicated through visual, detailed symbolism, and their gardens were selected in places where deities were believed to reside.

Harriet G. Barclay · *Sacred Lotus* · United States 1854 An illustration from *Sweet's Ornamental Flower Garden and Shrubbery*. The lotus grows pure and beautiful from the muddy waters and symbolizes the pureness of the human soul, no matter the life experience.

Jesus's resurrection is often celebrated with the Easter or Lily flower. Lilies also represent the virginal state of Mary, the purity inherent in the birth of Christ. The Passionflower, with its many spirals and tendrils, is said to represent Christ's crown of thorns. And of course, grapes and wheat and cereal grains are also important facets of Christian worship, with wine and unleavened bread said to symbolize the blood and body of Christ.

While wheat and grains represent the body of the savior in Christian religions, corn and maize were considered the food of the gods in the belief systems of the indigenous South American peoples. Corn and other flowers were believed to have been divine offerings from the Mayan and Aztec gods. The great Xochipilli known also as, "Flower Prince" was said to be the Aztec god of maize. Corn was often depicted in Aztec artworks and carved totems as both a young man and a young woman, a plant which symbolized the powers of both genders and represented strength, fertility, death, and rebirth. In North American indigenous cultures, corn was thought to be a gift from the Great Spirit and considered a sacred food, used in ritual and worship. In Native American cultures a mix of plants and herbs known by the Algonquian word, "Kinnikinnick" were often gathered, an array of botanicals often including sage, cedar, and tobacco. The plants were then dried, mixed together and placed into leather satchels to be used as ceremonial offerings.

Across cultures, mushroom species were also assigned various mythologies, symbolizing for instance, longevity and strength in ancient

Chinese and Asian cultures. In early Egypt, mushrooms represented immortality and were often depicted in their hieroglyphs, some thought to be over 4,500 years old. Circles of mushrooms found in the forests of Europe and Britain were sometimes referred to as "fairy rings," their appearance woven into the narratives of ancient folk tales as the signifiers of hidden fairy realms. Mushrooms also make an appearance in early Christian artworks and frescos, including depictions of psilocybin mushrooms. The use of mushrooms in ritual ceremonies is particularly prevalent in ancient Mesoamerica. Both Mayan and Aztec cultures were thought to use the hallucinogenic compounds of mushrooms in various shamanic rites. Stone figures formed into the shapes of mushrooms or carved with mushroom imagery, have been discovered by archeologists at various sites across Central America, with some "mushroom stones," as they are known, dating back 1000 years or more.

Again and again, across the world, our myths, spiritual beliefs, and shared stories are reflected in plants and nature. We see a mirror of our yearning for enlightenment in the lotus stalk, pushing up through silt and dark waters, seeking air and sunlight. We strive for the gentle purity embodied by the white Rose bloom. We see symbols of our shared joys and laments in the cycle of the seasons, in the seed birthing sprout, in the last dead leaf, falling softly from winter branches. We worship at the altar of nature herself, our deities continually transforming, taking the form of the plants, trees, flowers and fruits, the botanical world sustaining not only our bodies, but our spirits as well.

Henri Rousseau · *Eve* · France · 1906–1907 Amid a tropical garden Eve reaches for the apple offered by the serpent. The fruit in Christian myth is thought to symbolize forbidden knowledge and desire.

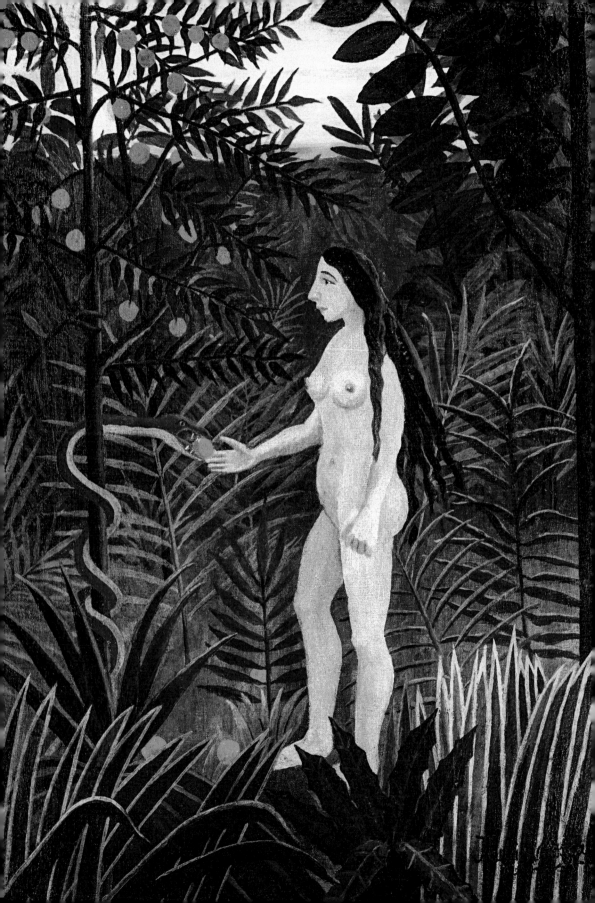

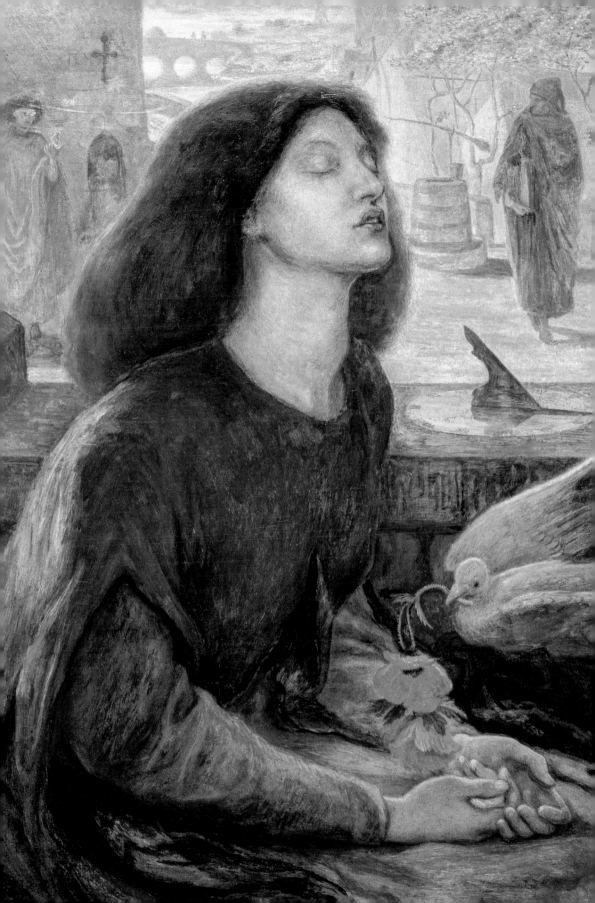

I've always been interested in the extravagance and the exuberance
that is a flower. It's like a living jewel that everybody has access to.
As a child, I used to watch my grandmother manipulate flowers into
arrangements and into headpieces for her church lady hats and the
transformation was quite magical to me. I've always been interested
in the element of magic; I've always been interested in the idea of
effortlessness — things that look easy but are hard to do. The art of
flower arranging is exactly that. It's very difficult to achieve simple
shapes and dynamic arrangements. As a black child raised in Califor-
nia, surprisingly/not surprisingly I didn't have a big connection to
nature. It wasn't until I became an adult playing with flowers that
I became interested in where flowers came from. Going on nature
walks in Griffith Park, going on hikes in Malibu and perusing the
botanical gardens at the Huntington really started to connect the dots
for me between how I relate to nature and how important it is as a
force. Being surrounded by trees, by blooms, by greens that you can eat,
flowers you can smell is what it means to be connected to the circle of
life. Which we obviously need. We need the oxygen that trees produce,
and they need the carbon dioxide that we produce. I think that in most
urban landscapes, we forget that nature has more power than we do.
As humans we think we rule the world and nature constantly has to
remind us that we are living in its world. The more present we are to
the gifts that nature gives us, the closer we get to respecting our world.

— MAURICE HARRIS, Florist, Multimedia Artist & Performer, 2022

Dante Gabriel Rossetti · *Beata Beatrix* · France
1877 The painting depicts Beatrice Portinari from
Dante Alighieri's 1294 poem *La Vita Nuova*, at the
moment of her death. Rossetti intended the dove

to be red and the poppies to be white symbolizing
the means to her death, but another artist finished
it and switched the colors.

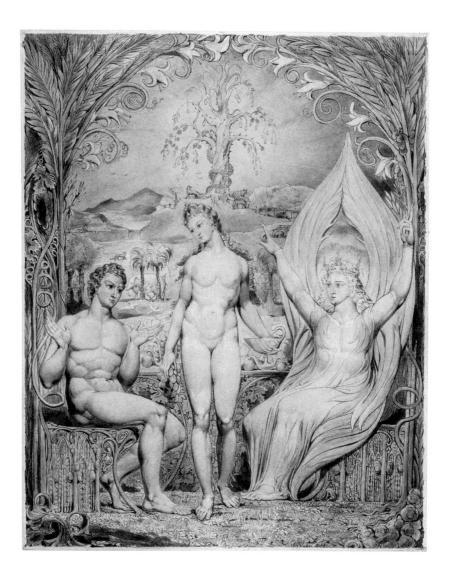

William Blake · *Archangel Raphael with Adam and Eve* · England · 1808 Archangel Raphael descends from heaven to an ornate garden of Eden to warn Adam and Eve not to be tempted by evil. The image is from Blake's illustrations of John Milton's poem *Paradise Lost*.

Unknown · *Terracotta sculpture from the site of Lavinium-Pratica di Mare* · Italy · 5th Century The hand offers a pomegranate, which has endless symbolism depending on the tradition. In ancient Rome, pomegranates had the paradoxical symbology of fertility, and the afterlife.

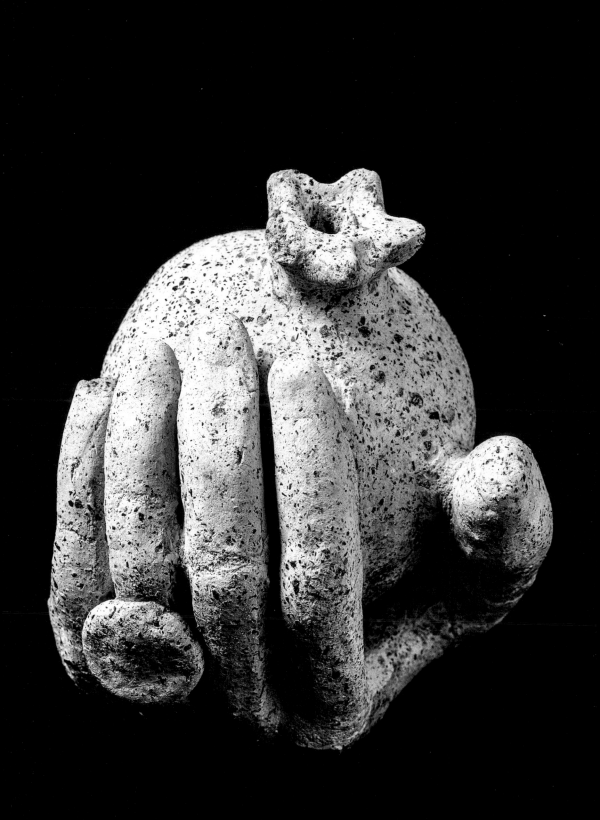

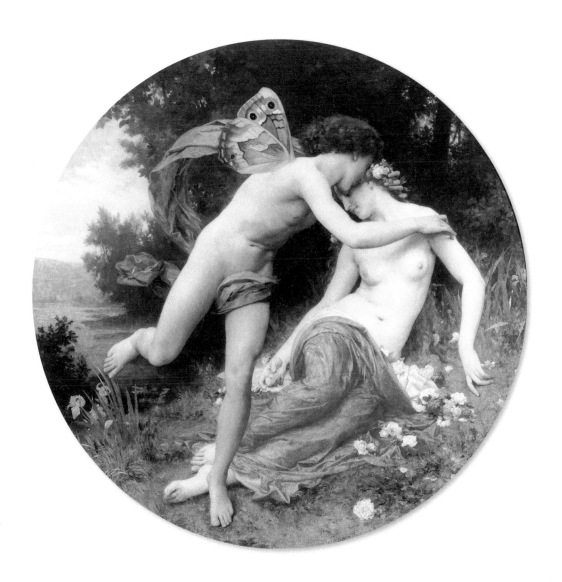

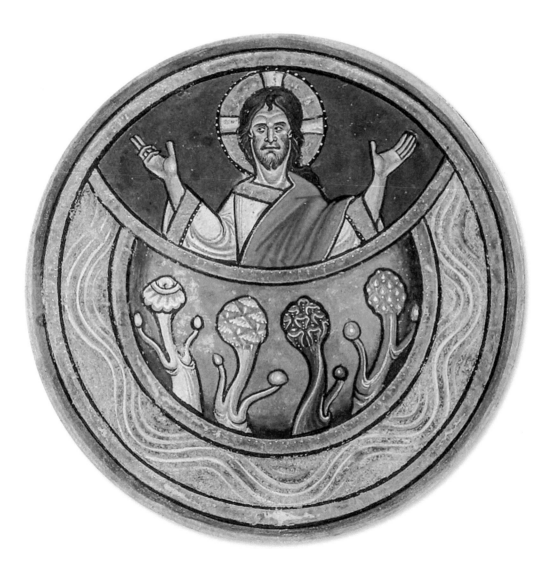

William-Adolphe Bouguereau · *Flora and Zephyr*
France · 1875 Flora the fertility Goddess of bud-
ding springs, fruit trees and flowers is imagined
with her consort, Zephyr, God of the west wind who
dons butterfly wings. Their embrace signals pollina-
tion in the circular painting.

Unknown · *Christ with Mushrooms* · France · 1200
Many theories discuss the biblical use of entheogens,
citing sources such as the *Great Canterbury Psalter*,
an illustrated manuscript of biblical scenes depicting
mushrooms and mycelium as a basis for many well-
known miraculous biblical occurrences.

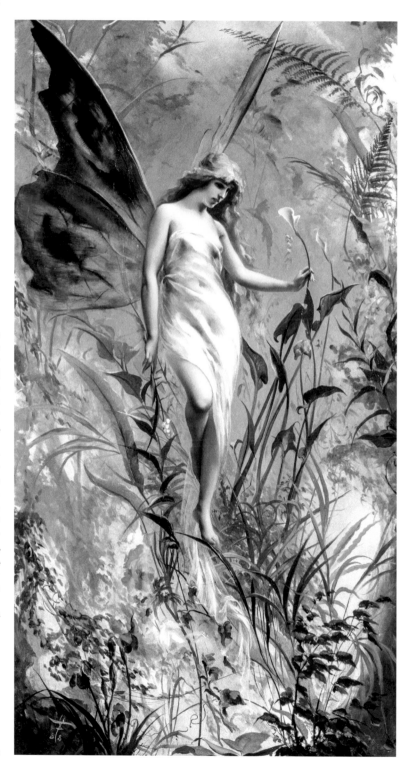

Luis Falero · *Lily Fairy*
France · 1888 White
Calla Lilies represent
purity, faithfulness, and
holiness, and are often
pictured in scenes with
the Virgin Mary or other
mystical beings.

Gaston Bussière
Bathing Nymphs · France
1897 Nymphs are
commonly featured with
Water Lilies, of which
their name derives. But
these water spirits bathe
among purple Irises,
symbolizing wisdom,
peace, purity and even
royalty. Bussière was
a mystic and
symbolist painter.

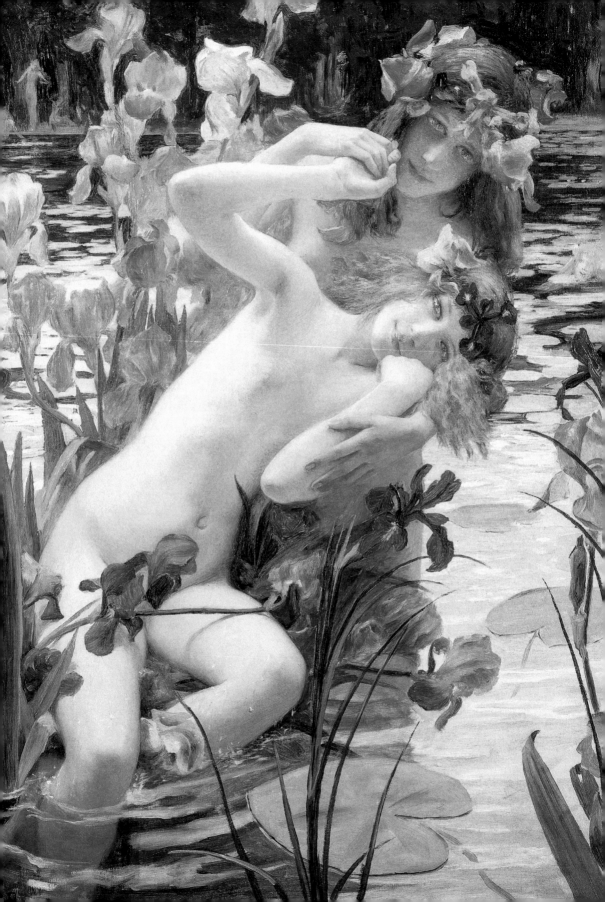

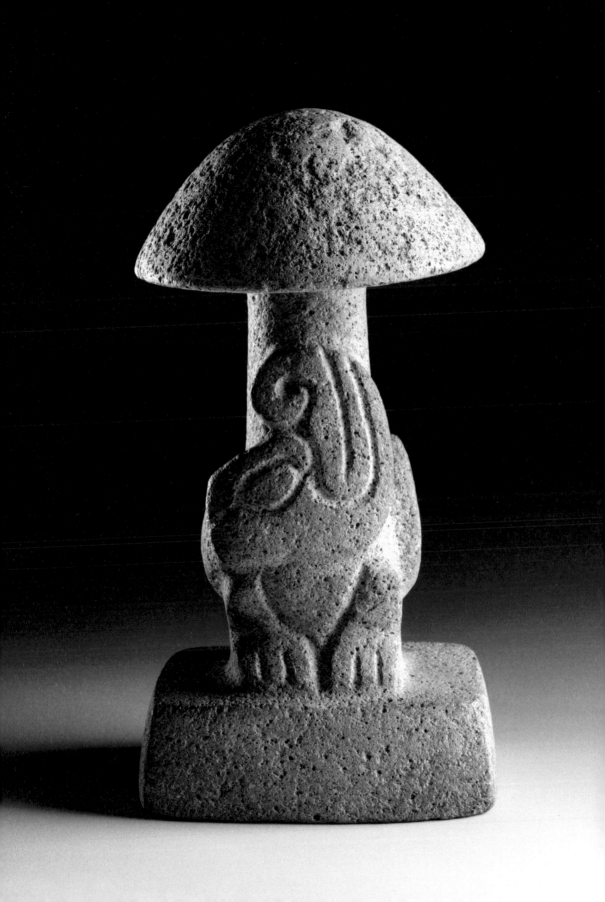

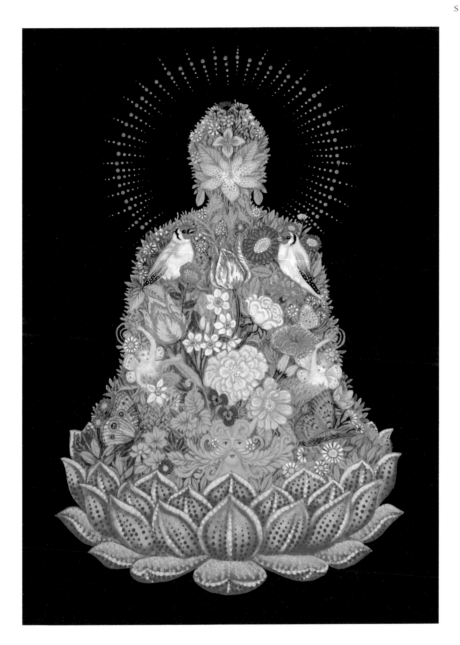

Unknown · *Mushroom, depicting a stylized snake*
Guatemala · 2000 BCE–250 CE Mayans honored
and used psilocybin-containing mushrooms during
rites and ceremonies for political alliances, social
order, and to communicate with the serpent God,
Quetzalcoatl. Photographed by Luisa Ricciarini.

Virgo Paraiso & Tino Rodriguez · *Inner Garden
Meditation (Botanical Buddha)* · United States
2022 In this vibrant collaborative piece, Paraiso
and Rodriguez create a detailed and multi-hued
floral and botanical rendition of the classic image
of the Buddha seated in meditation.

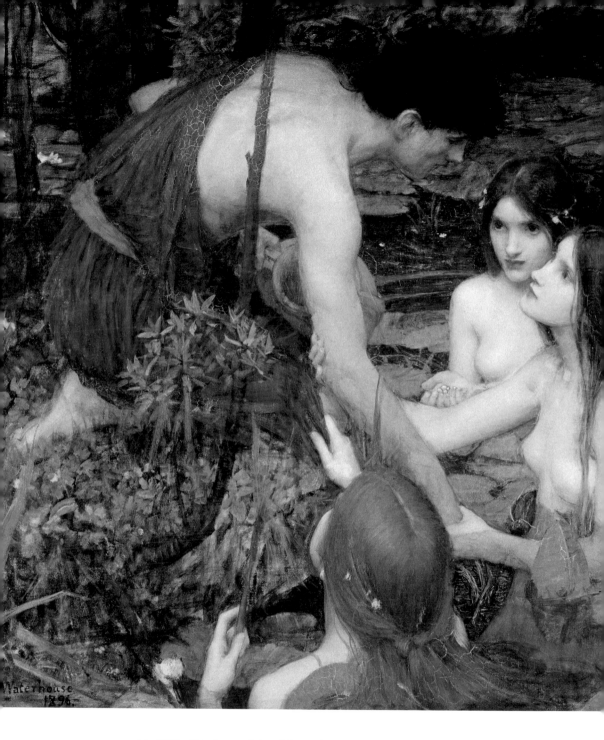

John William Waterhouse · *Hylas and the Nymphs*
England · 1896 Nymphs got their name from
Nymphaea, the water lily, which symbolizes inno-
cence and pleasure, enabling the nymphs to tempt
Hylas into their domain.

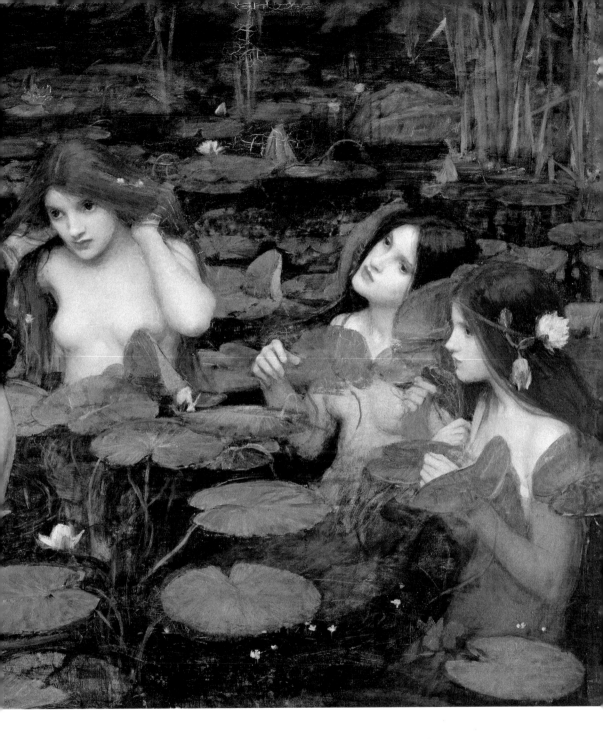

(following and left) Unknown · *Spring, maidens gathering flowers* · Italy · 15 BCE–60 CE From a fresco at the ancient Villa de Arianna, a maiden collects flowers symbolizing purity, and innocence.

(following and right) Charles Allston Collins *Convent Thoughts* · England · 1851 The painting shows a novice nun in a convent garden, contemplating a Passionflower, which symbolizes the crucifixion of Christ.

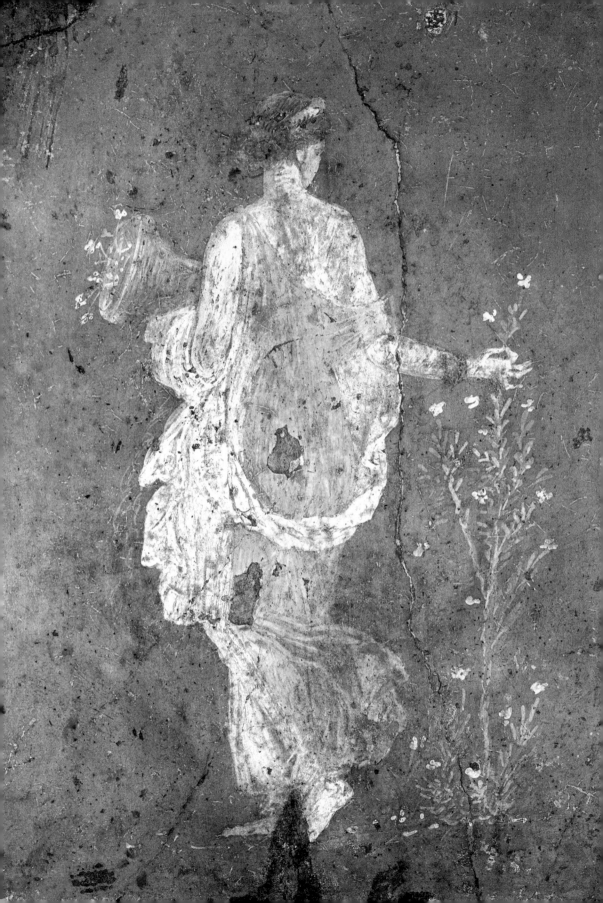

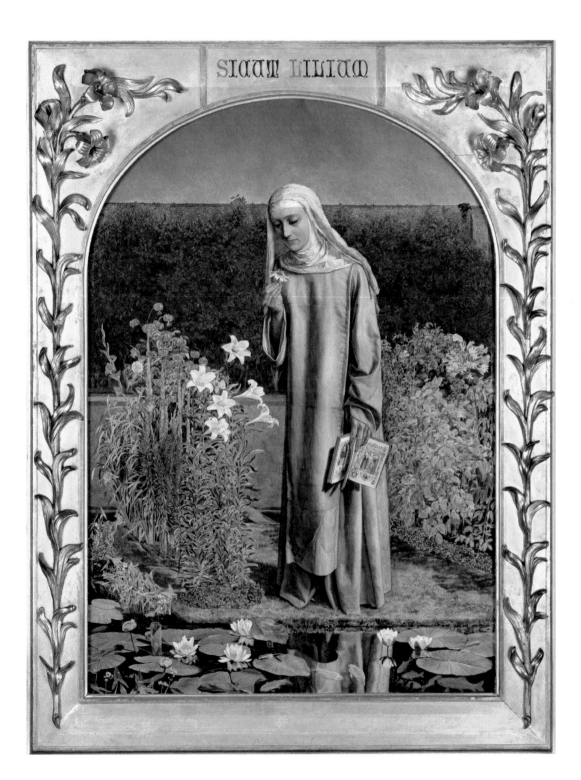

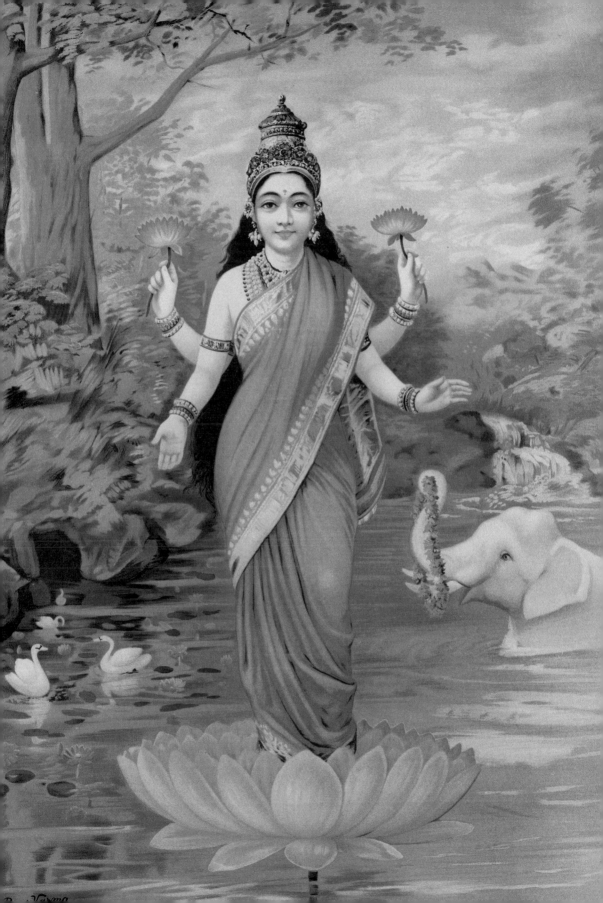

Raja Ravi Varma
*Lakshmi on her lotus in
the water with Elephant*
India · 19th Century
Like the lotus, the God-
dess Lakshmi transcends
material wealth for
spiritual progress. The
lotus symbolizes purity,
fertility, and beauty.

Unknown · *The Goddess
Chandi* · Unknown
19th Century Chandi,
meaning "to tear apart"
in Sanskrit, bestows
the power to tear our
thoughts away from
that which takes us
off our spiritual path.
She is surrounded
by and seated upon
the lotus flower which
symbolizes purity and
transcendence.

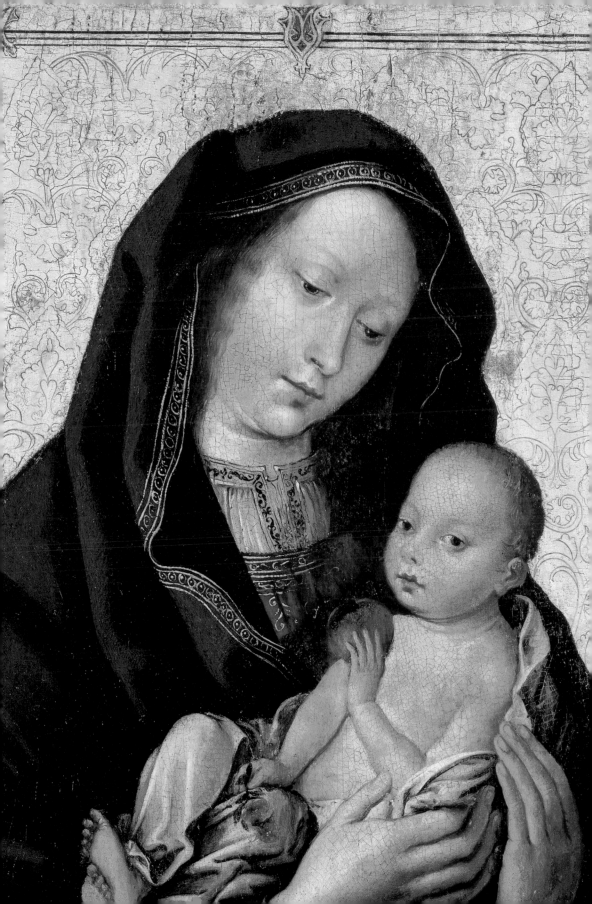

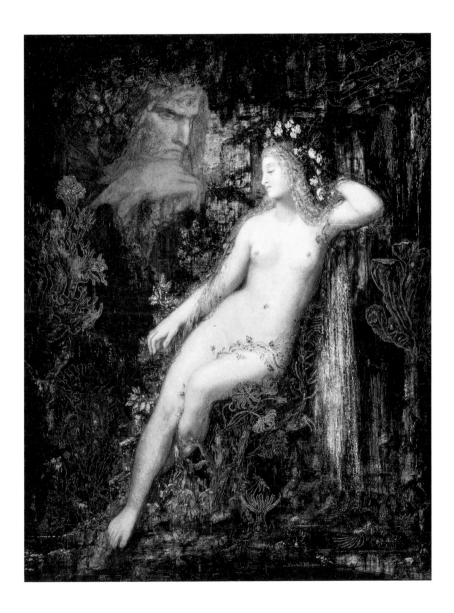

Unknown · *Virgin and Child with Apple* · Belgium
15th Century Part of the collection at the Smithso-
nian Museum, this early Flemish work features the
Christ child clutching a tiny apple, here shown as
a symbol of Jesus' redemption of mankind.

Gustave Moreau · *Galatea* · France · 1880 As a
sea-nymph, Ovid's Galatea was able to hide from
the jealous giant in a narrow sea cave filled with
beautiful marine life and too small for an ogre.

Unknown · *Miracle of the Lotus* · Thailand · 19th
Century From the cosmos dawns the stainless lotus,
symbol of purity, enlightenment and rebirth painted
on a fresco in the Wat Bovornivet Buddhist temple.

John William Waterhouse · *Narcissus* · England
1912 Goddess Persephone gathers Narcissus
blooms just before she is snatched into the under-
world by Hades.

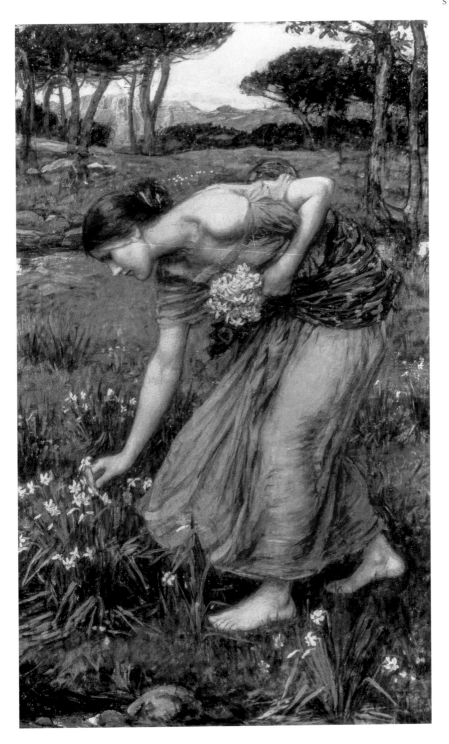

Albert-Louis Dammouse · *Ornamental wall plate*
France · 1899 A decorative wall plate by the pro-
lific French ceramist and painter features highly
detailed poppy flower ornamentation. Dammouse
was skilled in the difficult pottery process known as
"pâte-sur-pâte."

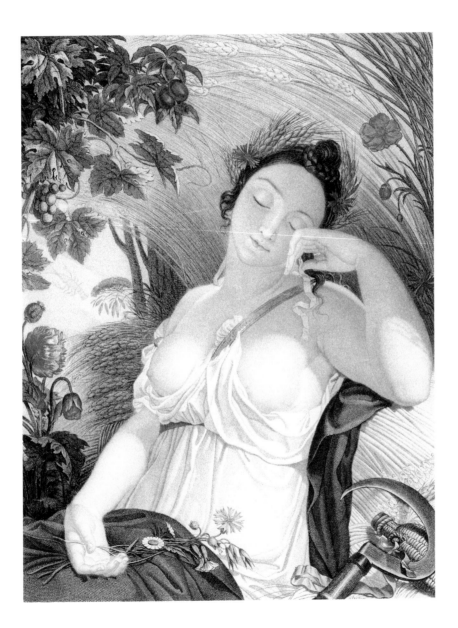

Salvatore Tresca and Louis Lafitte · *Messidor* France · 18th Century Messidor was the tenth month in the French Republican Calendar, depicted and described as a time of relaxation, rest and enjoyment after a period of labor, symbolized by the wheat and scythe.

(following pages) Peter Paul Rubens and Jan Brueghel the Elder · *The Garden of Eden with the Fall of Man* · Netherlands · 1615 Beneath the tree of the knowledge of good and evil, Adam and Eve are surrounded by many eco-systems and symbolic flora representing the sin about to be committed.

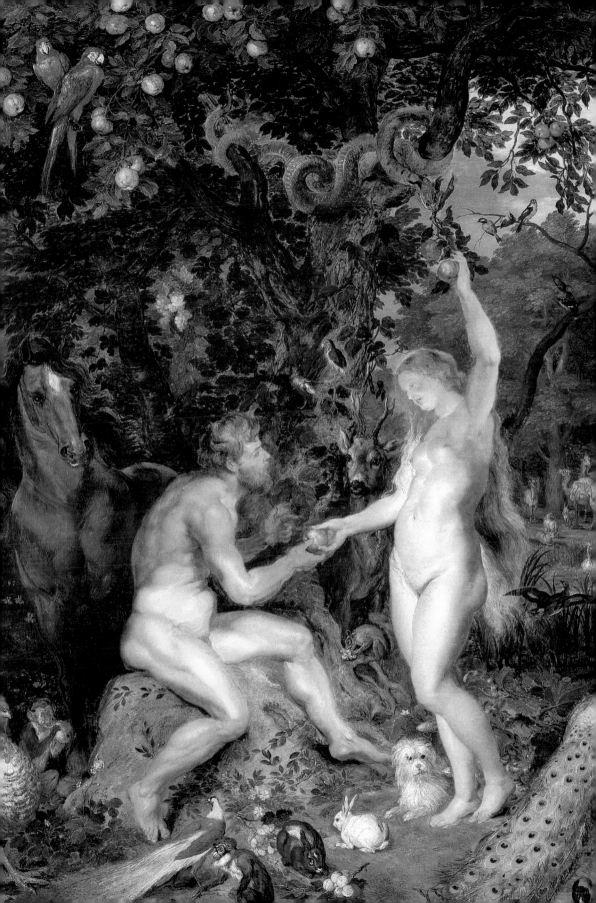

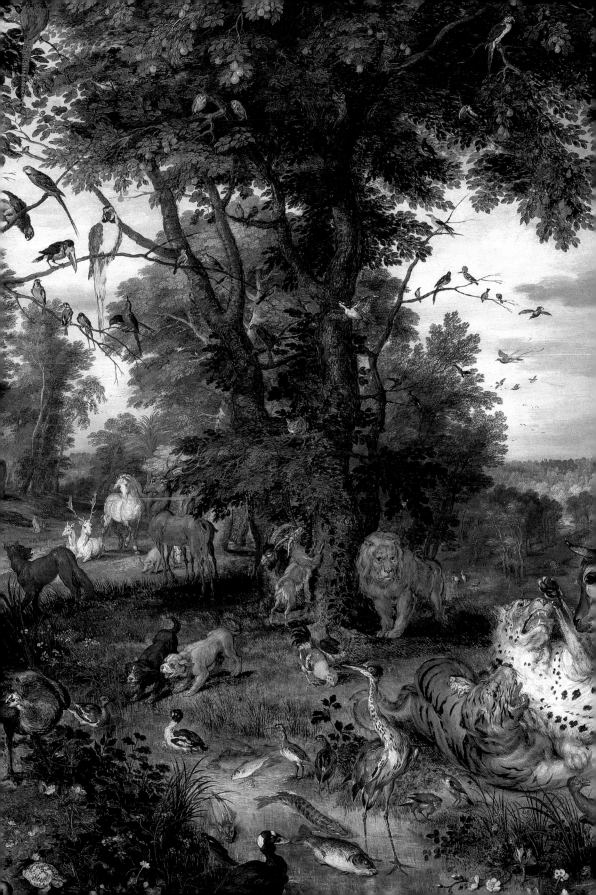

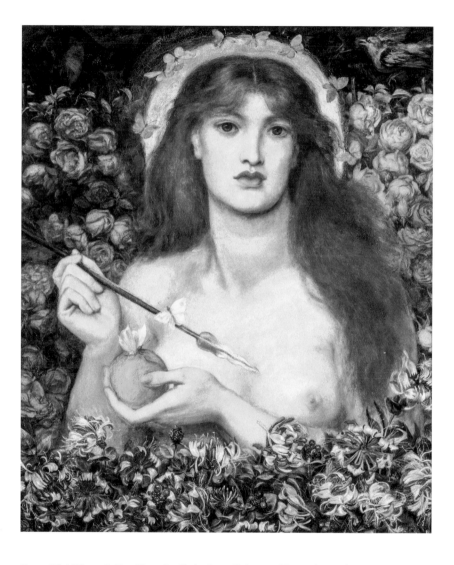

Dante Gabriel Rossetti · *Venus Verticordia* · England
1864–68 Venus, the Roman goddess of love
clutches an apple, the fruit that tempted the Biblical
Eve. The painting's title translates to, 'Venus, turner
of hearts' and is taken from a poem by the Roman
author, Ovid.

Unknown · *Vietnam: lotus sculpture* · Vietnam
14th–15th Century The Buddhist symbol of
enlightenment, the lotus rises out of the mud
and water, as the soul rises out of cosmic chaos
into a higher state of being.

I moved to Los Angeles from New York City in my 20s. The landscape felt so foreign, the bright colors of bougainvillea, palm trees, agave — all so different than the East Coast landscape of my childhood. Nextdoor to the house I grew up in, our neighbors had a sunflower garden, each summer the sunflowers would grow to mammoth heights, their dazzling, flowering faces were intoxicating to me. I admit I spent the first several years in Los Angeles longing to go back to New York. When my oldest son started school, I needed to volunteer at his school, and I chose gardening. Growing up, I had spent time with my own father in the small vegetable garden he cultivated each summer, and I really treasured that time with my dad. I loved gardening in the school garden, planting seeds, watching them sprout, nurturing the plants and then harvesting the food they produced. It seemed miraculous to me then and it still does. What began as a volunteer position turned into a full-blown passion for growing food. I went to the library every week and took out all the books I could find on vegetable gardening. I started a garden at home, asked farmers at our local farmer's market endless questions about how to grow good food. Many of those same farmers have become close friends, they taught me the art of growing food naturally and organically. Plants became the way in which I could communicate, create community, and build a new life for myself through the language of plants. Gardens can also provide a reminded of another time and place. In Los Angeles, I love growing sunflowers. Each summer when they come up on our farm, huge blooms in the sky, shining over me, I remember the neighbor's garden. In this way, gardening becomes a way hold our memories, a portal into special moments in our lives.

— LAURI KRANZ, Farmer, Author of *A Garden Can be Anywhere*,
Co-founder of Edible Gardens, 2022

(following pages) Guilio Romano · *Two Horae scattering flowers, watched by two satyrs* · Italy 1520s The Horae, goddesses of the seasons, scattered flowers over guests at the mythological marriage of Cupid and Psyche.

Unknown · *Four exceptional painted Bodhi Tree leaves with depiction of Luohan* · China · 18th/19th Century The Eighteen Arhats (orLuohan) are the original followers of Gautama Buddha, painted on leaves from the Bodhi tree (the tree under which the Buddha attained enlightenment).

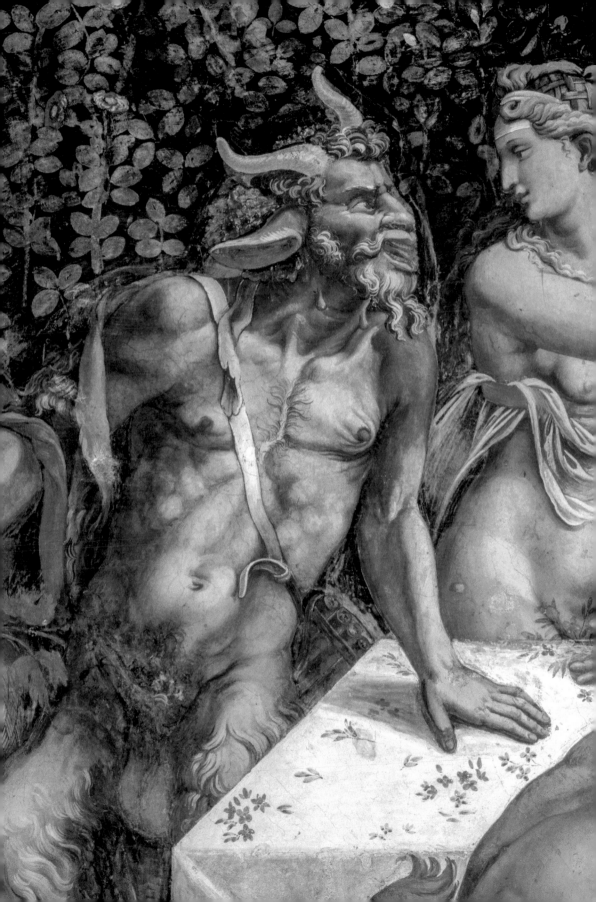

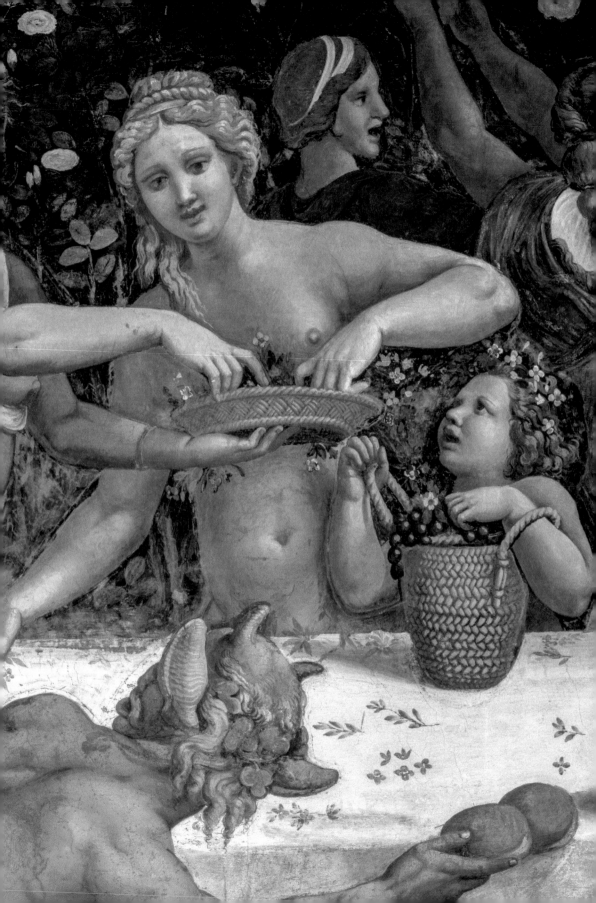

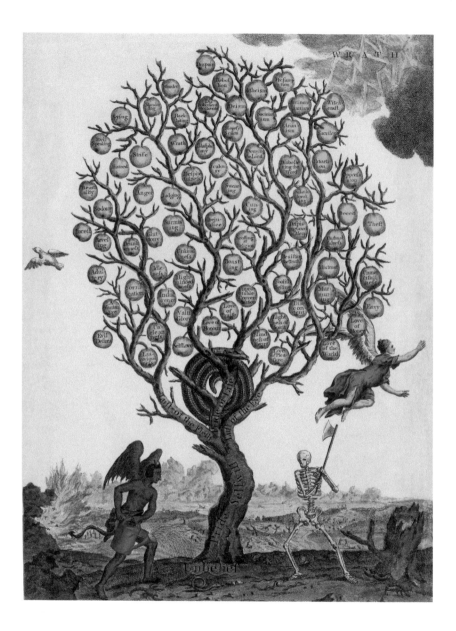

Edmund Burke Kellogg & Elijah Chapman Kellogg
The evil tree or hieroglyphics of the natural man
United States · 1842 One of a series of prints
produced by the Kellogg's lithographic firm explor-
ing esoterica symbology, this unique depiction
illustrates the sephiroth iconography.

Dante Gabriel Rossetti · *A Vision of Fiammetta*
Italy · 1878 Inscribed with a sonnet by the poet
Boccaccio, the painting depicts his muse, Maria
d'Aquino amidst flush apple blossoms which
represent fertility and plentiful bounty.

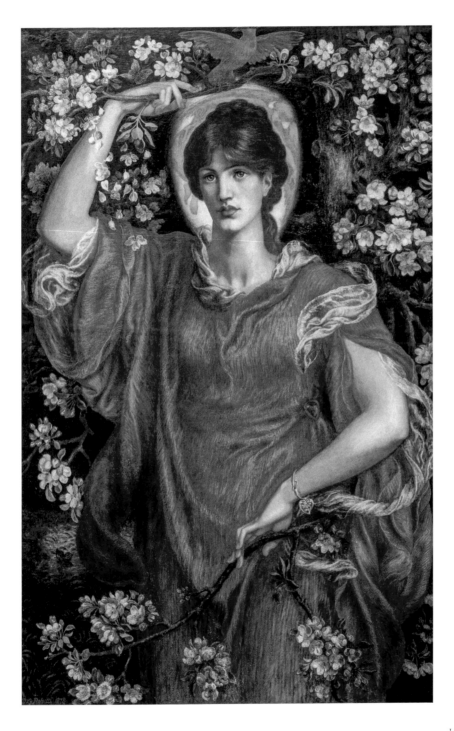

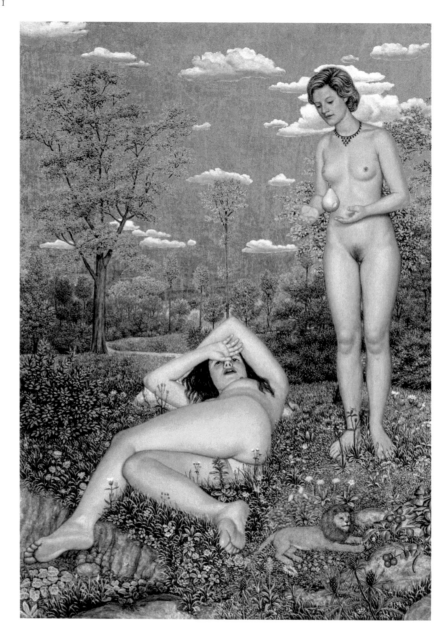

Adelchi Riccardo Mantovani · *Adam and Eve*
Italy · 2000 The modern artist's enchanted land-
scape style transmits a vibrant version of the garden
of Eden, producing a pear in lieu of the classic
apple as the temptation symbol.

Johfra Bosschart · *The Morning* · Netherlands
1986 A part of the Van Soest Collection, this
painting features Bosschart's wife as subject,
her likeness transformed by the artist's dreamy,
surrealistic vision.

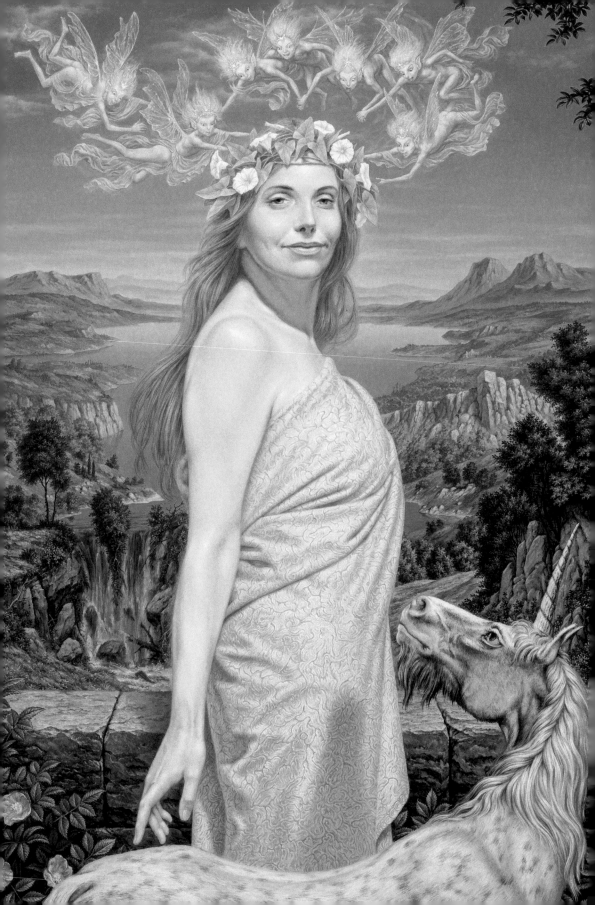

THE SEPHIROTH

The Enduring Symbolism of Trees

And I say the sacred hoop of my people was one of the many hoops that made one circle, wide as daylight and as starlight, and in the center grew one mighty flowering tree to shelter all the children of one mother and one father. And I saw that it was holy...But anywhere is the center of the world.

— BLACK ELK, from the collected works, *Black Elk Speaks*, edited by John G. Neihardt (1932)

As resonant mythological symbols and objects of veneration, trees have played a central role in our shared evolution on Earth. Trees provide us with sustenance and support, not only spiritually, but through the offerings of nutrients and their fecundity of fruit, nut, and seed. And, perhaps most importantly, through their life-sustaining process of photosynthesis, the miraculous transformation of carbon dioxide into precious oxygen. With life spans ranging from approximately hundreds to thousands of years old, trees are some of the oldest living organisms on Earth. One, a recently discovered Bristlecone Pine, still growing high in the mountains of California, and dubbed "Methuselah" by researchers, is thought to have pushed its way through topsoil nearly five thousand years ago. A sapling which swayed in the sunlight during the very dawn of human civilization, Methuselah was standing tall during the building of the Great Pyramid at Giza and the construction of the rock circle at Stonehenge. Other species of "clonal" trees, named as such because they grow individually

but are connected by a single root system, are thought to be even older. A Norway Spruce currently growing in Sweden, for instance, boasts a web of rooted trees that have been alive for nearly 10,000 years.

In her 2021 book, *Finding the Mother Tree: Discovering the Wisdom of the Forest*, ecologist, scientist, and scholar Susan Simard writes of the evolution of the trees and the ways in which they communicate and interconnect. She speaks of the forest as a mirror of the larger cycles of death and rebirth in nature. "Nothing lives on our planet without death and decay. From this springs new life, and from this birth will come new death. The forest itself is part of much larger cycles, the building of soil and migration of species and circulation of oceans." Simard also explores the ways trees support not only each other, through a vast network of roots, but also how they support all other life on Earth. "The source of clean air and pure water and good food. There is a necessary wisdom in the give-and-take of nature — it's quiet

J. Augustus Knapp · *The Tree of the Sephiroth* United States · 1928 One in a series of powerfully symbolic works created by visionary artist J. Augustus Knapp and commissioned specifically for scholar and philosopher Manly P. Hall's expansive tome, *The Secret Teachings of All Ages*.

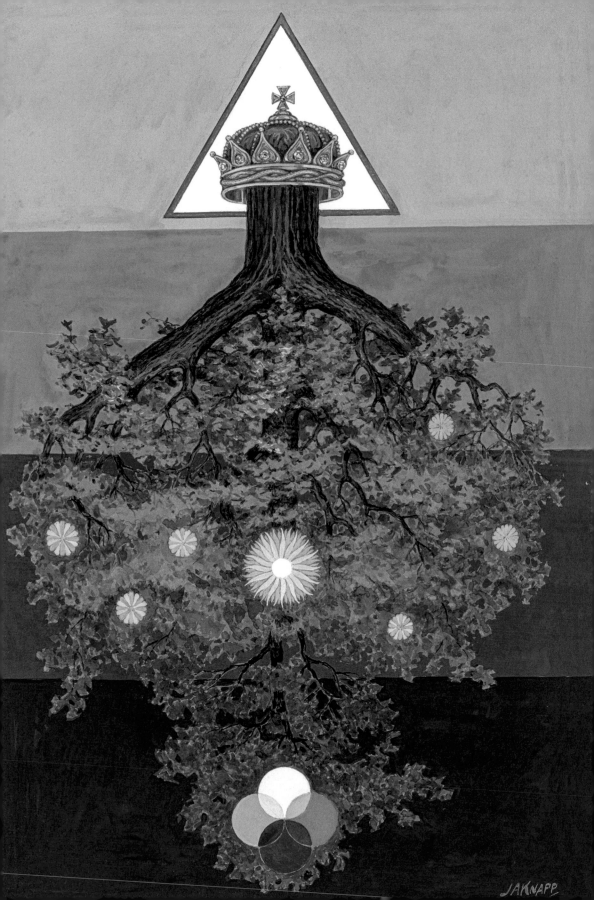

agreements and search for balance. There is an extraordinary generosity."

This generosity has long been understood and appreciated, particularly by our early ancestors, for whom trees were at the center of their earliest forms of worship and spiritual rites, as well as universal symbols of birth and life-giving bounty. Among world's many cultural mythologies concerning trees, nearly all are rooted in the symbolism of what is most often referred to as the "Tree of Life," thought to have its origins in the ancient Sumerian poem, *The Epic of Gilgamesh*, a tale carved into clay tablets more than 4000 years ago. One of the oldest known pieces of written literature in the world, *Gilgamesh*, tells of a hero's quest for immortality through his journey in search of a life-giving plant.

Egyptian myths tell of a sacred tree from which all gods were born, the tree a representation of the cycle of life and seasons, death, rebirth and the connection between the physical, terrestrial world and the afterlife. In ancient Norse and Germanic mythologies this sacred axis tree was known as the "Yggdrasill." Its branches were thought to spread across the world, nourishing all living things and linking the gods to the human realm. In the sacred Hindu texts, the *Upanishads*, written between 8th century and 3rd century BCE, the cosmic tree is called "Asvattha," and is said to grow upside down, its roots deep in the heavens, its branches reaching down toward Earth. Sumerian, as well as early Babylonian and Assyrian mythologies all shared belief in a maternal goddess, a matriarchal deity associated with the Earth — with growth, life,

and death. This goddess was often depicted as a great tree, branches lifted to sky, her leaves protecting all below, her roots running deep and strong in fertile soil.

Although meanings vary, the symbol of the tree as axis mundi, a representation of connection between our world and the heavens, roots and branches linking the realm of the corporeal to the realm of the gods, can be seen in early forms of spiritual worship across the globe. In the earliest iconography of the ancient Jewish gnostic tradition of the Kabbalah, the tree of life is referred to as the "Sefirot" (or "Sephiroth"), a sacred geometric diagram representing the birth of the universe as a tree-like form of divine archetypes and energies. In the indigenous Mesoamerican cultures of Central and South America, depictions of world trees have been discovered among numerous ancient artworks and artifacts. In Mayan, Olmec, and Aztec beliefs these trees are thought to represent the four cardinal directions, trunk and branches forming a central passage between the underworld, the Earth, and the sky.

In early African creation myths, the gods were said to have created the baobab tree, uniquely shaped to enable it to store water in its prodigious trunk. With its offerings of shade and nutrient-dense fruits, the Baobab was considered a symbol of hope and life amid a dry and arid landscape. In India, the coconut tree is particularly venerated, its fruits and leaves used often as religious offerings. Its name in Hindi, "Mahua" can be translated as "Great Gift." The mango tree is also considered sacred in Hindu cultures and utilized in various rituals

Louis Comfort Tiffany · *Magnolias and Irises* **United States** · 1908 Famed stained-glass artist portrays florals associated with feminine beauty, purity, faith, and hope. The commissioned piece was created with a special glass which produces a rich, iridescent light and color.

and festivals. Sandalwood is another symbolic tree across India, considered a link to the gods, specifically to Lakshmi, the goddess of wealth and good fortune. Sculptures of various Hindu deities are often carved of sandalwood and placed as offerings at altars and monasteries.

In Buddhist texts, Buddha is said to have attained enlightenment under the Bo or Bodhi Tree, known also as the "Tree of Knowledge." The spiritual symbolism of the Tree of

Knowledge appears in Christian mythologies as well, specifically within the Biblical chapter of Genesis, which tells of Eve's temptation in the Garden of Eden, tempted by the snake to eat the Tree's forbidden fruit. In the Old Testament story of Noah's Ark, a tree plays a symbolic role as well, a dove delivering Noah an olive twig to signify that God's wrath was waning and the floods would finally abate. The olive branch continues to remain a symbol of peace in cultures across the world.

Meagan Donegan · *The Helpers* · **United States** 2020 Created with graphite pencil and a gouache process using coffee, Donegan's soft-edged mystical scenes recall scenes from fairy tales and mythology.

(opposite) **Paul Gauguin** · *Te Raau Rahi (The Big Tree)* · **France** · 1891 Seeking a mythical paradise and pure living, the artist went to Tahiti where he became enamored by the local vegetation such as the hotu tree, said to be the mythical origin of the human heart.

In the pagan religions, particularly in Northern Europe and the British Isles, sacred trees also figured prominently. Druidism, a spiritual tradition thought to have originated during the Iron Age, over 2,500 years ago, places trees at the center of its rites and worship. The oak figures prominently in Druid mythology, and it is thought that Druidic rites were often performed amid oak groves. Mistletoe, a parasitic plant which often grows on host trees such as oak, was also gathered by Druids and used for both its medicinal qualities and in magickal fertility rituals. The word "Druid" itself is thought to have been derived from a Celtic word meaning, "knower of the oak tree." The first known written documentation of Druid tree worship can be found within the first century tome, *Historia Naturalis*, which describes the cutting of mistletoe for a fertility ritual. Written by Greek historian, Pliny the Elder, the book goes on to document the importance of trees within not only Druidic practices, but other global cultures as well. "Once upon a time trees were the temples of the deities," Pliny writes, "and in conformity with primitive ritual simple country places even now dedicate a tree of exceptional height to a god; nor do we pay greater worship to images shining with gold and ivory than to the forests and to the very silences that they contain. The different kinds of trees are kept perpetually dedicated to their own divinities."

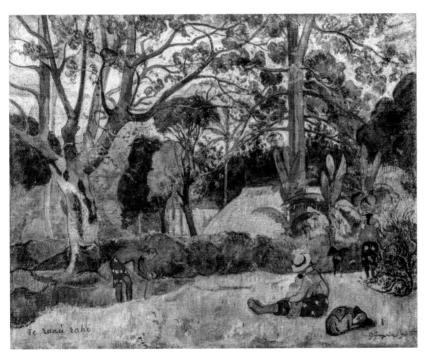

Te raau rahi

(following and left) Henri Rousseau · *Walk in the Forest* · France · 1886-90 A grove of autumnal trees, less leafy than the artist's typical lush style of detailed flora, gives a view of the vast forest through the trees.

(following and right) Charles Francis Voysey *Adam and Eve* · England · 19th Century The Arts and Crafts period portrayal of the great Tree of Life is filled with symbolism. The infamous serpent winds the central trunk.

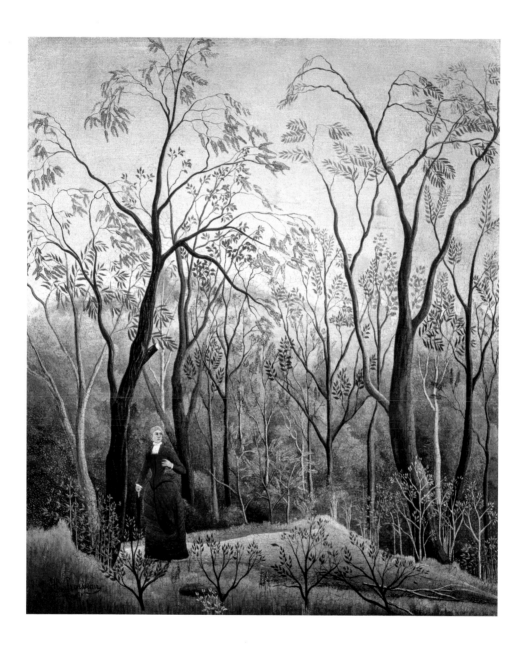

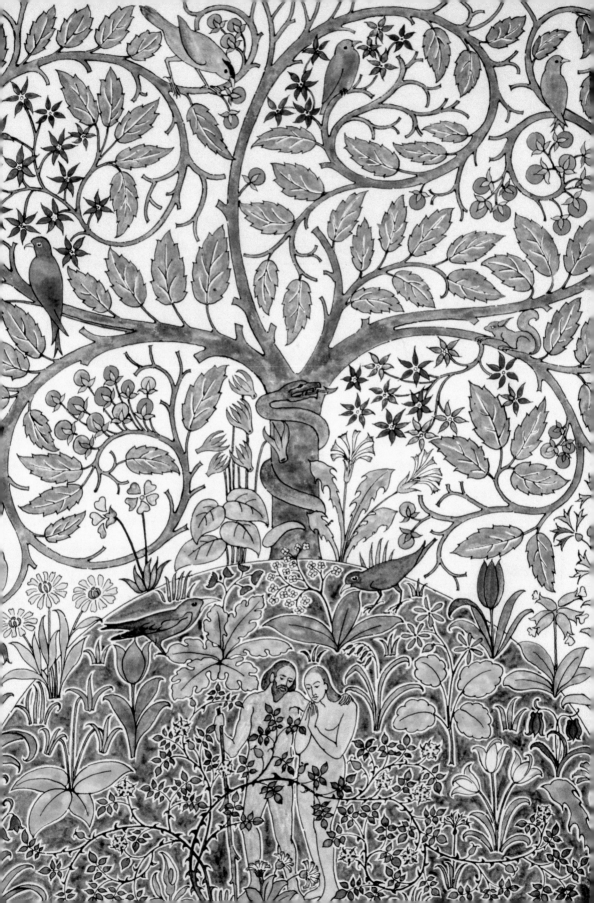

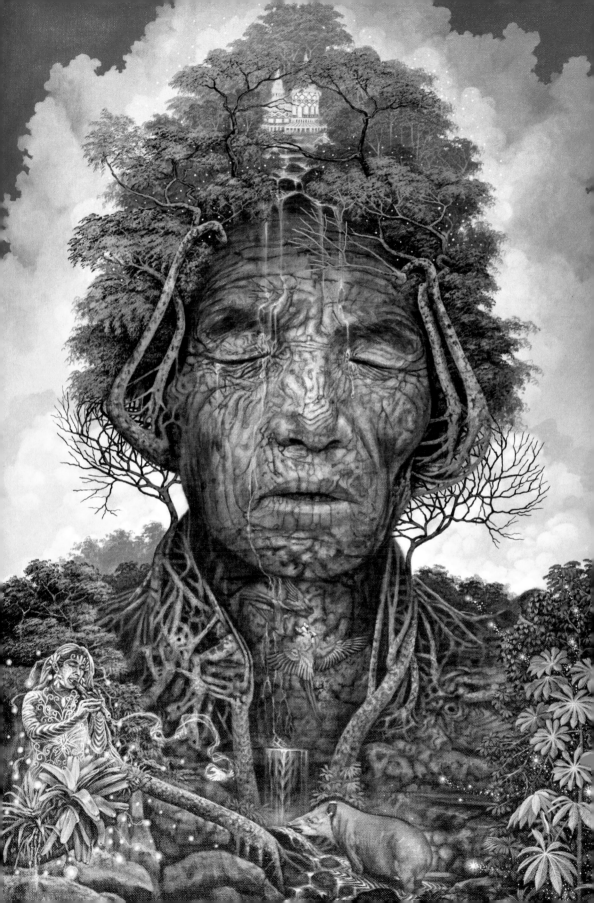

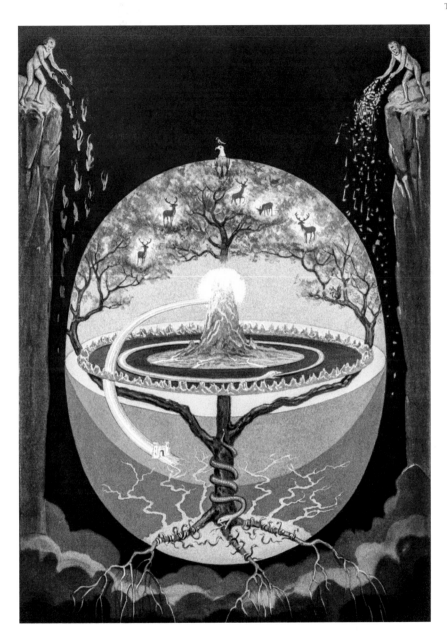

Luis Tamani · *Agua Viva* · Péru · 2020 Growing up along the banks of Ucayali River, the indigenous South American artist Tamani often pays tribute to the botanical realm in his visions works, the natural world, as he explains "a constant source of inspiration and balance in my life."

J. Augustus Knapp · *The Yggdrasil Tree* · United States · 1928 A detailed depiction of the mythical tree Yggdrasil, created in 1928 as a commission for the expansive philosophical tome *The Secret Teachings of All Ages* written by the 20th century American philosopher and esoteric scholar Manly P. Hall.

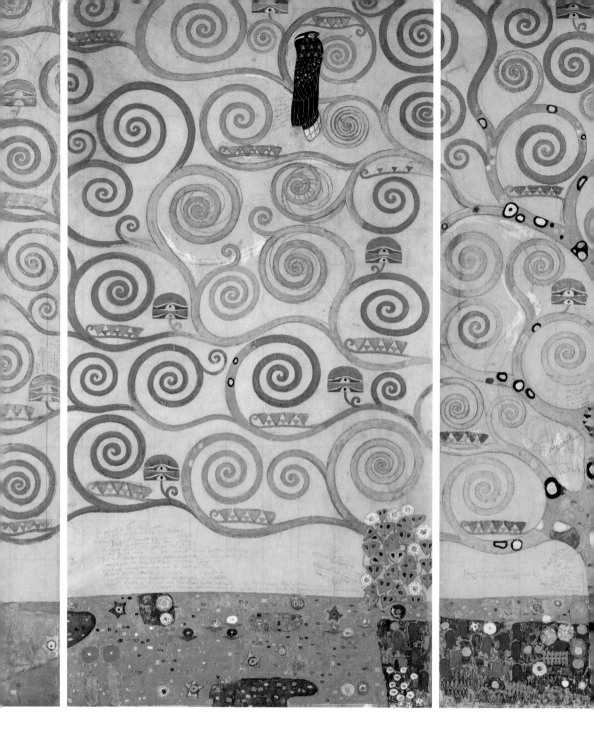

Gustav Klimt · *Sketches for The Stoclet Frieze* · Austria
1925 An initial sketch and notes for Klimt's expan-
sive multi-panel mosaic piece commissioned for the
Palais Stoclet in Brussels. In these early preparatory
works, the artist explores the iconic spiritual and
psychological motif of the Tree of Life.

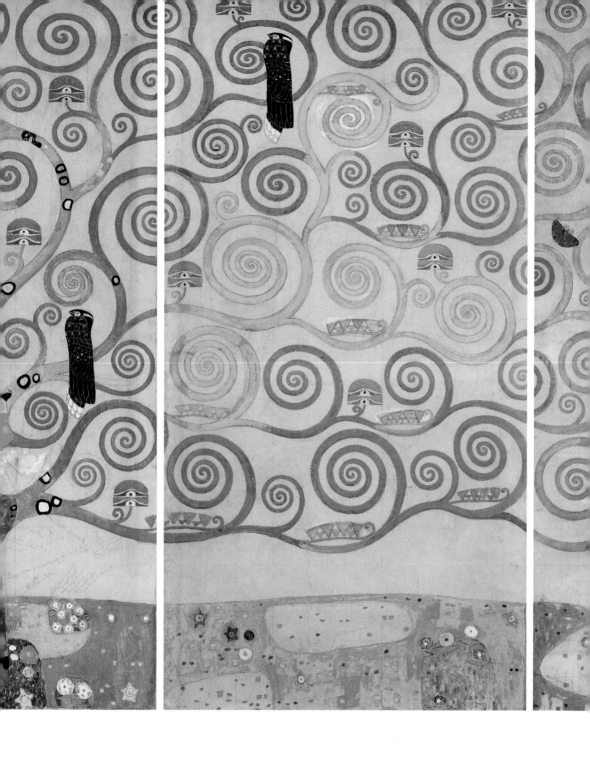

I'm an artist and a medicine person born and raised in Lenapehoking [New York City] to immigrant parents from Kiskeya Ayiti [Dominican Republic]. My ancient ancestral lineages of West African, Taino Arawak, and Southern European greatly influence my multi-faceted medicine practice. This hybridity of older traditions and a present engagement with evolving Earth energies creates an empowered path to the future. I understand the dynamic magic of being alive during this moment in history as a diasporic Black, Indigenous, queer, and non-binary person. Before I came out as a practicing herbalist and brujx, plants became a way for me to talk about origin stories, hybridity, the violent commodification of life, consciousness hidden in plain sight, and the dialectics of Western and indigenous epistemologies within my artwork. I was making scans of commodified plant images (scientific textbooks, supermarket flyers, floral wrapping paper) and using digital techniques of processing (erasing, cutting, pasting, downloading) to understand where modernity has been in terms of a relationship to plants and where I want to go. Because humans have evolved alongside plant life it's interesting to notice the way that these works activate a heart-based connection with people. All of Earth is sacred. From urban lands to forested landscapes, we are the Earth, the Earth is us. The break in our ideologies that created these disconnections stem from colonial systems. With affirming an interconnectedness, we begin to see with clarity the threads of life and our ideologies can shift on a collective scale. To be in right relationship with plants and the natural world is so important for our modern contemporary culture. If we want to survive in thriving ecosystems, we must develop our connection to the higher heart. This energetic language is the language of the sentient universe, and we can remember to communicate it and once again reclaim our role as guardians of Earth.

— STAR FELIZ, Artist, Herbalist, Founder of Botánica Cimarrón, 2022

Rick Griffin · *The Unnamable* · United States
1968 The renowned illustrator and Grateful Dead artistic collaborator creates a distinctly psychedelic version of the symbolic iconography of the sephiroth, or tree of life.

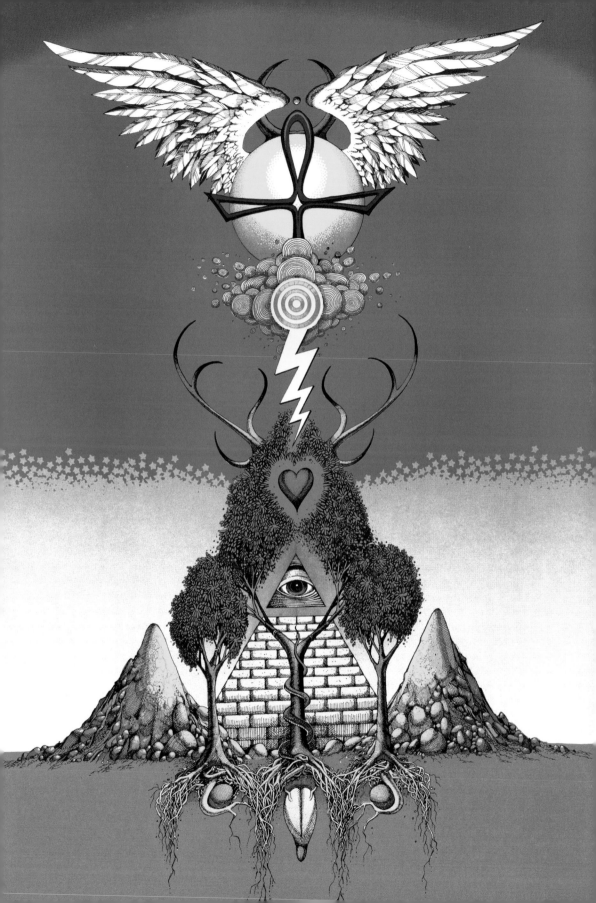

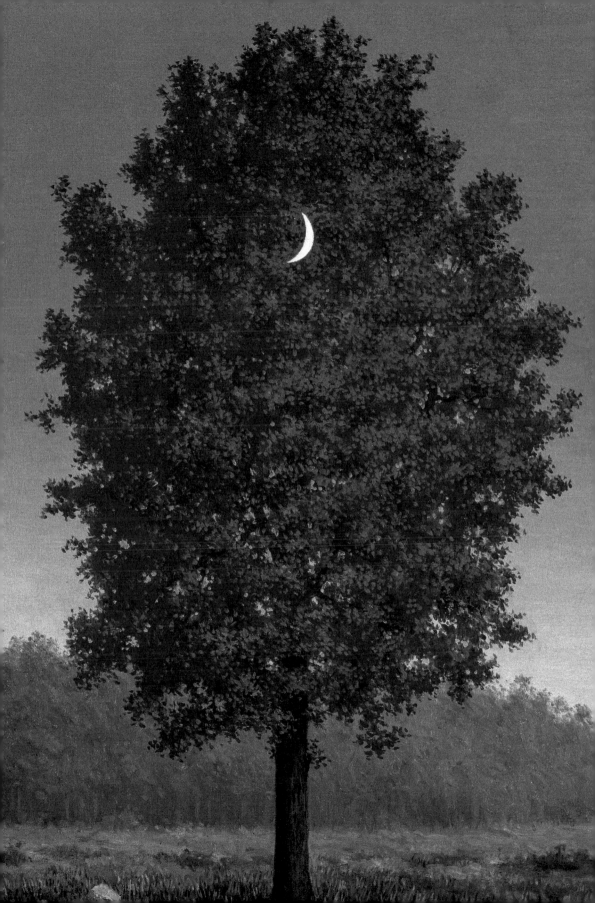

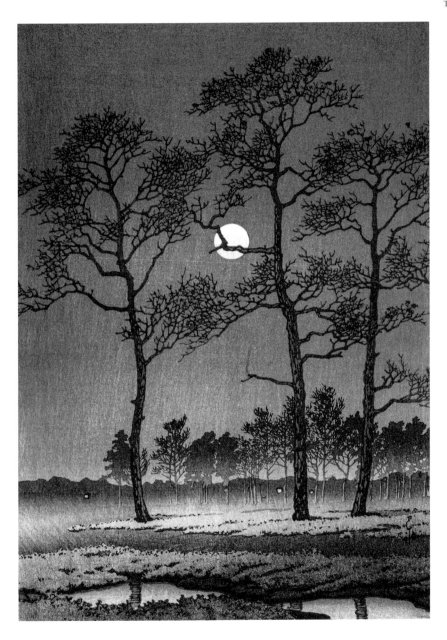

Rene Magritte · *The Sixteenth September* · Belgium
1956 Trees are a recurring subject in Magritte's art,
fixed majestically in the earth as tall as the moon's
orbit. He often subverted the laws of nature with
nature as the object.

Kawase Hasui · *Moonlight over Toyama* · Japan · 1931
Photograph by A. Dagli Orti of Hasui's woodcut of
peaceful trees in a field, from the modern, industri-
alized and restoration period in Japanese history
called Meiji Showa.

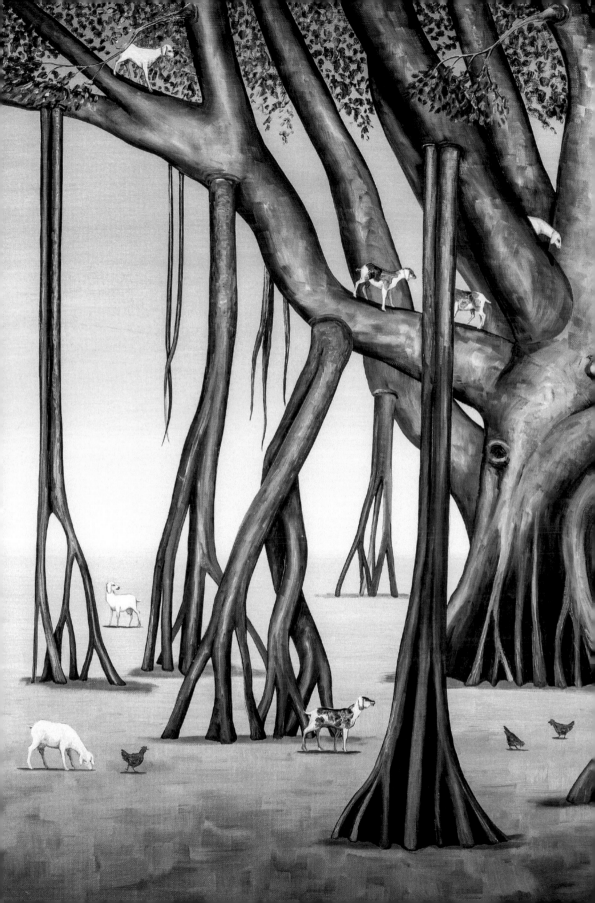

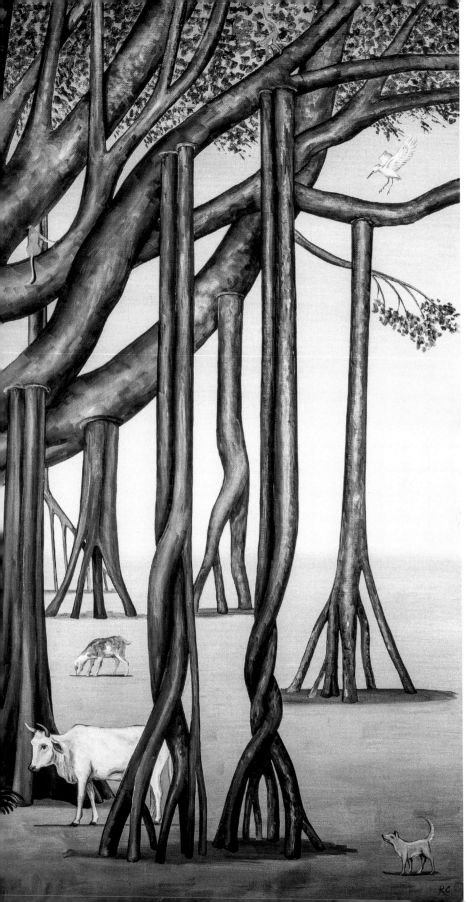

Rebecca Campbell
In the Shade of the Banyan Tree · England
2014 The contemporary artist explores the unique beauty of the Banyan, a tree thought to represent the Tree of Life in ancient Hindu cultures, its enormous roots thought to bring the divine down into the earthly realm.

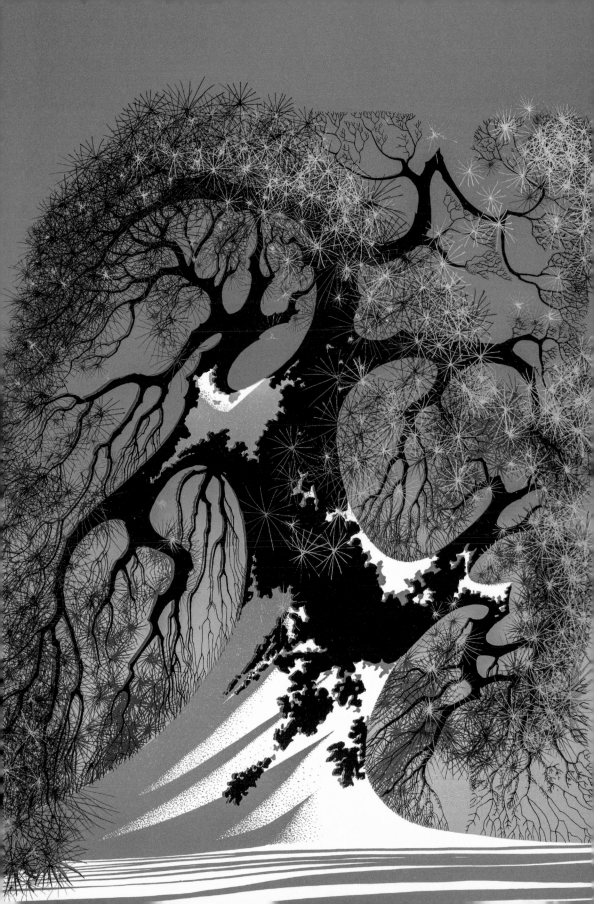

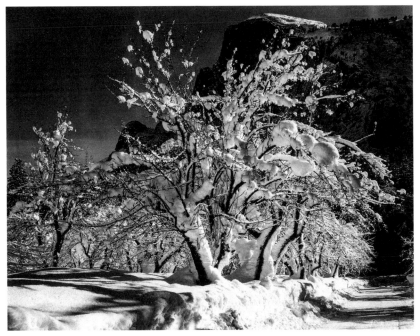

(opposite) Eyvind Earle · *Winter Bonsai* United States · 1982 Bonsai is an ancient Japanese art of cultivating and communicating harmony, peace, order, and balance, portrayed by the artist most known for creating and painting for Disney.

Ansel Adams · *Half Dome, Apple Orchard, Yosemite* · United States 1933 Adams captures bare and snow-covered apple trees at Yosemite, the national park he first visited at 14 years of age.

Ansel Adams · *Leaves, Glacier National Park, Montana* · United States 1942 Adams' storied career in photography was key in pushing forward legislation for the formation of various national parks across America, his moving portraits of landscapes inspiring the preservation and protection of expanses of wilderness. In nature, Adams discovered what he described as "a mystique: a valid, intangible, non-materialistic experience."

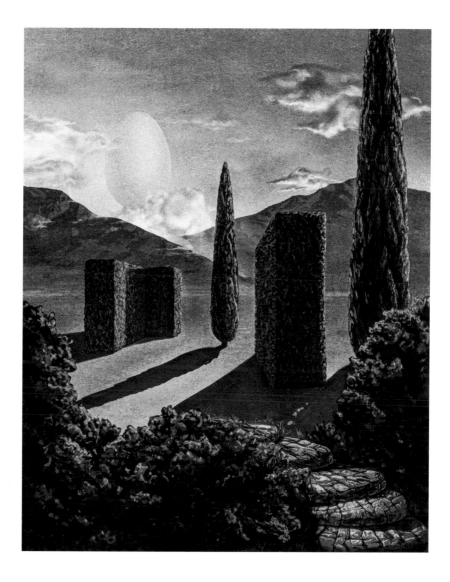

River Cousin · *Love as The End of Sound* · England
2021 The British artist known for their poster design
and album artwork turns to nature as muse in their
intricately detailed graphic depiction of a fantastical
landscape of trees.

Vincent Van Gogh · *Cypresses and Two Women*
France · 1890 The trees of mourning and death-
lessness, existing between worlds, were fascinating
to Van Gogh, who compared them to Egyptian
obelisks. The painting was done during the last year
of his life from the psychiatric hospital in Saint Rémy.

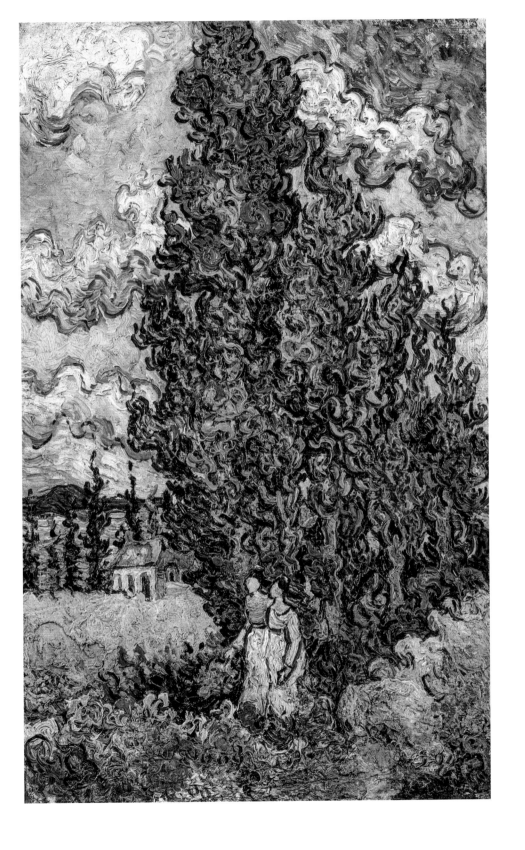

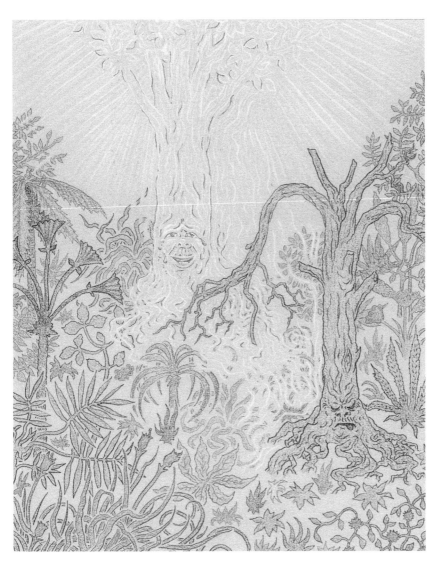

(previous pages)
Roger Dean· *Floating Islands* · England 1993 The English illustrator Dean, best known for his iconic album art, created a mystical depiction of fantastical forested floating islands for the gatefold cover for the live album, "An Evening of Yes" performed by members of the progressive rock band Yes.

Linda Westin · *Illuminated Dendrology – Dimensional Forest* · Sweden · 2019 Based in Stockholm, Westin is a PhD in neuroscience whose work with super-resolution fluorescence microscopy captures the natural world with visual sensitivity and methods culled from her experience in the sciences.

Casey Jex Smith · *This Oak Hath Gone to Heaven* United States · 2020 A multimedia and performance artist, Smith's elaborate and intricate work explores a psychedelic, surrealistic side of the natural world.

Piet Mondrian · *Woods Near Oele* · Switzerland 1908 Prior to his well-known line and color block style, Mondrian's art was more rooted in nature, interpreting the sweeping forms of abstract forests.

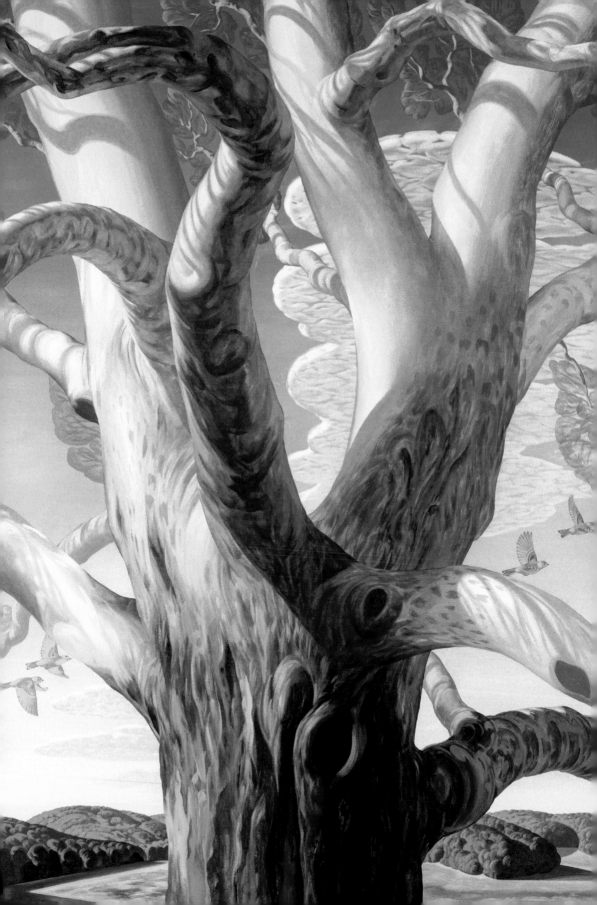

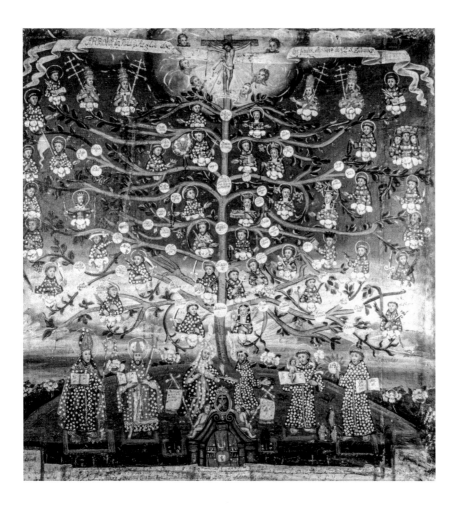

Bryan Haynes · *Above the Beyond* · United States 2006 The American artist is known for their visionary paintings of trees and plants, here Haynes explores the nuanced shape and color of a giant Sycamore tree, celebrating, as they explain, "the figurative quality of the species."

Unknown · *Tree of Life of the Franciscans* · Bolivia 18th Century This painting is based on the *Tree of Life* writings by Saint Bonaventure, an early follower of St Francis, presenting meditation upon the sufferings of Christ as an essential spiritual exercise for lay people.

Tuco Amalfi · *Vidas na Floresta* · Brazil 2002 The fantastical artworks of Amalfi are imbued with elements of surrealism and the artist's visionary take on the natural world. In this elaborately detailed painting, flowers and insects co-exist in a utopian botanical scene.

(following and left) Marlene Steyn *The Psychiatree* South Africa · 2022 In Steyn's whimsical surrealistic work, trees, plants, and nature become a conduit to exploring the subconscious and dreams.

135

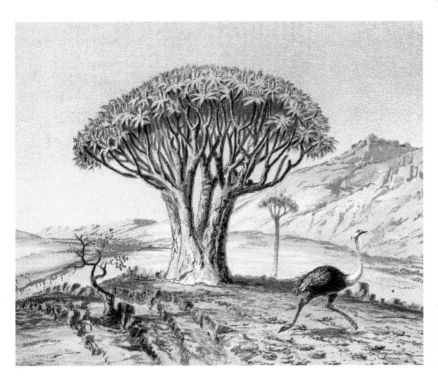

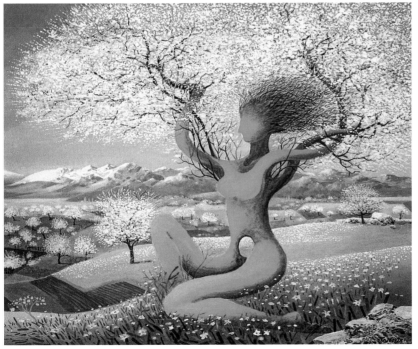

Thomas Baines
The Great Tree-Aloe of Damaraland · England
1866 Tree-aloe flowers are revered symbols of beauty, fortune, and good health. The flower blooms for three to four months making it a symbol of patience and endurance. The illustration is from the book *Nature and Art*.

Vasko Taskovski · *April*
Macedonia · 1999
As a part of his surrealistic zodiac and cycle of the season series, the painter re-imagines the month of April as a feminine tree form covered in delicate white blossoms.

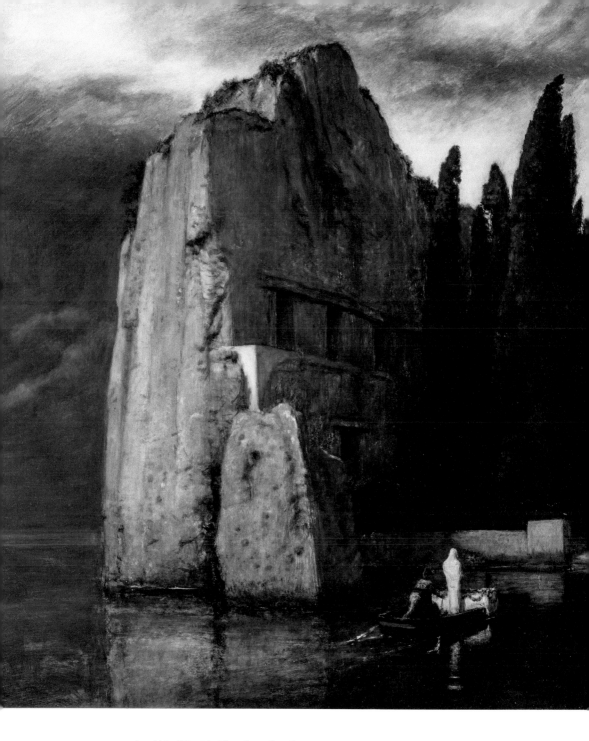

Arnold Böcklin · *The Isle of the Dead* · Italy · 1886
One of several versions of the vastly popular paint-
ing in which a dark grove of mournful cypress trees
creates a foreboding mystique.

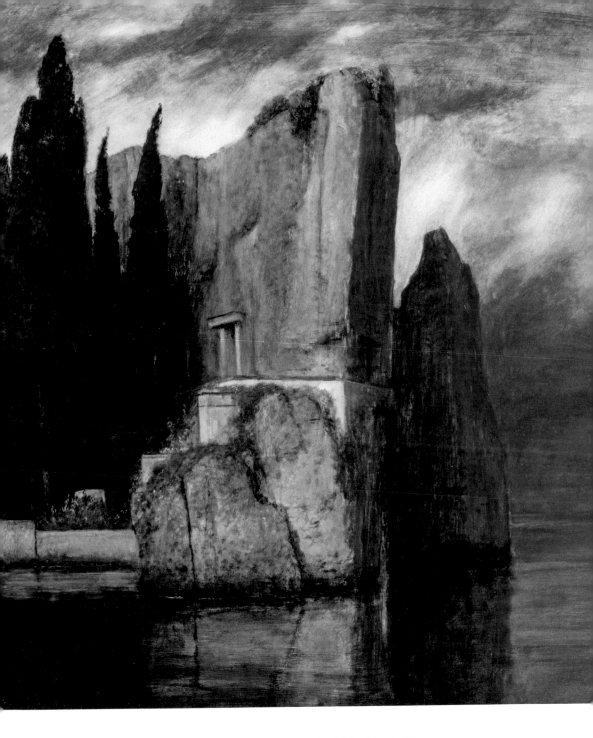

(following and left) Cornelius Cort · *Cyparissus from set The Rural Gods* · Italy · 1565 A tamed deer was the hunting companion of mythological Cyparissus until he accidentally killed it one day. Devastated, he transformed into a cypress tree, the classic symbol for mourning.

(following and right) René-Antoine Houasse *Apollo and Daphne* · France · 17th Century Apollo chases after Daphne as she pleads for help. Her father, the river God, Peneus, assists by changing her into a Laurel tree. Apollo vowed to keep her evergreen, creating the hardy bay leaf.

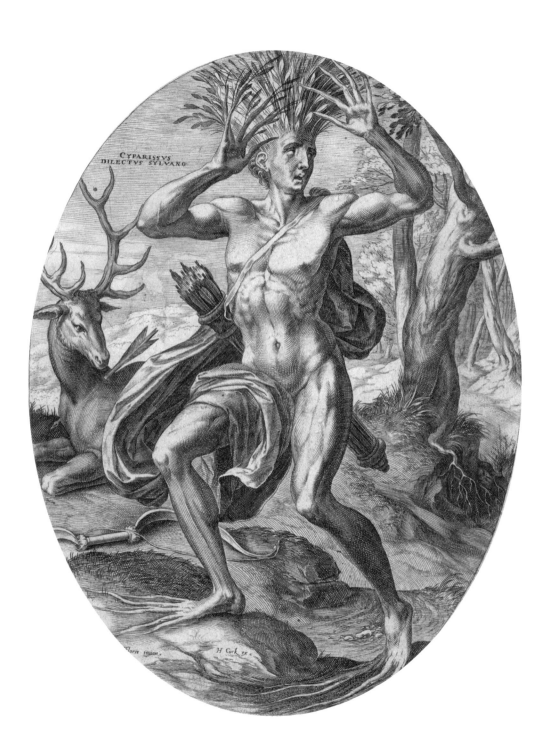

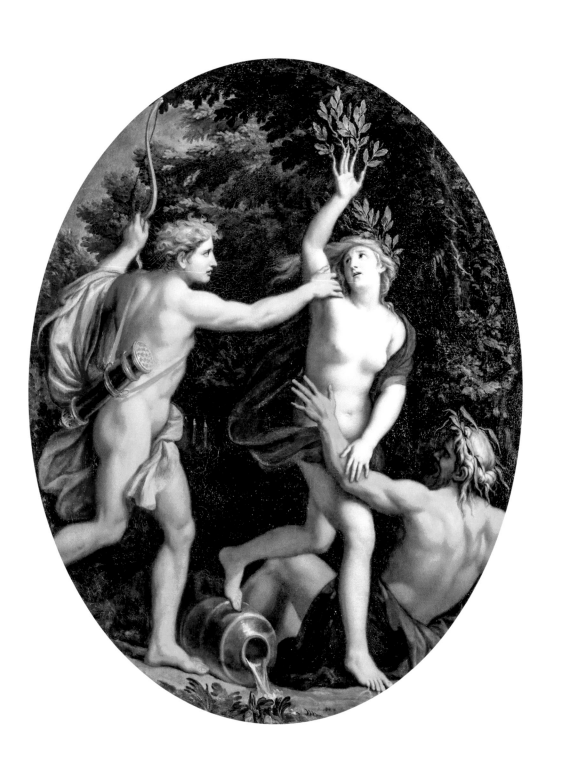

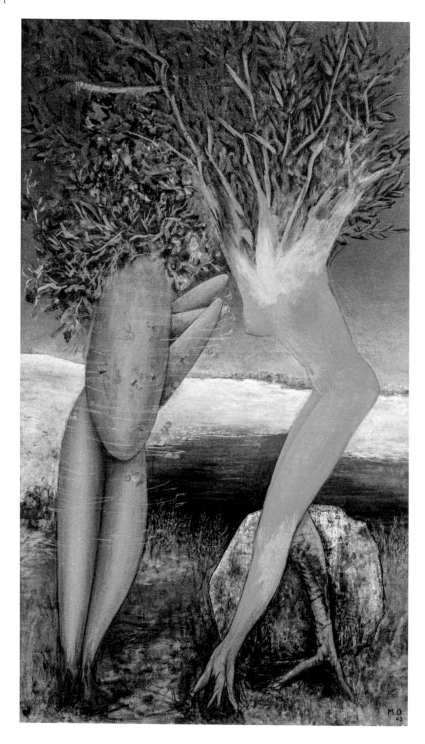

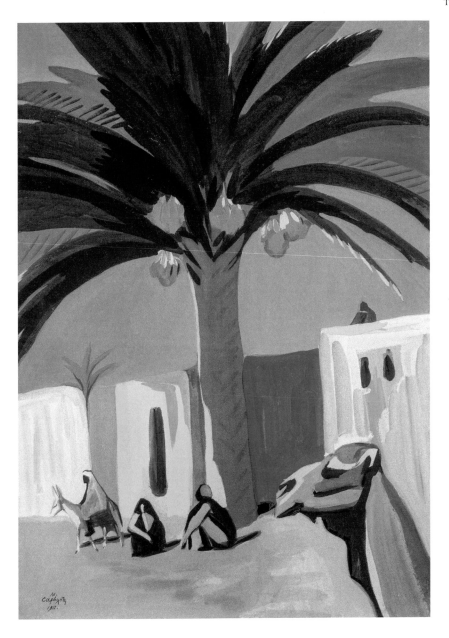

Meret Oppenheim · *Daphne and Apollo* · Switzerland · 1943 The surrealist's interpretation of the ancient mythological story transforms both Daphne and Apollo into trees.

Martiros Saryan · *Date Palm* · Russia · 1911
The date palm in Fauvism style is a symbol of prosperity and fertility. It is used as a visual language to depict the number of months in Egypt since it grows 12 new fronds a year. One frond represents one month, a whole tree represents a year.

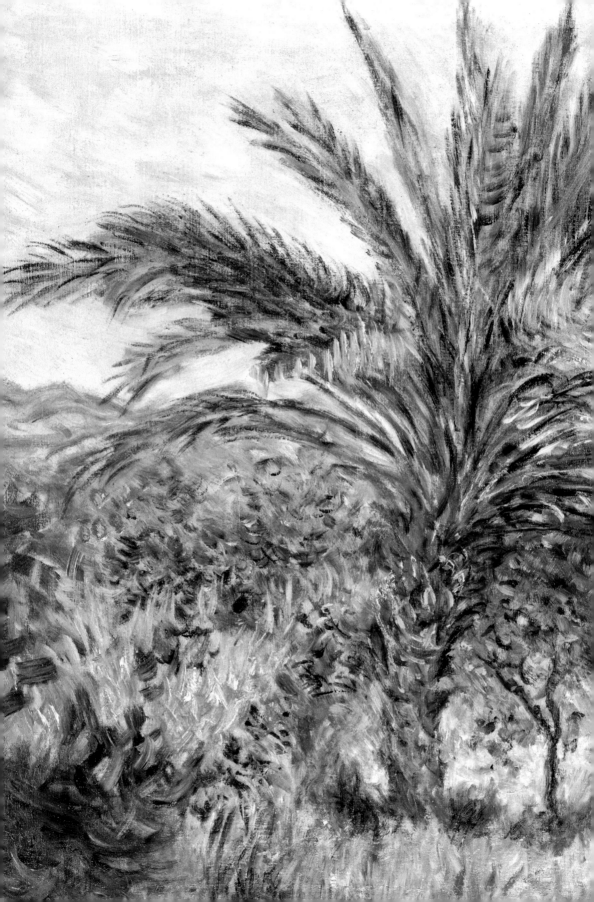

Claude Monet
Palm Tree at Bordighera
France · 1884 While
visiting Italy's southern
coast, Monet ventured
out in Bordighera
and was taken by the
views of Ventimiglia.
It inspired his paintings
of palms – symbols
of triumph, eternal
life, good luck, and
abundance.

145

(above) Unknown *Landscape with Palm Trees* · India · 1750 Indian miniatures are a tradition of painting in rich color and highly stylized detail influenced by literature and mythology. Palm trees and peacocks are both symbols of longevity.

(below) William Edward Webb · *Webb's Tree Wings No. 7* ·England ·1850s As part of a colored lithography series originally created as a reference for theatrical stage design, the artist creates a highly detailed stenciled pattern of palm trunks and fronds.

Sarah Paxton Ball Dodson · *Saint Thecla* · United States · 1891 In Christian iconography, the palm frond is regarded as a symbol of victory over enemies, as is exemplified in the life of Saint Thecla, who miraculously escaped being burnt at the stake, fed to wild beasts, and tied up before stampeding bulls.

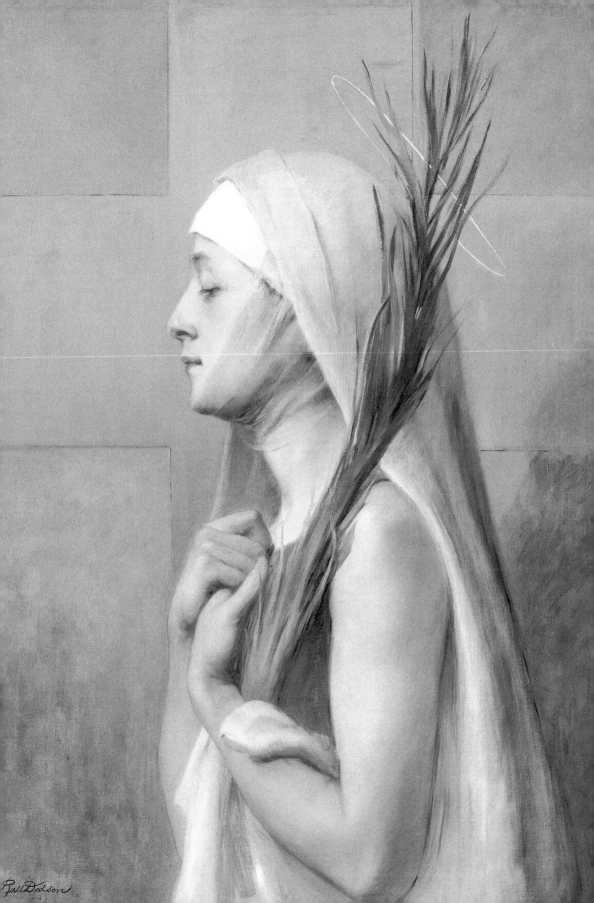

I grew up in Ojai, California surrounded by nature. We had an extensive garden growing up, I was in charge of growing the cherry tomatoes. There are so many childhood memories of interacting with plants and flowers One that particularly sticks out is watching how roses grow, how my mother would fertilize them with coffee grounds and prune them seasonally and how they would fantastically grow back larger and more stunning than ever. In 2010 I started working in the culinary industry. In 2012, I enrolled in an adult education class titled "Edible + Medicinal Plant Class" where our instructor would lead the class on hikes and teach the class about all the plants and how often many of them are edible and medicinal. At this time, I was working at a fancy hotel as a pastry chef. I started experimenting on my own time, combining the newfound plant knowledge I was learning about in class with the pastry techniques I was learning at work. That was the start of my business baking with botanicals and experimenting with infusing botanicals into my baking and cooking, for flavor, color, aesthetics, and medicinal health benefits. I've also felt an intrinsic connection to nature. Working with plants and spending time in nature has been a calming and epic presence in my life, one that both inspires, grounds, and renews my lifeforce. A connection with the natural world is so important within modern contemporary culture because it brings us back to our roots. It grounds us in a world that is often inundated with man-made external stressors. For me, balancing life in our modern culture with nature is the true key to a happy existence.

— LORIA STERN, Baker, Chef, and Author of *Eat Your Flowers*, 2022

Alex Grey · *Tree & Person* · United States · 2000
The mystic visionary Alex Grey imbues his work with resonant and vivid symbolism. In this psychedelic rendition of the cosmic tree of life, he places a figure with the mythic iconography, conveying the inherent iterconnectedness of humans and nature.

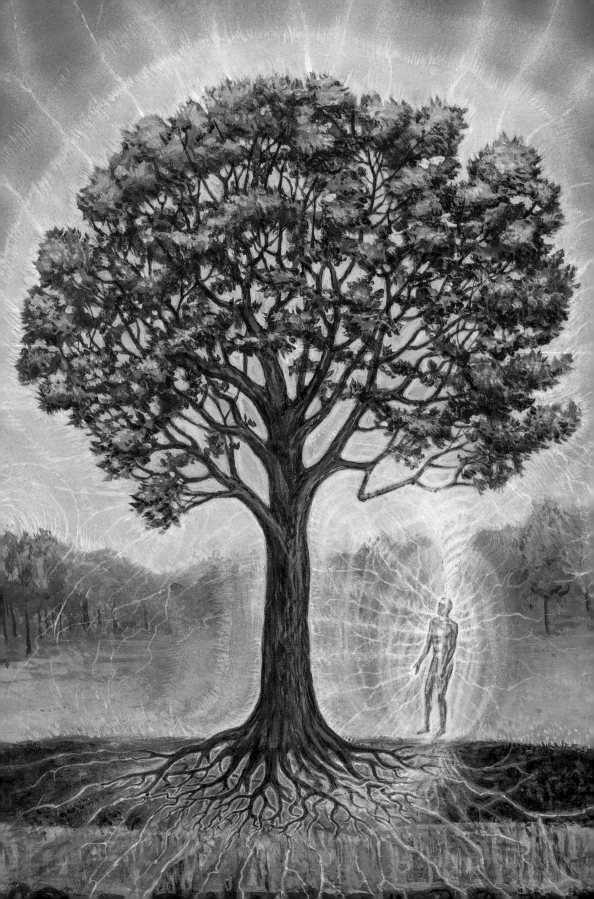

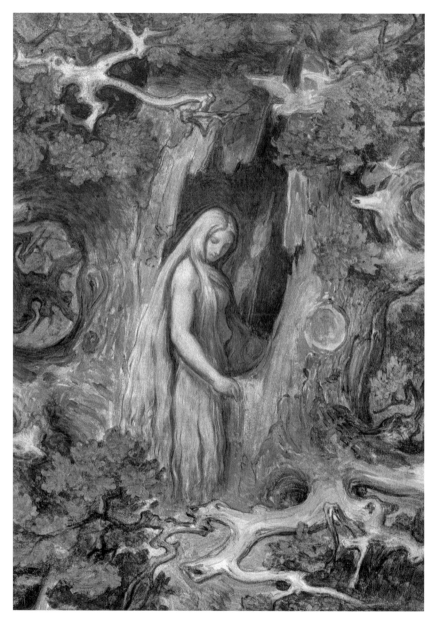

(following pages)
Karl Friedrich Lessing
*The Thousand-Year-Old
Oak* · Germany · 1837
A lush, romanticism-era
forest of old growth
trees provides the
perfect setting for
honoring a shrine.
From one of the many
versions of *The Seven
Ravens*, a Brothers
Grimm fairy tale, the
tree becomes a symbol
of protection or refuge.

Moritz Ludwig von Schwind · *The faithful sister
of the spinner in her hollow tree trunk* · Austria
1857–58 From one of the many versions of *The
Seven Ravens*, a Grimm fairy tale, the tree becomes
a symbol of protection or refuge as the loyal sister
journeys to save her brothers.

Unknown · *Morenia Poppigiana and Forest* · Germany
19th Century The color engraving comes from
the three volumes, illustrated *Historia Naturalis
Palmarum* or *Natural History of Palms* by zoologist
Johann Baptist von Spix and botanist Carl Friedrich
von Martius.

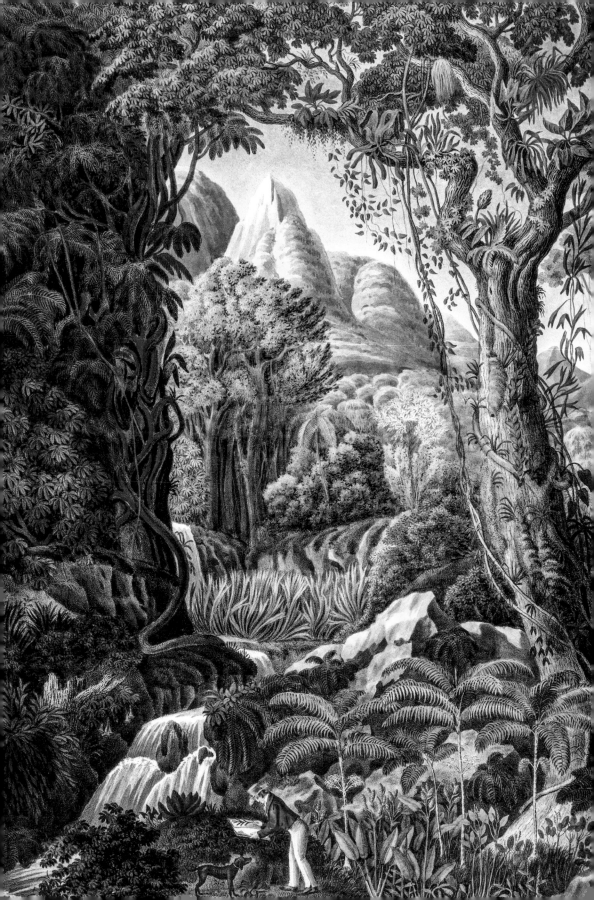

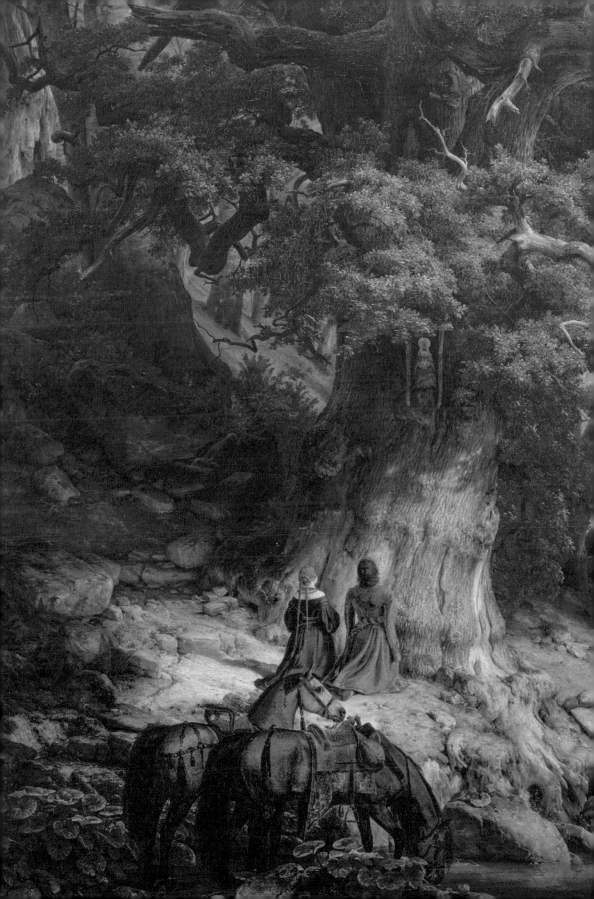

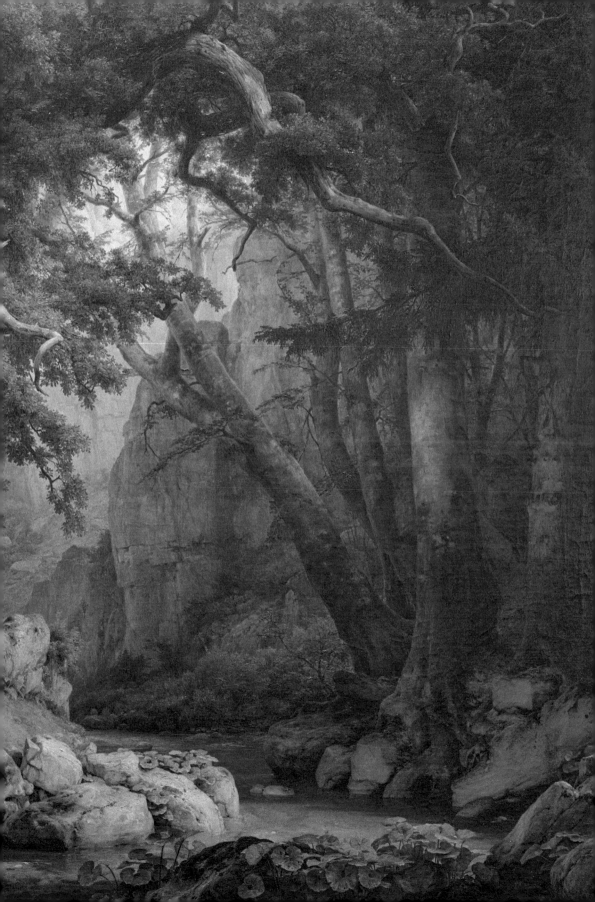

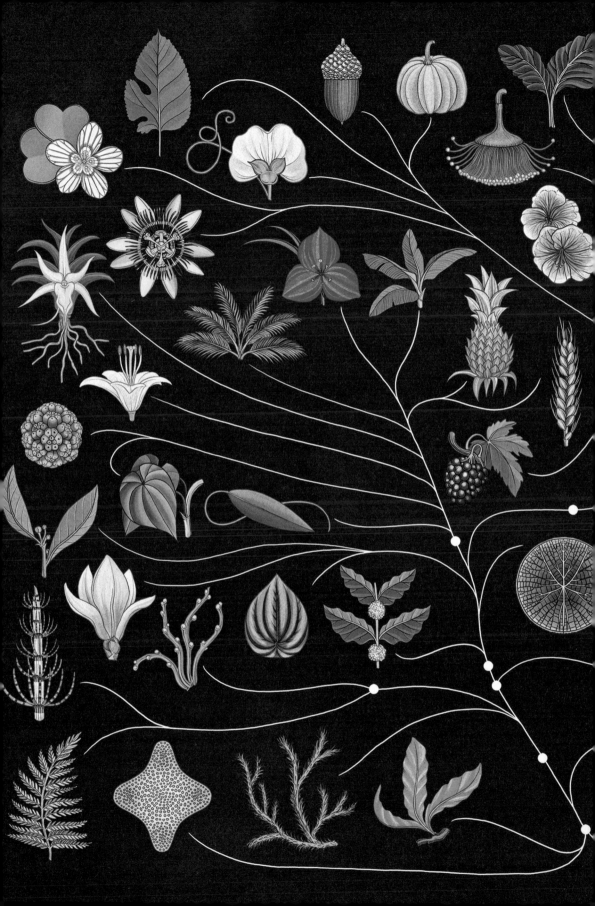

PART III

———

Germination

& Growth

PLANTS IN HEALING
AND CEREMONY

PLANTCRAFT

Botanical Spells & Green Witchery

When we live in harmony with the Earth, we are on one hand supported, aided, and needed and on the other hand, we need, aid, and support the Earth… finding harmony with the Earth offers a foundation for healing and magic to take place.

— PAIGE VANDERBECK, *Green Witchcraft: A Practical Guide to Discovering the Magic of Plants, Herbs, Crystals, and Beyond*, 2020

The age-old integration of plants, flowers, roots and herbs into teas, tinctures, and potions, have shaped a practice that has been called witchcraft but essentially encompasses ancient traditions of herbalism, healing, and natural medicine. Earth magick necessitates a deep knowledge of, and relationship to, nature and has long been practiced in all cultures, throughout history.

In mythologies around the globe, the use of plants in witchcraft and spellcasting is perhaps most deeply associated with the sorceress Circe, famous for her memorable role in the *Odyssey*, the epic Greek poem written in the 7th century. Banished to a remote island, Circe hones her magickal skills, studying herbs and plants and creating a potion that turns men to pigs, and back again. In ancient Greece, Mandrake root, with its narcotic and hallucinogenic qualities was also considered a powerful aphrodisiac in smaller doses and was used often in rituals celebrating Aphrodite, the goddess of love. In the rituals of the Celtic Druids several plants were considered sacred. The herb

Vervain, for instance, played an important role in Druidic rites and was also used by ancient Roman and Egyptian cultures to purify altars and temples. Henbane is another plant sacred to the Druids and long associated with spells and witchcraft. With its narcotic and toxic qualities, the henbane plant was known as "the witch's herb" throughout the Middle Ages, thought to be a primary ingredient in the "flying ointments" — magickal mixtures said to grant witches the ability of flight.

More recently, various contemporary interpretations of green witchcraft practices have evolved. There has been a surge of renewed interest in ancient Northern European pagan religions that worshipped the natural realm, as well as a revival of indigenous botanical teachings from Africa and Central and South America. A deep and ongoing concern for the environment has also ignited our fascination with the potent powers of plants, as a new generation seeks to both heal, and be healed, by nature.

(previous pages) Katie Scott · *Tree of Plant Life* England · 2016 The English illustrator created her vivid and detailed exploration of plants for the publication of the book *Botanicum* by Big Picture Press.

Elena Stonaker · *She Grows* · United States · 2021 A multimedia artist creating textiles, sculpture, painting, and immersive audience experiences, Stonaker's work often explores the archetypes of the feminine within the natural and botanical world.

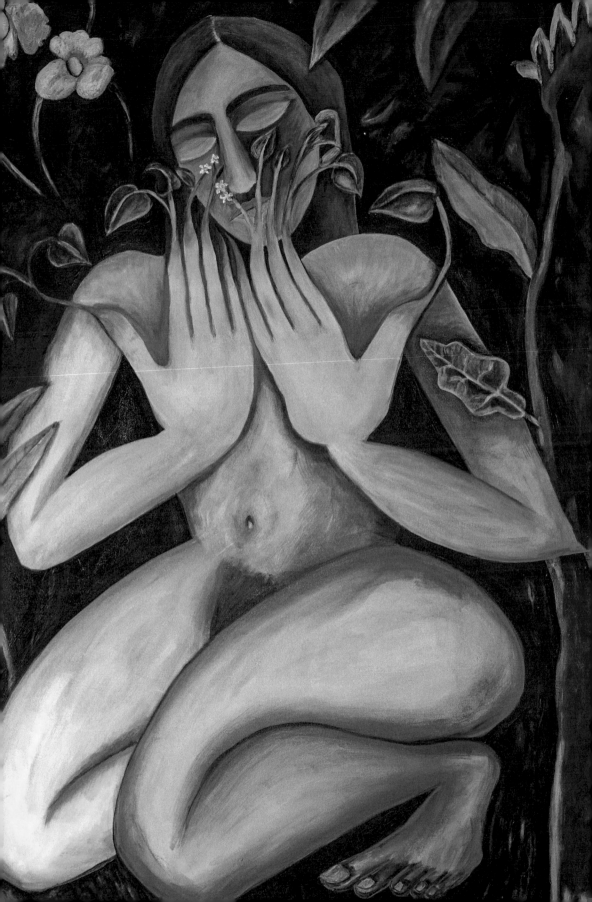

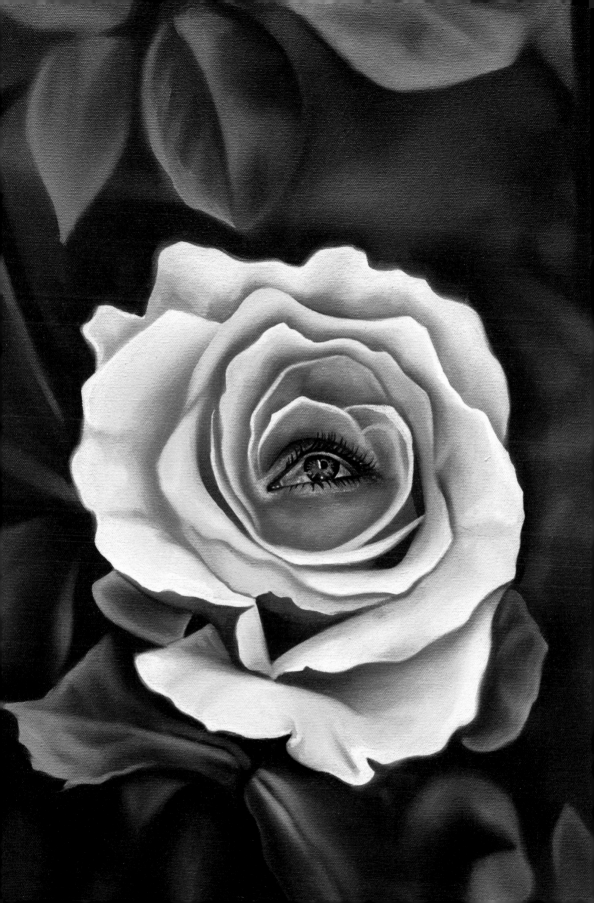

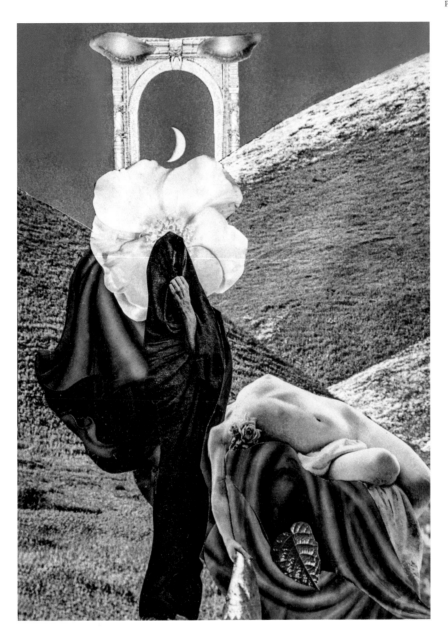

Ariana Papademetropoulos · *The Best Whistler in the World* · United States · 2021 A lushly blooming rose takes on a sly and playful element of consciousness in this seductive, mystical work by the California artist Papademetropoulos.

Penny Slinger · *Book of Matan* · United States 1977 Cover art created for a 1979 publication of the same name, a book which Slinger describes as, "a tale of awakening."

Henry Fuseli · *The Witch and The Mandrake* England · 1812
The supernatural subject painter captures the root containing hallucinogenic alkaloids often resembling human figures due to which have been widely associated with magic and witchcraft throughout history.

L · *Talisman to ward off the evil eye and nefarious entities* · United States · 2012-2022 L, a mage based in Los Angeles, practicing folk and holaetherial magic, created this talisman, using the alchemical power of lemons and a rusty nail to absorb and hold unwanted negative forces and beings.

Leonora Carrington · *From the Holy Weed* · Mexico 1975 In "De la Hierba Santa," the Surrealist painter pays homage to the consciousness of plants with her imaginative vision of a sacred herb imbued with a feminine mystique.

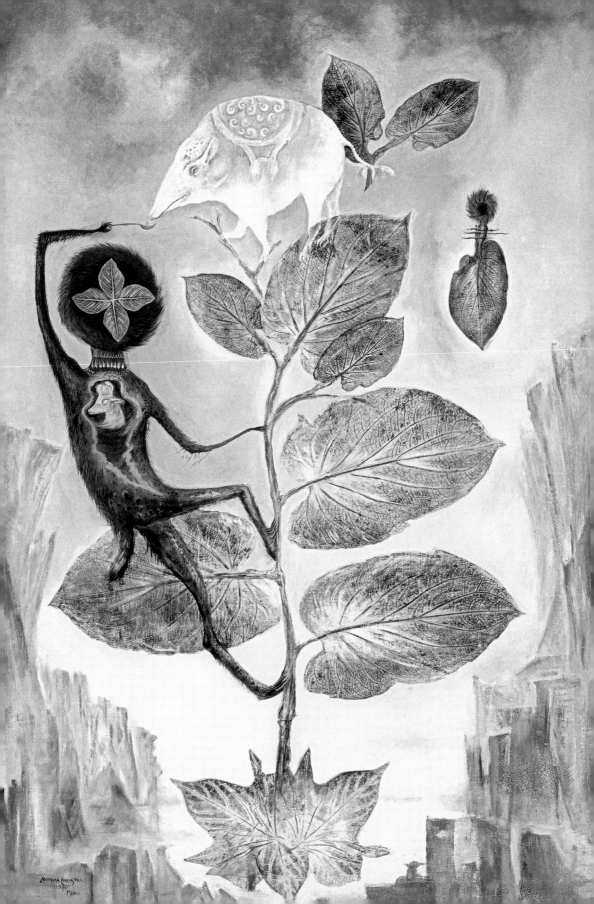

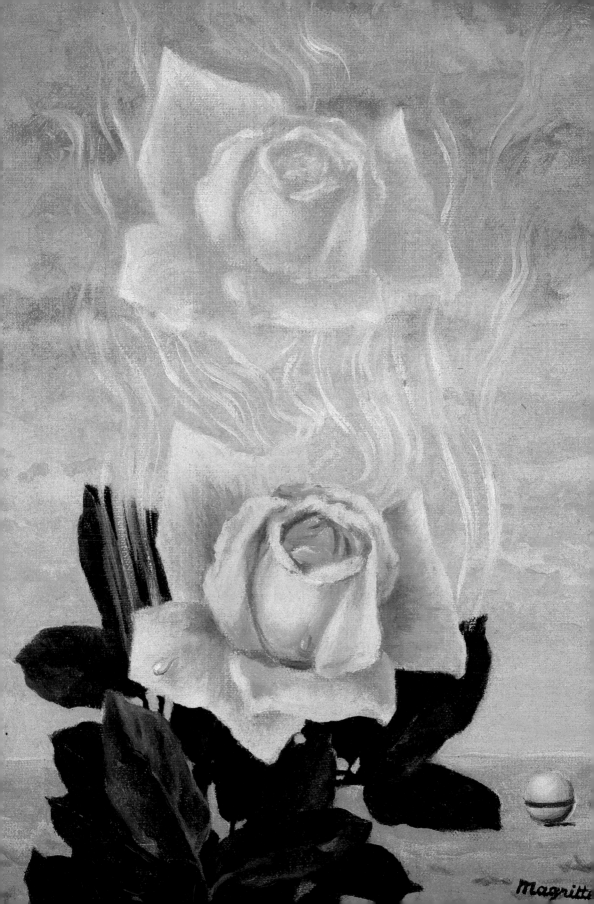

René Magritte · *The Enchanted Domain* · Belgium 1957 A common trope in the art of Magritte, the rose mystified him.One of a series of five, created for the entrance hall of collector Freddy Wolff's Brussels apartment.

William Lemon · *Flexibility in Wind* · United States · 2022 Part of a series called "Spells for the Home," the artist created these works "to generate calm and inspiration." In this spell, Lemon lists the active ingredients as "Yucca/Plumeria Leaf/Gerber Daisy/Seashell."

HEALING
BOTANICALS
The Use of Plants as Medicine

Nature itself is the best physician.

— HIPPOCRATES OF KOS, Greek physician thought to have been
born in 460 BCE and considered the forefather of modern medicine

The use of plants in healing is a practice that goes back as far as ancient Sumer. Archeologists have discovered written documentation of medicinal botanicals, carved by Sumerians onto clay tablets dating to approximately 3000 BCE. Employing the curative qualities of plants, flowers, herbs, and certain species of mushrooms, may go back even farther still, to the very dawn of humankind, to our ancestors, plucking Nettle and Dandelions to fight off illness, or tending a wound with an herbal poultice in the flickering firelight of a cave dwelling. The *Ebers Papyrus*, an early Egyptian scroll thought to be written in 1550 BCE, documents hundreds of plants, and their medical applications. In Hindu Vedic scriptures, the use of plant medicine is mentioned in various writings, most notably in the *Atharva Veda*, a volume likely penned sometime between 1200 and 1000 BCE. In China, the famous texts of the *Shennong Ben Cao Jing*, written between 206 BCE and 220 CE were said to document the use of hundreds of healing botanicals. Ancient Greek physicians, including those schooled under Hippocrates, born in

460 BCE and widely considered to be "The Father of Medicine," often prescribed herbal remedies native to the Mediterranean, from Rue to Sage, Oregano to Bay Laurel. There are hundreds of plant-based prescriptions included in *The Hippocratic Corpus*, the collection of writings most associated with Hippocrates and his teachings. In 60 CE the Greek scholar and physician Pedanius Dioscorides wrote one of the most extensive overviews of plant medicine ever recorded, *De materia medica*, a work which would serve as a foundational manual for much of the world, for the next thousand years and more.

The gifted Persian philosopher Ibn Sina created two important volumes of plant medicine with his *Canon of Medicine*, published in 1025 and *The Book of Healing*, published in 1027. In Baghdad of the 11th century, the Islamic physician Ibn Buṭlān compiled the vast encyclopedia known as *Historia Plantarum*. The latter used the work of Dioscorides as a primary source, with Buṭlān expanding upon the Greek author's

Mariela de la Paz · *Plant Medicine* · Chile/USA · 2021 In this vivid depiction of various plants and herbs, the artist references a healing mix of botanicals known as the "Black Salve," used for centuries to treat skin ailments.

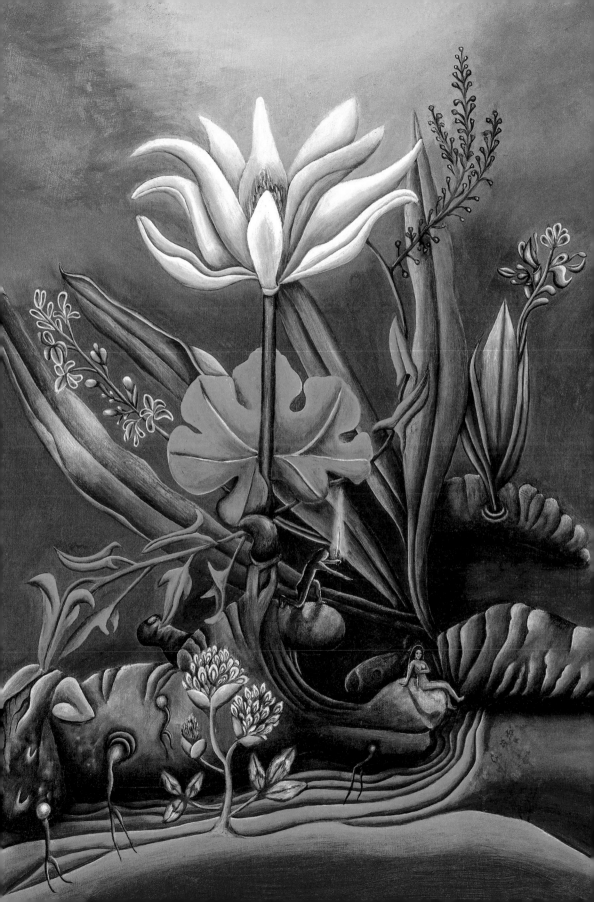

work with information on additional plants, herbs, and botanicals native to the Middle East and Asia. This was just one of the many books that used Dioscorides' famous volume as inspiration. *De materia medica* has become, over the course of two centuries, perhaps the most influential tomes on plant medicines ever written. Translated into Arabic, Greek, and Latin, and illustrated with detailed drawings, copies of *De materia medica* were painstakingly hand-made into the Middle Ages. With the advent of the printing press the book was mass distributed in multiple languages and finally translated into English in 1655 by the botanist John Goodyer. Goodyer, along with fellow botanist Thomas Johnson, was also responsible for editing and updating the herbalist John

Gerard's *Herball*, or *Generall Historie of Plantes* — a thousand page illustrated overview of herbs and plants, first published in 1597. Gerard's original manuscript took much of its information from *Cruydeboeck* (herb book) written by the Dutch physician and botanist Rembert Dodoens in 1554. These books, as well as the Renaissance-era innovations of woodblock printing and engraving, hugely expanded the knowledge of plant medicine and ignited a renewed interest in botany, natural history, and gardening throughout the Renaissance period. In fact, during Rembert Dodoens' lifetime, his extensively illustrated "herb book" became one of the most translated volumes in the world, second only to the Bible.

Unknown · *Aesculapius discovering betony* · France 19th Century Aesculapius, the Greek God of medicine and Earth is reimagined from a manuscript by Antonius Musa, a Greek botanist famed for curing an illness of the emperor with plant compresses and medicines.

The Bible itself mentions hundreds of medicinal plants, as well as numerous distilled botanical oils known to have healing qualities, although specific formulations were rarely put into detail, perhaps to avoid spreading knowledge of what early Christians considered pagan or magickal practices. However, throughout her lifetime, the mystic, musician and Benedictine Abbess Hildegard of Bingen managed to find time away from her Biblical studies to contribute a vast amount of scholarly work on plants and their medicinal qualities. She famously wrote, "Gaze at the beauty of earth's greenings. Now, think. What delight God gives to humankind with all these things. All nature is at the disposal of humankind. We are to work with it. For without, we cannot survive." Bingen's nine volume series *Physica*, as well as in her book *Causae et Curae (Holistic Healing)*, both written between 1150 and 1160, documented not only her own studies of botany, but also the experiences of other (primarily female) healers, many illiterate, whose vast, generational knowledge may have otherwise been lost to time.

In China of the late 1500s, the naturalist, herbalist, and physician Li Shizhen, spent 27 years compiling his *Compendium of Materia Medica*, which lists hundreds of plants and herbs key to Chinese Medicine modalities. In 16th century Mexico, what is now known as the *Badianus Manuscript* was first penned, a detailed overview of ancient Aztec plant medicines, written by the physician, Martinus de la Cruz, and translated into Latin by Juannes Badianus. Both authors were of Aztec descent and students at the College of Santa Cruz in Tlalatilulco, which the Spanish had built

soon after colonizing the country. The manuscript is evidence of the incredibly advanced knowledge and sophisticated plant and herbal healing treatments practiced in Aztec cultures.

Throughout the long history of plants and healing there are specific botanicals which have been celebrated again and again as particularly potent curatives. In much of Asia, for instance, Ginger has long been used for its antibacterial and antiviral qualities, as well as to enhance digestion and the absorption of nutrients into the body. Ginseng is another plant used for centuries in Chinese Medicine as a powerful anti-inflammatory. Turmeric has been used across cultures for 4000 years or more and is a core foundational plant in Ayurveda – the holistic, whole body healing practice first founded in India over 3000 years ago. In tropical climates, the Coconut has long offered a host of both medicinal and nutritive qualities. Lavender, native to the Mediterranean, Middle East, and India, was first brought to Europe by the Romans nearly 2000 years ago, and still prized not only for its fragrance, but for its potent healing qualities as well.

In North America, indigenous cultures have long used plants like Yucca, Thistle and Echinacea for curing a variety of illnesses. In his 2020 book, *Iwígara: American Indian Ethnobotanical Traditions and Science*, indigenous scholar, and ethnobotanist Enrique Salmón documents the extensive knowledge of plant medicine shared by tribal elders and passed on from one generation to the next. "Europeans reached the shores of North America only 400 years ago…" he writes, "…native peoples have been studying, observing, and using the

plants of North America for at least 20,000 years." Salmón goes on to cite over 200 examples culled from this vast Native American pharmacopeia, a range of botanicals prized by indigenous tribes for medicinal use; including plants such as Slippery Elm and a root known as Osha, which Salmón, explains as, "one of the most widely known and used plant remedies." Sometimes called Bear Root or Indian Parsley, Osha is used for coughs, digestive ailments, and for alleviating headaches and fevers.

In addition to indigenous remedies, much of the plant medicine of the last four hundred years in America, integrate the many cultures arriving to the continent, including an array of traditional healing modalities brought to the United States from Africa. In Michelle E. Lee's 2014 book, *Working the Roots*, the author documents several centuries of both African American and Native American plant medicines. In her introduction, Lee explains her thesis for the project was to represent, "a small portion of the medical expertise that enslaved Africans brought from their homeland and blended with the knowledge of the healing arts they found already present among the indigenous people of America." Lee's volume documents plant-based teas, tinctures, poultices, and various herbal remedies that were used for both preventive care and serious ailments. Pine tree sap, for example, was utilized to boost immunity. Okra was a staple food on most supper tables for centuries but was also used for its laxative qualities. Elderberry was steeped in boiling water to suppress coughs and soothe sore throats. Most of Lee's research was conducted through interviews with elders in the African

and Native American communities, *Working the Roots* shows how folk remedies, most consisting of botanical ingredients found within close geographical proximity, have helped nurture the health and well-being of generations.

As we move into the new millenium, there has been a groundswell of interest in plant medicines and holistic healing. Young botanists, foragers and herbalists are returning with enthusiasm to the traditions of their ancestors, seeking methods of not only healing the body, but also the mind. In his 2010 article *"Why Plants Are (Usually) Better Than Drugs,"* the pioneering physician Dr. Andrew Weil, explains one of the core tenets of integrative medicine, a practice which encourages not only conventional medical remedies, but the integration of plant medicines as well. "Human beings and plants have co-evolved for millions of years," he writes, "so it makes perfect sense that our complex bodies would be adapted to absorb needed, beneficial compounds from complex plants and ignore the rest." That co-existence, thousands of years of symbiotic evolution, has resulted in a bountiful botanical pharmacopeia, a vast apothecary in our forests, our fields, and kitchen gardens. According to Rosemary Gladstar, considered one of the founding voices of the modern herbalism movement, the use of botanicals for healing goes far beyond physical ailments. Gladstar, who has written books on plant medicine and who lectures all over the globe, speaks on the curative powers of plants, professing that the botanical world offers remedies capable of restoring our health, and our emotional, mental, and spiritual well-being. "The plants," she claims, "have enough spirit to transform our limited vision."

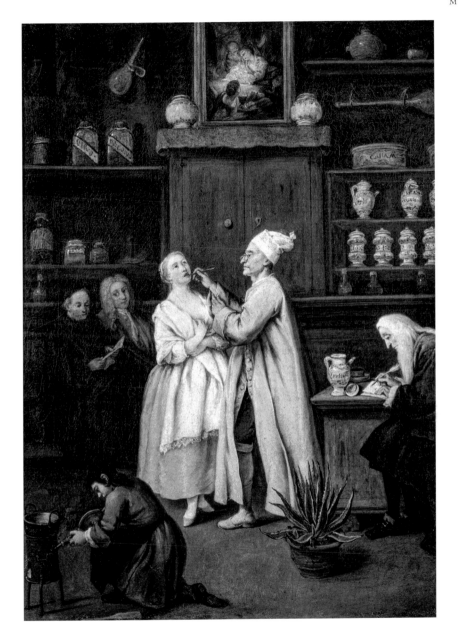

Pietro Longhi · *The Pharmacist* · Italy · 1752
Apothecaries once distributed herbal remedies,
kept in ceramic jars, as medicine. Pharmacists
played the role of chemist, doctor, surgeon, and
dentist, all in one.

Henri Doré · *Ma Kou Carrying Medicinal Plants*
France ·19th Century Doré was a missionary and
sinologist who wrote the eight volume, *Research
into Chinese Superstitions*. Five of the volumes were
devoted to superstition, while the remaining three
cataloged the Chinese pantheon of religious figures.

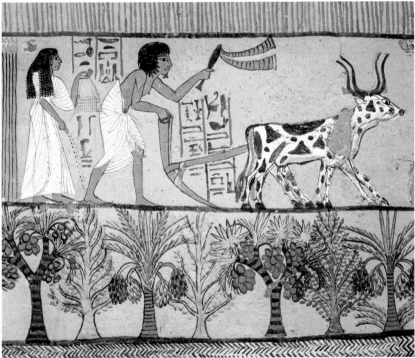

Unknown · *Pharmacy: An apothecary, the picking of plants and the preparation of medicine* · France · 1461 From the book, *L'Antidotaire* by Bernard de Gordon, such apothecaries in the Middle Ages prepared all curatives from plants and mushrooms.

Unknown · *Sennedjem and his wife in the fields sowing and tilling* · Egypt · 1292-1187 BCE From the tomb of Sennedjem, an ancient Egyptian artisan, who is shown farming a grove of date palms, sacred plants whose ribs were turned into the paint brushes of which he used to decorate tomb walls.

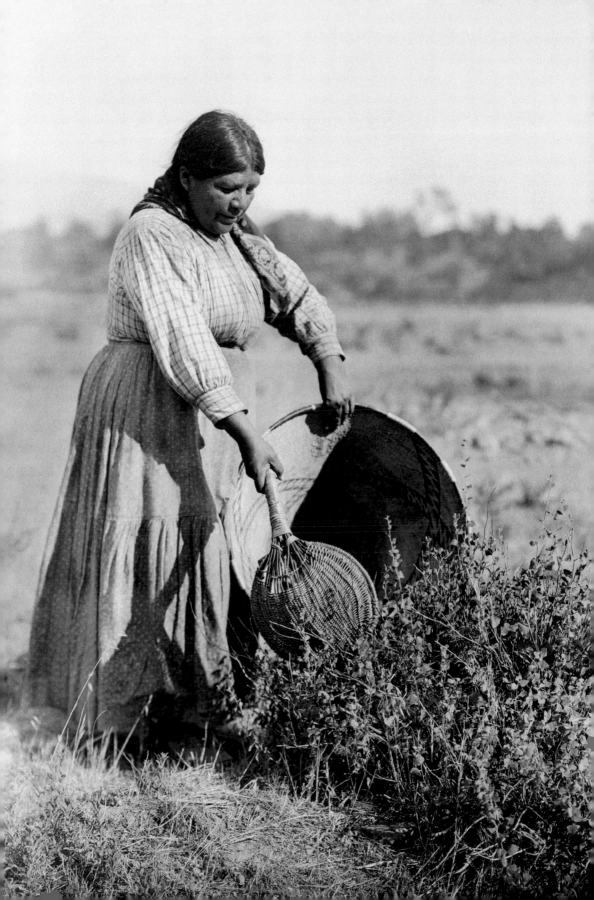

Unknown · *Gathering Seeds* · United States · 1924
Pomo Indian women were famous for their basket
making and harvesting seeds from native grasses
and wildflowers, using seed beaters to collect them.

Unknown · *Cinnamon Merchant* · Italy · 15th Century
Cinnamon bark, is beautifully illustrated in the *Trac-
tatus de Herbis*, a visual treatise of curative plants
created to help apothecaries and physicians from
different linguistic backgrounds identify plants used
in their medical practice.

I grew up in the Caribbean. I grew up in nature. I grew up outside.
I was building my relationship with plants, even then. I think that's
one of the most important things that traveled with me in my herbal
journey is this intimate relationship with plants. I began studying
what we call Western herbalism, 25 years ago, at an herbalism school
in Arizona. At that time, I was the only black woman in the school.
When I got to New York and I started to teach herbalism, that slowly
began to change and now we're in community together. BIPOC people
have come to herbalism, it is part of the movement. It is part of this
big liberation movement, part of people speaking from a place of
complete frustration with the systems that existed, but also frustration
with the systems of care that has existed for black people. And what
we started to realize is that the only way that our ancestors could have
survived the hard circumstances that they were faced with, is because
they were well aware of their indigenous technologies that existed. They
used those indigenous technologies such as spiritism and plant medicine
to be able to survive through some really dire circumstances. So we
started to remember those tools. And folks like me, being able to share
those tools with people who were ready to hear, that was our passion
all along. People are learning to be reliant on something that is older
and greater than them and ancestral. It's survival. It's as simple as
that. To me it is the medicine for what we need to survive. It's the
relationship that we need to build to survive, that relationship with
nature. And understanding you're in allyship with anything in nature,
you become a protector and a steward. And that is the key — not only
for the survival of us, but the survival of our planet.

— KAREN M. ROSE, Master Herbalist, founder of Sacred Vibes Healing and
Sacred Vibes Apothecary and Author of *The Art & Practice of Spiritual Herbalism:
Transform, Heal, and Remember with the Power of Plants and Ancestral Medicine*

(following pages)
Diego Rivera
*The History of Medicine
in Mexico: The People's
Demand for Better Health*
Mexico · 1953 The
detail from a large trip-
tych portrays a patient
being sutured with ease
and sleeping as a result
of ingesting medicinal
peyote. The mural was
commissioned by the
Mexican government to
celebrate their recently
implemented, socialized
health care.

(opposite) Gherardo Cibo · *Asarum Europa*
England · 16th Century Asarum Europa means
"altar" or "sanctuary." Used as a spice, medicine
and snuff, the giant portrayal of European wild
ginger comes from the Cibo series, *Paintings of
Flora of the Roman States.*

(page 180–181) Émile Belet · *Seaweed, Fishes, Seahorse,
Crab and Shellfish* · France · 19th Century From
the book *La Vie sous Marine*, Belet's Art Nouveau
plates of underwater marine life explore the rich
array of sea plants. Seaweed has a long history of
medicinal use in cultures across the world.

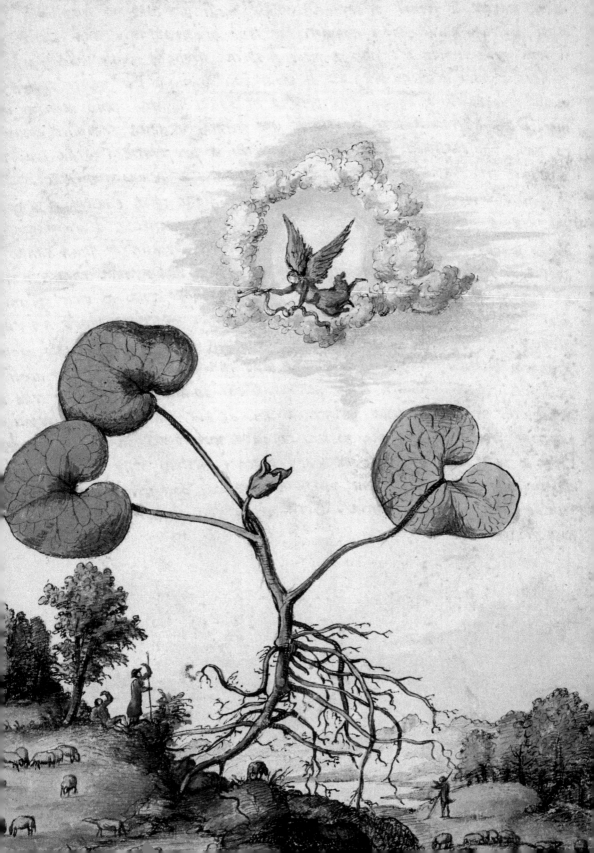

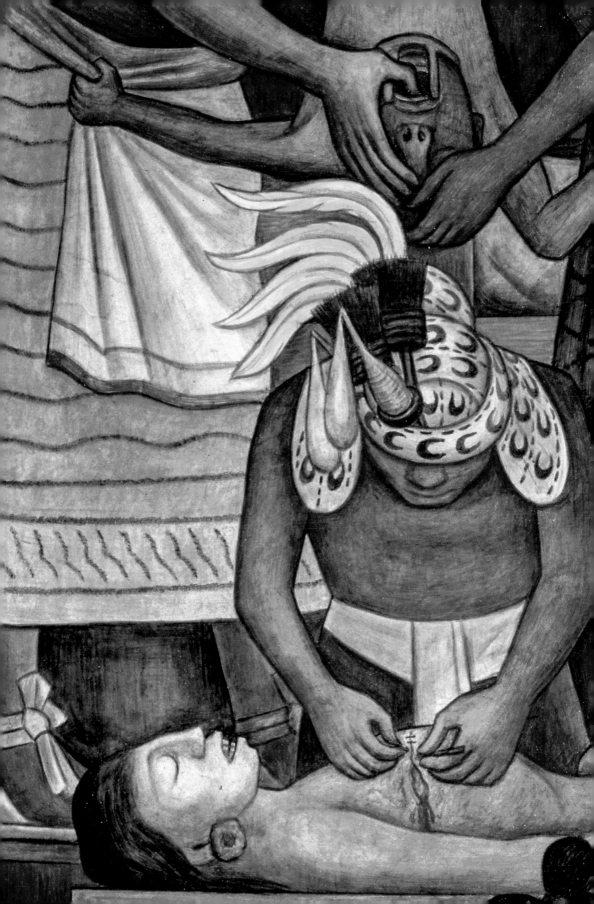

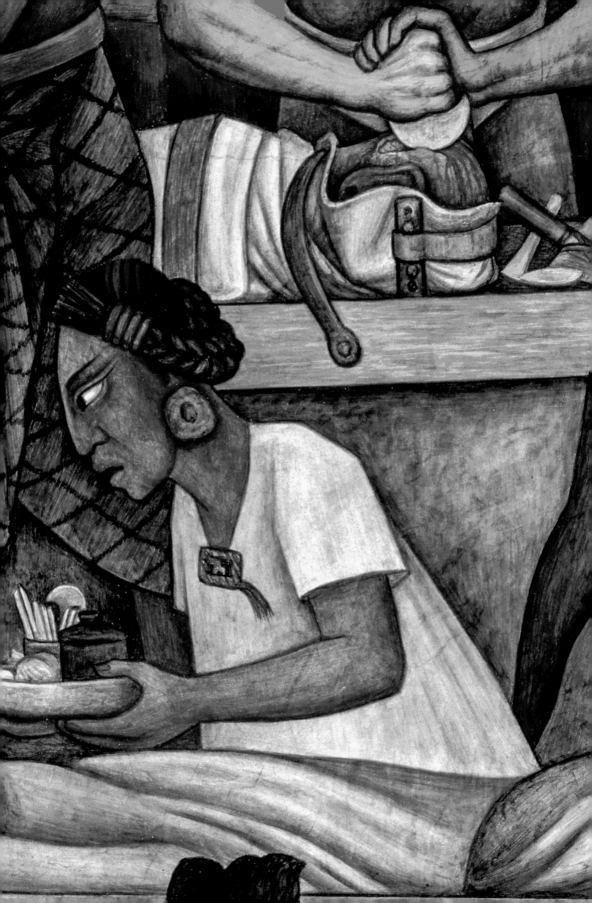

Tab. 133.

ZORN. IC. PL. MED.

Panax quinquefolium. L.

B. Thanner del. J. S. Leitner fec.

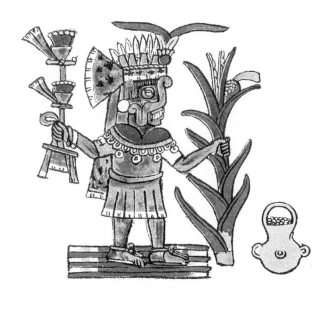

B. Thanner · *Panax quinquefolium* · England · 18th Century Engraved by T. S. Leitner, this illustration shows the different parts of the American Ginseng plant, an endangered species due to its highly prized, plethora of benefits.

Unknown · *The Codex Magliabechiano* · Italy ·16th Century Exploring the religious and medicinal rites of the Aztec peoples, the *Magliabechiano* is archived in Florence, Italy. In this page of the extensive tome, an illustration depicts the use of various plants used by the Aztecs for both rituals and healing practices.

P Gauguin 89

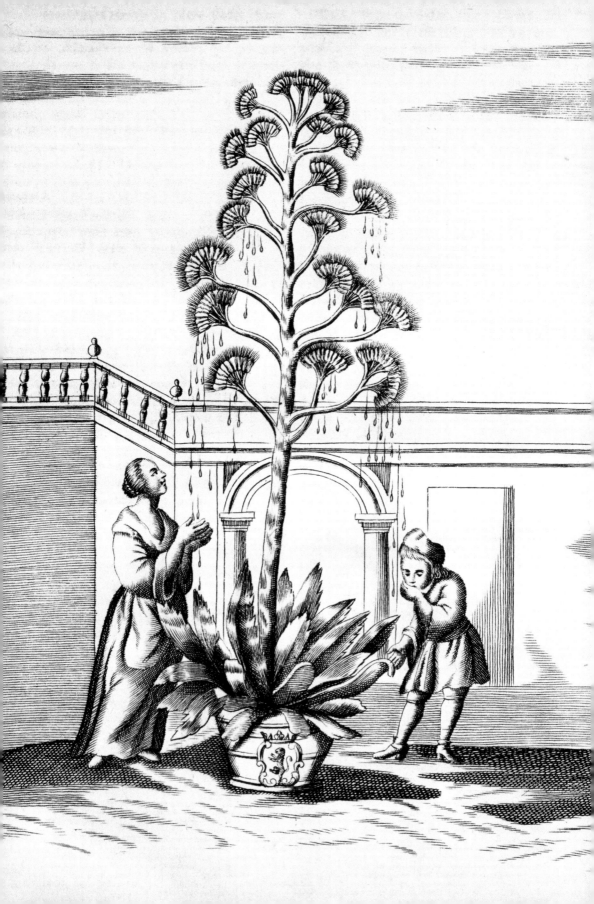

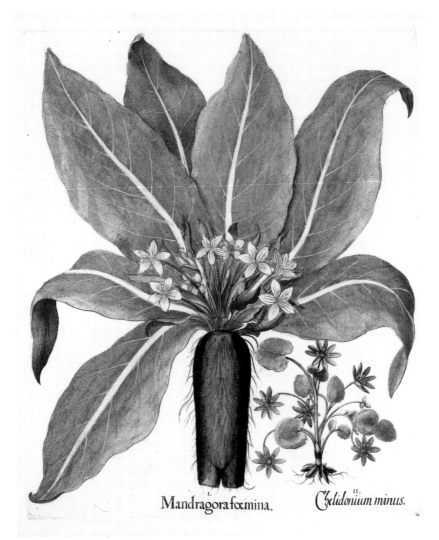

Mandragora fœmina. Chelidonium minus.

(previous pages)
Paul Gauguin · *Seaweed
Gatherers* · France
1889 Brittany, France
grows hundreds of
different varieties of wild
seaweed along its rocky
shores. As a sailor in
the merchant marine,
Gauguin had an affinity
for sea life and was
privy to the harvesting
practices of seaweed
collectors.

Noel-Antoine Pluche · *Collecting Agave Juice* · France
18th Century A most famous work on natural his-
tory, *Spectacle of Nature* contains the illustration of
agave nectar being harvested. It can provide relief
from stomach inflammation and contains vitamin K
and folate which may offer mental health benefits.

Basilius Besler · *Autumn Mandrake* · Germany · 1613
A mandrake illustration from Besler's *Hortus Eystet-
tensis*. This codex of 367 copperplate botanical
engravings captured the spectacular diversity of the
palatial gardens of Prince-Bishop Johann Konrad
von Gemmingen, in Eichstätt, Bavaria, Germany.

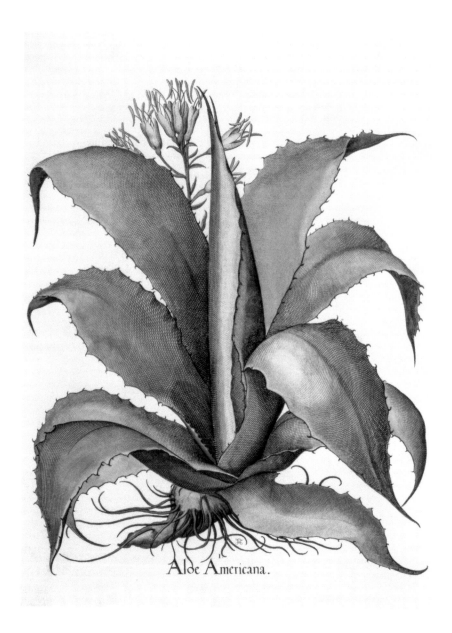

Aloe Americana.

Unknown · *American Aloe (Aloe Americana)* · Germany 1613 For centuries, aloe has healed and helped humans with its copious beneficial properties. The illustration is from *Hortus Eystettensis* by Basilius Besler, a Nuremberg botanist, describing the plants in the garden of a Prince in Bavaria.

Gherardo Cibo · *Eryngium Maritimum* · England 16th Century Beneficial for the spleen and liver, nutrient-rich sea holly is also used for snake bites and hovers above the man poised to strike a serpent. Illustration is from Cibo's series, *Paintings of Flora of the Roman States.*

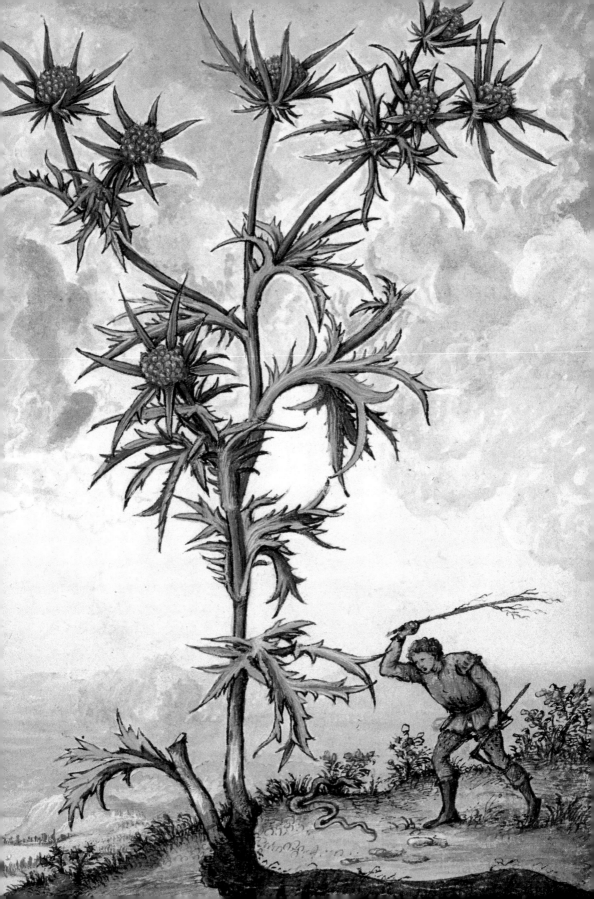

2
BASKET OF YUCCA SUDS.

1
PINE BOUGHS ON SAND BED.

3
BASKET OF PINE NEEDLES AND CORALS.

(opposite) Adolphe Philippe Millot *Illustration of Flowering Plants* · France · 1923 The French naturalist illustrates a flowering Adam's Needle Yucca, used for diabetes and to induce sleep, surrounded by a host of many other edibles.

(above) Unknown · *Pine boughs on sand bed, Basket of Yucca suds, Basket of pine needles and corals* United States · 19th Century Illustration from "Ceremonial of Hasjelti Dailjis and Mythical Sand Painting of the Navajo Indians," an article by James Stevenson detailing a multi-day healing ceremony.

(below) Unknown · *A Pharmacist Making Medicine from Honey* · Iraq · 1224 Preparing the ancient medicinal elixir of honey, used more in those times as a curative and to preserve dead bodies for burial rites, is illustrated for Dioscorides' well-known *De materia medica*.

The first time I began learning about the healing power of plants was when I was 19 years old, and I had pneumonia. I grew up having pneumonia quite a bit as a child. The first time I had pneumonia I was six weeks old, and then I was two years old, so antibiotics absolutely saved my life. But I had pneumonia at 19, and I felt like I didn't want to take antibiotics again. So, I went to this used bookstore and there was a small aromatherapy section. I pulled out a book talking about medicinal properties of essential oils. I looked in the glossary for pneumonia, and it pointed me to a number of essential oils, and lavender was one of them. I turned to lavender, and it had all this amazing research and clinical trials and informa-tion on the history of lavender and how it was used for bronchitis and pneumonia. I got the book, The Practice of Aromatherapy by Jean Valnet. I bought lavender essential oil and put a couple drops in water and drank it every day for a week or for two weeks. Within two weeks, my pneumonia was completely gone. So, I dove into the world of these essential oils and wanted to learn how to grow them and then that got me into the world of plant healing. I got my first job as an herbalist when I was 21 years old at a small herbal apoth-ecary in Seattle and I was able to study under master herbalists there. Since then, I've continued to learn and to practice and over the last two decades since then, there has been a huge shift, a renewed interest in herbal medicines, along with spiritualism and psychedelics. People are seeing plants as healing, seeing what nature can do for you as a human being. There's so much happening right which is very much about us getting back to what it means to be in tune with our natural world. People are using herbs to become more in tune with their body, people are using those herbs and plant medicines to live a healthy life and in general be more in tune with the Earth around them.

— LAURA ASH, Clinical Herbalist, Healer & Founder
of The Scarlet Sage Herb Co.

(following pages)
Kan'en Iwasaki
Korean mint, Agastache rugosa (Lophanthus rugosus Fisch.) and anise hyssop, Agastache foeniculum (Lophanthus anisatus) Japan · 1884 Traditionally used to relieve nausea, vomiting and poor appetite, the Korean mint plant illus-tration is from *Honzo Zufu, an Illustrated Guide to Medicinal Plants* which combines Japanese and western herbal knowledge. Pictured also is anise hyssop, containing simi-lar healing properties.

Martin Engelbrecht · *The Parterre Gardener* · Austria 1730 The Flower Gardener is just one example from Engelbrecht's many colored engravings of workers featured alongside the tools of their trade.

The artwork is featured in Taschen's reproduction of J. C. Volkamer's expansive volume of engravings, *The Book of Citrus Fruits*, first created between 1708 and 1714.

白花の物

排草香 <ruby>排<rt>をさう</rt></ruby><ruby>草香<rt>かう</rt></ruby> かうみどう

武州道灌山ゆもあり宿根より生ば葉の莖は
似て小く尖て狹く方莖對生し長さ四五尺 夏
秋の間穗をあらはし小紫花を開く紫蘇花よ
似て密なり一種二尺許みて花あるものあり一種
白花の物あり俗よ青葉藿香（クワクカウ）とい非也
根よ鬚多く長さ五六寸あり莖葉良香あり
本經逢原云以排草葉偽藿香とあり舩来
の埋藿香ハからみどうの苗あらうと先輩云り

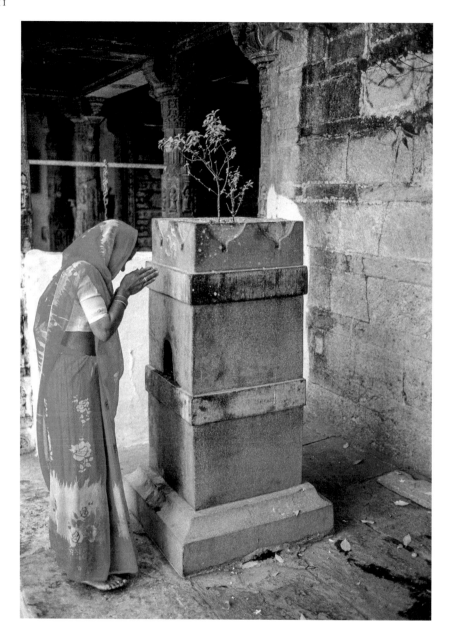

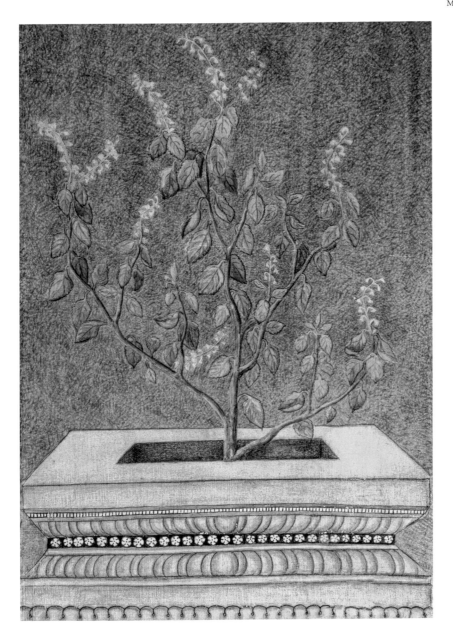

Roland and Sabrina Machaud · *Woman Worshipping a Tulsi Plant* · India · 20th Century Homage is being paid to the medicinal holy basil herb during Tulsi Vivah celebrations (the ceremonial marriage of the Tulsi plant to the Hindu god Vishnu or Krishna).

Unknown · *Holy Basil* · Unknown · Unknown Native to India, Holy Basil or Tulsi is regarded as an incarnation of Lord Vishnu with both spiritual attributes and a broad spectrum of medicinal properties.

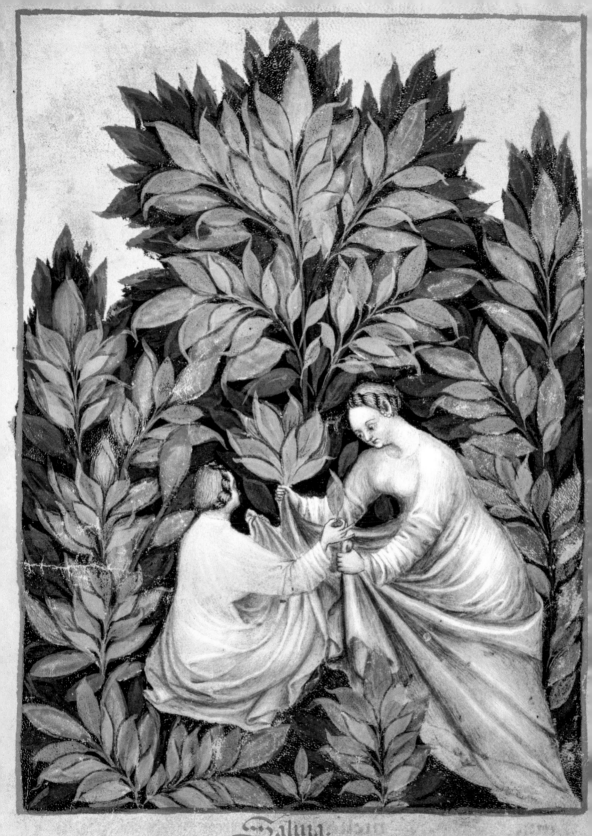

Salina.

Naturæ. c. 7. h. i. 2. melior ereta domestica. Iuuamentum
paralesi. et neruis. noeumentum. denigrat capilos. remotio

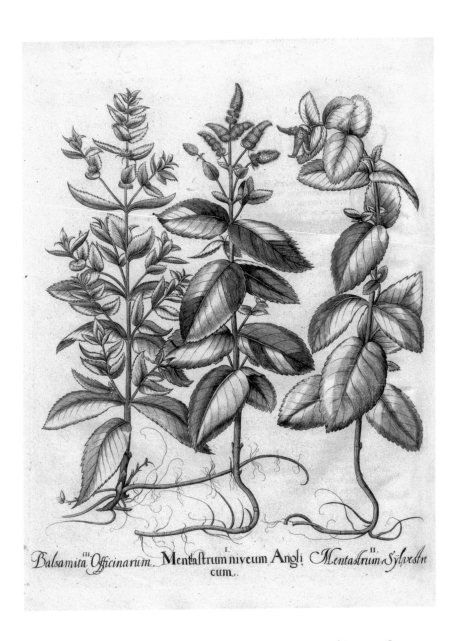

Balsamita Officinarum. **Mentastrum niveum Angli** *Mentastrum Sylvestre* cum.

Unknown · *Two Women Picking Sage* · Italy · 14th Century Sage has an array of medicinal uses and was thought to prevent plague in the Middle Ages. Its benefits are described in detail in the *Tacuinum Sanitatis*, an illustrated medical manual based on texts translated from Arabic into Latin.

Unknown · *Horsemint and Spearmint* · Germany 1613 The *Hortus Eystettensis* is a codex by Basilius Besler, apothecary and botanist, containing the illustration of mint herbs, aromatic and used for their flavoring, fragrance, and preservative properties. They also have diverse medicinal purposes.

Unknown · *The Ancestral Gods of Medicine* · France
19th Century Hwang-ti, Fuh-hsi holding the T'ai-ki
and Shen-nung tasting a medicinal plant illustration,
from popular Chinese lore.

Martin Engelbrecht · *A Woman of Medicine*
Germany · 18th Century Following the Middle
Ages, more and more women were able to use
their natural healing talents and medicine making
skills, as pharmacists.

MYCELLIAL MAGICK

The Power of Mushrooms

Fungi constitute the most poorly understood and underappreciated kingdom of life on earth. Though indispensable to the health of the planet (as recyclers of organic matter and builders of soil), they are the victims not only of our disregard but of a deep-seated ill will, a mycophobia…This is surprising in that we are closer, genetically speaking, to the fungal kingdom than to that of the plants. Like us, they live off the energy that plants harvest from the sun.

— MICHAEL POLLAN, *How to Change Your Mind*, 2018

A unique species unto their own, mushrooms have been used by humans as food and medicine since our earliest civilizations. In Chile, evidence of edible mushrooms has been found in archeological sites dating back 13,000 years or more. In ancient Egypt, mushrooms, considered a symbol of immortality, were so prized their consumption was relegated only to royalty. Hieroglyphs thousands of years old, depict mushrooms painted alongside various Egyptian deities. Mushrooms were also considered sacred in ancient Greece and Rome, where they were referred to as the "food of the gods."

In South America, the edible huitlacoche fungus, was celebrated by early Aztec cultures for its healing attributes. In Asia, mushrooms such as Maitake, Enoki and Shiitake have been used for centuries in cuisine and in various medicinal remedies. In Europe, wild mushrooms such as Chanterelles and Porcinis were foraged for their healing qualities and nutrients. During the reign of King Louis XIV, the first

commercial mushroom farms were established in the fields, catacombs, and caves of France, igniting the country's long and enduring culinary romance with edible fungus.

Categorized apart from the plant and botanical world, approximately 40,000 known varieties of mushroom fungus have been discovered in locations nearly all over the globe. Today, they are embraced the world over, not only as delicious, nutritious food, but for their healing and medicinal qualities. In his 2005 book, *Mycelium Running: How Mushrooms Can Help Save the World*, the pioneering fungi scholar Paul Stamets lauds the species and their vast and multi-faceted powers. Writing in what he calls his "manual for the mycological rescue of the planet," Stamets cites ways mushrooms can be utilized not only for food and medicine but for healing the environment as well. "The age of mycological medicine is upon us," he states, "Now is the time to ensure the future of our planet and our species by partnering, or running, with mycelium."

(following and right) Elias van den Broeck · *Still Life of Forest Floor with Flowers, Mushrooms and Snails* · Netherlands · 1650-1708 The Golden Age artist explores the sacred and beautiful partnership between fungi and flora. Looking at a plant, means looking at a fungus. They have a magical symbiosis.

J. Chenantais Pinx ·*Amanita Muscaria* · France 1961 A vivid illustration of the colorful poisonous Amanita mushroom from the English edition of the book *Exotic Mushrooms*, edited by Rhea Rollin and E.W. Egan.

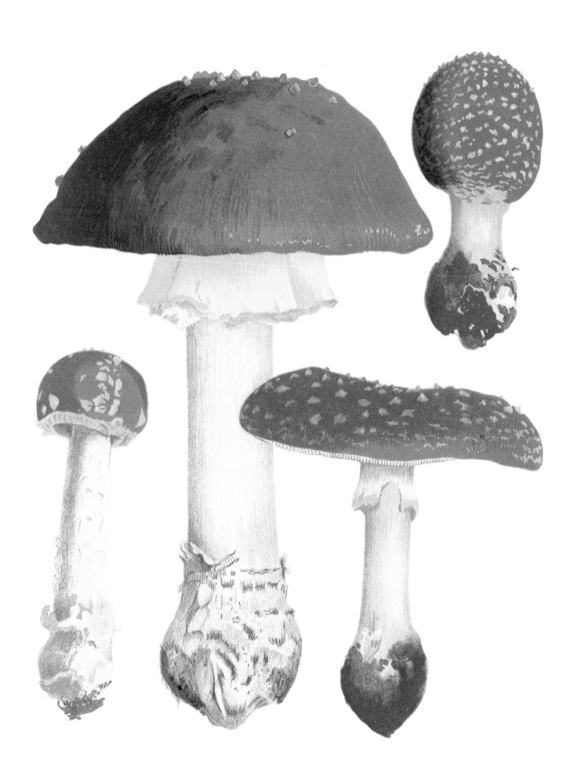

Arik Roper · *Ascending Mushrooms* · United States · 2009 Roper, known for creating album art for hard rock bands such as Sleep and High on Fire, turns his fantastical vision to the world of fungi in his popular series of intricately detailed mushroom illustrations.

I was always so enamored with nature and the esoteric world even from a very young age. How I began working with plants was very kismet and a totally organic unfolding. After studying years of energetic and esoteric healing, I realized we are these spiritual beings having a very physical experience. You can work on the spirit but not without the body (and truly vice versa) I wanted to understand how to heal from a physical perspective, this brought me to the profound magic of plant medicine. Growing up in the suburban landscape of Sydney, Australia my initiation with nature was in found pockets of wildness in amongst the tameness. My grandma lived out in the countryside, her garden was full of fruit trees seemingly always bearing bounty, long green grasses and had an unkempt flair about it. This most definitely informed my aesthetic and appreciation of nature and fueled my pursuit of wild green spaces. There is simply no separation between the people and the plants. Plants are my love language, the center of my passion and purpose. I write about them, I grow them, I forage them, I pour them into a tincture, I teach others of their stories and abilities. When I am with nature, I feel a deep sense of belonging. Belonging is such a reassuring feeling in this uncertain world, yet there is a certainty to belonging that cannot be quantified. It is a knowing feeling; nature assures us that we are all one. We are existing in such a time of drastic disconnection, operating with a severe nature deficit collectively. It is more important now than ever to re-wild ourselves, to remember the plants of our past (present and future), to recalibrate our bodies and beings to the beat of the natural world. I believe it is not a luxury to spent time in nature, it is our birthright to be at one with the nature and our key to health and happiness.

— ERIN LOVELL VERINDER, Herbalist, Nutritionist, Scholar, and
author of *Plants for the People* and *The Plant Clinic*, 2022

Edouard Pingret · *Mushroom Sellers in Pau* · France
1834Pau France overlooks the Pyrenees, a wonderland of mushroom varieties which, to this day, still draws crowds of fungi foragers each season.

(following and left) J. Augustus Knapp · *Etidorhpa, or the End of Earth* · United States · 1895
A commissioned work by Knapp created as an illustrative accompaniment to the fictional work of the same name by the author and esoteric scholar John Uri Lloyd.

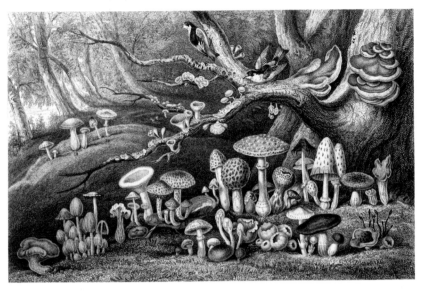

J. Stewart · *Fungi
or Mushroom Plants*
England · 19th
Century Conks and
other families of fungi
whimsically gathered
in illustration from the
tome, *A History of the
Vegetable Kingdom* by
William Rhind, consid-
ered by scholars to be
a culturally important
book.

Unknown · *Couple
holding big mushrooms*
France · 1920
Foragers in France,
considered one the
best hunting grounds
for fungi, display
one of several large
mushroom varieties.

RITES OF PASSAGE

Symbolic Plants of Birth, Love, Victory, & Death

Between our two lives there is also the life of the cherry blossom.

— MATSUO BASHŌ, from a collection of journal writings by the Japanese poet
written in 1689 and later published as *Oku No Hosomichi (The Narrow Road to the Interior)*

The use of plants as signifiers and symbols of transition is a practice deeply embedded within rites of passage rituals throughout the world. As humans, we have long incorporated herbs, flowers and trees into our birth, death, and spiritual rites. Certain plants symbolize love, union, purity, renewal, respect, and victory, depending on the culture and era. Flower petals strewn along the wedding aisle mark the evolution into womanhood and marriage. A wreath of white lilies stands sentinel over an open grave. A lover's bouquet awaits upon the doorstep, the choice of flower or herb a coded message of adoration. A May Day pole is encircled by dancing girls, heads crowned with florals, celebrating the first blooms of spring. An evergreen is hewn and decorated with garlands to mark the Christmas holidays. These are just a few of the many rituals still practiced today, which link us directly to our roots in the ancient religions which long ago initiated us into the worship of the natural realm.

Our relationship to the natural world is aligned with our relationships to each other, nature a mirror reflecting the cycles of our own lives. We mark our most important celebrations and ceremonies with plants. We mourn the dead with herbs and incense. We honor births with gifts of foods and flowers. Some believe these traditions may in fact pre-date our human evolution and go as far back as the Neolithic period. Archeologists in the 1950s, for example, discovered what was thought to be a ceremonial burial site while exploring the Shanidar caves in Iraq. Several bodies were found estimated to be approximately 60,000 to 80,000 years old. One skeleton, placed in the fetal position, was surrounded by the pollen of various wildflowers and herbs. And although there is some debate regarding whether these flowers were in fact part of a burial ceremony or merely brought into the cave later by animals, the discovery ignited discussion regarding the possibility of ritualized burials performed by our prehistoric ancestors.

John William Waterhouse · *The Soul of the Rose*
England · 1908 A work inspired by the Lord Alfred Tennyson poem, 'Maud,' and from the line, 'And the soul of the rose went into my blood'.

As recently as 2013, another archeological discovery gave additional credence to this concept when researchers uncovered another ancient gravesite at Mt. Carmel, in Israel, this one estimated to be between 15,000 to 11,000 years old. Believed to be created by a non-nomadic culture known as the Natufians, the site featured several bodies laid out with apparent reverence and decorated with mineral pigments and beads. Beneath some of the dead were the faint impressions of plants, their shape and form pressed indelibly into the sediment, suggesting that the bodies had been placed ritualistically, perhaps atop a thick carpet of herbs and flowers. In the history of humankind, the origins of our symbiotic relationship with plants and sacred ceremonies can be traced clearly to our very earliest civilizations. Perhaps one the first and most notable examples of this use of plants in ritual is within the ancient process of embalming and mummification, burial rites which often involved specific flowers and herbs used to wash, prepare, and preserve the body. In *The Histories*, written in 430 BCE, the Greek scholar Herodotus offers one of the earliest known written descriptions of the mummification process. In *Book II* of his opus, the historian meticulously documents the ways in which Egyptians readied a body for embalming; "washing it thoroughly with palm wine, and again frequently with an infusion

William Holman Hunt · *May Morning on Magdalen College Tower* · England · 1893 Since the early 16th century, the first day of May has begun at 6am as the Magdalen College Choir sings from the top of the Great Tower, welcoming the rising sun and coming of Spring.

of pounded aromatics. After this they fill the cavity with the purest bruised Myrrh, with Cassia, and every other sort of spicery except Frankincense…"

In addition to the use of plants in embalming and mummification, early cultures often integrated herbs and flowers within funeral ceremonies as offerings or decorative memorials. In ancient Egypt, coffins were often adorned with flowers such as lotus, or with garlands plucked from the branches of sacred trees. Offerings were also made using fruits and seeds such as Pomegranates, Grapes, Barley, and Wheat, providing the dead with a celebratory feast for the afterlife. Egyptians are also thought to have planted elaborate funerary gardens near or atop their tombs, where trees like Sycamore and vegetables such as Lettuce were planted to represent both fertility and resurrection. Flower and plant offerings for the deceased are present in many ancient cultures. In ancient Greece, a circular funeral wreath symbolized continuity, the cycle of life, and death. Often these memorial wreaths were made of evergreen branches, such trees were believed to symbolize strength, representing the endurance of the soul beyond death.
In the pagan cultures of Northern Europe, trees were considered sacred. In the 1st century, the Roman naturalist Pliny the Elder published *Naturalis historia*, a vast encyclopedia documenting what Pliny himself described as "the natural world, or life." In its 37 volumes, the author tells of various rites and rituals. In one passage, he describes a Druid ceremony where Mistletoe was cut ceremonially from an Oak to ensure fertility. "The Druids…" he writes, "held nothing more sacred than the mistletoe

and the tree that bears it, supposing always that tree to be the oak." Ritual bonfires were also prevalent in pagan cultures, certain symbolic trees cut and burned to celebrate the harvest or to welcome in the cycle of the seasons.

Various plants were also burned as incense during funeral ceremonies in many ancient cultures or distilled into oils for anointing the dead. The burning of plants and herbs in the form of incense or the distillation of plants into ceremonial perfumes are also prevalent in many birth and funeral rites. Incenses were used to purify and prepare the body for the grave. They were burned upon altars during various spiritual ceremonies. Ancient Sumerian and Assyrian texts mention the use of Frankincense as early as 3000 BCE In Mayan culture, amber-colored tree resin, called Copal, was considered sacred and purifying and was often burned in ceremonies and rituals. In Biblical writings, ceremonial incenses and perfumes are mentioned, perhaps most notably in the *Gospel of Matthew*, which tells of three Magi, celebrating the birth of Christ with gifts of Frankincense and the fragrant sap of the Myrrh tree.

In many Native American traditions, incense use, or smudging – the act of burning certain sacred plants – remains integral to various rite-of-passage ceremonies. Early indigenous American cultures made offerings to the dead using herbs, flowers, and plants. Tribes such as the Ute, Navajo, and Sioux tribes constructed wooden funeral platforms which towered in the air, tree-like, and were thought to carry the dead closer to the sky. In Robin

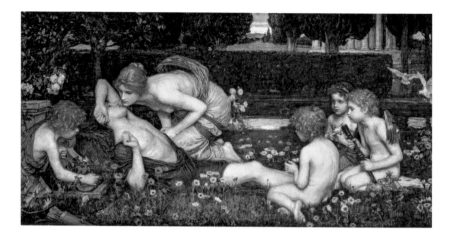

Wall Kimmerer's introduction to her 2013 book, *Braiding Sweetgrass: Indigenous Wisdom, Scientific Knowledge, and the Teachings of Plants*, she comments on the relevance of plants in indigenous ceremonies, particularly those botanicals known as "The Four Medicines"; Tobacco, Cedar, Sage and Sweetgrass. Explains Kimmerer, a scientist and member of the Citizen Potawatomi Nation, "Our stories say that of all the plants, wiingaashk, or sweetgrass, was the very first to grow on the earth, its fragrance a sweet memory of Skywoman's hand. Accordingly, it's honored as one of the four sacred plants of my people. Breathe in its scent and you start to remember things you didn't know you'd forgotten. Our elders say that ceremonies are the way we 'remember to remember,' and so sweetgrass is a powerful ceremonial plant cherished by many indigenous nations."

In Latin America, the ancient Aztec funeral traditions are rooted in the Day of the Dead, a day linked to the goddess Mictecacihuatl,

also known as the "Lady of the Dead." A key part of the celebrations is the honoring of ancestors through the creation of elaborate altars or "ofrendas," often copiously decorated with Marigolds, a flower sometimes referred to as "flor de muerto." The Marigold's vibrant blooms and heady fragrance are said to attract souls, encouraging ancestors to return to the ofrenda to accept ritual offerings such as mezcal and hand-crafted skulls made of sugar. These flower-centered rituals date back centuries, and are first mentioned in the *Florentine Codex*, a recording of Aztec culture penned by the Spanish Franciscan friar Bernardino de Sahagún in the 16th century.

Plants as markers of pivotal moments of remembrance have long been inherent in not only rituals of death and birth, but in celebratory events as well. From courtship to marriage, plants and flowers have long communicated and symbolized the ways in which we love. In India, the

John William Waterhouse · *The Awakening of Adonis* · England · 1899 The tears that fell from Aphrodite onto Adonis' wound turned the droplets of his blood into beautiful red anemones, which have since symbolized the act of forsaken love.

Jean-Honoré Fragonard · *The Happy Accidents of the Swing* · France · 18th Century Known for his veiled erotic subject matter and lush, detailed gardens, the artist hides a man in the bushes sneaking a peak.

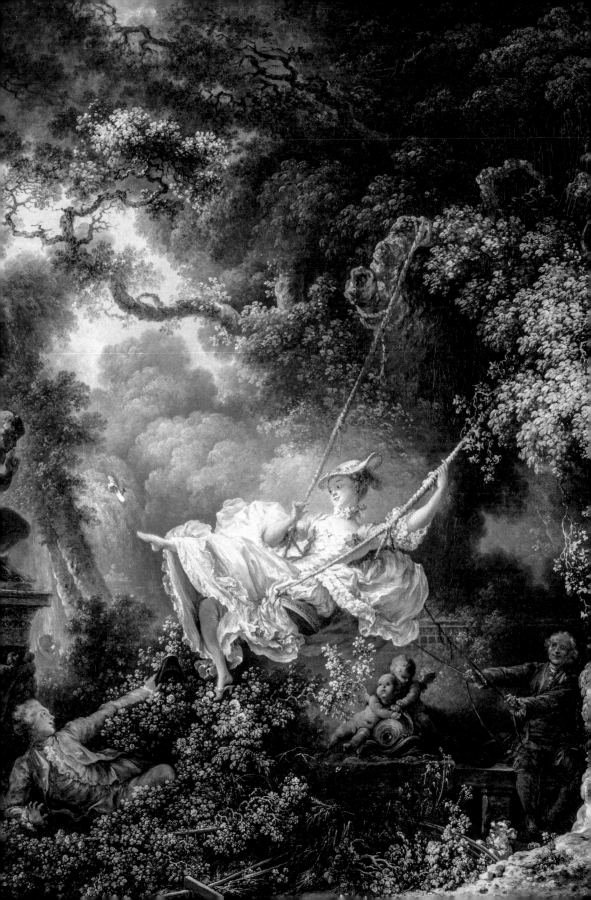

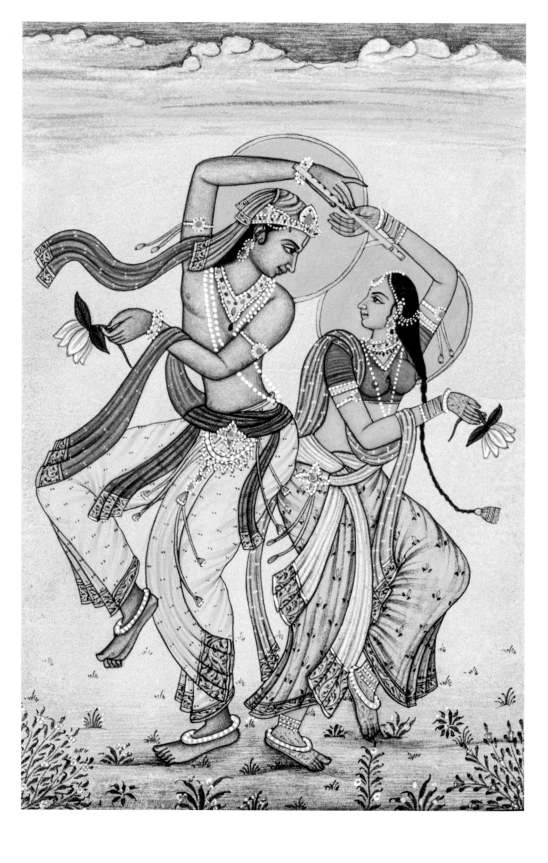

ritual exchange of floral wedding garlands between bride and groom is a custom traced back to ancient Vedic literature and religious texts and holds the same relevance as the exchange of rings in Western culture. Wedding garlands are also linked to the mythology of Lord Vishnu and the Goddess Lakshmi, whose celestial marriage is considered an aspirational partnership. Known as a "varmala" or "jaimala," these flower garlands are traditionally woven with Roses, Jasmine flowers, and Marigolds; the latter is a popular flower in many Hindu ceremonies, said to symbolize the powerful and vibrant energy of the sun.

Time-honored traditions involving flowers and plants exist in innumerable wedding rituals across cultures, evolving through each generation. During England's Elizabethan age, the use of small bouquets known as "kissing knots" became a popular practice. Much like the custom of the holiday mistletoe, a pagan-rooted tradition that has been part of Christmas celebrations since the 18th century, these Elizabethan "kissing knots" were held above the heads of lovers to encourage a tender embrace. Later, amid England's Victorian era, a complex symbolic language evolved around flowers and plants. Floriography, or the language of flowers, became a popular preoccupation, a way of communicating desires through an intricate code of floral arranging. "Talking bouquets" or "Tussie Mussies" held secret messages conveyed through the selection of flower or color combinations — intent and emotion encrypted amid petal and leaf.

In Eastern cultures, both ancient and modern, flowers are particularly revered. Sakura (cherry blossom) and the Chrysanthemum are both important elements in Japanese rituals, events, and ceremonies. Presentations of flowers in the Ikebana style, a specialized art of flower arrangement which dates to the late 700s, are still offered as gifts at weddings, with red flowers connoting luck and good fortune. Funeral rites in Japan also feature intricate memorial arrangements known as Seikasaidan complex and sometimes vast flower altars traditionally composed solely of white Chrysanthemums. In Thailand, elaborate flower hangings decorate doorways and windows, offerings of intricately interwoven garlands tied to marriages and numerous spiritual ceremonies. In Polynesia, bright garlands of flowers known as "leis" were offered as ceremonial gifts and originally worn around the neck by Native Hawaiians as a symbol of rank, and as a method of honoring each other and their gods.

Birth, unions, and burials — victory laurels, proclamations of passion in the form of crimson roses, rice thrown at the feet of bride and groom in the hopes of a fertile and prosperous marriage, all these are moments that incorporate the plant world symbolically into our lives. Our shared transitory cycles of joyful celebration and deep grieving are marked with herbs, flowers, grains, or branches of trees — this integration of nature — one of humanity's core methods of signifying catharsis.

Unknown · *Radha and Krishna* · India · Unknown
Radha, the beloved of Lord Krishna, is shown holding the sacred lotus flower, symbol of purity, which rises stainless from the mud.

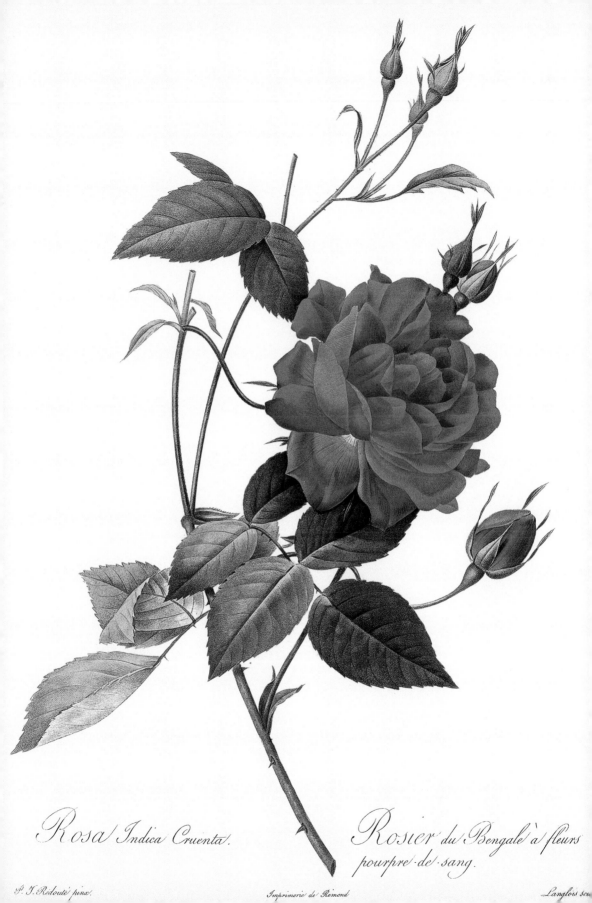

Rosa Indica Cruenta.

Rosier du Bengale à fleurs pourpre de sang.

P. J. Redouté pinx.　　　　Imprimerie de Rémond.　　　　Langlois sc.

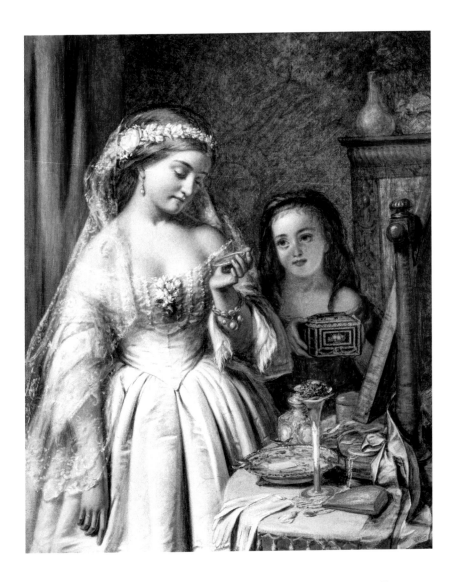

Leonhart Fuchs · *Slater's Crimson China Rose*
Switzerland ·1542 A classic symbol of romantic
love, this intricately detailed rose from the master
botanical artist is included in the Taschen edition
of his book, *Fuchs Herbal* and is based on the
illustrator's personal, hand-colored original.

Joshua Hargrave Sams Mann · *The Wedding Morning*
England · 19th Century Wedding preparation
begins with an intricate flower crown and decorat-
ing the body and gown with celebratory floral
adornment.

As a child, I was given ample freedom to explore outside solo, as we were blessed with backyards almost everywhere we lived. Still to this day, one of my most reliable grounding practices is spending time in the garden, moving slowly, tending to the land. Falling into rhythm with the garden requires stepping out of the linear and into the slow, deep waves of cyclical, natural time — never hurried or in a rush, always in flow. At the beginning of my practice, while I was always drawn to work with nature, I was more curious about the feeling, rather than the plants themselves. I wanted to understand how our sensory, felt environment affects our wellbeing, and how being immersed in a peaceful space can restore balance and gently unwind the nervous system. I began to research emerging ideas around polyvagal theory, meditation, and breathwork as I deepened my relationship with my own nervous system. Perhaps this inquiry is also linked to my curiosity about the nature of reality itself — I've explored the relationship between consciousness and the material world — and how cultivating peace within might ripple out into the collective- and furthermore how the implications of this realization might lead us to restructure our societal blueprint with very different priorities. If we're all interconnected, then the well-being of each of us is affecting the health of the whole. This creates an imperative to care for all aspects of that collective. Few experiences in my life have transmitted an embodied awareness of our interconnectedness as fully as an immersion in nature. I've found that singing and moving together are also reliable pathways to this truth. I wish for everyone this joyful revelation, should they wish to receive it, and I'll continue to nurture the vision that the result of this shift in consciousness will manifest heaven on Earth.

— LANI TROCK, Multimedia Artist & Activist, 2022

Julia Margaret Cameron · *For I'm to be Queen of the May, Mother* · England · 1875 From Lord Tennyson's poem, "The May Queen" Emily Peacock holds the flower crown of the goddess of spring, queen of the faeries, and the lady of the flowers.

Kate Greenaway
*A Young Girl Seated in a
Chair, a Bowl of Cherries
in Her Hand* · England
19th Century Under
a bower of roses, sym-
bolic of innocence and
purity, the girl holds
cherries which similarly
convey purity and
sweetness.

John Lavery · *Spring*
Ireland · 1904
White dress and white
flowers often repre-
sented springtime,
new beginnings and
of course, purity.

(following pages)
William Blake
Richmond · *Venus
and Anchises* · England
1889–90 The Goddess
Venus tricked Anchises,
shepherd of Mount
Ida, in a floral vision of
ecstasy and love, in the
Greek mythological tale.

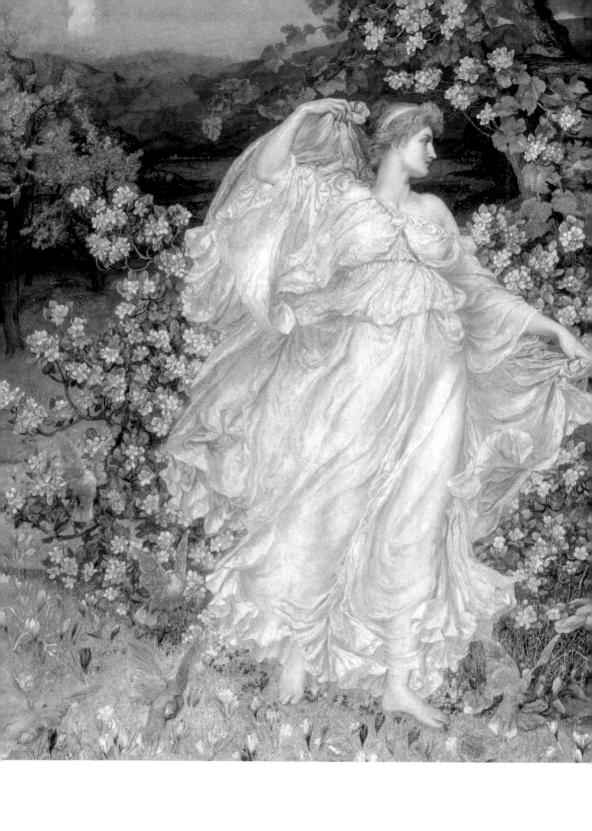

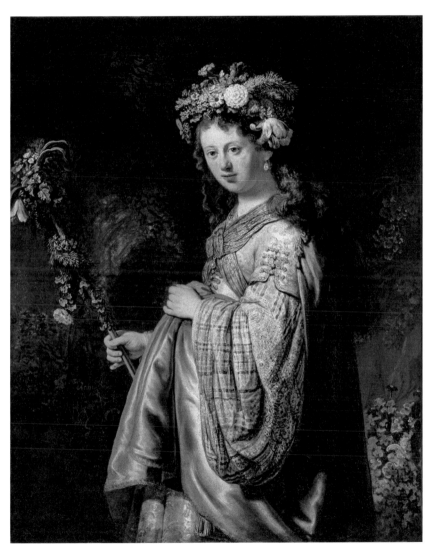

Rembrandt · *Saskia as
Flora* · Netherlands
1634 Saskia was Rem-
brandt's wife, whom he
painted as the Roman
Goddess of spring and
abundance. A symbol
of nature and flowers,
she is often represented
in a floral headdress
and staff.

(opposite and above) Alfredo Ramos Martinez
Casamiento Indio II · México · 1934 In this portrait
by Martinez, considered one of the founders of
Modern Mexican art, an indigenous couple are
wed amid an array of celebratory florals.

(opposite and below) Herran Saturnino · *The
Offering* · Mexico 1913 Now on display at Museo
Nacional de Arte, Saturnino's painting depicts a
boat overflowing with Marigolds, a flower in Aztec
mythology thought to honor the goddess of death
Mictēcacihuātl.

Luigi Serra · *The apparition of the Virgin to St Francis of Assisi and Bonaventure* · Italy · 19th Century The Virgin Mary rises out of, and appears to be one with, the flowers in one of Saint Francis's many visions.

Marc Chagall · *The Bride of Notre Dame* · France 1970 A bride hovers above and from the iconic French cathedral, against a brilliantly colored and large-looming wedding bouquet.

José Garnelo Alda
Death of Saint Francis
Spain · 1906 The
beautiful soul, Saint
Francis, is laid to rest,
surrounded by flowers
and an angel. He was
canonized two years
later as patron saint of
the natural environment.

Unknown · *Floral Collar*
from Tutankhamun's
Embalming Cache · Egypt
1336–1327 BCE
Tutankhamun burial
collars have been found
to contain olive leaves,
cornflowers, nightshade
berries, and poppies.
They were made with
papyrus and linen,
well-preserved and
found in accompanying
burial jars.

(opposite) Adolphe
Alexandre Lesrel
The Lily is Dead
France · 1890 Known
to represent death,
the dying lilies evoke
something that has
clearly passed but isn't
being recognized by the
woman attempting to
revive them.

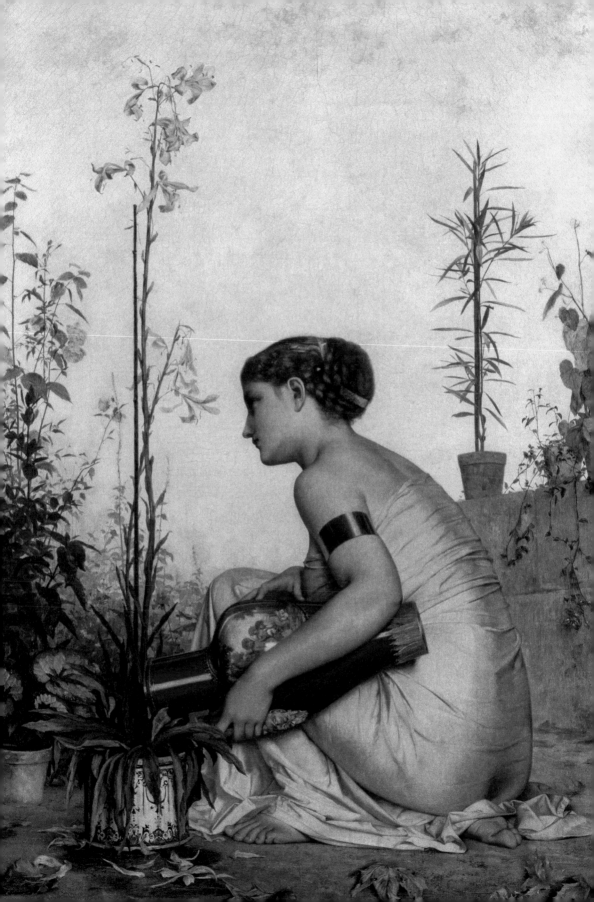

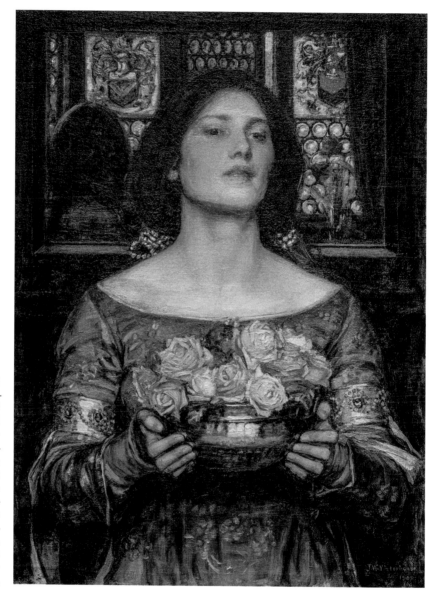

(following pages)
Lawrence Alma-Tadema · *The Roses of Heliogabalus* · England 1888 The emperor Heliogabalus unsuspectedly covers his dining guests with pink rose petals that fall from a false ceiling, smothering some of them to death. Pink petals typically symbolize gentle affection, comfort and joy yet do not convey that in the painting.

John William Waterhouse · *Gather Ye Rosebuds While Ye May* · England · 1908 The second of two paintings inspired by the poem "To the Virgins, to Make Much of Time" by Robert Herrick. Roses are symbolized by their life and eventual death in this allegory.

William Powell Frith · *The Proposal* · England 1853 In the Victorian-era, courtship, affairs, and proposals relied on floriography or 'the language of flowers.' Secret messages and responses were spoken by way of flowers, leading to the popular artistic use of flowers to convey hidden truths.

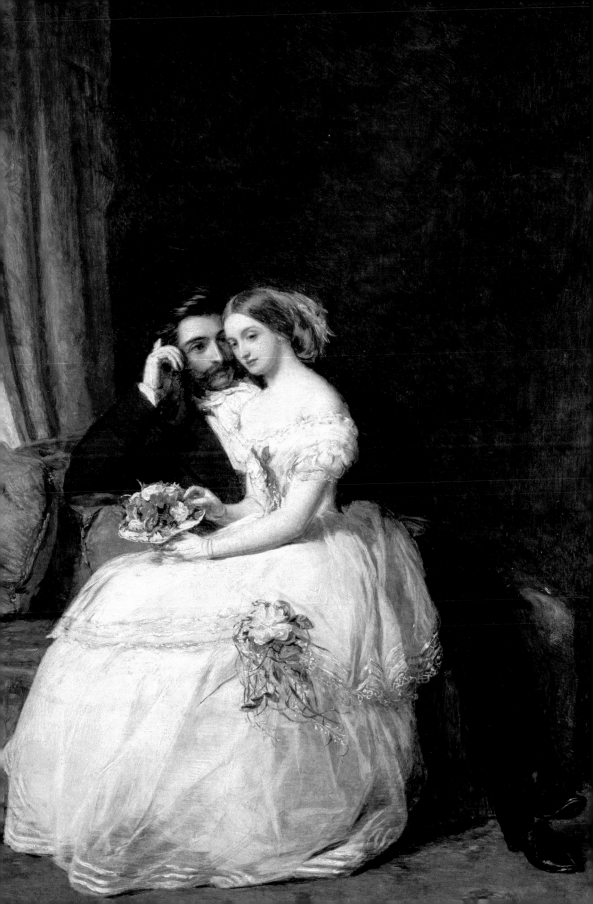

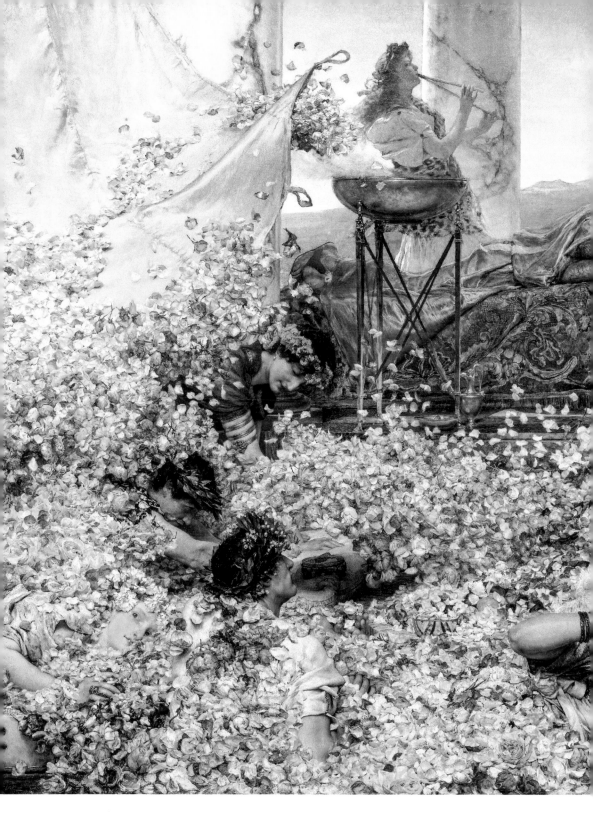

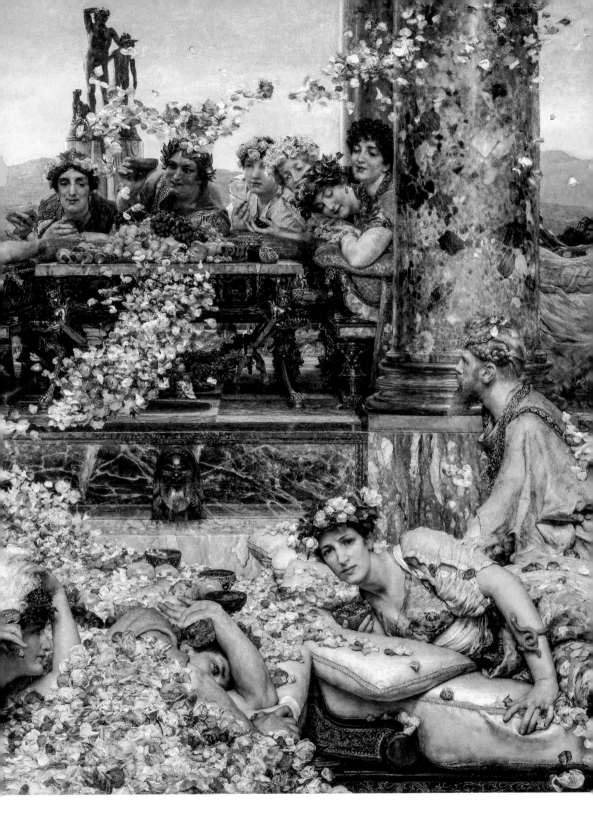

Julius Gari Melchers
The Bride of Brabant
United States · 1928
From the ancient
Roman tradition,
bridal bouquets were
known as symbols of
new beginnings,
fidelity, and fertility.

A. B. Mason · *Newly Wed Couple* · France · 1876 A bridal pair starts life's voyage framed by ceremonial floral plumage. The bird symbolizes fidelity, whilst its flower feathers embody the traditional meanings of new beginnings, joy, and happiness.

Jan Josef Horemans the Elder · *The Four Seasons: Spring* · Netherlands · 18th Century From a set of four paintings, the season of renewal and beginnings was celebrated through ritual. To ensure fertility, a dance was performed around a tall maypole garlanded with woven ribbons, greenery, and flowers.

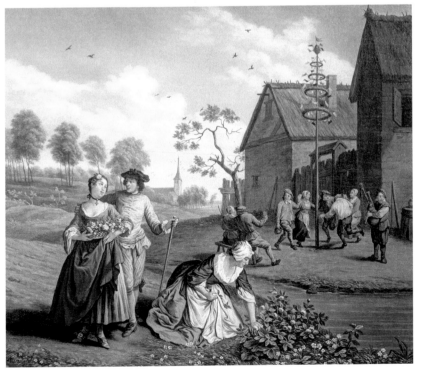

Walter Crane · *Summer*
England · 1895
The field of daisies
symbolizes purity,
innocence, new begin-
nings, and fertility in
Crane's allegorical,
neo-romantic style.

Douglas Volk · *After
the Reception* · United
States · 1634 Bridal
flowers were historically
filled with herbs and
spices to ward off evil
spirits and bring about
fertility and new begin-
nings. Brides were con-
sidered lucky and threw
the bouquet to extend
their luck to others,
unlike this exhausted
newlywed still clutching
tightly to her withered
bouquet.

As a child, I sensed magic in the weeping willow tree in our back yard. At age 19, I climbed Mt. Sinai under a full moon and lived in the desert for months. A few years later I was mesmerized by a single, small tree atop a cliff in Zion National Park. I sensed I was looking at a living expression of divinity. I didn't understand it, I just knew. I work as an herbalist/green witch, so plants are front and center. I focus on the nourishing, healing properties of common plants and guide my students to connect to the spirit of the plants, to enter into reciprocal relationships with them as elders, teachers, and healers. As a writer, plants often show up in my stories and poetry. Nature is my mentor. Nature invites me to recognize myself as an integral part of her. When I first sought healing from an herbalist, I was given white oak bark tea. That health challenge led to my becoming an herbalist. Ten years ago, I lost my beloved life partner to lung cancer; the oak trees in the forest behind our home helped me find my way back to joy. Today, I often ask for guidance from a grand old oak tree a couple of miles from my home, and the guidance always comes. Walking in a forest is my bliss; redwoods, tropical jungles near the ocean, the eastern woodlands I call home, I love them all. Plants know who they are, and they can lead us home to the truth of who we are. All plants are consciousness altering. If we are humble and respectful enough to ask these loving allies for help, we can heal ourselves and rebuild our broken societies. The plants will help guide us through the evolutionary chaos of now.

— ROBIN ROSE BENNETT, Herbalist, Green Witch & author of
The Gift of Healing Herbs: Plant Medicines and Home Remedies for a Vibrantly Healthy Life
and *Healing Magic: A Green Witch Guidebook to Conscious Living*, 2022

(previous and left) John Singer Sargent · *Gathering Flowers at Twilight* · United States · 19th Century 'Children Picking Flowers' is another name for the famous painting, since white roses represent purity. They also mean youthfulness, innocence, young love, and loyalty.

Angelica Kauffmann · *Cleopatra Decorating the Tomb of Mark Anthony* · Italy · 18th Century Like many ceremonies, burials are also marked with floral bouquets. Tomb and grave flowers serve a dual purpose as tokens of respect for the deceased and as an act of remembrance for the living.

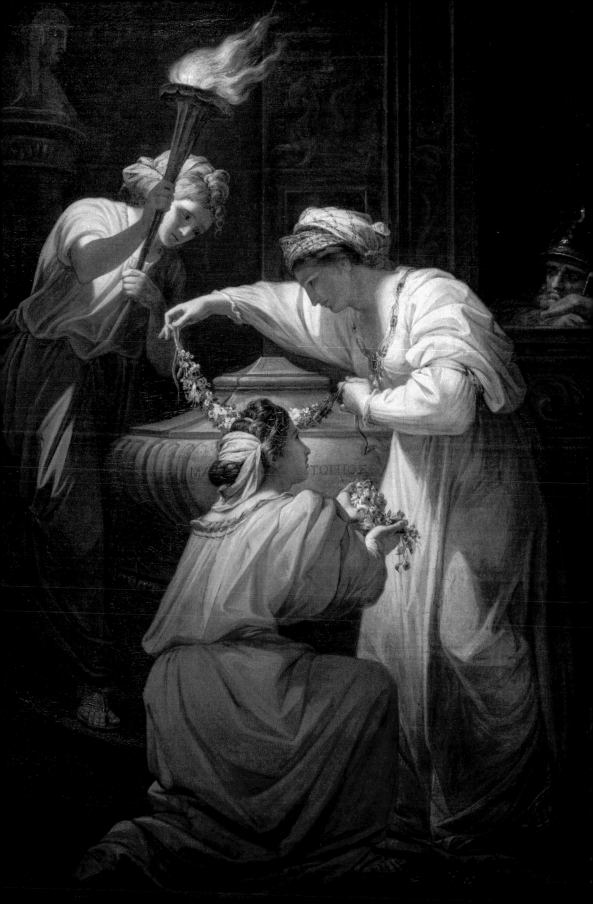

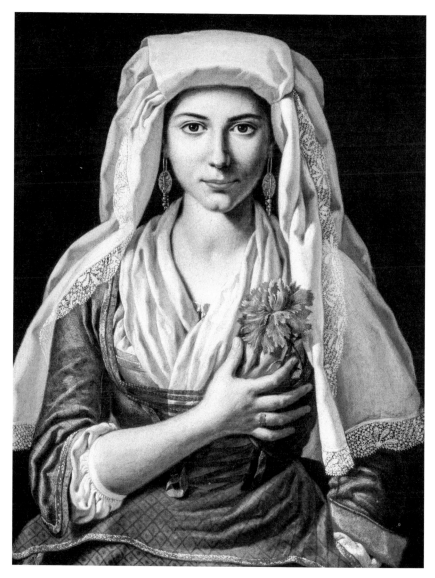

(following pages)
Jan Davidsz de Heem ·
*A Vanitas Still-Life with
a Skull, a Book and Roses*
Netherlands · 1630
Lacking endurance, the
mildly wilted rose sug-
gests the fleeting nature
of earthly existence and
the inevitability of death.

Francesca Cozza · *Portrait of a Young Woman, three-
quarter length, Holding a Carnation* · Italy · 19th
Century From Renaissance to Baroque period art,
portraits of women and men were often holding
pink carnations. They symbolized betrothal or newly
married, and sometimes divinity.

Henri-Paul Motte · *Druids Cutting the Mistletoe on
the Sixth Day of the Moon* · France · 19th Century
Druid priest and priestess cut the sacred mistletoe
plant from trees with a golden sickle. Suspended
from tree branches, between heaven and Earth, it
symbolizes a portal to another world.

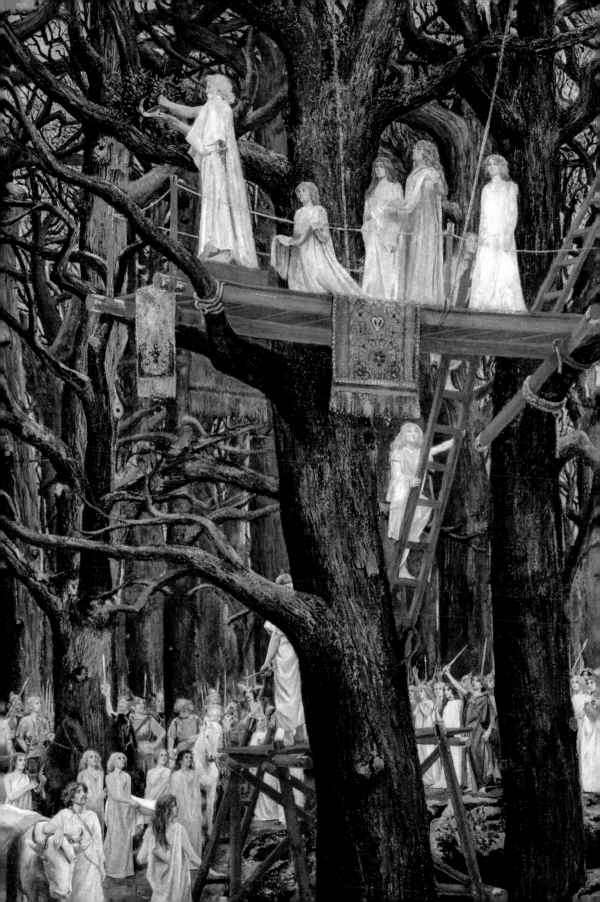

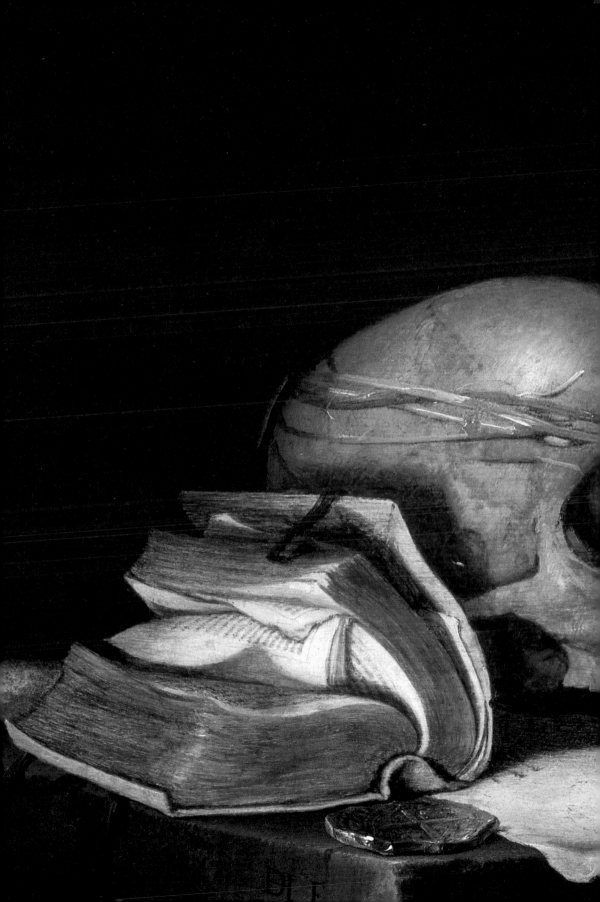

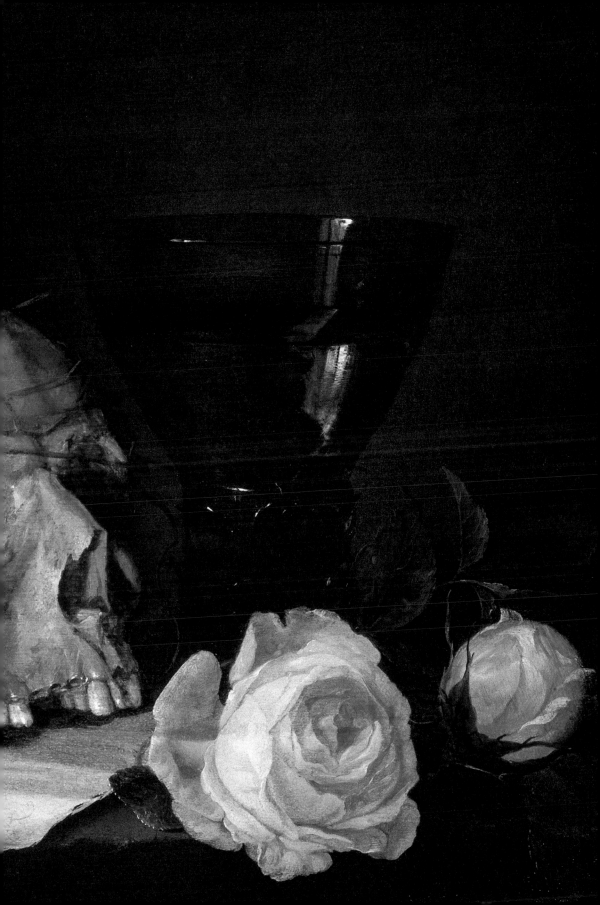

PISTIL AND STAMEN

Sensuality & The Botanical Realm

The sturdy seedling with arched body comes
Shouldering its way and shedding the earth crumbs.

— ROBERT FROST, "Putting in the Seed," from the poetry collection *Mountain Interval* (1916)

The sensual symbolism of plants resonates within nearly all the world's ancient mythologies, the sexual cycles of many botanicals are embraced as symbolic representation of fertility and love. In the Greek cults of Aphrodite, the goddess was associated with sexual attraction and beauty. In the famous "Venus Genetrix," a statue of Aphrodite carved in Rome in the 2nd century, she stands with one alabaster breast exposed, hand reaching out with the offering of a small apple. In various myths, Aphrodite's magical fruit is said to be made of solid gold, a talisman with the power to make any woman or man fall in love with those who possessed it.

The goddess was also associated with the pomegranate, a fruit that in Greek and Roman culture was thought to represent lust and sensual pleasure. In many pre-Christian and pagan religions, certain trees are considered to represent sexual fecundity. In early Celtic beliefs, for example, pinecones were associated with regeneration and often placed under pillows to help ensure fertility.

In his book, *Red: The History of a Color* first published in 2000, the historian Michel Pastoureau explains the symbolism of red fruits throughout the Middle Ages. "Cherries," he writes, "were a symbol of love... figs, with purple rather than red exteriors, were charged with strong exotic connotations and directly evoked the female genitals." In addition to the color of plants, their scent has also been long associated with attraction and seduction.

Botanical fragrances, thought to have originated in ancient Egypt, have long been distilled into resins, oils, and perfumes. Plants were used in early cultures as medicines purported to promote libido and virility. In the 15th century Arabic tome, *The Perfumed Garden of Sensual Delight*, a tincture consisting of pepper, lavender and ginger is recommended in a chapter titled, "Prescription for Increasing the Dimensions of Male Members and for Making Them Splendid." India's ancient sexual handbook, *Kama Sutra* includes several recipes and potions which function

River Cousin · *Of Blue and Mauve* · England · 2021
A flower takes on elements of the feminine in this sensual and surreal botanical work by the London-based graphic artist and illustrator.

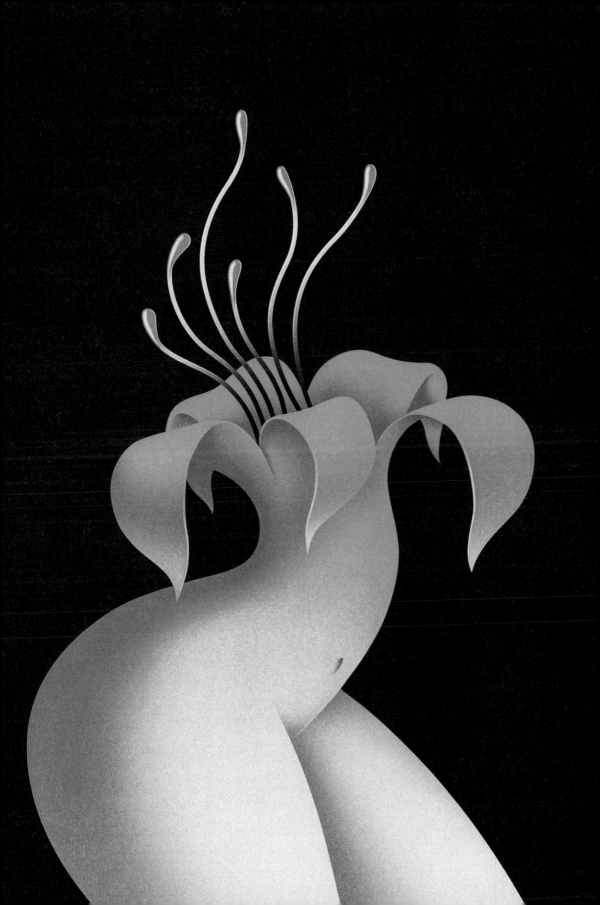

as aphrodisiacs and love potions. A section titled, "On the Means of Attracting Others to Oneself" includes suggestions such as, "By eating the powder of the blue lotus...a man becomes lovely in the eyes of others." Plants such as the cocoa bean were considered aphrodisiacs in Aztec cultures and Chinese medicine has long purported the sexually stimulating powers of ginseng, which loosely translates to, "man root."

Throughout the 20th century, artists and photographers explored the sensuality of flowers through their work, most notably Georgia O'Keeffe, with her distinctly feminine depictions of flowers. Later, the photographer Robert Mapplethorpe would

continue to explore seduction in the forms of Calla Lilies and Orchid stamens in his sexually charged *Flowers* series. And in Diane Ackerman's 1990 book, *A Natural History of the Senses*, the naturalist and poet memorably documents the enduring sensuality of the botanical realm. "A flower's fragrance declares to all the world that it is fertile, available, and desirable, its sex organs oozing with nectar," she writes, "Its smell reminds us in vestigial ways of fertility, vigor, life-force, all the optimism, expectancy, and passionate bloom of youth. We inhale its ardent aroma and, no matter what our ages, we feel young and nubile in a world aflame with desire."

Unknown · *The Banana* · Germany · 1929
Bananas, the most phallic of fruit, lend themselves to the erotic visual in the photograph from the German publication, *Erganzungsband zum Bilder-Lexicon Kulturgeschichte – Literatur und Kunst Sexualwissenschaft.*

Unknown · *Nude woman on swing* · Germany ·1925
In this erotic work, a beautiful woman sits seductively on swing decked in blossoms. Roses, a common symbol of love and sensuality, are strewn at her feet.

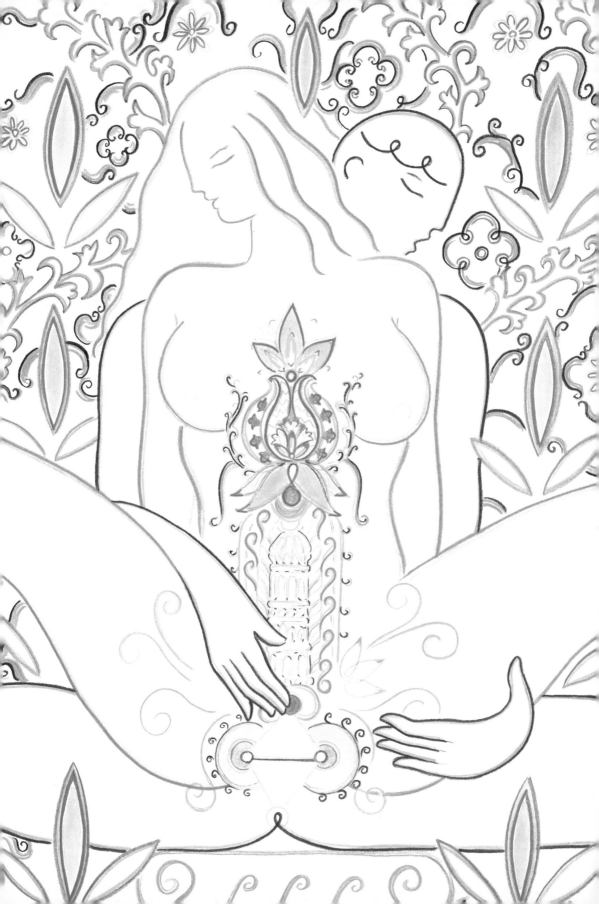

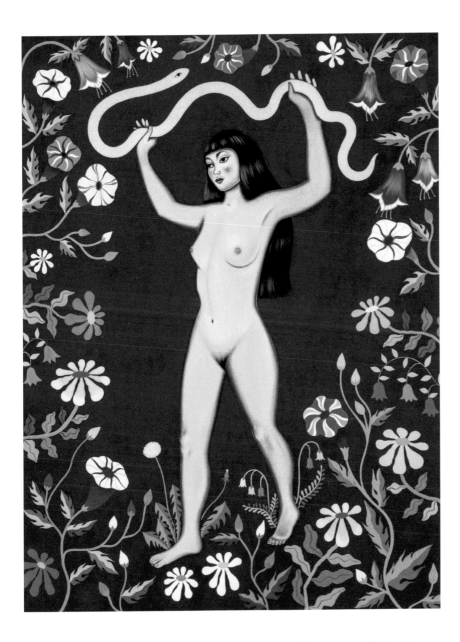

Alphachanneling · *Harmonic Awakening of The Living Temple* · **United States** · **2021** Celebrating sensuality, erotic play and the botanical realm, the artist transforms the act of sex into dreamily expressive illustrations and paintings which place a focus on transformative, orgasmic connection.

Paula Duró · *Lilith* · **Argentina** · **2018** A celebration of the sensuality of Lilith, the first wife of Adam in Mesopotamian myth, this erotic illustration is an example of the artist's interest in, 'observing the human spirit and the spirit behind all things folk, psychedelia and nature."

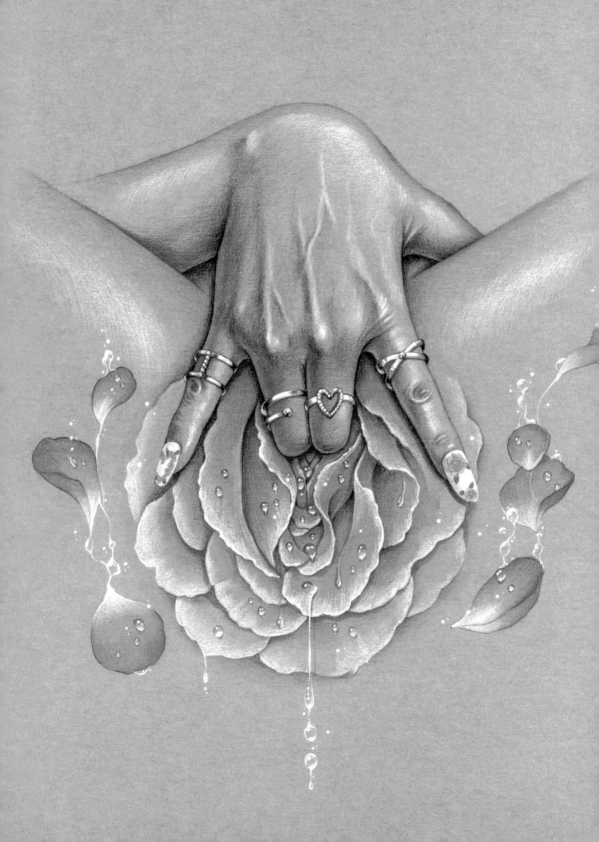

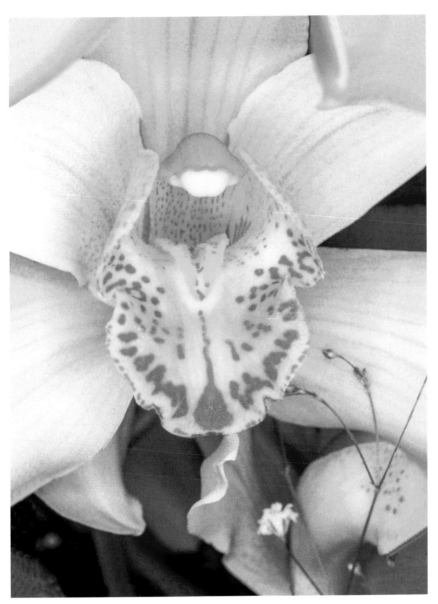

Nobuyoshi Araki
Flowers · Japan · 1985
Flowers and other
plants are often
fetishized in the erotic
photography of Araki,
the prolific Japanese
artist known for his
works exploring bond-
age and sensuality
within a contemporary
art setting.

Joyce Lee · *Rose* · South Korea · 2021 The artist
Joyce Lee creates luscious, vibrantly detailed erotic
drawings and paintings. In this playful image, the
symbol of the rose takes on distinctly feminine
qualities.

(following pages) Penny Slinger · *The Golden Triangle*
United States · 1976–77 Included as part of the
erotic collage series; *Mountain Ecstasy*, this piece
was created through a process Slinger describes as
"the alchemy of pornography."

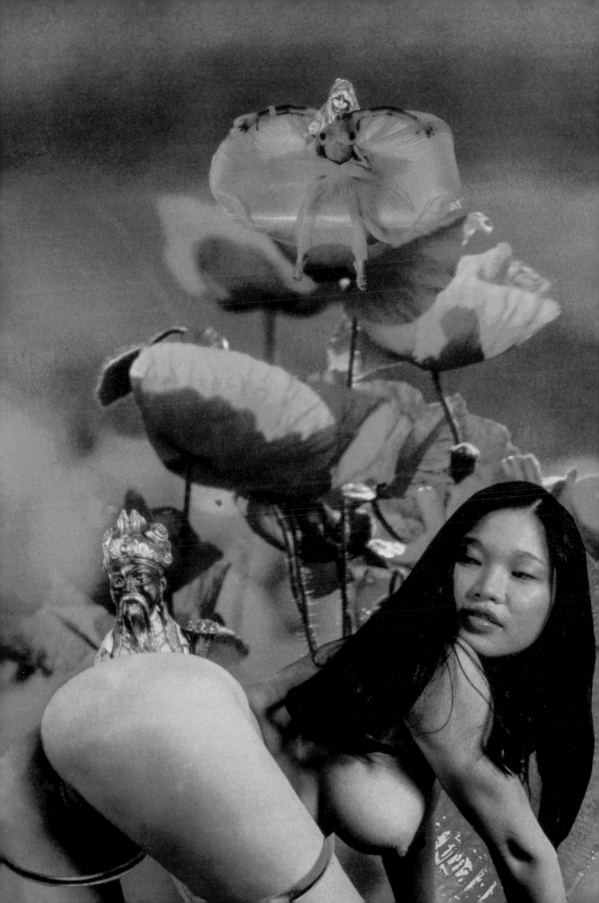

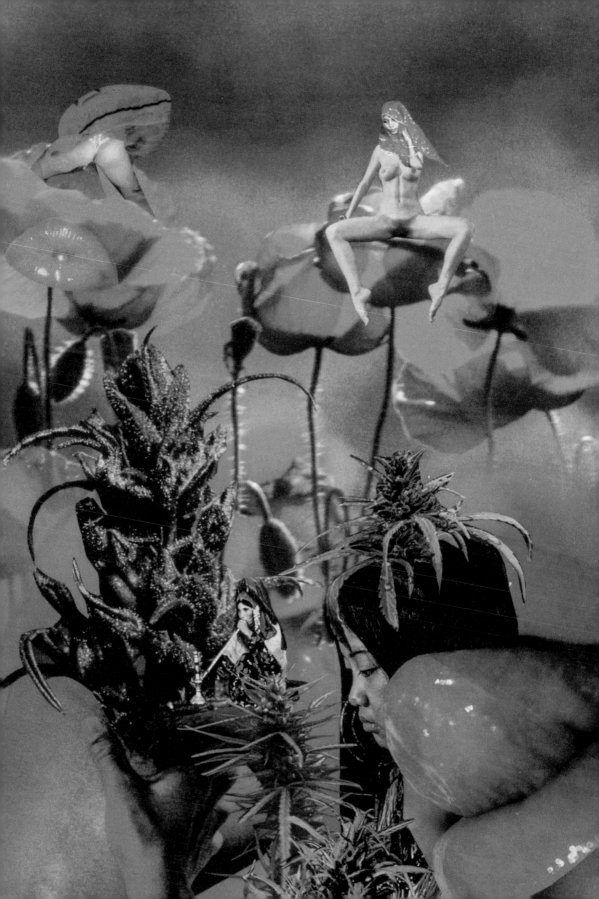

Valentine Cameron
Prinsep · *The First
Awakening of Eve*
England · 19th Cen-
tury Pre-Raphaelite
brotherhood rendition
of the coming to life
of Eve in the pure
and untouched, sacred
garden of Eden.

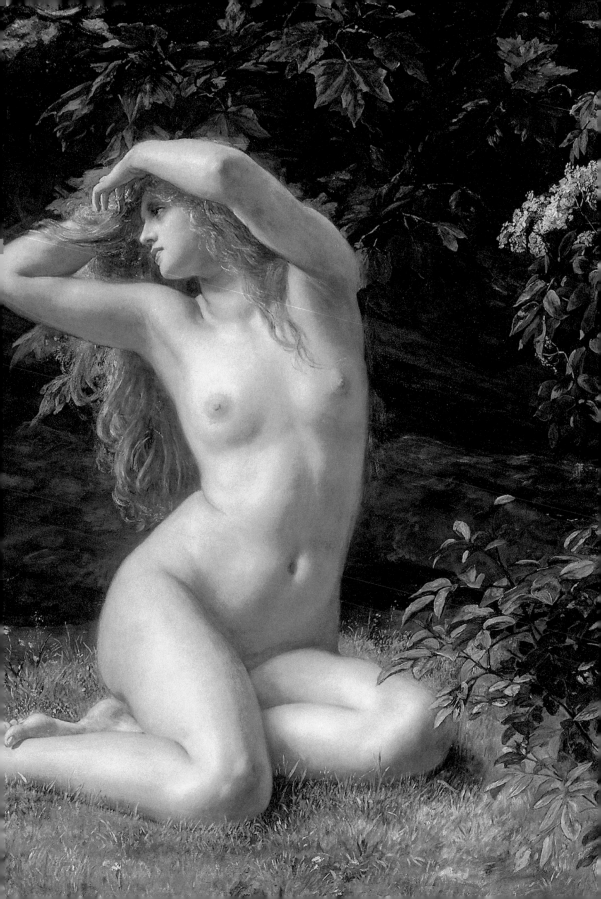

I came the practice of working with plant through my near-death experience. When I was 30, a woman ran me over with her car. When the paramedics found me, I was clinically dead. When I woke up from the coma, I'm not walking, talking, reading, writing. So that sets me out on a journey of speech therapy, physical therapy, learning to walk again. During that time, I went to see a shaman, who told me, 'You have a South American bloodline that goes back to the Amazon rainforest. You can talk to the plants. The Jaguar's going to come through and guide you.' She did not know this about me, but my dad was born in a river in the Amazon rainforest. His father grew up on in Guyana. As predicted, the jaguar started coming to me. What was happening on the outside was called seizures, but what was happening for me on the inside was that I was journeying. The jaguar was coming to me and talking about plants, the womb, and how to become guide of transitory energy. Initially it was not about plants, but it was more just about this energy of moving from one side of the veil to the next. For me, it's all things Mother. It's Mother Earth, the mother womb. We come into the world, in this explosion of light. And we die, no matter our color, socioeconomic status, or race. We go back into the Earth. The Earth turns us into flowers. We then take those flowers and plants, put them back into our body, and give them back into the Earth. Our relationship with the divine mother, the goddess, all those principles, is spiral, a cycle. As above, so below. Plant medicine attunes you with the mother, to the Earth energy that is rising now.

—JAGUAR WOMBAN, Herbalist, Healer and
Visionary Mother of The WombNation community

(following pages) Tuco Amalfi · *Seguindo o Amor* Brazil · 2001 Translated to "following love" this dreamlike painting places two lovers within a mystical garden, exploring the concept of love as transcendence, a connection of both body and spirit.

Ferdinand Georg Waldmuller · *The Nymphs in Homer's Odyssey* · Austria · 1856 In the lands of the The Odyssey, nymphs abound as personifications of the springs, groves, sacred rivers, and trees. They tend to be experienced at the meeting grounds of man, land, and God, in the epic poem.

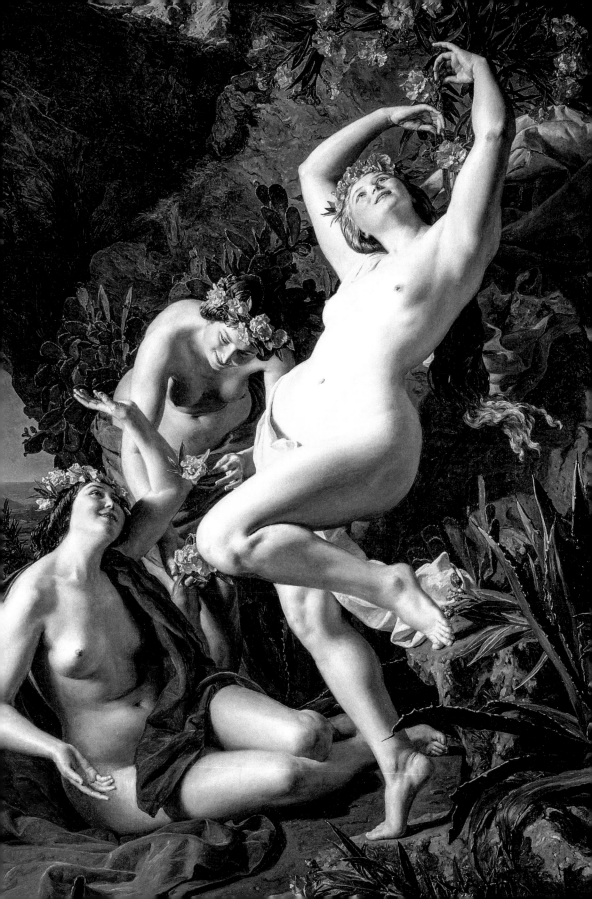

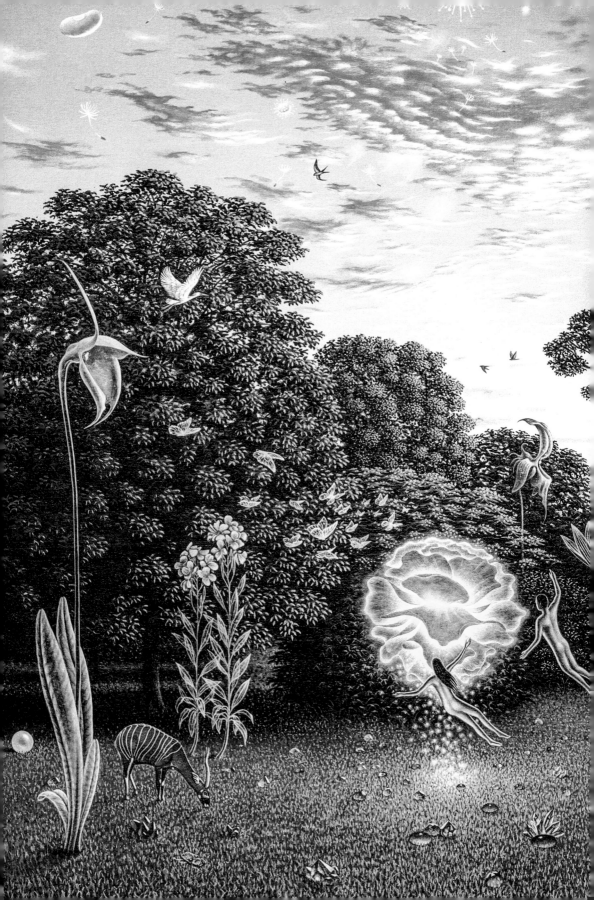

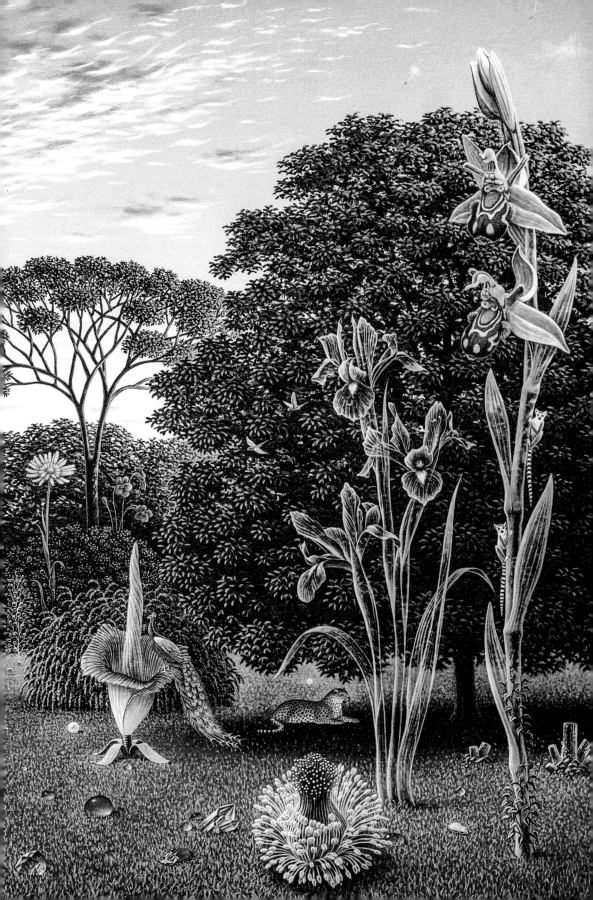

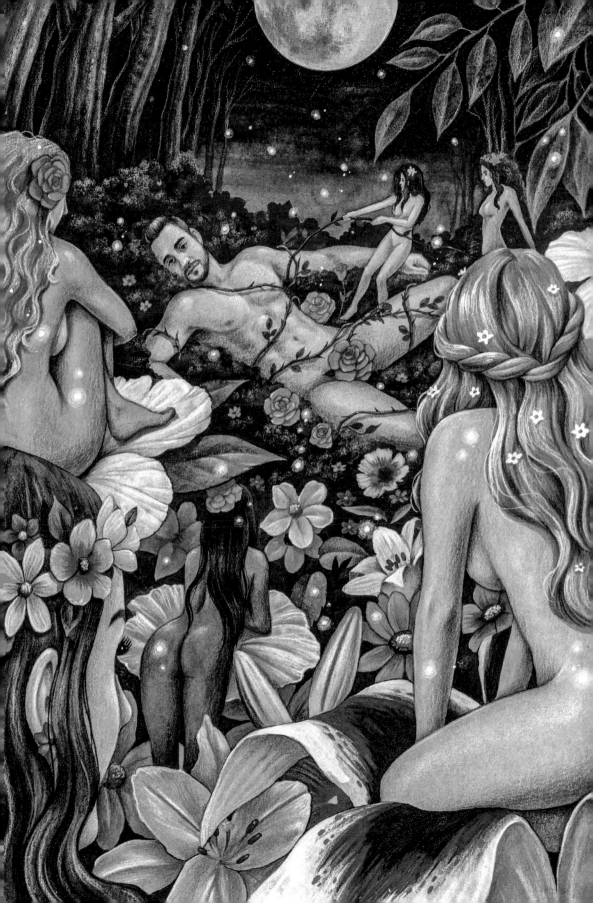

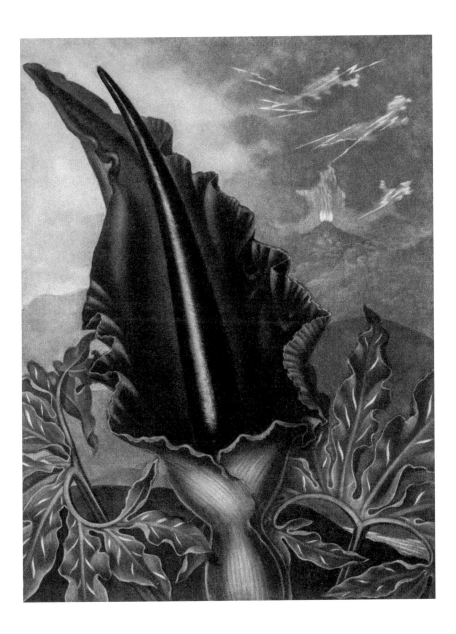

Joyce Lee · *One Fine Night* · South Korea · 2021
In this highly charged erotic depiction, lovers con-
verge in a fantastical garden, the verdant display
of botanicals and flowers mirroring a feeling of
blossoming desire.

Robert Thornton · *Common Snake (or Small Com-
mon Dragon or Snake Goulet) Strong water* · England
1812 From *The Temple of Flora*, a monumental
work of illustrated botanicals, the black calla lily is
considered the flower of mystery, beauty, and grace.

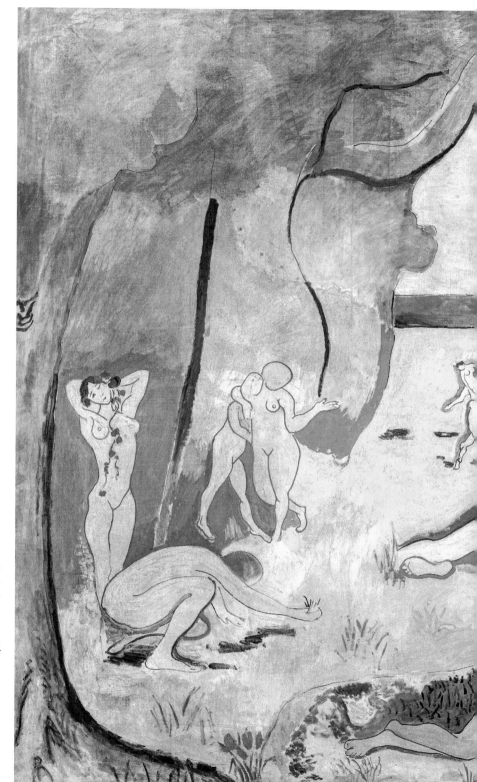

Henri Matisse
The Joy of Life · France
1905–06 Matisse adds
brilliant color to the
landscape of trees, with
nude figures as varied
and free as nature itself.

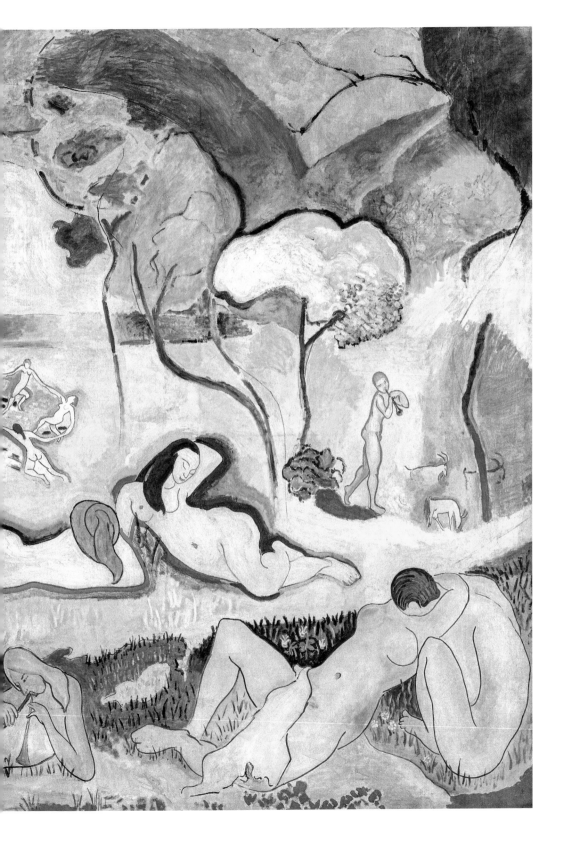

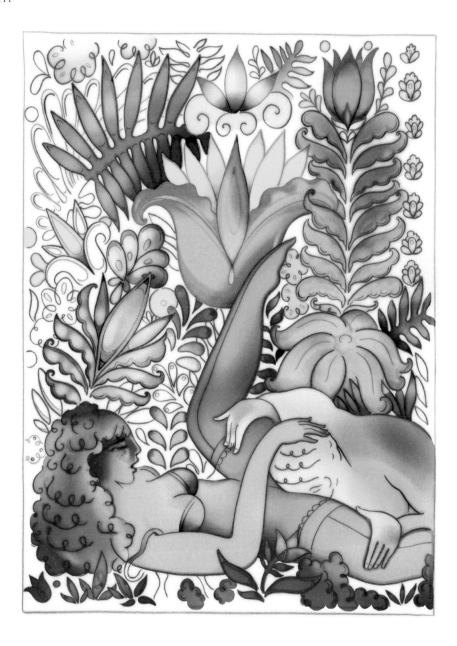

Alphachanneling · *Loves Revelation* · United States 2021 Unbridled, unapologetic eroticism is a favorite subject of the artist known as Alphachanneling, whose vibrantly colorful illustrated works often feature nude bodies in the throes of sexual pleasure.

Steven Arnold · *Untitled (Quan Yin Official)* United · 1988 The visionary artist Steven Arnold captures one of his many muses Quan Yin. As Vishnu Dass, director of the late artist's archives explains, "Steven's tribe referred to Quan Yin as the "Drag Buddha."

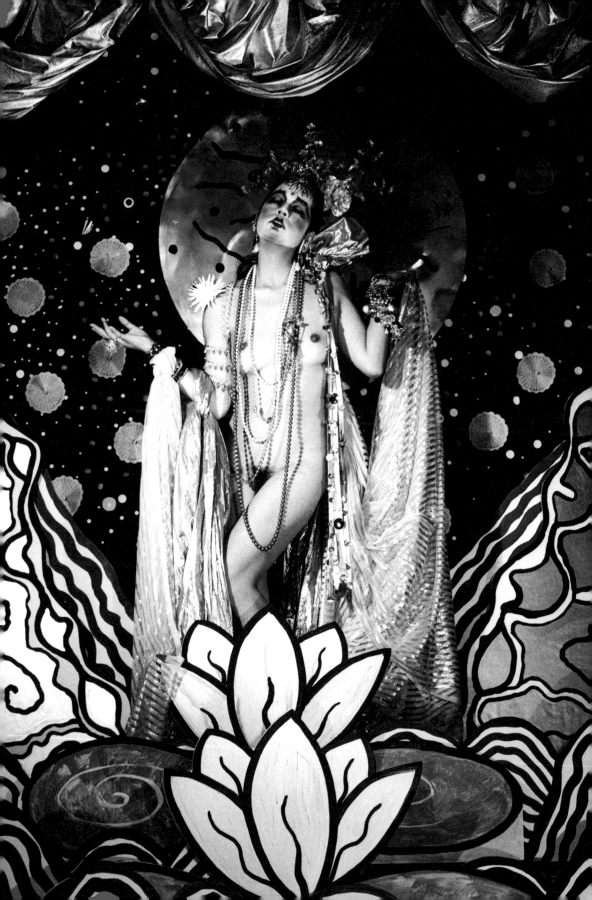

PART IV

—

The Blossom Opens

PLANTS &
HIGHER STATES

RITUAL ELATION

Stimulating Plants

Coffee became tied to what I called 'The Art Life.' I loved to go to diners and drink coffee and try to catch ideas for the work. Coffee has always seemed to facilitate thinking and catching ideas. Not only that, but the flavor of coffee is beyond the beyond good. Even bad coffee is better than no coffee at all.

— DAVID LYNCH, painter, filmmaker, meditator, and coffee enthusiast.
Excerpt from an interview in the Huffington Post, 2012

Cacao and coffee bean, tea and tobacco leaf, the ritualistic use of plants for stimulation, meditative clarity and focus is a tradition going back thousands of years, perhaps to when the first tea leaves were brewed in water above an open flame. Traced back to areas of Tibet, India and to the era of China's Shang Dynasty, Tea was used both medicinally and in ceremony. Root, leaf, twig, and blossom were used for their healing qualities and as offerings to ancient deities. The first documented use of Tea in Japan dates to the 9th century; the culture's ritualistic tea ceremonies evolved out of Zen spiritual practices. Today, the drinking of tea as an act of meditation has been embraced by a new generation seeking calm amid a turbulent world. In his best-selling 1996 book, *The Miracle of Mindfulness*, the late Zen master Thích Nhất Hạnh writes, "Drink your tea slowly and reverently, as if it is the axis on which the world earth revolves…" Where herbal teas relax, the energizing qualities of caffeinated green and black teas as well as the powerful, stimulating attributes of the coffee bean have also been long embraced. The first coffee farms were planted in the

Arabian Peninsula during the 15th century, where drinking the potent brew was celebrated by everyone from Sufi holy men to early Ottoman royalty. In Mesoamerica, the Cacao bean — which is native to the Amazonian rainforest — was first cultivated by the Olmec over 4000 years ago. Considered sacred within the traditions of numerous indigenous cultures of Central and South America, the plant was a feature of rituals ranging from feasts to fertility rites. Both in Mesoamerica and among the Native American indigenous traditions to the north, the Tobacco plant was held in a similar regard, and placed among the pantheon of botanicals revered for their spiritual importance and medicinal potency. In his book, *Iwígara*, published in 2020, ethnobotanist Enrique Salmón explains the deep reverence for tobacco in North and South American indigenous traditions. "No other plant holds as much universal importance." he writes, "When we inhale the smoke of tobacco leaves, we are creating a unifying connection with all the cosmos. The smoke flows in and out of our bodies, carrying with it our thoughts, further solidifying our connection to all things."

(previous pages) Elena Stonaker · *Things that Bloom in the Dark* · United States · 2022 Working across multiple mediums the contemporary artist Elena Stonaker explores dreamlike narratives which incorporate nature in fantastical ways.

Unknown · *Habit of a wealthy lady* · Netherlands 1630 Smoking tobacco was initially adopted by the upper classes — first among men and then among women. It was a symbol of sophistication and wealth.

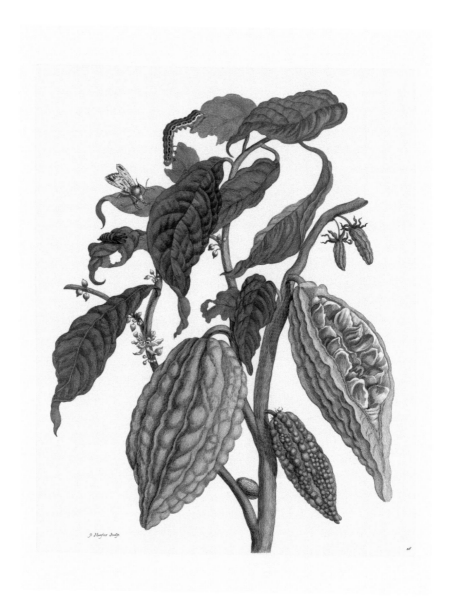

Maria Sibylla Merien · *Cacao or Cocoa Tree and Fruit* · Germany · 1705 From the book, *Metamorphosis of the Insects of Surinam*, the caterpillar crawls on a mature cacao plant, the wonder bean from which chocolate is made.

Konstantin Yegorovich Makovsky · *Tea Time* Russia · 1914 A Boyar woman, in traditional Moscow duchess dress and headdress, is seated near a samovar and drinks tea from the saucer of her cup. Tea-drinking in Russia was an aristocratic privilege and practice.

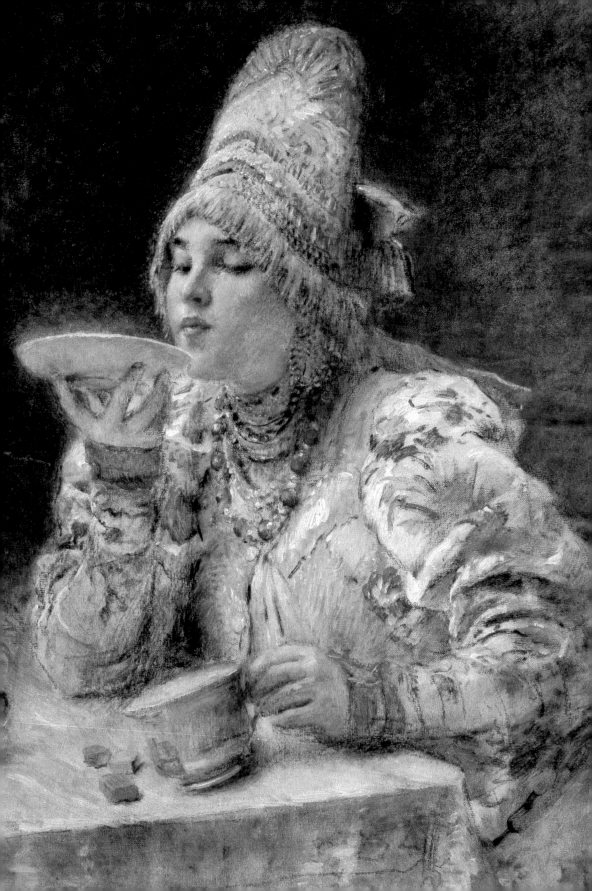

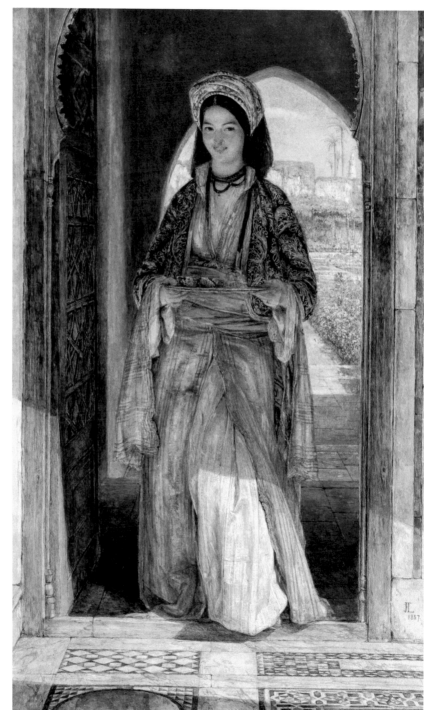

John Frederick Lewis
The Coffee Bearer
England · 1857
The artist lived for
some time in Egypt
and painted in the
Orientalist style, depict-
ing the serving of
coffee in elaborate
costume, assumedly
within the Ottoman
quarters of Cairo.

Unknown · *Medicine bag*
Péru · 6th Century
Constructed of alpaca
or llama hide, this
centuries – old medicine
bag was ornately dec-
orated with a face and
real human hair. Inside,
coca leaf remnants
were discovered, along-
side various plant and
mineral pigments.

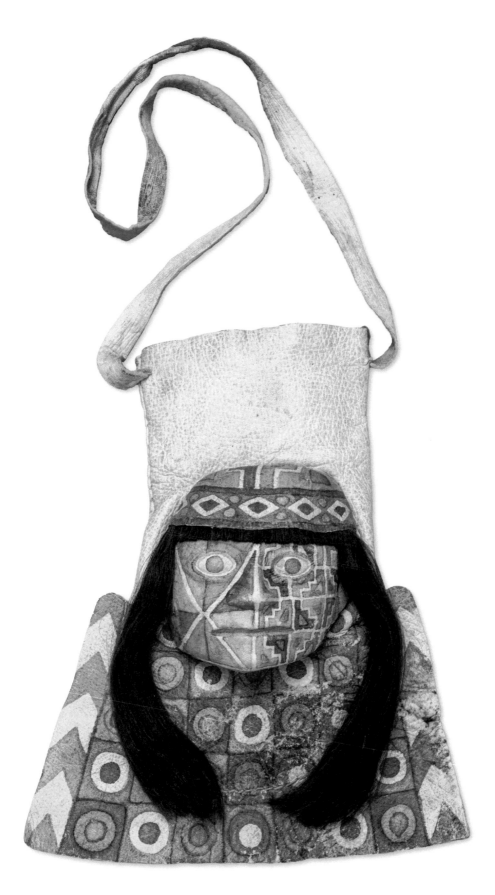

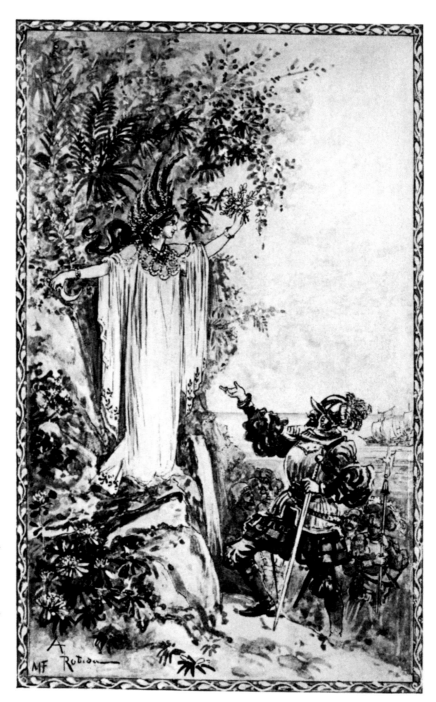

William Golden
Mortimer · *Mama Coca*
United States · 1901
An illustration titled
"Mama Coca" from
the first edition of *Péru:
History of Coca; The
Divine Plant of the
Incas* by Mortimer,
a physician and early
researcher into the
effects of coca
plant on the human
nervous system.

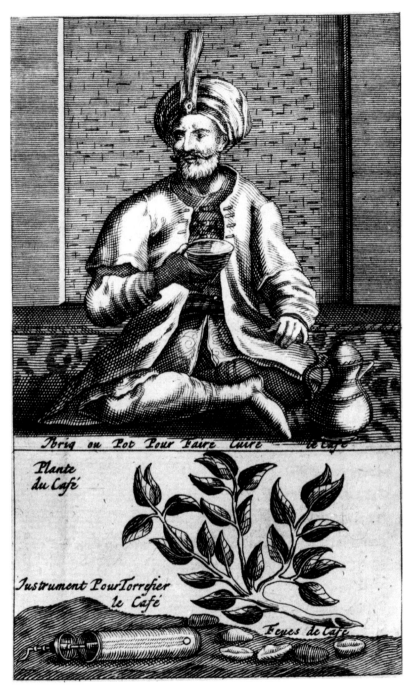

Toriq ou Pot Pour Faire Cuire le Café

Plante
du Café

Instrument Pour Torrefier
le Café

Feues de Café

Unknown · *A Pot for Making Coffee* · France 1693 Brewing coffee was first introduced in Turkey, where beans were ground with a mortar and pestle and steeped in pots called ibriks. The engraving is from the book *The New and Curious Treatise of Cafe, The and Chocolate* by Philippe Sylvestre Dufour.

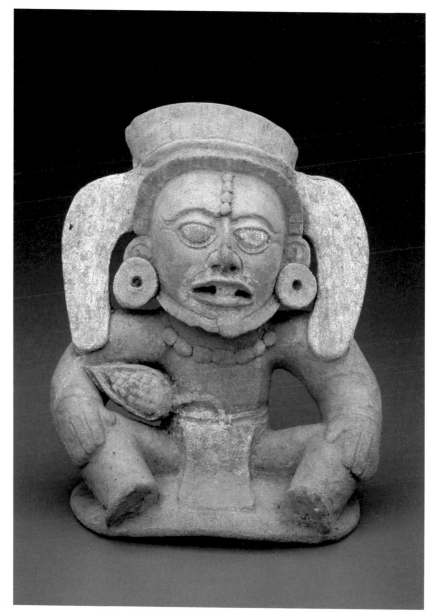

Unknown · *Figure from a vessel top in the form of cocoa deity* · Central America · 10th Century The Mayans placed cacao at the center of ritual ceremony and community interaction. It was associated with fertility and marriage rituals, and rites of death The Maya would drink from carved cups that had cacao God inscriptions. These inscriptions made sipping the chocolate a sacramental act.

(opposite) Luis Tamani · *Flor de Tabacco II* · Péru 2020 In this work by the indigenous Péruvian artist, Tamani explores tobacco as traditional ceremonial medicine, explaining of the plant; "Its light guides our mind. Its wings refresh our spirit. It surrounds us with its perfume."

(following pages) Shunsho · *Courtesans of the Okaneya* · Japan · 1776 From the book *Mirror of Beautiful Women of the Pleasure Quarters* women practice tea ceremony, of which a customer must take part in to call upon the pleasures of the highest-ranking sex workers.

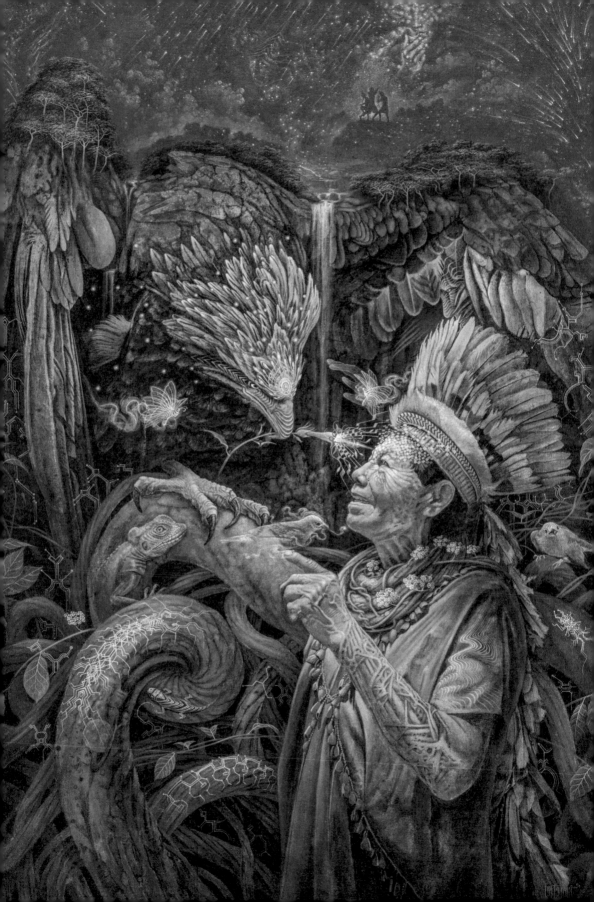

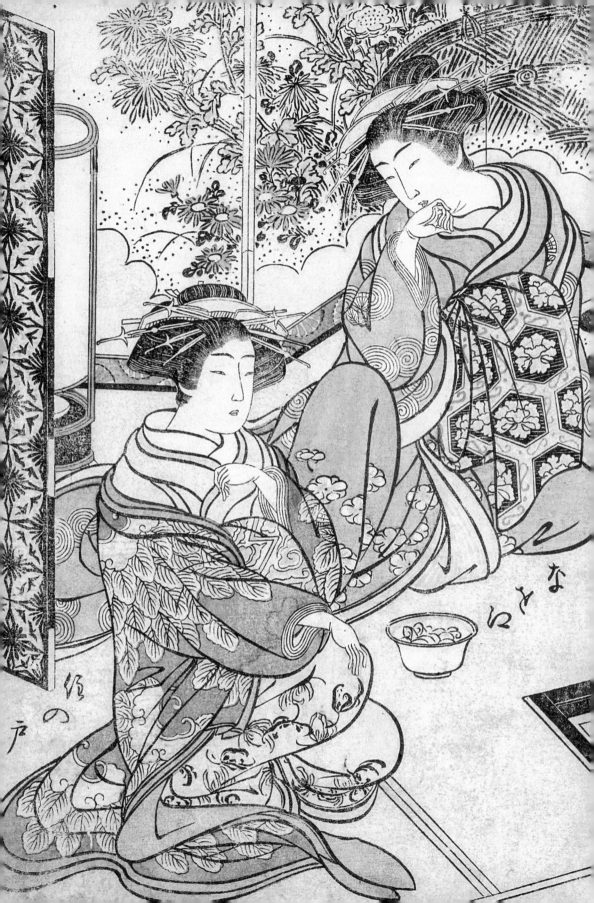

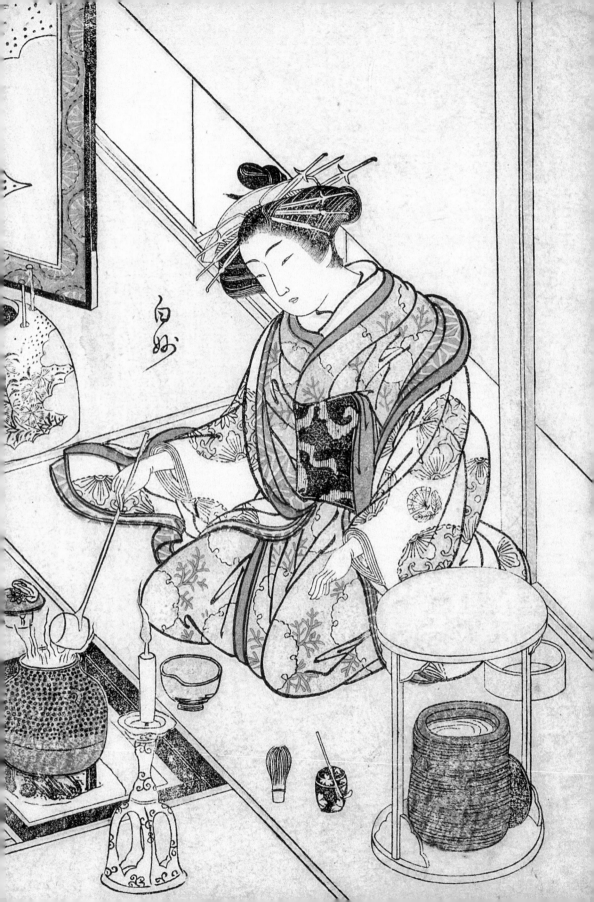

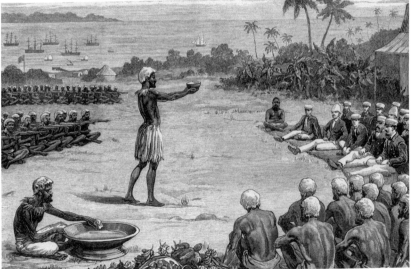

(opposite) Unknown *Presentation of the Yaqona Cup* · Fiji · 1965 A mildly narcotic root, kava is presented in yaqona rituals to mark life cycles, healing ceremonies and community gatherings of many Pacific societies.

(above) Theodore Wores · *Making Kava, Samoa* United States · 1901 A member of the pepper family, kava is used to make a drink that has sedative effects and is often used in ceremony and ritual.

(below) Unknown · *The Sailor Princes at the Fiji Island* · England · 1882 The illustration was done for the *Illustrated London News*, exhibiting a ceremony of incantation over the yaqona, or kava bow, prior to imbibing the sedative beverage to welcome royalty to the island.

My first peer-reviewed article was that the tribal community where I worked did not have a word for "nature." And the concepts they had that were closest were all intersubjective: nature and aspects of nature had agency, had will, could both have intentions and act on those intentions. Nature isn't some depersonalized object or separate "landscape" to view. Those perceptions resonated with my childhood, when I was roaming by myself throughout the deserts and forests of New Mexico. As the Director of the Archive of Healing, I am constantly combing through the sayings and stories about plants in the database, collected of a hundred years by various scholars. In my private practice, I am regularly relying on plant magic that either I have made or that I source from other medicine makers. For example, I have been working on a dreaming tincture for a few years now, combining Blue Lily Flower, Chasteberry, and Zacatechichi. We are very lucky. Many before us went to great lengths to protect knowledge-making practices from the various inquisitions and witch hunts that attempted to extinguish plant medicine, women's wisdom, and those rituals that help us humans maintain right relations with our other-than-human kin. There's no way around it: colonialism and capitalism have conjoined in some seriously damaging ways to our health and the health of the planet. But shutting down and giving up were never practical options. We have an opportunity to grow back to the sources of nourishment: the soil, the plants, our animal friends, and non-human allies. Esoteric knowledge has been there all along, just off the radar of authorization. It's rarely too late to right our relations.

— DR. DAVID DELGADO SHORTER
(UCLA) Director, Archive of Healing, 2022

Felice Beato · *Tea Ceremony in Japan* · Japan 1900s Originating from a Zen Buddhist practice based on four core principles: Harmony, Respect, Purity, and Tranquility, Chado, "The way of tea" is the ancient, multi-hour, formal event, being performed by Geisha on traditional tatami mats.

Jean-Étienne Liotard · *Still Life: Tea Set* · Switzerland · 1781 Tea parties with a full set of fine china has long been a ceremonial act easily performed in daily life. Tea is steeped, poured and sipped with baked goods as a social ritual.

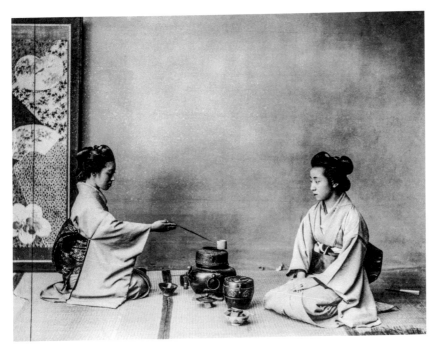

Harold Knight
In the Spring · England
1908–09 Teatime in
the Edwardian era
took place in bucolic
settings, under trees
and in fine linens.

Jean Baptiste Vanmour
Sultana Taking Coffee
France · 18th Century
The Ottoman Empire
tradition of taking
Turkish coffee with a
glass of water and
a square of Turkish
Delight, which is how it
is served in Turkey today,
was started by Hürrem
Sultan – wife of Sulei-
man the Magnificent.

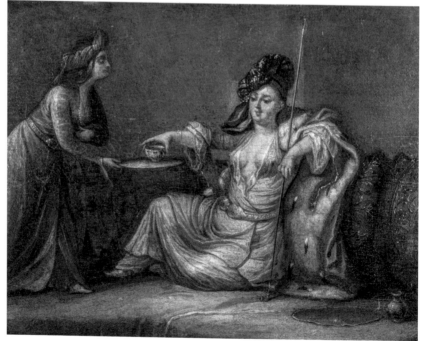

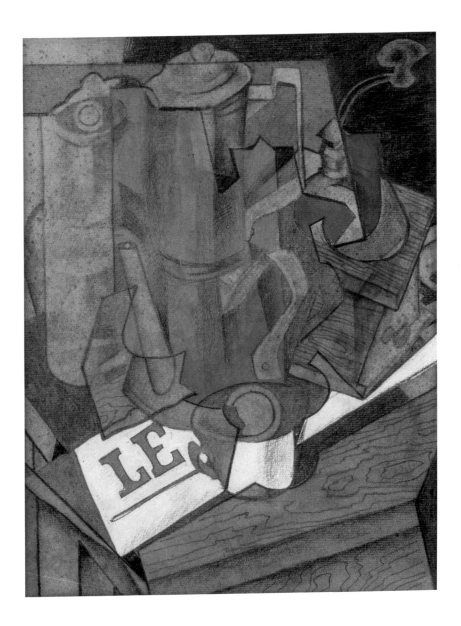

Juan Gris · *Still Life with Coffeepot* · France · 1916
Distinctive cubism style from the still life artist who
did many different pieces of work portraying coffee
apparatus.

Robert Delaunay
Coffee Pot or Portuguese
Still Life · France · 1964
An important and
ceremonial partaking in
everyday life, brewing,
pouring, and drinking
coffee has made its way
into every kind of art
through the centuries.

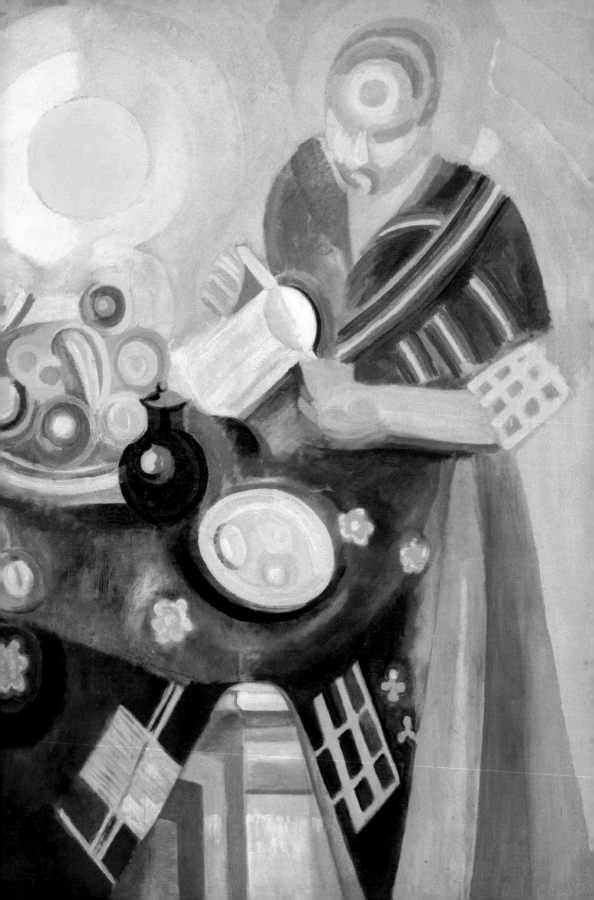

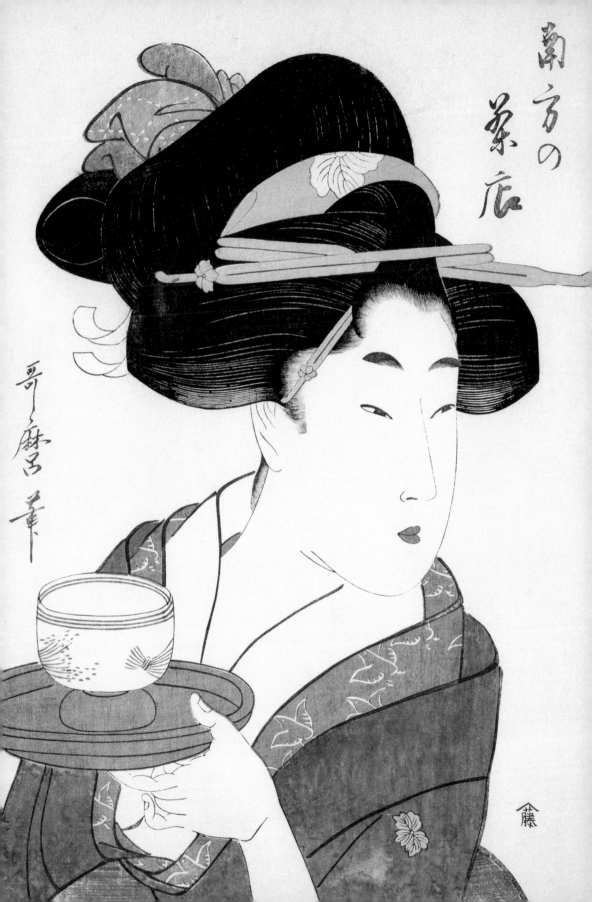

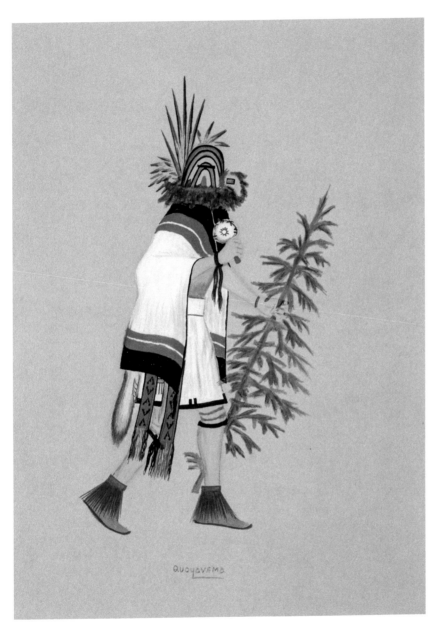

QUOYAVEMA

Riley Sunrise
Quoyavema
*Chi-To-To, Chief
Kabolima of Tobacco
Clan (S'A Towa) of
Tewa (Hano)* · United
States · 1930–1940
Tobacco is grown and
used by indigenous
people for ceremonial
or medicinal purposes.
Prescribed properly as
a medicine, it can pro-
mote physical, spiritual,
emotional, and commu-
nity well-being.

Kitagawa Utamaro · *Southern Teahouse* · Japan
1753-1806 Tea ceremony in Japan is a valued
art itself, made with matcha and served by women
in ceremonial kimonos at teahouses.

THE BACCHANAL

Plants & Intoxication

Enkidu knew nothing about eating bread for food,
And of drinking beer he had not been taught.
The harlot spoke to Enkidu, saying:
"Eat the food, Enkidu, it is the way one lives.
Drink the beer, as is the custom of the land."
Enkidu ate the food until he was sated,
He drank the beer-seven jugs! and became expansive and sang with joy!

— from *The Epic of Gilgamesh*, written by an unknown author, sometime between 2100–1200 BCE

The history of ritual intoxication, the ingestion of fermented grains, fruits, and other botanicals to attain a trance-like euphoric state, can be traced back to the earliest human civilizations. Some of the oldest historical evidence of beer brewing has been documented at a prehistoric burial site in Israel, where traces of a wheat and barley residue thought to be at least 13,000 years old was discovered by archeologists. Whether intentionally placed as a funerary offering or part of a complex death rite, this discovery led some researchers to believe that the making of alcoholic drinks may pre-date agriculture itself, with the drinking of fermented fruits, plants, herbs and flowers practiced by our most ancient ancestors.

Evidence has been found of wine-making processes from as far back as 6000 BCE Neolithic-era residues from fermented drinks made with honey and rice have been discovered in archeological sites in China. Beer, wine, and other alcoholic beverages were integrated into spiritual worship across cultures, with deities associated with drink appearing in numerous religions and mythologies. In Japan, the Shinto goddess Inari is associated with both fertility and the fermented rice beverage, sake. In Norse myth, the brewing of mead or ale is linked to the god Aegir. In early Egypt, Bes was considered the god of drink, dance, and other sensual pleasures. In African traditions mythologies spoke of the fierce warrior deity Ogun as the God of rum-making.

In Pre-Columbian Mesoamerica, the female deity Mayahuel was considered the personification of the maguey, the flowering portion of the agave plant, an ingredient used in the creation of the ancient alcoholic drink octli. Sacred to the Maya and Aztec, octli was also known as pulque, a potent predecessor to

Guido Reni · *Drinking Bacchus Boy* · Italy · 1623
Son of Jupiter and God of wine and pleasure as a baby, complete with vines and his signature habit.

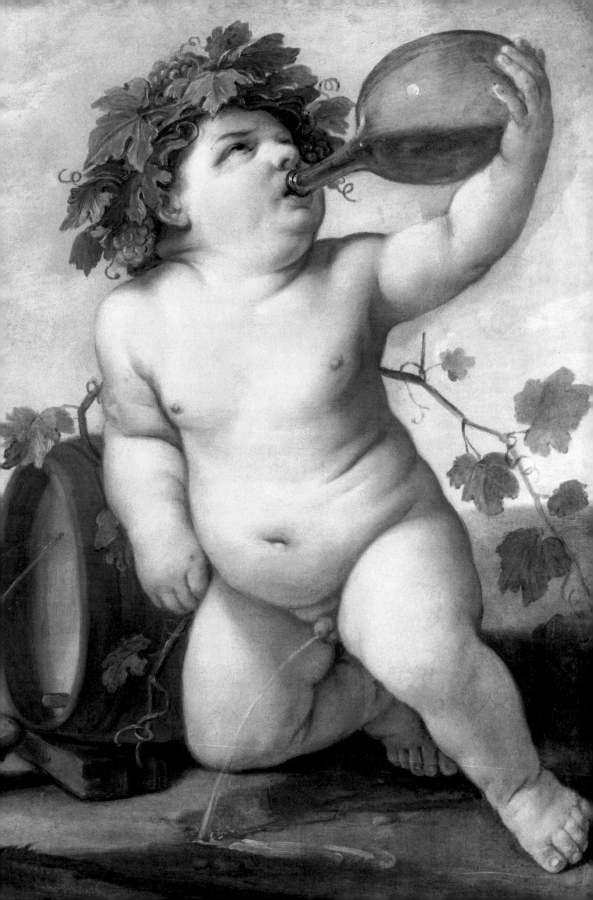

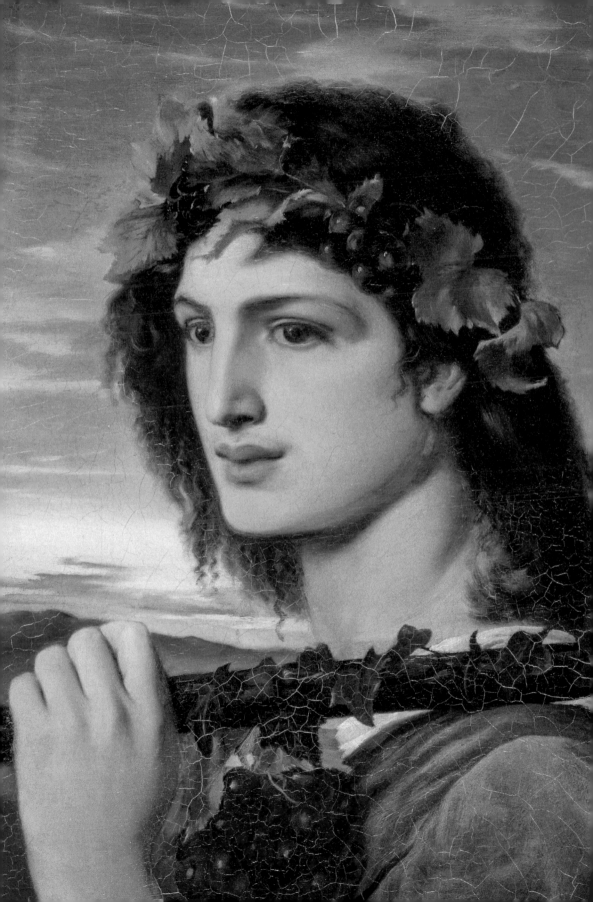

modern day tequila and mezcal. In Hindu myth, the eldest of the "Varuni," – the three daughters of the water god Varuna – is considered to be the goddess of wine. In early Christianity, the abbess Brigid of Kildare, credited with founding several convents in Ireland, was made the patron saint of brewers after her death in the year 525.

Perhaps the most well-known of mythological figures related to alcohol is the Roman god Bacchus, the beloved deity of wine and drunkenness. Known to the Greeks as Dionysus, this wine god was worshipped in celebrations of sensual pleasure and ecstatic states of drunkenness. During these multi-day feasts, or "Bacchanalias," as they were called – inhibitions were released, the self was set free, libidos erupting into an alcohol-inspired mystical madness. Most often depicted in artworks in the midst of wild revelry, Bacchus was synonymous with decadence and a lusty, insatiable appetite for pleasure and mischief. The god was also associated with abandonment of morality, loss of constraint and sometimes insanity. As Iain Gately explains in his 2008 book, *Drink, A Cultural History of Alcohol*, "In both ancient Greece and the present Millennium, alcohol has been credited with the powers of both inspiration and destruction."

Barley and grape, rice and corn, juniper berry and more, a vast and diverse botanical bounty has been and continues to be used in the making of alcoholic beverages. Over the course of our shared history, humans have also developed a wide range of techniques for transforming plants into intoxicating

drinks, potions, and tinctures – from boiling and distillation, fermentation, and in some cultures, a process of chewing plants in order to use the enzymes in our salvia to break down starches into fermentable sugars. These processes have evolved over centuries, allowing for complex blends and nuanced flavors, from the peat moss smoke of a fine Irish whisky to the delicate elegance of Japanese sake and Korean soju.

In Switzerland of the late 18th century, a vibrant green herbal concoction was first introduced, a heady mix consisting of Wormwood, Anise, Fennel, and various other botanicals. Absinthe, as it was called, became an immediate sensation, in part due to its euphoric, mildly hallucinogenic qualities and was later embraced by the artists and creatives of 19th century Paris as the drink of choice. Our ancestors had believed alcoholic beverages to be nothing less than conduits to the gods, an ancient method of releasing inhibition and achieving visionary states. For the poets and painters in the Bohemian circles of France of the late 19th century, absinthe held a similar promise of elation and euphoria, an escape from the everyday into a madness that became for some, muse. According to the painter Paul Gauguin, "Absinthe is the only decent drink that suits an artist." The writer Charles Baudelaire, a frequent visitor in the Parisian absinthe bars of the era, agreed. Exploring the euphoric escapism inherent in drinking of alcohol, he wrote, in his aptly titled prose poem, *Get Drunk*; "Always be drunk. That's it! The great imperative! Get drunk and stay that way. On what? On wine, poetry, virtue, whatever. But get drunk."

Simeon Soloman · *Bacchus* · England · 1867
The God of vegetation, wine, and pleasure, wears his traditional grapevine-wrapped flower crown and staff.

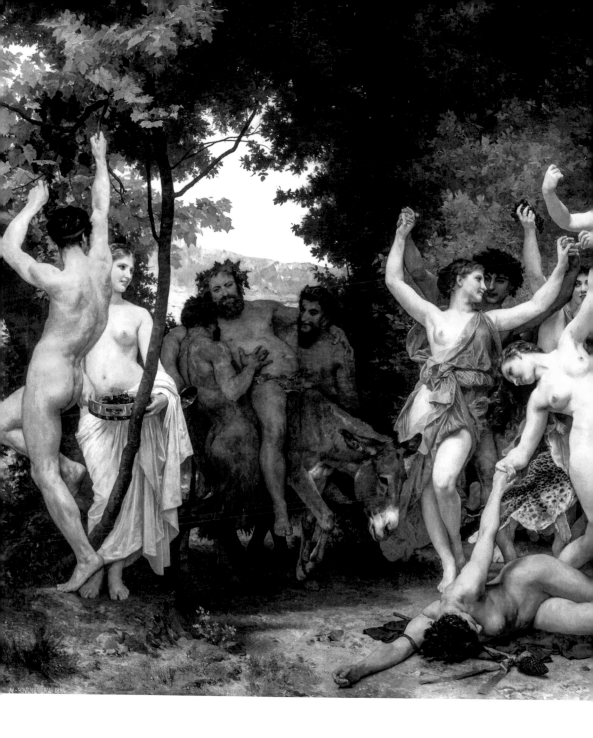

William-Adolphe Bouguereau · *The Youth of Bacchus*
France · 19th Century Under a grove of trees, a
bacchanalia ensues. One of the female followers
carries a thyrsus – a staff made of fennel with a
large pinecone on the end. This was traditionally
carried by Bacchus and his follower's symbolizing
fertility and hedonism.

296

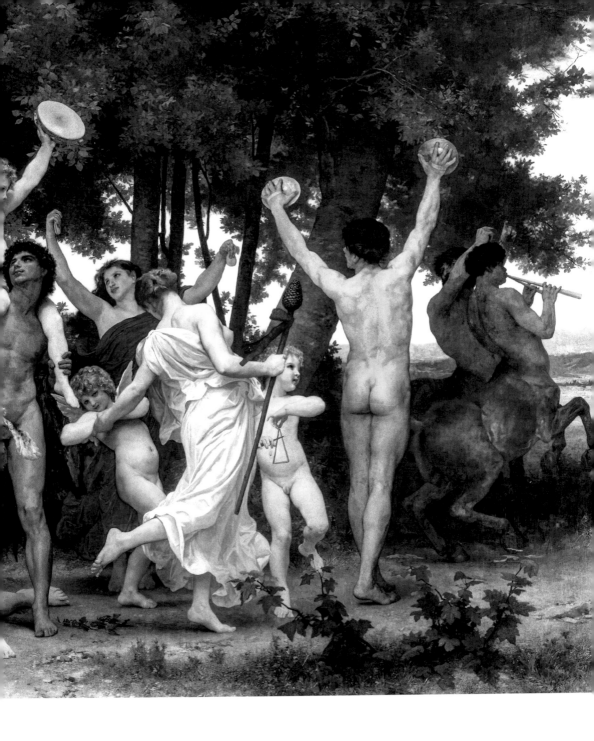

Unknown · *Absinthe Blanqui* · France · 1895
Absinthe advertised as "bringing about the pleasures of the Orient" in Art Nouveau style, before the herbal elixir was banned in 1912 for its hallucinogenic effects.

Jean Beraud · *The Absinthe Drinkers* · France · 1908
Absinthe, the great elixir of medicinal and culinary herbs, known as "the green fairy," was highly controversial primarily due to its rise in popularity with the bohemian set in early-20th-century Paris.

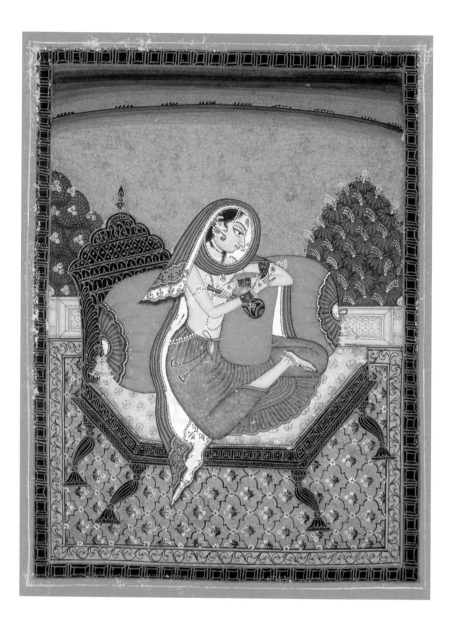

Unknown · *Woman Drinking Wine* · India · 1750
In a miniature painting, a woman drinks in the privacy of her garden. Although not prohibited in India, imbibing wine by women was considered taboo.

Johfra Bosschart · *Faun Head* · Netherlands · 1982
The Dutch surrealist offers a vivid depiction of the mythical half-goat, half-human god Pan, whom the Romans identified with Faunus, a frequent companion of the wine god Bacchus.

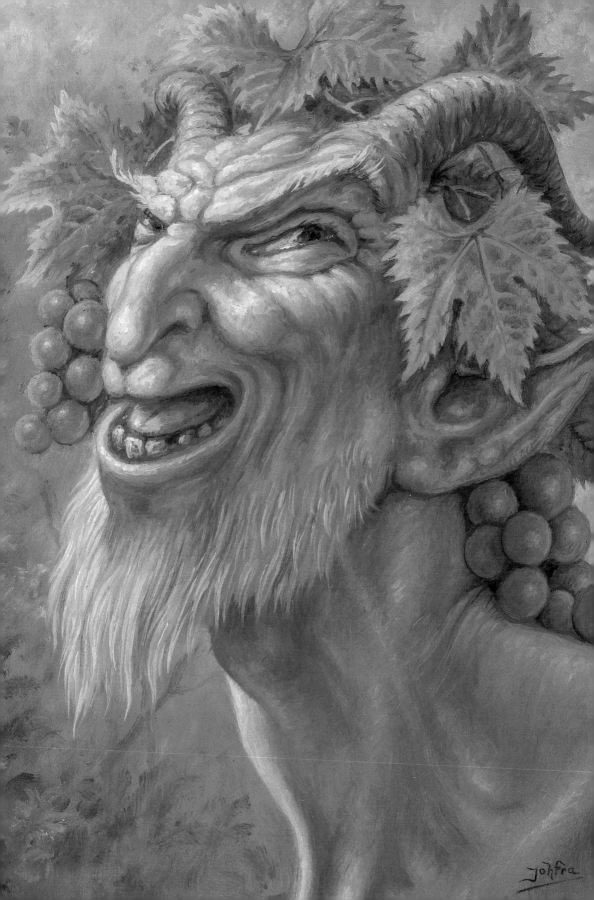

Louis Dorigny
Bacchanal · Italy · 18th
Century Grapes and
vines trail below a clas-
sic celebratory scene on
a fresco at Giacomelli
Palace in Treviso.

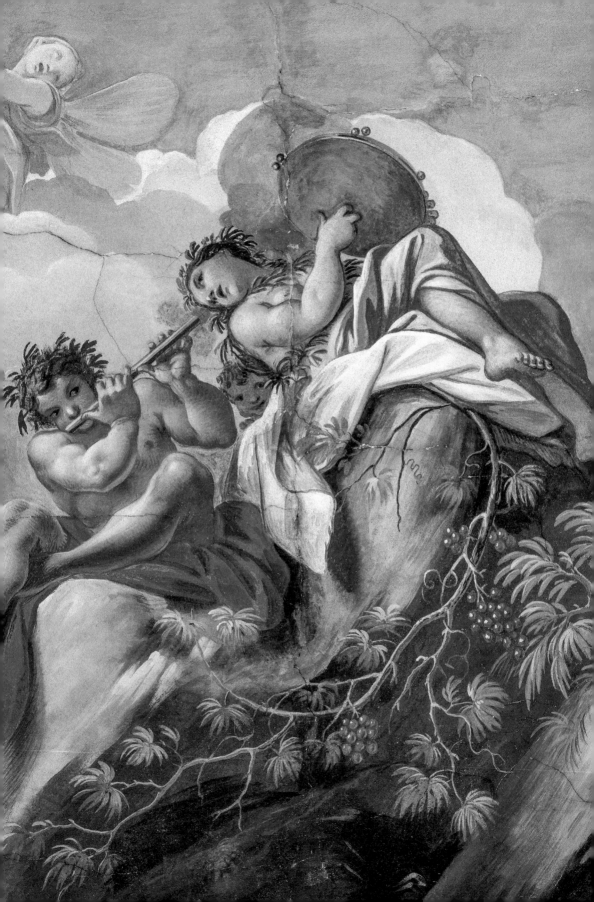

Louis-Théophile
Hingre · *Champagne
Theophile, Roederer & Co.*
France · 1897
Young vines from the
Roederer vineyard, still
in production today,
create the champagne
in the promotional art,
framed by a nouveau
floral and vine motif.

Unknown · *Picking
Grapes* · Egypt
1567–1320 BCE From
the tomb of Nakht, an
astrologer and grape-
vine gardener, grapes
are picked for Egyptian
wine. Grapes and wine
in Egyptian culture
symbolized revitalization
and rebirth. They saw
a connection between
their red color and the
blood of Osiris.

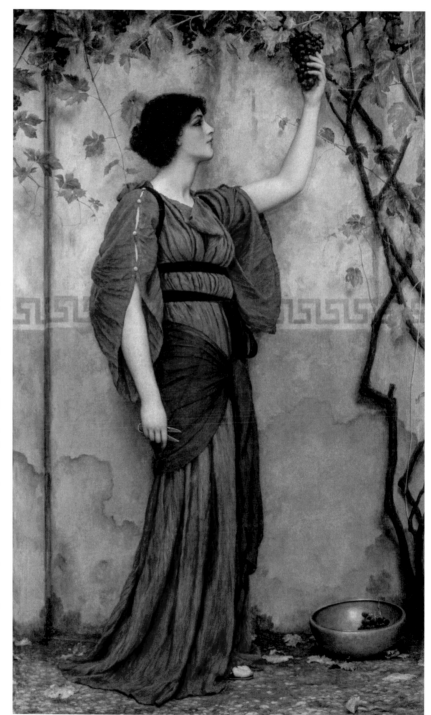

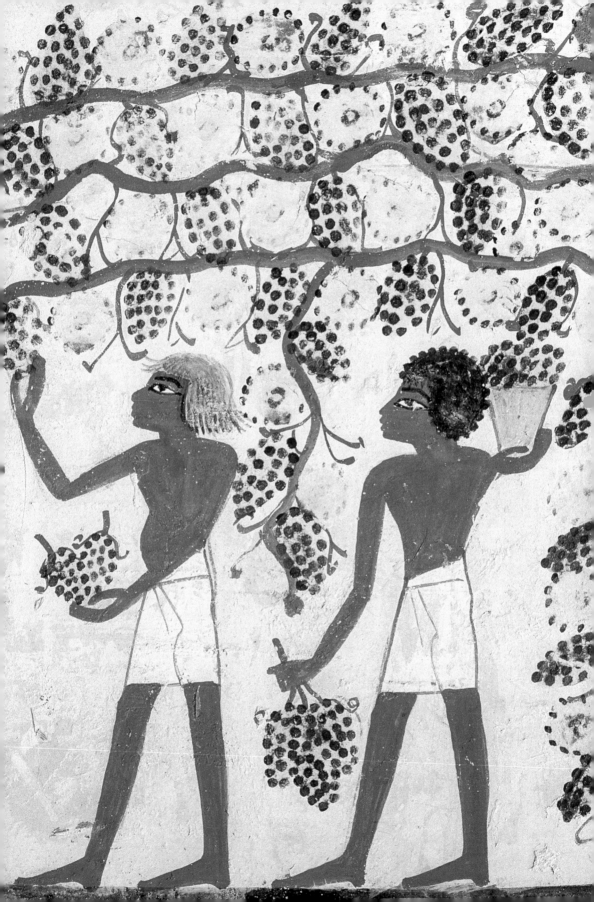

Saint Hops

Olga Volchkova · *Saint Hops* · United States · 2012
Trained as an icon painter and conservator, Volch-
kova uses her knowledge of Orthodox iconography
and her love of botany to create provocative paint-
ings that explore traditional icon writing and the
history of florae.

Elizabeth Blackwell · *Wheat, and Bearded Wheat*
Scotland · 1737 The wheat varieties are from, *A
Curious Herbal* containing five hundred illustrations
and descriptions of plants, their medicinal prepara-
tions, and the ailments for which they are used.

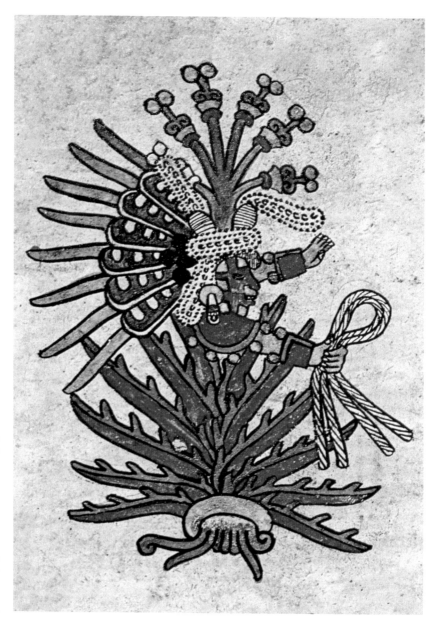

Unknown · *Tonalamatl* South America · 16th Century From the Aztec *Codex Borbonicus*, written by Aztec priests, the Goddess Mayahuel is sitting on an agave plant. She came to Earth with Quetzalcoatl to become a tree, but jealous grandmother followed her and split the tree in half, tearing her into pieces. Quetzalcoatl buried her remains which grew into the agave plant.

Unknown · *Wooden Palm Wine Cup* · Africa Unknown The carved vessel from what was Zaire, was made by the Bakuba tribe. It was used for drinking palm wine which contains nutrients beneficial to the skin, the hair and even the nails, and vitamins and minerals like zinc and magnesium.

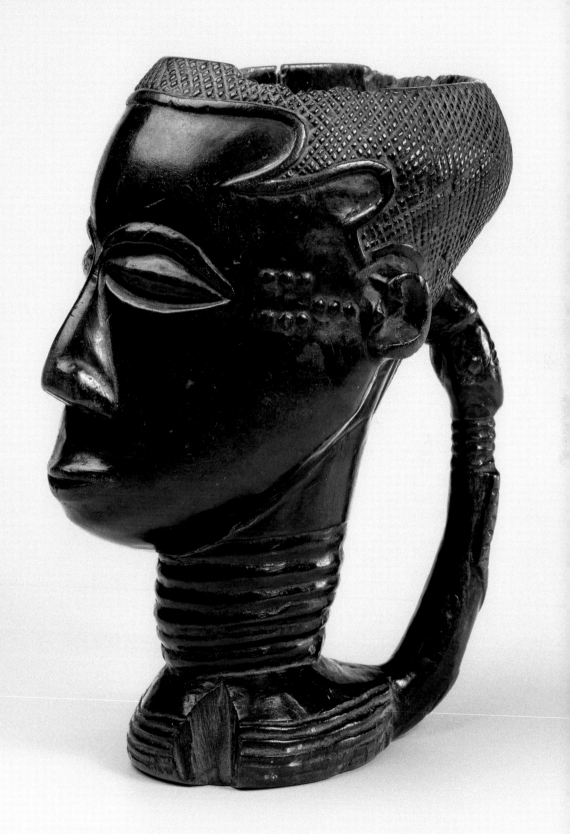

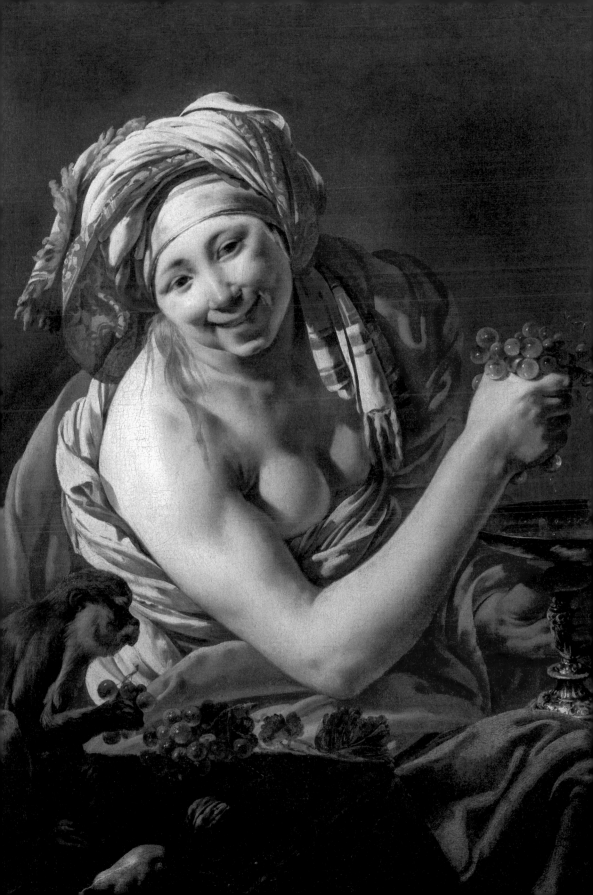

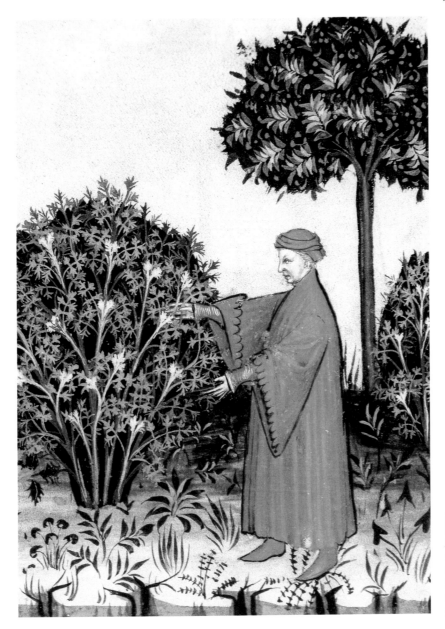

(following pages)
Unknown · *Bacchanalia*
Austria · 17th Century
Grapevines abound
in the symbolic festival
honoring the God
of wine and ecstatic
pleasure.

Hendrick Ter Brugghen · *Bacchante with an Ape*
Switzerland · 1781 A monkey mimics the follower
of Bacchus by squeezing grapes into a receptacle.
The scene portrays a typical, provocatively intoxi-
cated drinker openly endorsing the pleasures of
the vine.

Unknown · *Man harvesting absinthe* · Unknown
14th Century Its most famous association is the
liquor absinthe; however, the wormwood bush
renders a medicinal herb used to treat digestive
issues, liver disease and worm infections. Image
is from the herbal text *Tacuinum Sanitatis*.

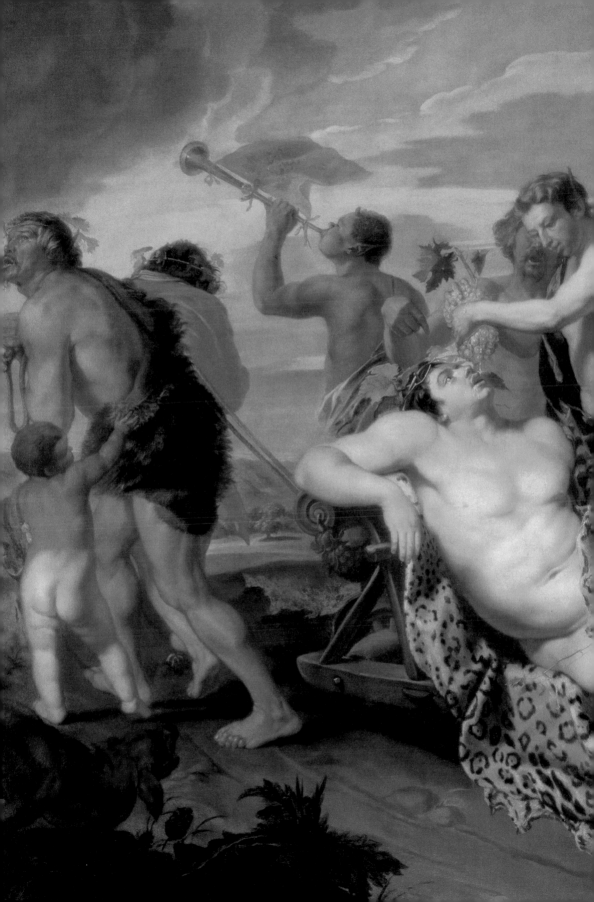

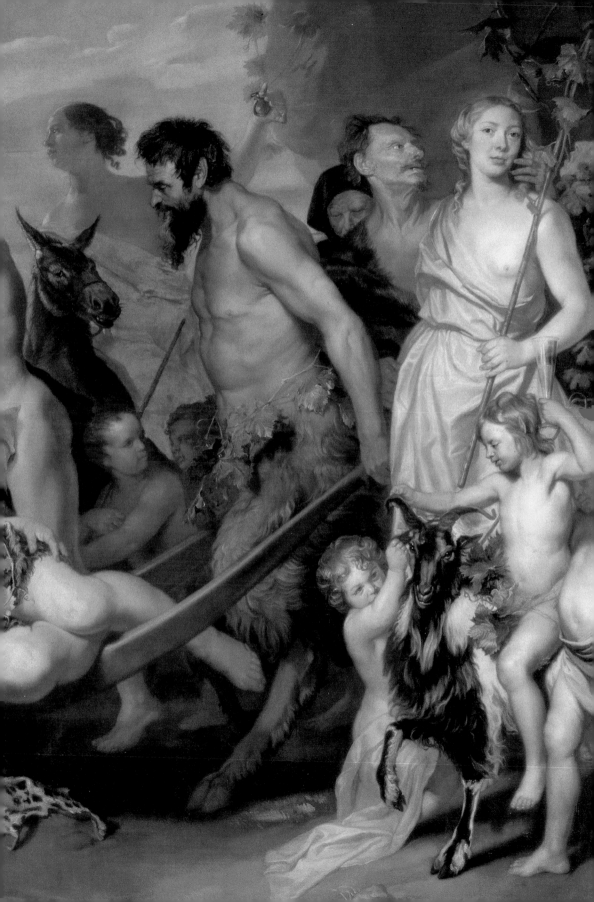

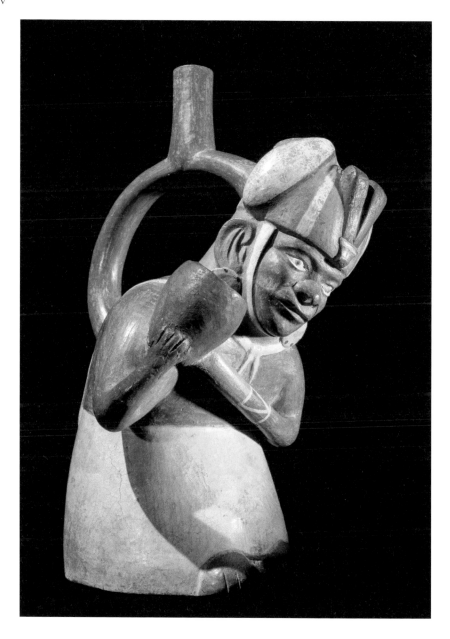

Unknown · *Stirrup-spouted Moche Jar* · Péru
0–700 AD This vessel carved with a noble of
the Moche is thought to be associated with fertility
rites, depicts the pouring of chicha beer, made
from corn and other wild plants.

Sandro Botticelli · *Autumn or Allegory Against Wine
Abuse* · Italy · 1490 Drunken Bacchus children with
grapevines present a cautionary tale intended to
encourage moral, religious behavior while simulta-
neously heralding the autumnal plant abundance.

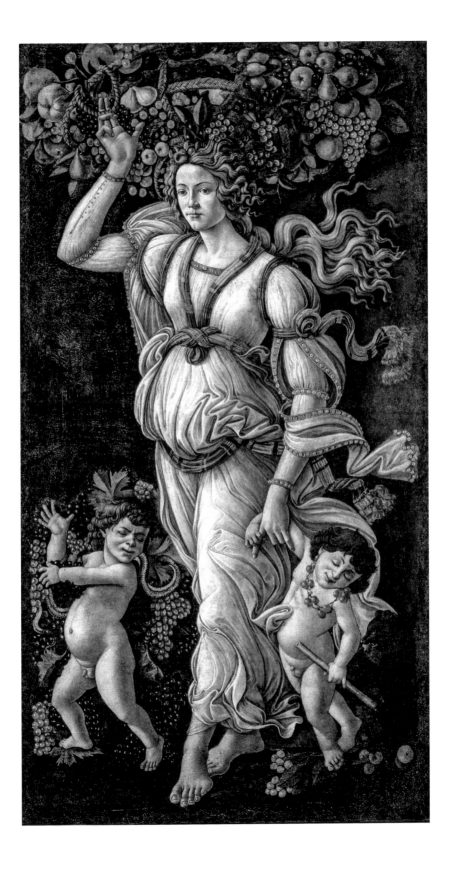

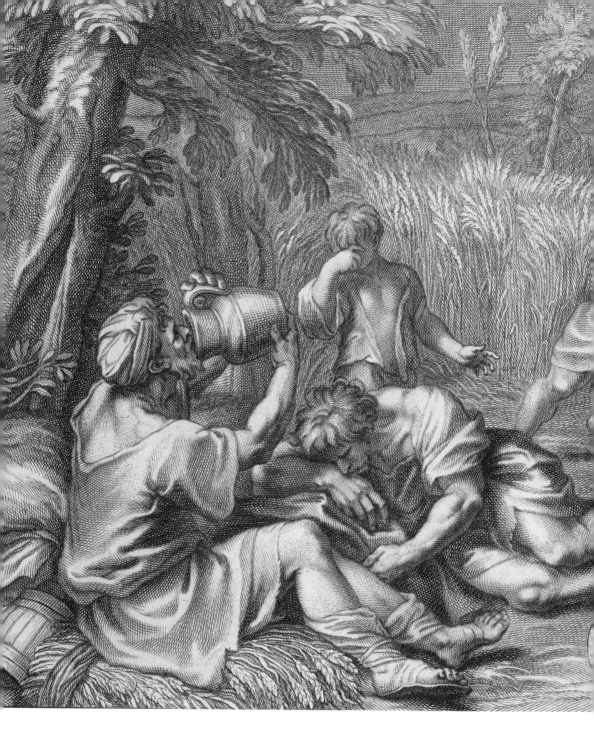

Giovanni Girolama Frezza · *Reapers of Grain*
Italy · 1704 Often called the staff of life, wheat
is a long-standing symbol of fertility, bounty, and
resurrection. Sheaves of wheat reflect the sowing,
growing, reaping, and harvesting as a metaphor
for the cycles of life.

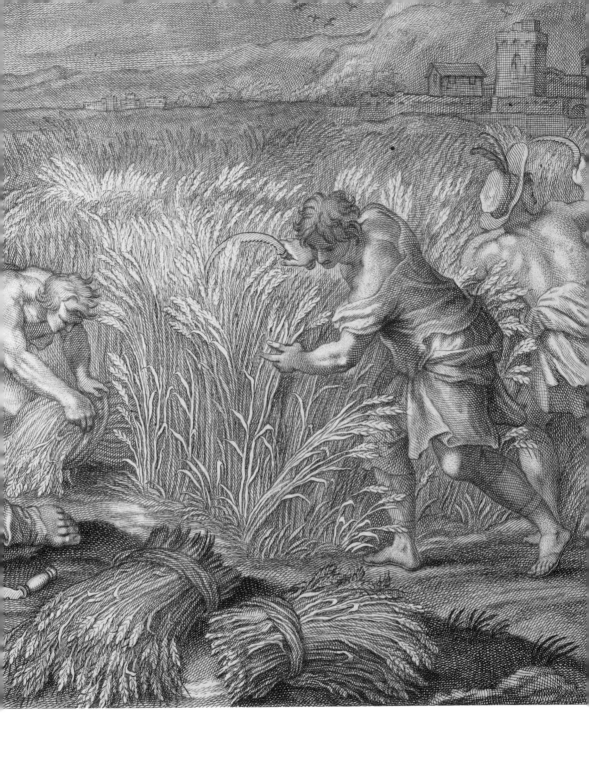

317

Our root understanding of the world is in nature, in the more-than-human world. You could say that our minds run on plants. As a species, human beings have co-evolved with every other living thing on this planet, over millions of years, to communicate and understand the demands of the other species and the landscape itself with which we actually live our lives. You are doing this right now: paying attention to the weather, to the shadow thrown by the tree outside, to the carrot you're crunching as a snack, to the shape of the bedrock underneath your building. Your mind never stops processing this information. It is how your mind is designed and that information keeps you alive and sane. Contemporary culture, however, tries hard to convince us that the material world, and the idea of 'reality' no longer matters. Instead, hard empirical evidence of troubles like climate change, which the body senses as real because we see it in the beetle-infected pines, in the failure of the stone fruit crops, and the new warmer-weather species that migrate into our neighborhoods, are dismissed because its politically inconvenient. Events in nature and in our human culture that we actually watch with our own eyes, and experience in person, are wiped away by conspiracies or buried in lies. We're encouraged to embrace absolute horrors like the Metaverse instead of paying attention to reality. Knowing and understanding the lives of plants is what our Pleistocene mind is designed to do, and we ignore the real world at the potential risk of our sanity.

— DEAN KUIPERS, Farmer, Journalist, co-founder of
Edible Gardens and Author of *The Deer Camp:*
A Memoir of a Father, a Family, and the Land that Healed Them

Jacob Jordaens · *The Triumph of Bacchus* · Belgium 1640–50 In Baroque style, Bacchus is depicted with plentiful grapevines which were synonymous with jubilance. He symbolized the liberator of the common people, rewarding them with wine to temporarily release them from their problems.

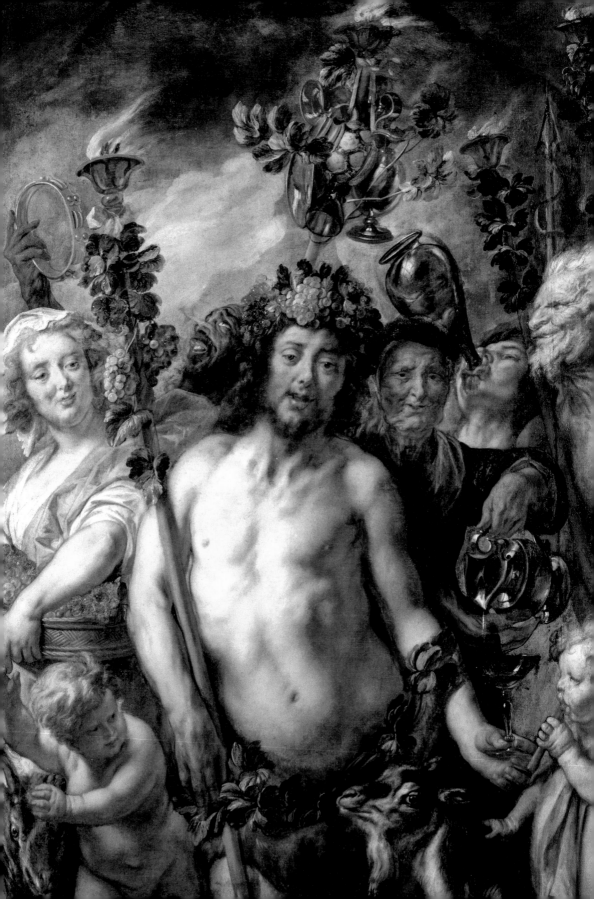

Cesar Boetis van Everdingen · *Bacchus with Two Nymphs and Amor* · Netherlands 1650–60 Flower crowns were worn at festivals for Bacchus, God of wine, to ease or prevent intoxication, as portrayed in Everdingen's early study of the notorious festival.

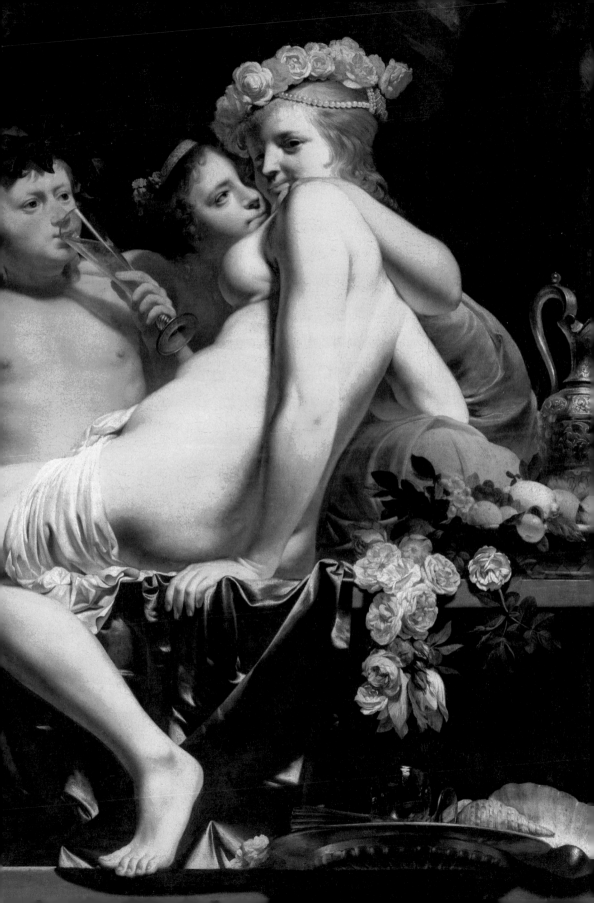

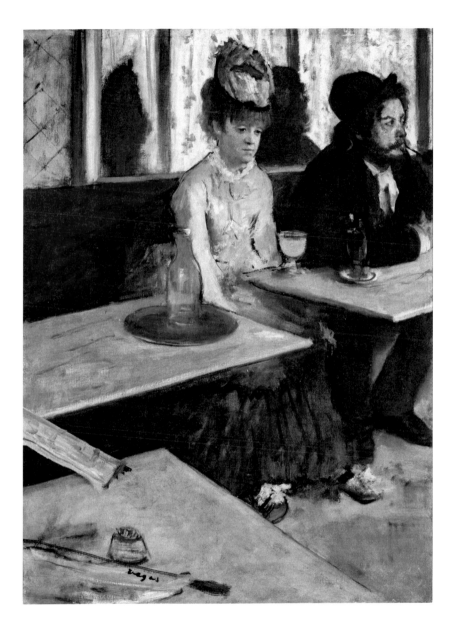

Edgar Degas · *Absinthe Drinker* · France · 1876
Drinking the intense herbal intoxicant in the Cafe
de la Nouvelle-Athènes in Paris, the painting was
thought to capture absinthe's downward spiral and
therefore was considered uncouth and morally
degrading.

Gabriel Metsu · *The Old Drinker* · Netherlands
1661–3 A jolly elderly man enjoys his beer and
pipe in this expressive portrait. Beer and mead
were common beverages in Europe of the late
Middle Ages.

Niko Pirosmani · *Woman with a Mug of Beer* · Russia
19th Century Beer, an elixir of hop flowers, barley,
and other grains, was a common subject for the
artist who earned his living making art for taverns
and pubs, until he died from hunger and cold
resulting from an alcohol ban in Georgia.

George Cruikshank · *Brewers Drayman* · England 1827 Horse-drawn wagons carrying beer to be delivered where driven by the drayman. The illustration comes from *The Gentleman's Pocket Magazine*.

(following pages) Tobias Stranover · *Parrots and Fruit with Other Birds and a Squirrel* · Germany 1710–24 A decadent tabletop landscape by the German artist represents prosperity, with the rare and exotic fruits and bird symbol of abundance and decadence.

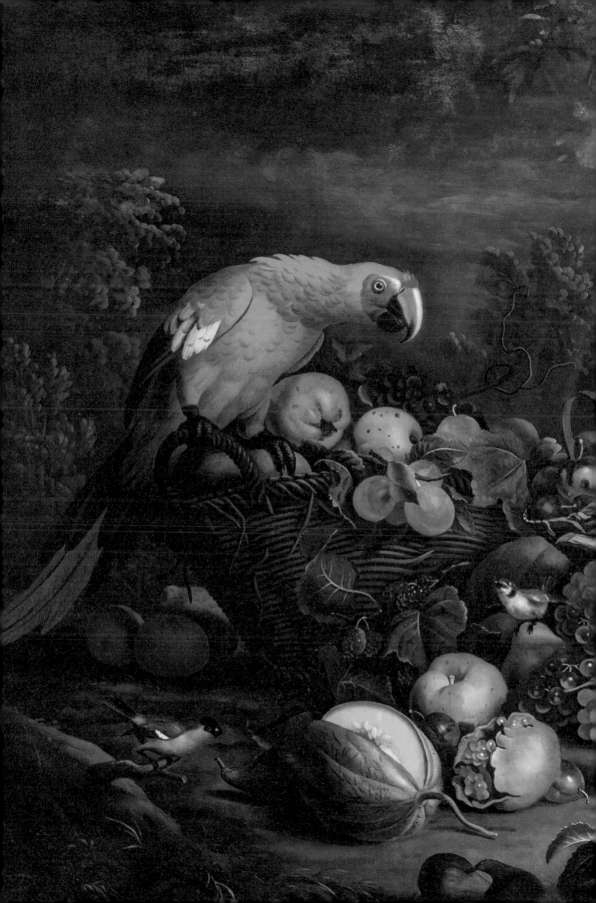

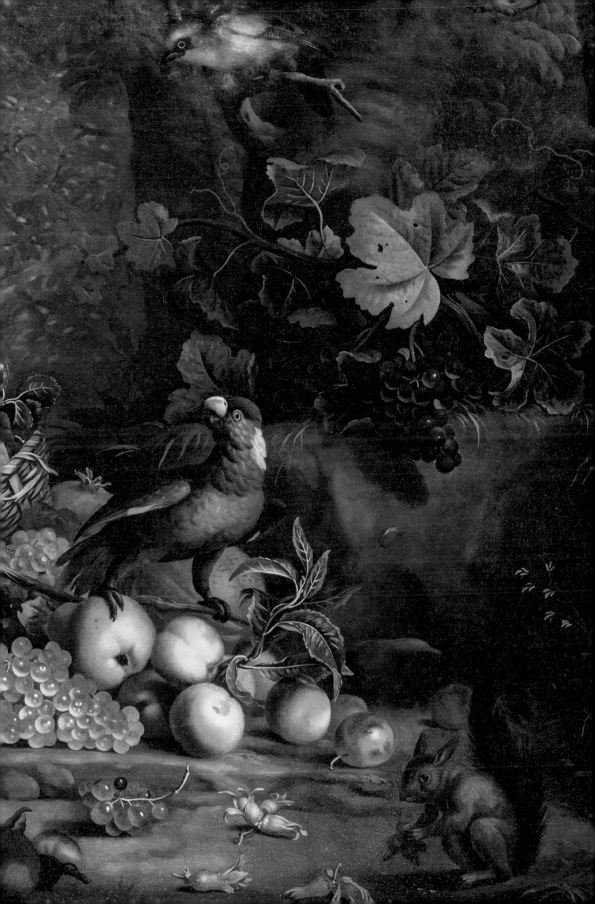

SOMA

Plants & The Expansion of Consciousness

I think of going to the grave without having a psychedelic experience is like going to the grave without ever having sex. It means that you never figured out what it is all about. The Mystery is in the body and the way the body works itself into nature.

— TERENCE M^cKENNA, Ethnobotanist, Mystic & Author,
from the lecture *Conversations on the Edge of Magic*, 1994

With its roots in the Greek words "psykhē" which means "mind" or "soul," and "dēloun" which translates to "reveal or make visible," the term "psychedelic" can be loosely defined as "manifesting the mind" or "making the soul visible." The word was first coined by the pioneering psychiatrist and researcher Humphry Osmond, who, in the late 1950s, conducted some of the first experiments with hallucinogens as potential therapy for mental illness. A friend of the novelist Aldous Huxley, Osmond conferred with the writer on a word to describe the effects of plant and mushroom-based psychoactives, eventually announcing the term, "psychedelic" at the New York Academy of Sciences in 1957. Although the word for visionary states may have been formed in the 20th century, ingesting sacred plants goes back to our earliest ancestral ceremonies. Hindu Vedic teachings mention a mysterious substance "Soma" as an important drink in certain spiritual rituals. In the Persian religion of Zoroastrianism, another unknown botanical, "Haoma" is praised as a divine plant. The ritualistic ingestion of psychoactives is particularly linked with an early, enigmatic festival known as the Eleusinian Mysteries. Held in secret, in Eleusis, an area north of Athens, Greece, this ancient celebration of the harvest included offerings to the Earth goddess Demeter, and many scholars believe its rites involved a psychedelic sacrament. In the book *The Road to Eleusis: Unveiling the Secret of the Mysteries*, co-authors R. Gordon Wasson, Albert Hoffman, and Carl A.P. Ruck suggested that this drug was likely ergot, a parasitic fungus (Claviceps purpurea) which grows on grains and contains psychoactive substances. Robert Graves, the English writer, and psychedelic pioneer, posited that the Mystery rituals may have involved the ingestion of psilocybin or "magic mushrooms." Regardless, it is widely believed that the festival at Eleusis centered around a botanical hallucinogen that offered participants transformative, cathartic visions. Of these famous but clandestine rites of Demeter, the Greek poet Pindar, living between 498–436 BCE wrote, "Blessed is he who has beheld the mysteries...He knows the aim; he knows the origin of life."

Agnes Pelton · *Star Gazer (detail)* · United States
1929 A transcendental act is revealed in Pelton's vision to merge the budding flower with cosmic energy, a true example of as above, so below.

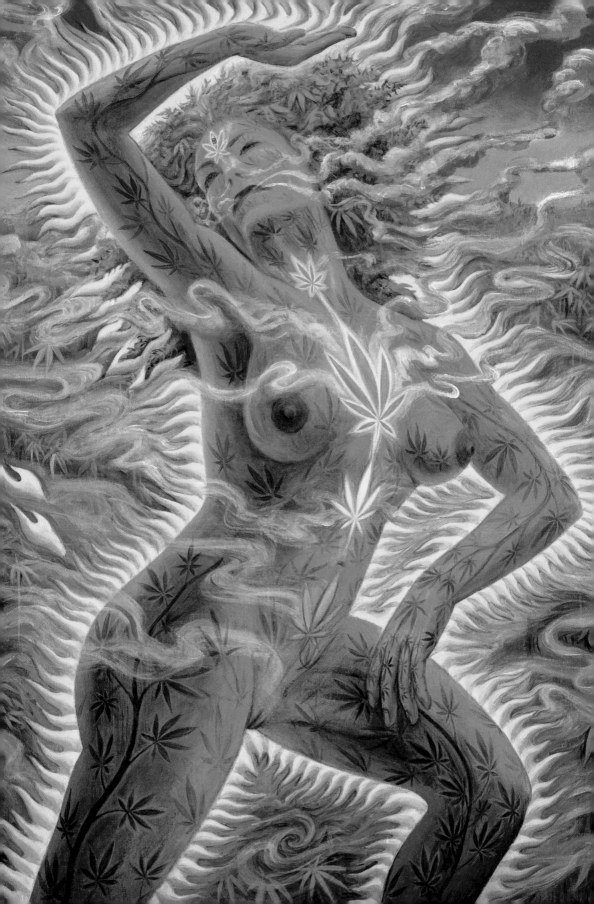

FAMILY
Cannabacae

ACTIVE COMPOUND
Tetrahydrocannabidiol

THC

CANNABIS

Cannabis indica
Cannabis sativa

EFFECTS
Euphoric
Serene
Aphrodisiacal

CULTURAL NAMES
Bhang · Doña Juanita
Ganja · Santa Hierba
Kerala Grass · La Santa Rosa
Siddhi · Zacate Chino

USAGE
Inhalation
Edible
Topical

COLLOQUIALISMS
Blaze · Bud · Cheeba
Collie · Flower · Ganja
Grass · Green · Kind
Mary Jane · Reefer
Rope · Sinsemilla · Skunk
Trees · Weed
Zoo-wee-mama

Cannabis

No other plant has been with humans as long as hemp. It is most certainly one of humanity's oldest cultural objects. Wherever it was known, it was considered a functional, healing, inebriating, and aphrodisiac plant. . . Through the centuries, myths have arisen about this mysterious plant and its divine powers.

— CHRISTIAN RÄTSCH, Anthropologist, Ethnobotanist & Author of
The Encyclopedia of Psychoactive Plants: Ethnopharmacology and Its Applications, 1998

The ritualistic use of cannabis is thought to have first evolved as a funerary rite, dried marijuana leaves set aflame in ancient tombs some 5000 years ago, an intoxicating smoke drifting from braziers as mourners grieved. Perhaps thousands of years prior, farmers across Central Asia are thought to have grown the first cannabis crops, harvesting hemp to make fiber, paper, and cloth. As a religious sacrament, it is generally believed that those following the early Persian faith of Zoroastrianism were among the first to embrace marijuana as a sacred ceremonial plant. In Hindu traditions, the ritual drinking of bhang, a beverage made from the leaves and stems of the cannabis plant, remains associated with Holi, the festival of spring. Over the centuries, cannabis has continued to be embraced by various cultures around the globe as both medicine and as a conduit into the mystical realm. The wandering Sadhu holy men of India and the Rastafari of Jamaica are two such examples. When asked about his use of marijuana, musician and Rastafarian Bob Marley once noted, "When you smoke the herb, it reveals you to yourself." One of the most popular forms of cannabis use consists of smoking or eating hashish, a substance processed from the resin of the marijuana plant. Linked to cultures throughout Central and South Asia, the Middle East, and North Africa — hash-making traditions are passed down through generations. In the late 19th century, the popularity of hashish use spread across Europe, introduced by Napoleon's armies returning from campaigns in Egypt. Hashish was embraced by bohemians and artists, most notably at the Club des Hashischins, a private salon in Paris frequented by some of the most successful literati of the era, William Butler Yeats, Charles Baudelaire, and Victor Hugo, as well as the poet Arthur Rimbaud and his lover, Paul Verlaine. After a visit to this "hashish-eaters" clubhouse, Yeats famously wrote of the experience; "It is absolute bliss. . . It is a calm and placid beatitude. Every philosophical problem is resolved. Every difficult question that presents a point of contention for theologians, and brings despair to thoughtful men, becomes clear and transparent. Every contradiction is reconciled. Man has surpassed the gods."

(previous page) Alex Grey · *Dance of Cannabia* United States · 2014 Cannabis and other plant medicines are often the subject of Alex Grey's intricate and visionary art. Drawing upon science, botany and sacred geometry, Grey imbues his works with overtones of psychedelia and mysticism.

Theodora Allen · *The Cosmic Garden I* · United States · 2016 A cannabis plant forms the framework for vision into a mystical botanical utopia, in the California artist's series of dream-like portal paintings.

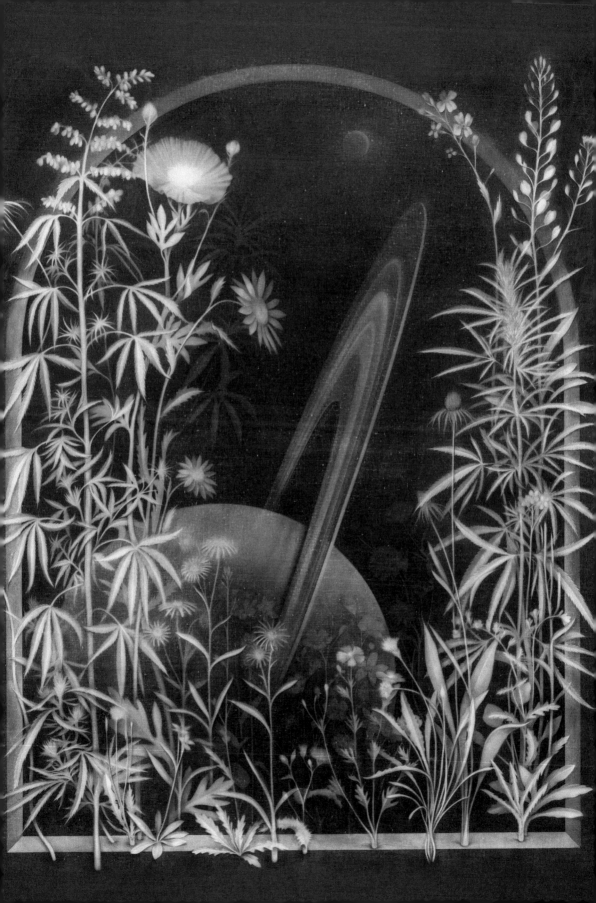

WES WILSON~MOUSE~KELLY~VICTOR MOSCOSO~RICK GRIFFIN

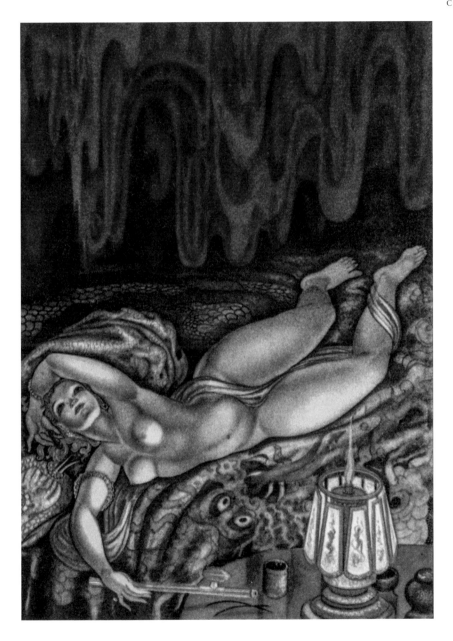

Rick Griffin · *Joint Show* · United States · 1967
A prolific comic and album art illustrator Griffin
was known for his psychedelic imagery depicting
surf and music counterculture of the era. Here
he celebrates the origins of cannabis in a playful
poster art piece.

Mario Labocetta · *I was in a state of langour* · Italy
1933 In *Artificial Paradises*, Charles Baudelaire
wrote about his adventures with opium and hashish,
expounding the dreamlike visions he experienced
during narcotic states, as is imagined in lithograph.

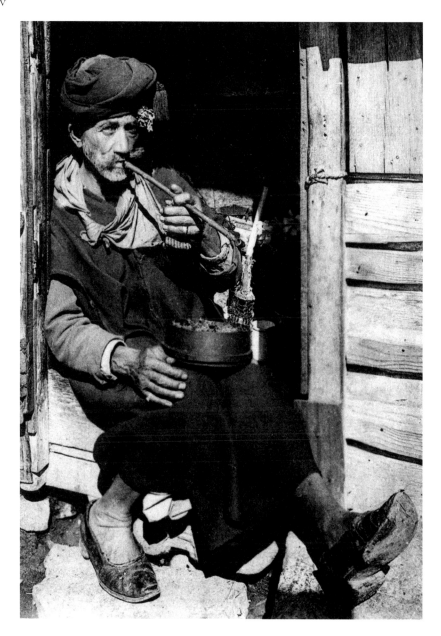

Unknown · *Kief Smoker* · Algeria · 1900 Kief is the resin of cannabis, accumulated in containers or hand-sifted from loose dry buds to be made into hashish.

Unknown · *Allen Ginsberg* · United States · 1965 The American beat poet, with a group of demonstrators at the Women's House of Detention in Greenwich Village, calls for the release of prisoners arrested for use or possession of marijuana.

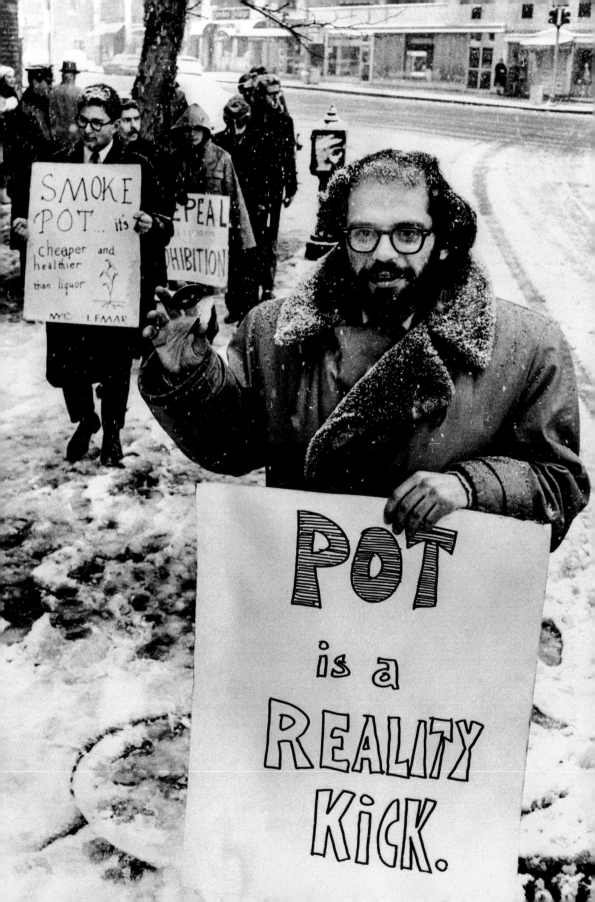

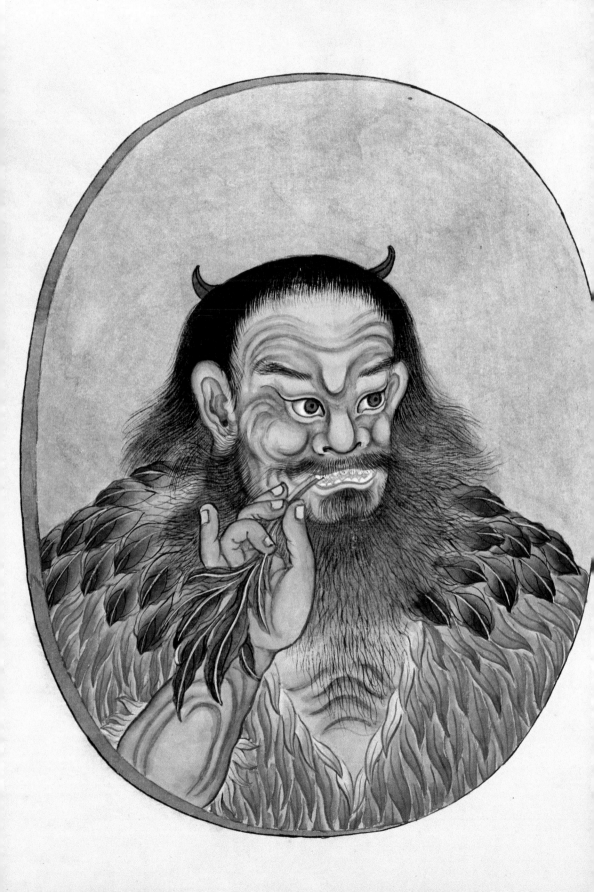

When we started the DoubleBlind platform, the current psychedelic renaissance was already somewhat in effect. Part of our goal was to re-envision how people think of psychedelics, explore the stereotypes, the aesthetics, the stories. We wanted to expand upon and give more of a kaleidoscopic image of the psychedelic experience and try break outside the stereotypes. We have had the opportunity to dig into the depths of this culture and interview people from indigenous backgrounds or see where psychedelics intersect with a culture or with people from all different types of cultures. We're using psychedelics as a jumping off point to explore other things like social equity, or environmental justice, or spirituality, or sexuality, or science, and policy, and culture. This is part of the ethos of the medicines themselves. When you're under the influence, you're not having a self-referential experience, but you're often actually thinking much more expansively, you're considering everything else in the world. And the experience may cause you to think differently about these things. I would hope that our approach to journalism is a reflection of that kind of psychedelic experience. We focus on storytelling that is not just talking about psychedelics, but how our experiences with these plant medicines can influence systems that are part of the larger collective ecosystem.

— MADISON MARGOLIN, Journalist, Co-founder & Editorial director of
media and education platform, DoubleBlind

Unknown · *The Legendary Emperor Shen-Nung* · China
18th Century A figure said to be the founder of
Chinese Medicine; Shen-Nung is reputed to have
documented the uses of hundreds of healing plants
and to have discovered the medicinal and thera-
peutic benefits of cannabis.

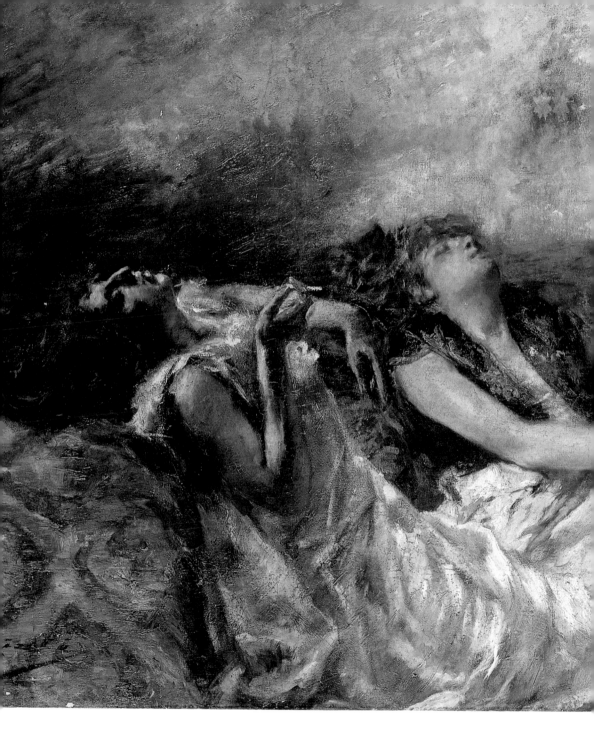

Gaetano Previati · *Hashish (The Hashish Smokers)*
Italy · 1887 In this lushly sensual oil painting
a group of female hashish smokers luxuriate
in a state of blissful euphoria after smoking the
cannabis-based resin.

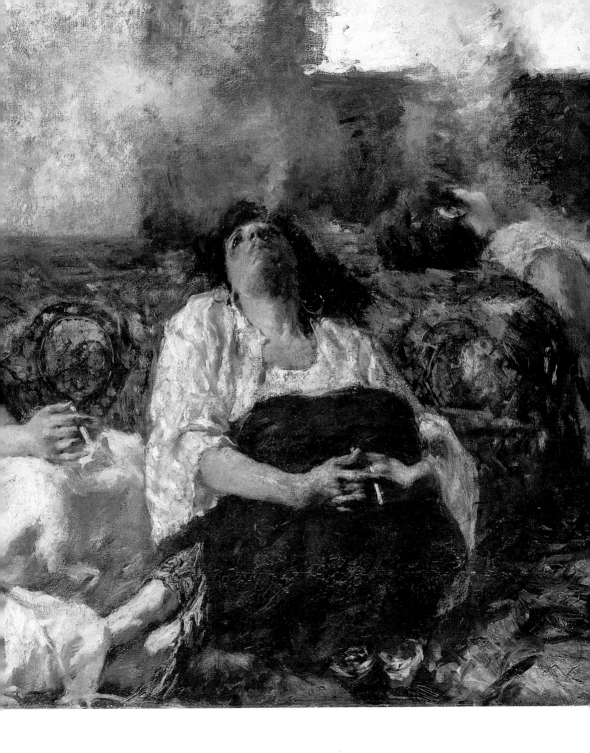

341

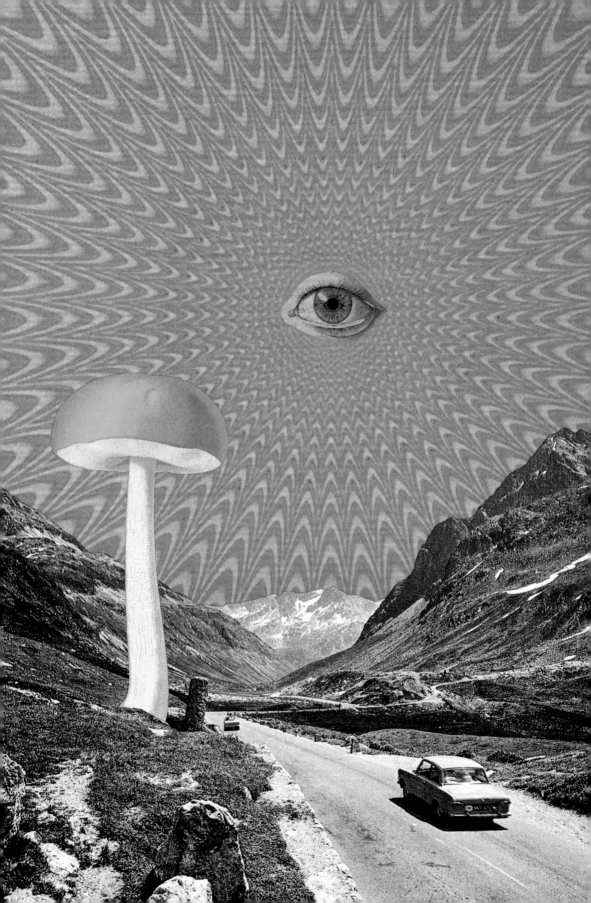

Agariceae
Amanitae
Psilocybe
Strophariaceae

Psylocibin
Psylocin
Imbolic Acid
Muscimol

PSILOCYBIN

MAGIC FUNGI

Amanita muscaria
Psilocybe azurescens
Psilocybe cubensis
Stropharia cubensis
(and other species)

EFFECTS
Hallucinogenic
Sense of Awe
Strong Visions
Shamanic Characteristics

CULTURAL NAMES
Äh kib lu'um · Aka-haetori
Flugsvamp · Fly Agaric
Ha-ma chün · Itzel ocox

Azureus-kahlkopf · Blue Runner
Flying Saucer Mushroom
Düngerling · Pixie Cap · Witch Cap
Teotlaquilnanácatl

USAGE
Edible
Inhalation
Fermented

COLLOQUIALISMS
Blue Meanies · Boomers
Divine Dung Mushroom
Golden Cap · Penis Envy

Magic Mushrooms

Psilocybin seems to me to be some sort of psychic godsend.

— ALLEN GINSBURG, in a letter to Dr. Timothy Leary, 1961

Psilocybin mushrooms, with their hallucinogenic and visionary qualities, have been used by indigenous cultures around the globe as a means of divination and as a method of attaining access to the spirit realm. Perhaps the earliest evidence of ritualistic use can be traced to rock paintings depicting the species discovered in Australia and dating back to 10,000 BCE. In early Mesoamerica, statues of mushroom deities have been uncovered that may have been carved as early as 200 BCE. The consumption of these "magic" mushrooms for medicinal and transformational purposes has been documented in nearly every region on the planet, hallucinogenic mushrooms central to the pagan rites of the Vikings as well as to early Siberian tribes and the ancient Mayan and Aztec peoples of South America. The latter named these potent psychedelic mushroom species, "Teonanacatl," which translates roughly to "flesh of the gods." The American ethnobotanists Terence and Dennis McKenna's, "Stoned Ape Theory," explored in their 1992 book *Food of the Gods*, suggests that the effects of eating magic mushrooms may have helped to usher prehistoric humans into modern consciousness. The ingestion of mushrooms within contemporary Western culture can be linked directly to a 1957 article in *Life* magazine titled "Seeking the Magic Mushroom" in which American businessman and amateur mycologist Robert Gordon Wasson documented his participation in a traditional mushroom ceremony lead by the Mazatec shaman and curandera Maria Sabina. The article resulted in a mass pilgrimage to Sabina's tiny village, scientists, researchers, and counterculture creatives flocking to Mexico to receive her magic mushroom medicine. Sabina would ultimately lament offering Wasson entry, but Pandora's (or rather Psilocybe's) Box had been opened and the world would never be the same. Wasson would take samples of the magic mushrooms to Europe, where, in 1958, the Swiss chemist Albert Hofmann — creator of lysergic acid, better known as L.S.D. — would isolate and synthesize the mushroom's active ingredient. Not long after, Harvard professors Dr. Richard Alpert (Ram Dass) and Dr. Timothy Leary began using Hofmann's brew in their now legendary, "Harvard Psilocybin Project" and with that — the psychedelic era, ignited by Leary's oft-cited, mantra, "turn on, tune in, drop out" — officially began.

(previous page) **Mariano Peccinetti · *Mushroom Day*** **Argentina · 2020** One in a series of vividly psychedelic collage pieces, *Mushroom Day* celebrated the potent and transformative effects of hallucinogenic mushrooms.

Alex Grey · *Flesh of the Gods* · United States · 2021 Multidisiplinary artist Alex Grey creates visionary works drawing on his personal experience with plant medicines. In this vivid homage to magic mushrooms, Grey references the name first given to Psilocybin in ancient Mesoamerican cultures.

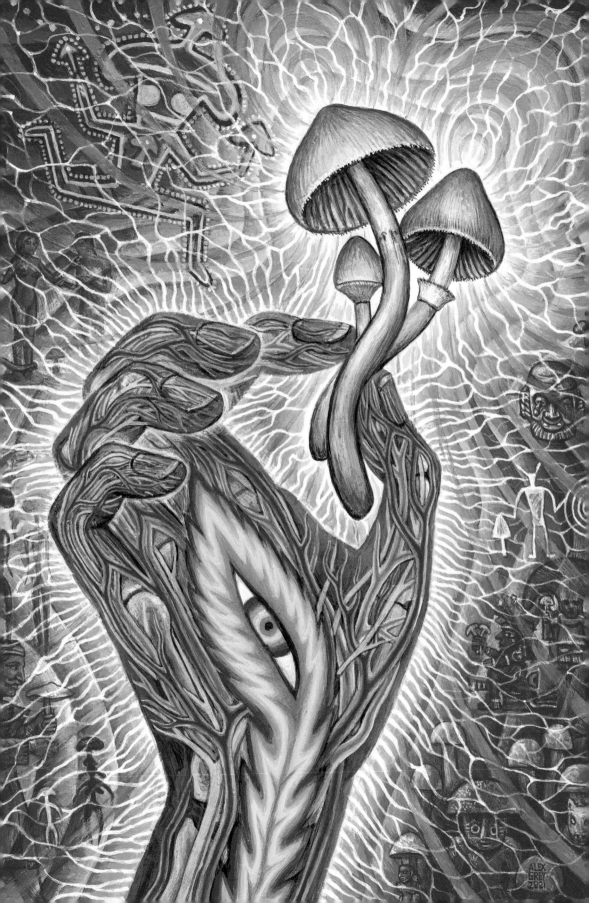

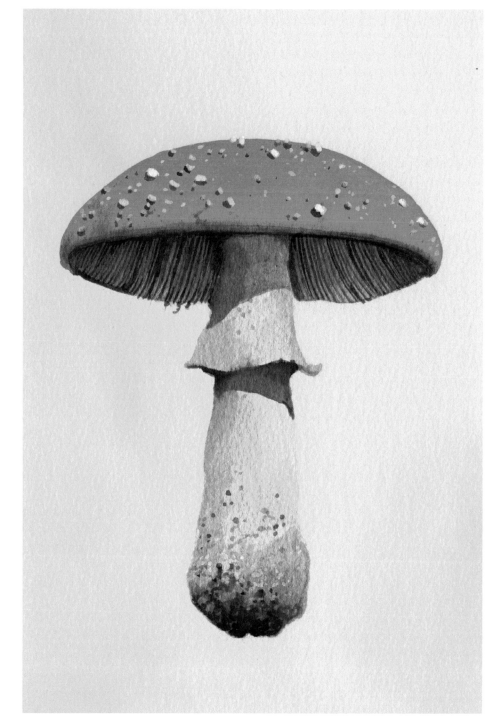

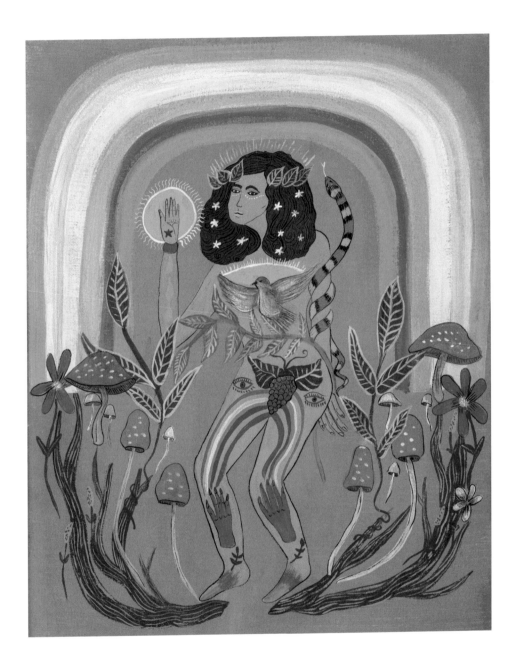

Arik Roper · *Amanita Muscaria* · United States 2009 A finely detailed illustration from the artist's extensive series titled, "Visual Codex of Psychoactive Mushrooms," documenting several species of psychedelic fungi.

Meagan Boyd · *Giuliana the Fungi Goddess* · United States · 2021 This painting by the California-based artist offers a visionary take on organic psychedelic substances, featuring Amanita Muscaria and various psilocybin mushrooms.

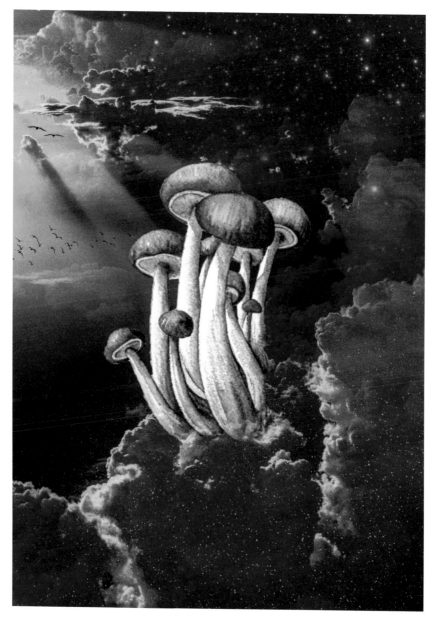

(following pages)
Arrington de Dionyso
Amanita Crows · United
States · 2020
The multimedia creator
and musician often
produce their work
through, "high dose
ceremonies with psilo-
cybin mushrooms. Not
'integrating' the expe-
rience or reflecting on
it afterwards, but while
in a state of expanded
consciousness in which
I am able to tune into
messaging from a
realm of spirits beyond
the normal human
experience."

Daniel Meijome · *La Vida Secreta de las Plantas*
Argentina · 2021 Working in collage and other
creative mediums, Meijome draws inspiration from,
"spirituality and love of nature and the plant world.
I believe that nature is a path to spirituality."

Nicole Nadeau · *The Golden Teacher* · United States
2021 By making the organic encapsulated material
eternal, Nadeau displays its powerful, secretive,
seductive nature. Nadeau's book of the same name
comprises artworks and short stories from years of
experimentation with psilocybin (golden teachers).

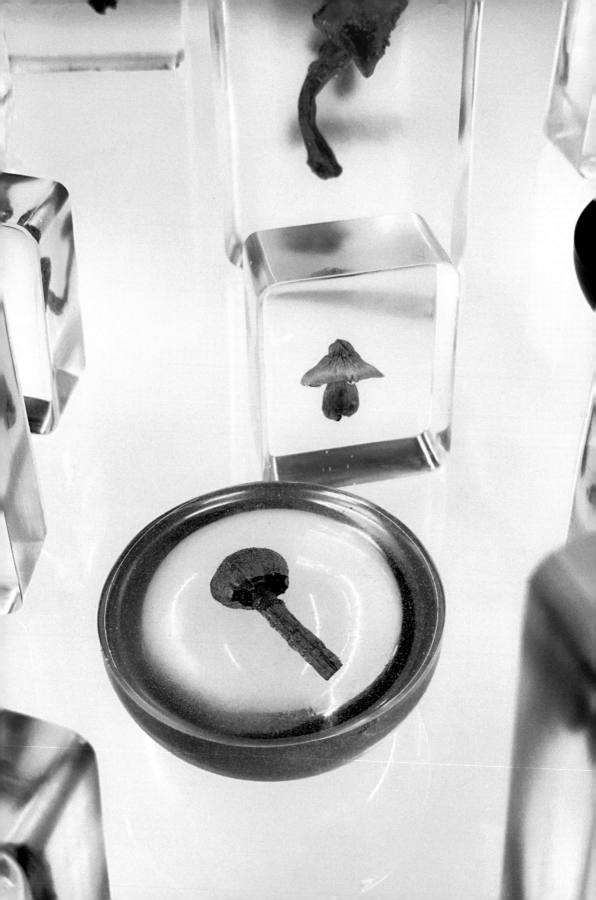

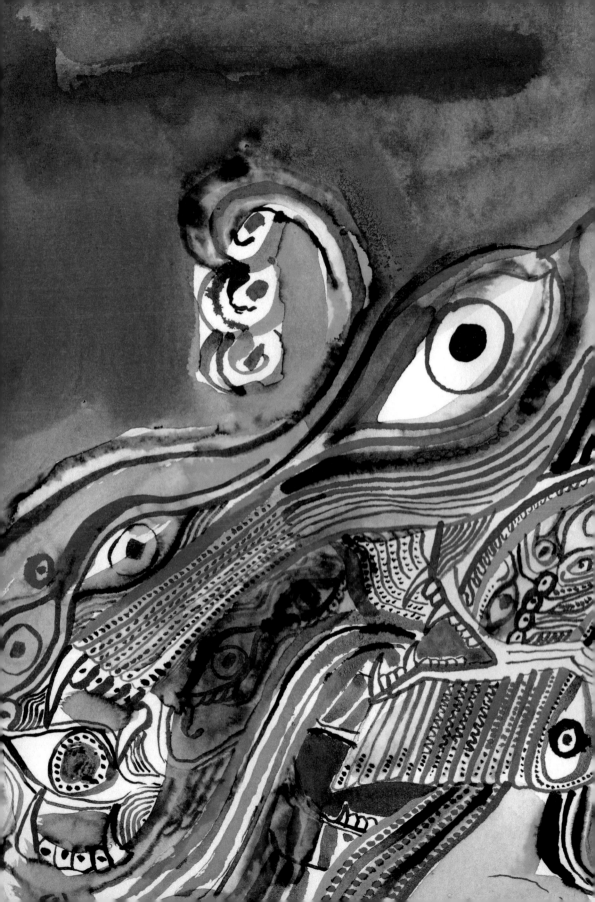

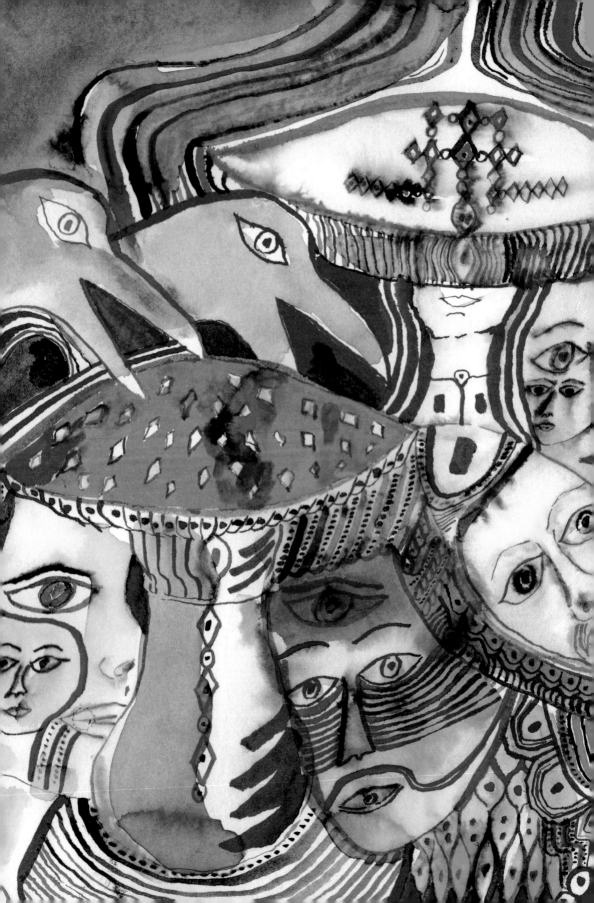

I had the idea for the DoubleBlind platform when I was meditating, but my co-founder Madison and I had both been already writing about psychedelics and plant medicines in cannabis for a number of publications. We also were both on our own personal journeys with psychedelics and knew a lot of people within the psychedelic space. What we were observing is that there were a lot of nuanced conversations happening around the growth of the psychedelic industry and the psychedelic movement. But we weren't seeing a lot of the more nuanced conversations that were happening in the realm of academia and business making their way into mainstream media. And so, for us, we were interested in finding ways of introducing these conversations to the mainstream. I think that in the Western community, we have a lot of ideas around psychedelics that probably do come from the "Free love" 1960s and 1970s era. And in some ways, this is projection of our own cultural framework around what the purpose of these plants quote "should be." I think Madison and I are aligned in believing that plant medicines, psychedelics, are about much more than individual healing. We wanted to explore bringing in a lot of other kinds of modalities and cultures that give reverence to the fact that these medicines are so much more dimensional than we are allowing them to be within the Western medical paradigm.

— SHELBY HARTMAN, Journalist, Co-founder & Editorial director of media company and education platform, DoubleBlind

Luke Brown · *Xōchipilli* · Canada · 2019 The visionary artist Brown creates work that is, as they explain, "direct translations of his personal experiences of heightened inner-vision." Here his explorations feature the figurative totem associated with the Aztec god of flowers and fungi, Xōchipilli.

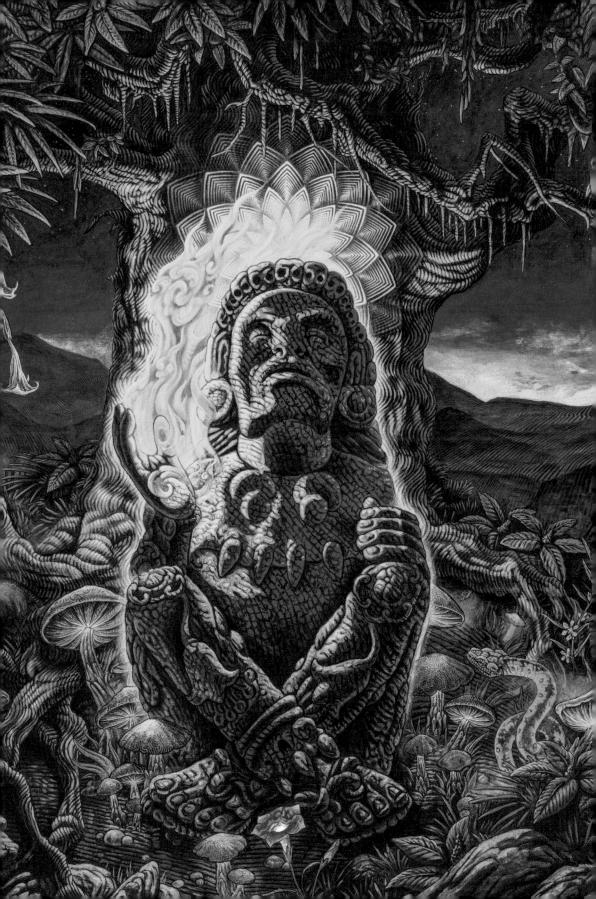

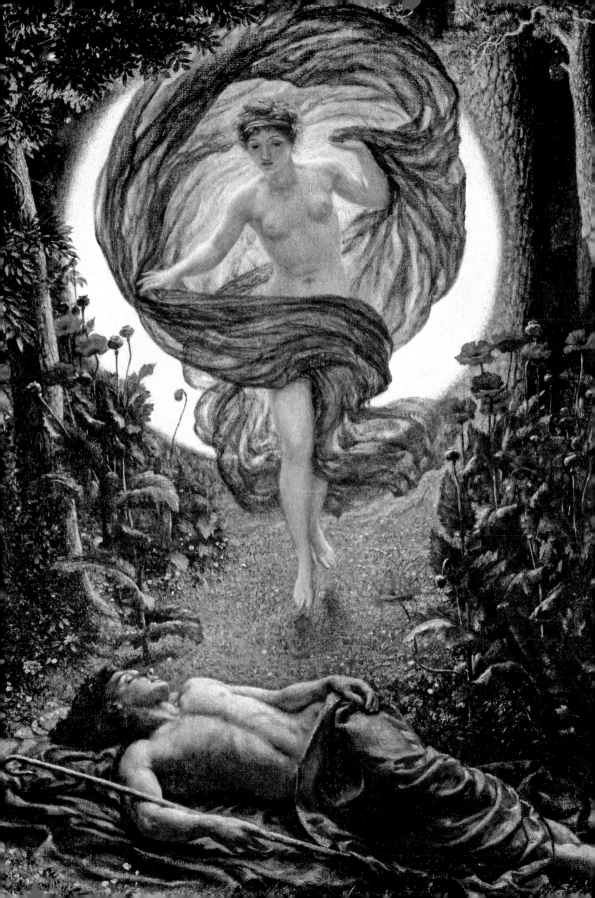

MORPHINE

OPIUM

Papaver Somniferum
Papaver Rhoeas
Papaver Officianalis

EFFECTS

Sedative / Hypnotic
Blissfulness
Ecstasy

CULTURAL NAMES

Adormidera · Affion
Black Poppy
Pôst-a-kûknâr
Milk of Poppies · Misri

USAGE

Edible
Inhalation
Injected

COLLOQUIALISMS

Auntie Em · Black
Chocolate
God's Medicine
Midnight Oil · O
Tar
The Dragon

Opium

Weave a circle round him thrice,
And close your eyes with holy dread
For he on honey-dew hath fed,
And drunk the milk of Paradise."

— SAMUEL TAYLOR COLERIDGE, an excerpt from the poem
Kubla Khan (Or, a vision in a dream. A Fragment), 1816

Poppy, long a symbol of sleep, death, and the underworld, has most likely been domesticated by humans since sometime between 6000 and 3500 BCE. Embraced as a medicine for its sedative qualities in early Sumerian and Egypt cultures, the seeds and oils from the plant contain morphine and codeine, opiates prized by healers for their ability to induce sleep and reduce pain. A powerful narcotic, the poppy plant was a frequent mention in ancient botanical texts such as *Ebers Papyrus* and within the writings of the famed Greek botanist and physician Dioscorides. Its ritual use as an offering and sacrament can also be traced back to the earliest religions, the poppy associated with the powerful Egyptian deity Thoth, god of wisdom, as well as Hypnos, the Greek god of sleep. Depictions of the flower have been discovered ornamenting early Egyptian jewelry, decorating the statues of Greek and Roman gods, and carved onto tombs — the poppy seen as a fitting offering to the dead. The first distillation of the poppy plant into the drug known as opium is credited to the Swiss Renaissance physician Paracelsus.

A highly addictive substance, opium immediately became a sought-after cure-all and was used both medicinally and recreationally across Europe. In 19th century England, opium became a major import from countries such as Egypt and Turkey and in the form of the tincture Laudanum, became the drug of choice for many of the British creatives and bohemians of the era, embraced for inducing euphoric and trance-like states. Opium-use is particularly linked to the Romantic Movement in literature and the writings of poets such as Lord Byron and Percy Bysshe Shelly. One of the most famous literary odes to the drug was published by the writer Thomas De Quincey in 1882. The latter's *Confessions of an English Opium-Eater* explores the author's obsession with opium, "Not the opium-eater, but the opium, is the true hero of the tale," he writes, "and the legitimate centre on which the interest revolves." Opium is also thought to have inspired Romantic poet Samuel Taylor Coleridge's visionary epic, *Kubla Khan*, a mystical narrative in which the writer takes us on a feverish journey to, "A savage place! as holy and enchanted."

(previous page) **Edward John Poynter** · *The Vision of Endymion* · **England** · 1902 In the mythological scene, poppies give hints to Endymion's perpetual trance sleep, and his ability to have mystical meetings with Selene, Goddess of the moon.

Daniel Meijome · *Ishwara* · **Argentina** · 2021
Meijome often explores themes of plant medicine in his work. As he explains, "plants (and fungi) can help to achieve spiritual vision. Giving eyes to plants is to me a way of representation of this spiritual sight, and the fact that the plant universe has consciousness."

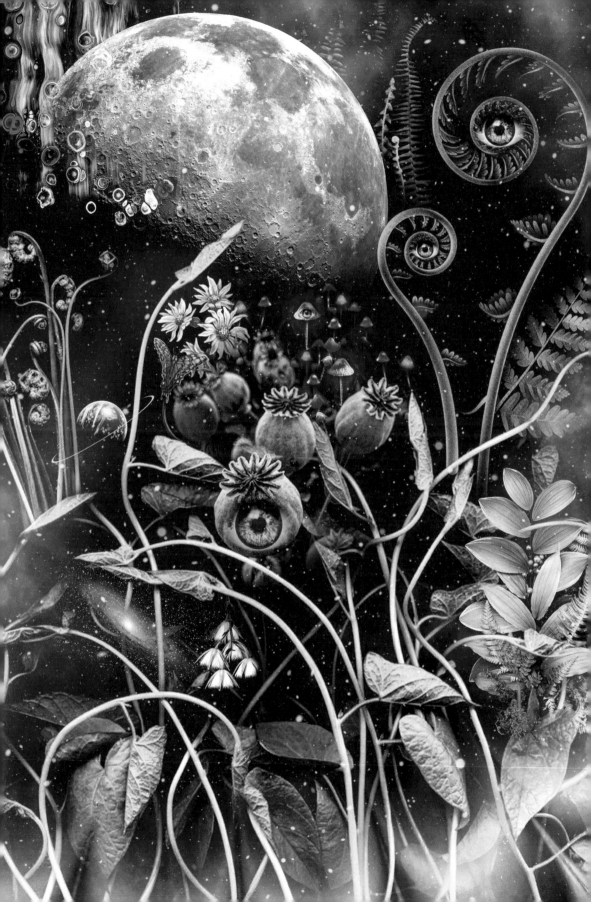

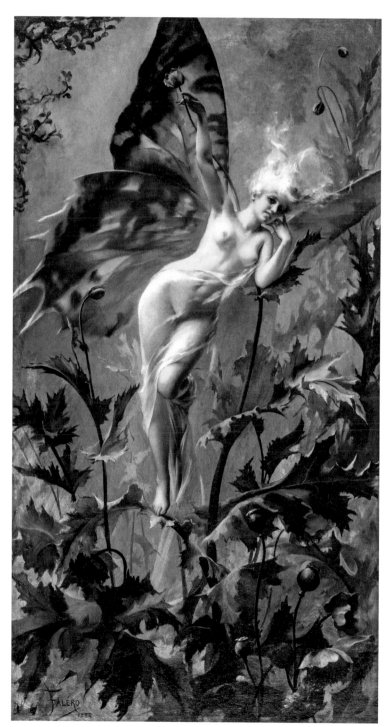

Luis Ricardo Falero
Femme Papillon · Spain
1888 The sensual work
of Spanish artist Falero
often explores the
feminine form in unex-
pected and fantastical
settings. His poppy
fairy is one of a series
of whimsical works
featuring fairy women
associated with various
flowers and plants.

Victor Prouvé
Opium · France · 1894
An Art Nouveau painter,
sculptor, and engraver,
Prouvé often explored
nature and plant
themes in his prolific
work across mediums.

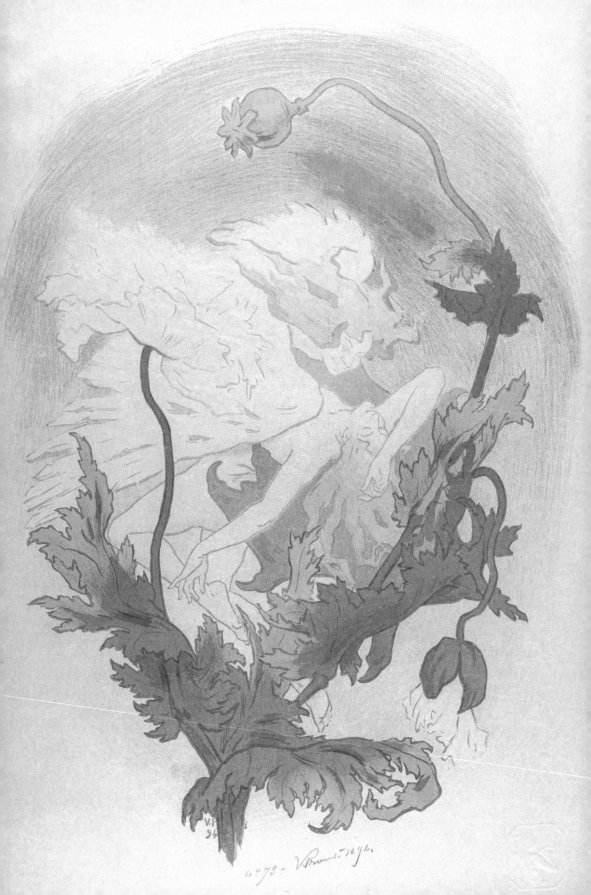

Arthur Henry Church
Papaver somniferum
(Opium Poppy)
England · 1905 The
beautiful poppy was
first discovered as a
pain reliever in the 7th
century. From opium
to morphine to heroin,
what was once consid-
ered a wonder drug
has become an
unfortunate, world-wide
addiction dilemma.

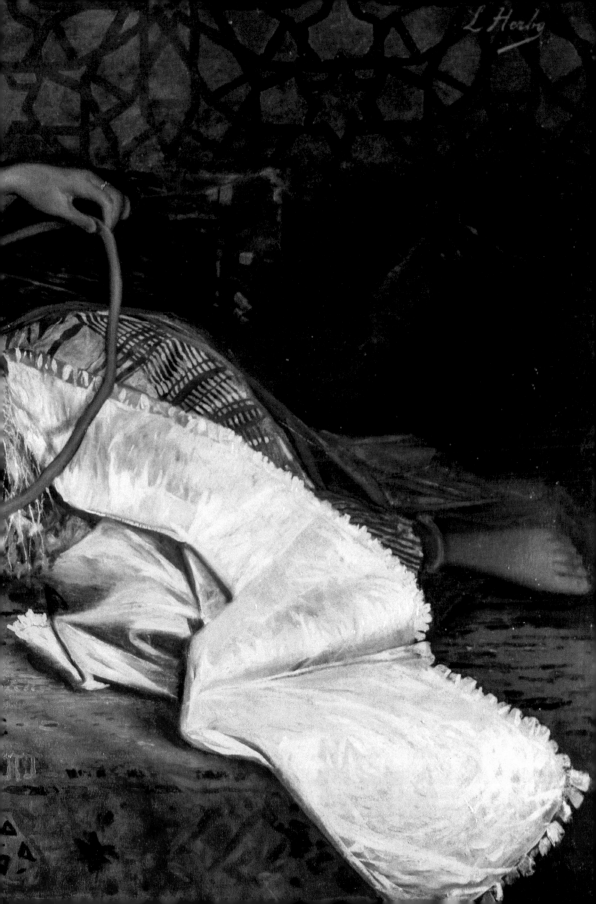

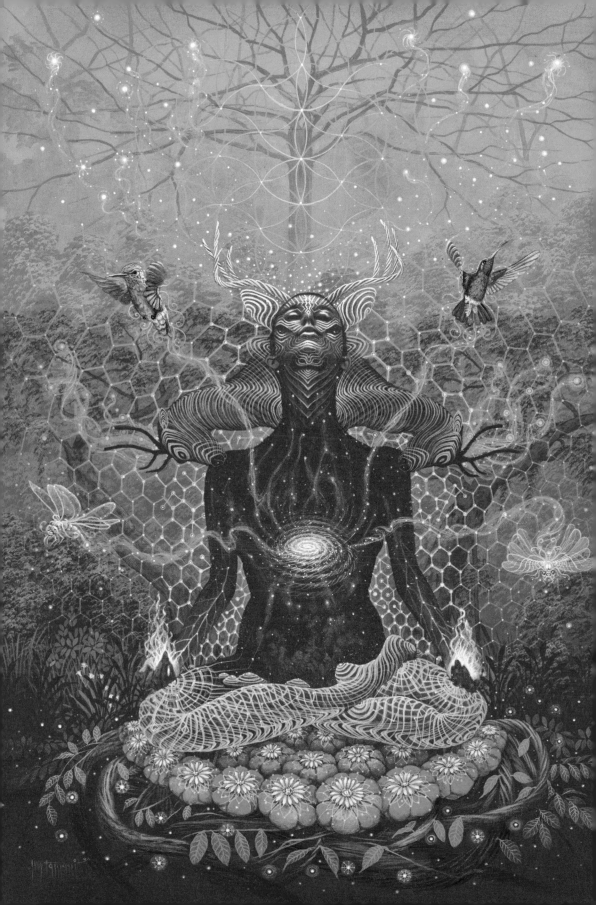

MESCALINE

CACTI

Lophophora williamsii
Trichocereus pachanoi

EFFECTS
Hallucinogenic
Healing
Visionary

CULTURAL NAMES
Azee · Dumpling Cactus
Jicule · Medicine of God
Mescalito · Peyote
White Mule

Achuma · Aguacolla
Alucinógena · Gigantón
Huachuma · Sampedro
San Pedro Cactus

USAGE
Edible
Brewed
Dried · Powdered

COLLOQUIALISMS
Green Button · Half Moon
Hikori · Shaman · Big Chief

Peyote & San Pedro

In consciousness dwells the wondrous, with it, man attains the realm beyond the material, and the Peyote tells us where to find it.

— ANTONIN ARTAUD, actor, poet, playwright – excerpt from *The Peyote Dance*, 1976

The psychoactive compound of mescaline – found in both the San Pedro cactus of South America and the Peyote cactus of Mexico and the Southwestern U.S. – has been used for at least the last 8000 years in visionary rites and rituals and as a potent medicine in traditional healing modalities. Rooted in the Nahuatl word "mezcalli" the mescaline is thought to be a conduit between worlds and both the cacti containing the substance have been embraced as sacred plants in numerous indigenous cultures. Written documentation of its use goes back to 1560, when Spanish priest Bernardino de Sahagún wrote in his expansive *The General History of the Things of New Spain*, of complex Aztec peyote ceremonies. Archeological evidence can be traced back to ancient carvings of a figure holding a San Pedro, thought to have been created by the Chavin artisans who flourished in Péru between 1200 and 200 BCE. Archeologists have also uncovered preserved peyote effigies in the Shumla caves along the Rio Grande dating back as early as 4000 BCE. In the late 19th century, the use of psychoactive cactus was documented by the physician Havelock Ellis, who is thought to be responsible for introducing mescaline to the Western world in his 1898 essay, *Mescal: A New Artificial Paradise*. The paper details his research into indigenous ceremonies as well as his own personal experience after ingesting peyote. Throughout the century following Ellis' publication, countless ethnobotanists, artists, and seekers of all sorts would follow suit. In their expansive 1979 book, *Plants of the Gods*, scholars Albert Hofmann, Richard Evans Schultes, and Christian Rätsch, PhD describe the sacred peyote rituals of Native American tribes and the enduring importance of the plant in both medicinal and spiritual healing. "Peyote eaten in ceremony has assumed the role of a sacrament in part because of its biological activity: the sense of well-being that it induces and the psychological effects (the chief of which is the kaleidoscopic play of richly colored visions) often experienced by those who indulge in its use. Peyote is considered sacred by Native Americans, a divine messenger enabling the individual to communicate with God without the medium of a priest. It is an earthly representative of God to many peyotists."

(previous page) Luis Tamani · *Luz Universal* · Perú 2015 A figure sits meditatively, surrounded by sacred peyote cacti. As the artist explains, the work is meant to encourage a reconnection, "To nature and to our own essence. We are all receptacles of the Universal Light."

Edward S. Curtis · *A Cheyenne Peyote Leader* · United States · 1927 Curtis spent much of his career traveling throughout North America documenting Native American tribes, one of the first Westerners ever to capture images of the indigenous peoples of the continent.

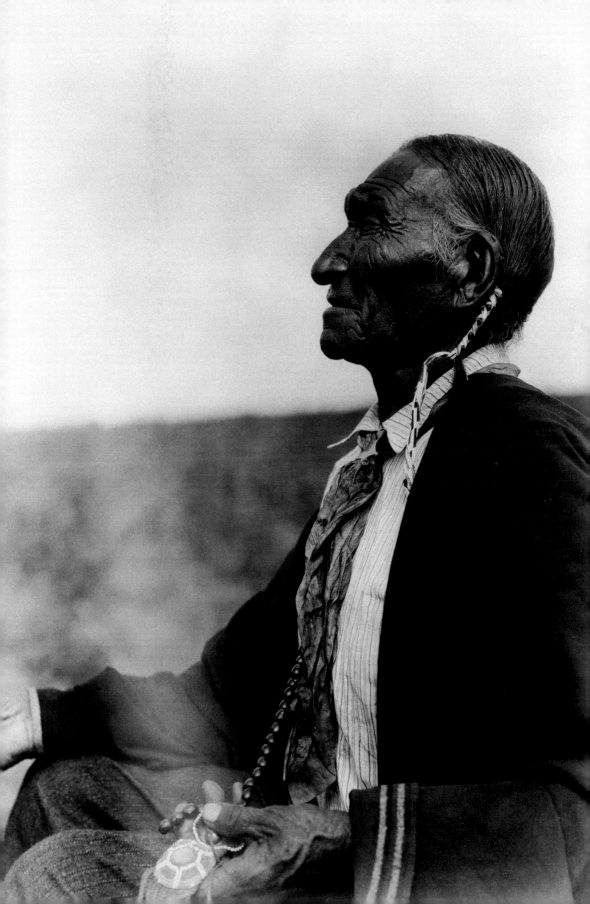

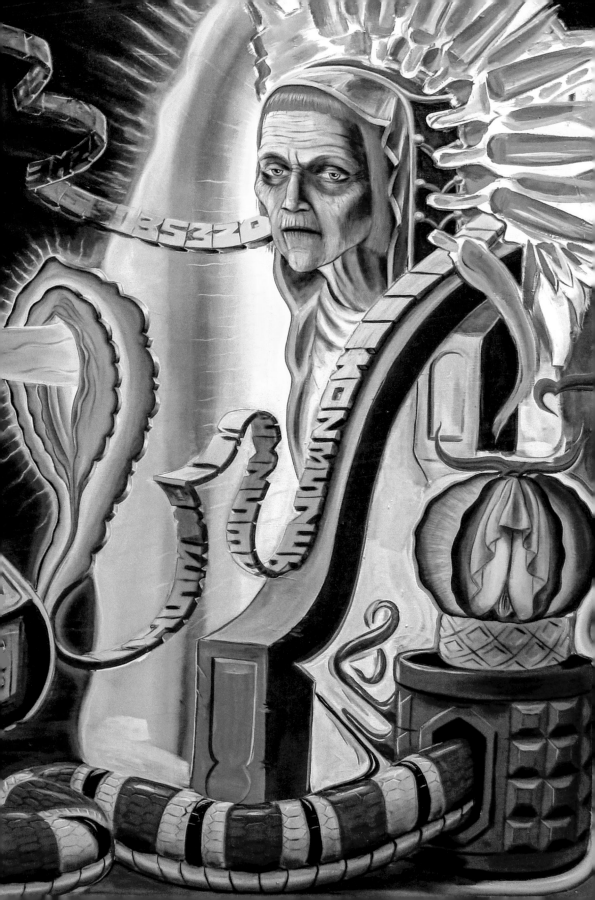

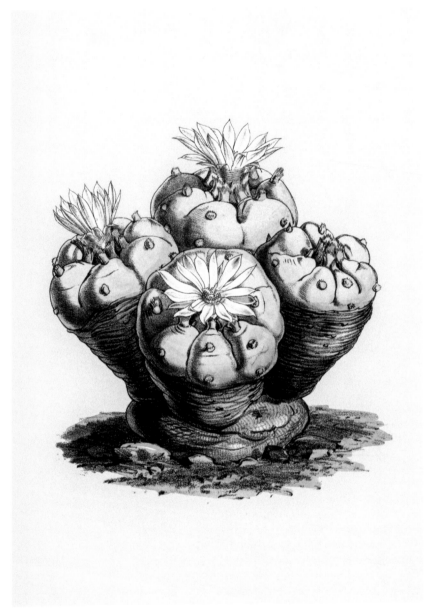

(previous pages) Jason Traeger · *Wisdom Teeth* United States · 2009 The visionary artist Traeger often explores modern mythologies in his psychedelic works. In describing the inspiration behind Wisdom Teeth, the artist states; "A cactus witch emerges from the Light of the Divine Feminine to subdue the Blind Penis Lizard of Progress."

Walter Fitch · *Peyote Cactus* · England · 1847 Hand-colored botanical illustration, drawn and lithographed from Sir William Jackson Hooker's *Curtis's Botanical Magazine.*

DRx · *Peyote Hawk* · United States · 2021 The multimedia and collage artist Darren Romanelli is known for his collaborative design, sculpture, and immersive work. His pieces frequently use found, recycled and vintage materials and often focus on the subject of psychedelia and plant medicines.

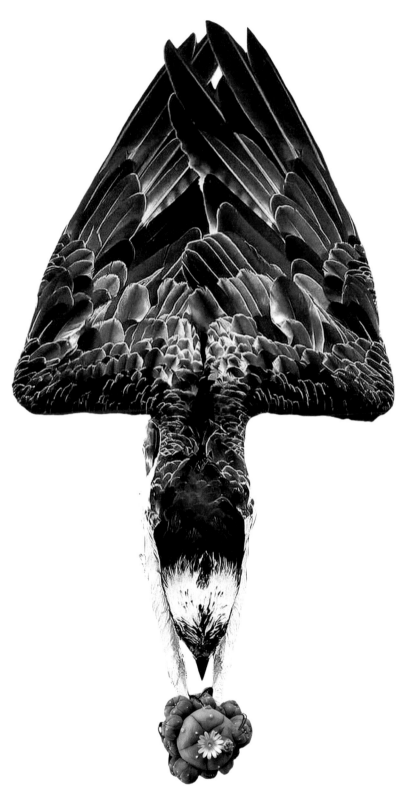

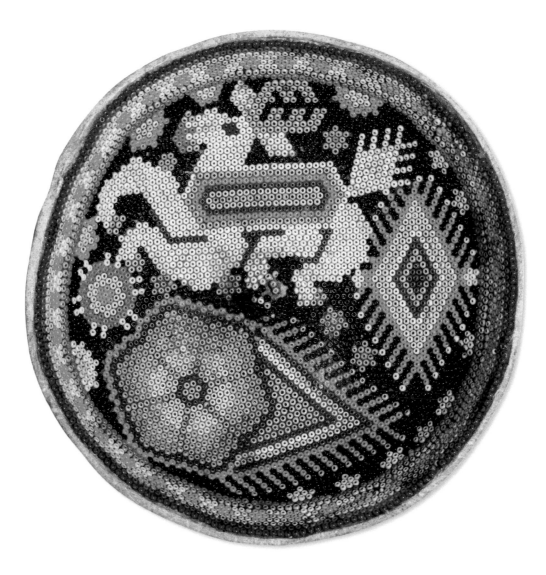

Unknown · *Huichol bowl* · Mexico · Unknown
A beautiful example of craftsmanship by the indige-
nous Huichol peoples of Central America. The
colors and patterns of traditional Huichol beading
are inspired in part through ceremonies with sacred
cacti such as peyote and San Pedro.

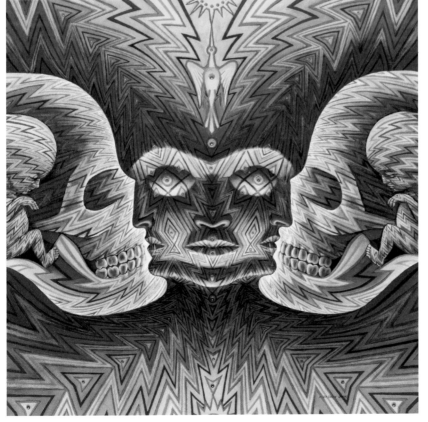

The Bautistas and The Ortiz Families *The Vochol* · Mexico 2010 Commissioned by Museo de Arte Popular in Mexico City, this elaborately beaded Volkswagen was created by hand by two indigenous Huichol families. The Huichol are renowned for their vibrant artwork, in part inspired by their traditional use of peyote. The images on the car represent various important aspects of Huichol deities and culture.

Alex Grey · *Peyote Being* United States · 2005 The visionary art of Alex Grey often explores and celebrates the transcendent effects of plant medicines. In this work, peyote becomes muse, a portal for accessing the subconscious and connecting with oneself.

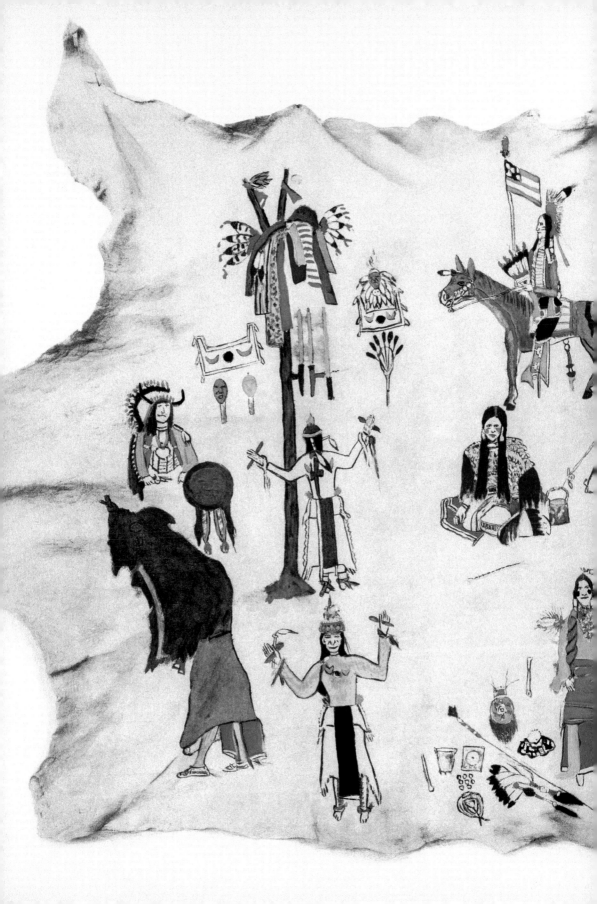

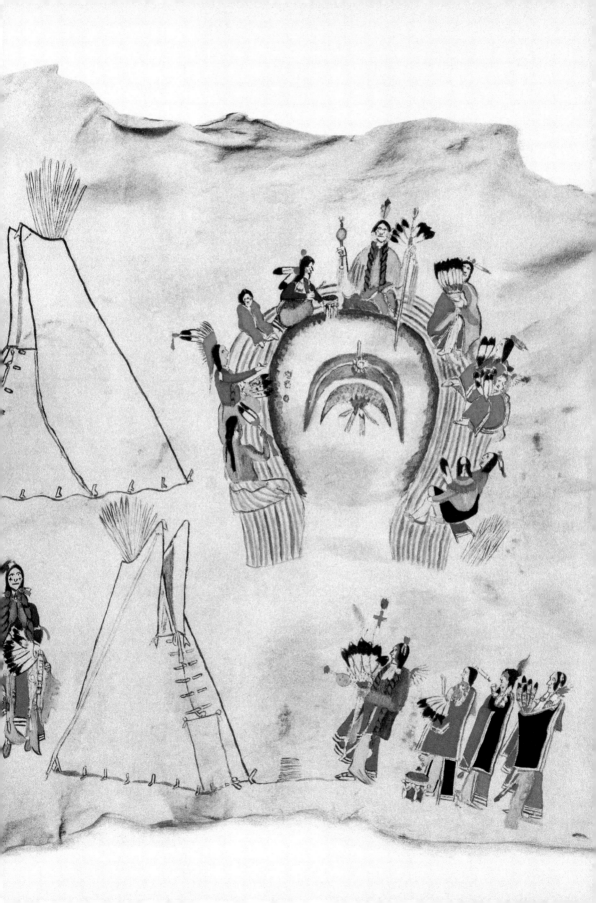

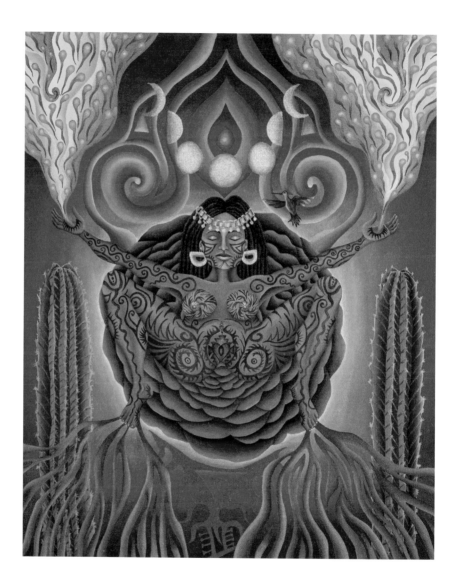

(previous pages) Silver Horn (Haun-goo-ah)
The Shoshone Sun Dance and the Peyote Cult · United
States · 1869 A replica of a deerskin painting of
ceremonial scenes depicts a peyote cult, a pole,
erected and decorated for the sun dance, and four
priests approaching a ritual tipi.

Mariela de la Paz · *Return of the Divine Feminine*
Chile/United States · 1998 This piece is inspired
by the artist's personal experience with plant medi-
cines, the image representing, as de la Paz explains,
"the feeling of the most complete surrender to the
higher planes of existence."

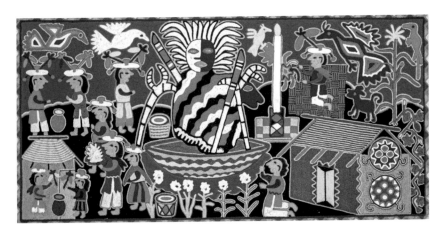

(above) Unknown · *Huichol yarn art* · Mexico
Unknown The traditional beaded, embroidered
yarn art of the Central American indigenous
Huichol peoples often depicts a cosmology based
on three entities: the deer, the corn, and the peyote.

(below) Unknown · *Peyote Rattle* · United States
Late 19th Century The peyote rattle is traditionally
used during Native North American ceremonies
where the sacred hallucinogenic cactus is ritually
ingested to induce visions.

My herbal path started as a young child and even in the womb with my mother who has been practicing herbalism my whole life. I was born on Earth Day. My mom was a hippie woman, and she was always studying and learning about plants, natural medicines, and healing modalities so my childhood was based around these things. As an adult my connection to nature and plants really helped me when I wanted to go deeper on the plant path. It started almost 20 years ago when I learned how to balance my hormones using herbs and I discovered that one plant could make my menstrual cycle regular. This fascinated me. My life took me traveling around the world and this is where I learned about how different cultures were using plants as medicine. While traveling and living abroad I was working with clients doing unique healing modalities for trauma and I would incorporate a regimen of diet and herbs to help assist with their healing. My mother introduced me to psilocybin a few years ago and it was this mushroom that has guided my entire vision, the creations, and everything I'm doing. The mushroom tells me what to make, how to make it and what people need. I believe we have forgotten who we are and where we came from. We are a part of Earth; we are the cells in the mother's body. The plants show us this very truth and help us heal, help us to remember and help us to feel alive again after being numbed from our over stimulated society. Nothing has helped me heal more than the medicine of the plants. I was in therapy for most of my adult life and tried every healing modality and guru out there and it wasn't until I ate the mushroom when I found the healing. I feel like we are at the cutting edge of something so magical, to finally understand the plant and Fungi world. All we have to do is listen.

— TIANA GRIEGO, Artist, Herbalist, Medicine Maker,
and founder of Stardust Apothecary

Alfredo Ramos Martinez · *Reina Xóchitl (Xóchitl Queen)* · Mexico · 1900s One of the founding fathers of modern Mexican art, Martinez often explored the country's cultural legacy in his work.

In this homage to the Aztec deity Xochiquetzal, she holds the bloom of a San Pedro cactus. Xochiquetza was considered the goddess of flowers, love, pleasure, and beauty and a patron of artists.

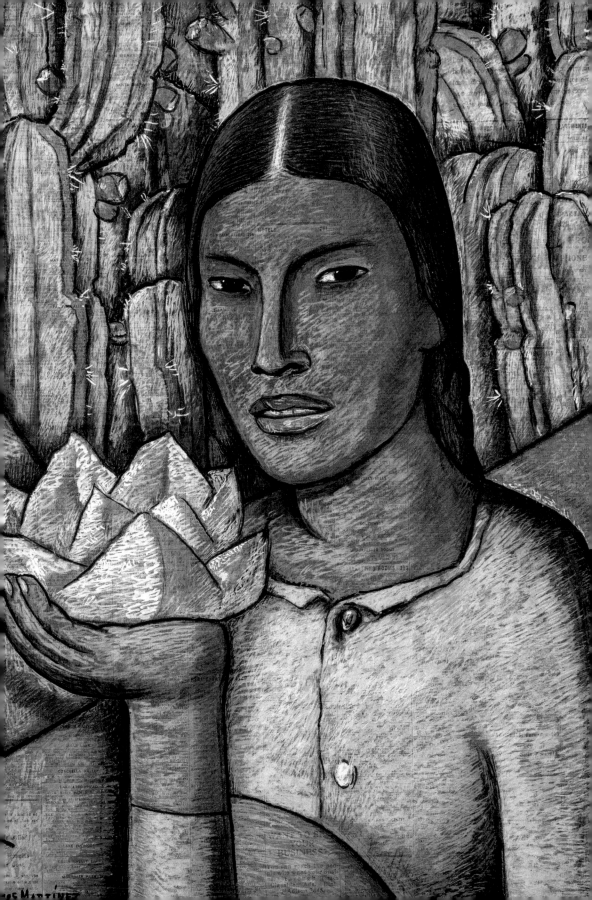

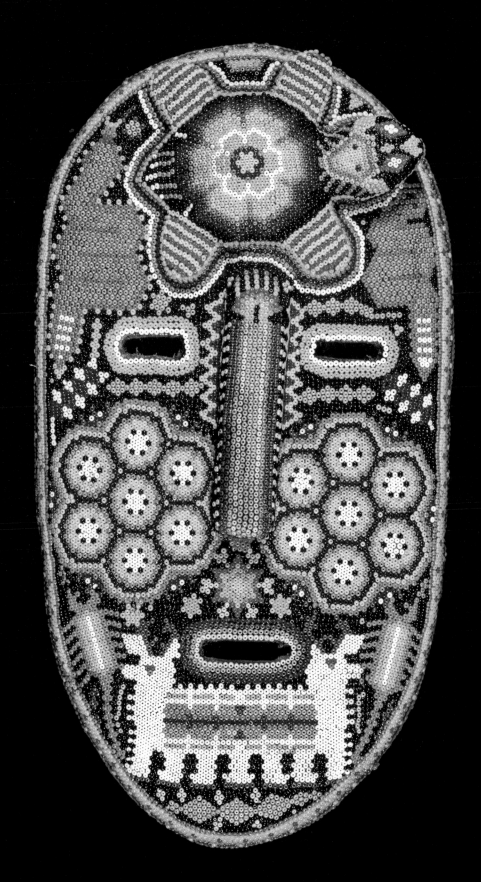

Unknown · *Wooden, Beaded Huichol Mask* · Mexico
Unknown Huichol patterns and designs have reli-
gious and cultural significance. Peyote is used for
their ceremonies, and in their colorful beadwork,
which reflects their symbiotic relationship with nature.
The mask was photographed by Jean Bernard.

Tom Benton · *Thompson for Sheriff* · United States
1970 Featuring a hand clutching a peyote button,
this poster was created by Benton for the journalist
Hunter S. Thompson's infamous campaign run for
sheriff of the city of Aspen, Colorado.

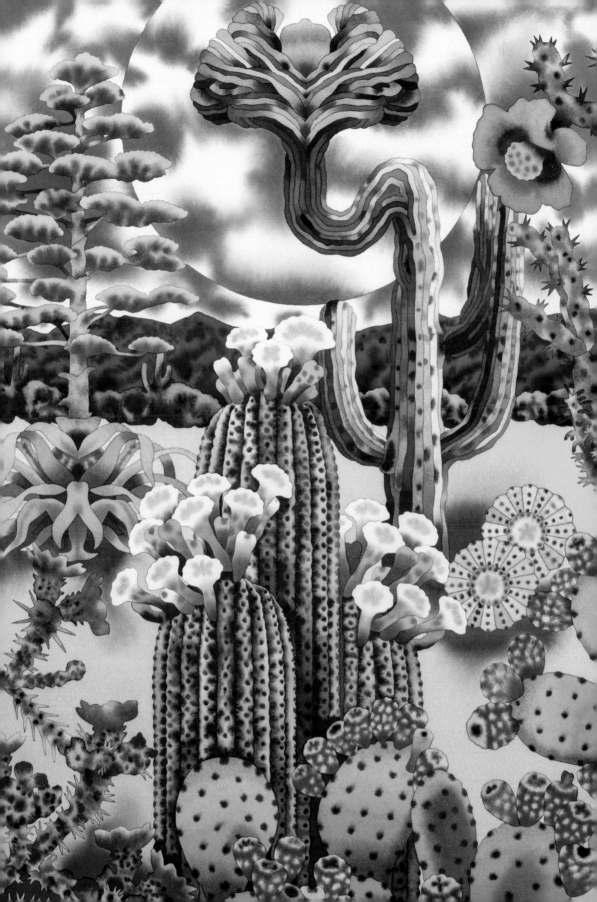

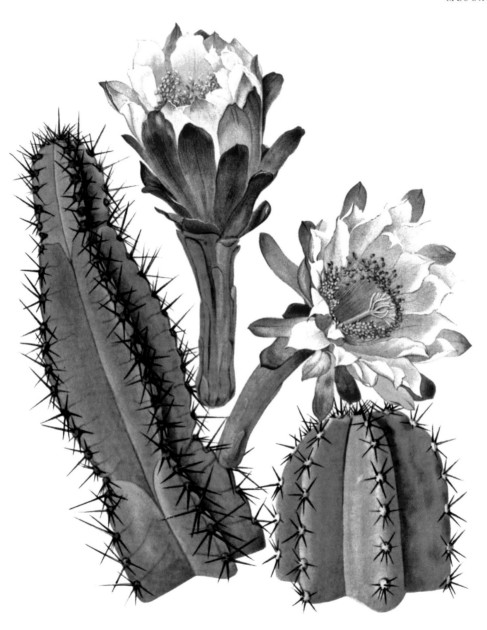

Matthew Palladino · *High Desert Bloom* · Bolivia /
United States · 2018 American multimedia artist
Palladino currently lives and works in Bolivia, often
exploring the indigenous flora and cacti of the
South American as muse for his wildly vivid botani-
cal paintings.

Mary Emily Eaton · *Cereus alacriportanus* · England
1919 One in a series of illustrations created by
English botanical artist Eaton for a volume titled
The Cactaceae, by Nathaniel Lord Britton, an Amer-
ican botanist and co-founder of the New York
Botanical Garden.

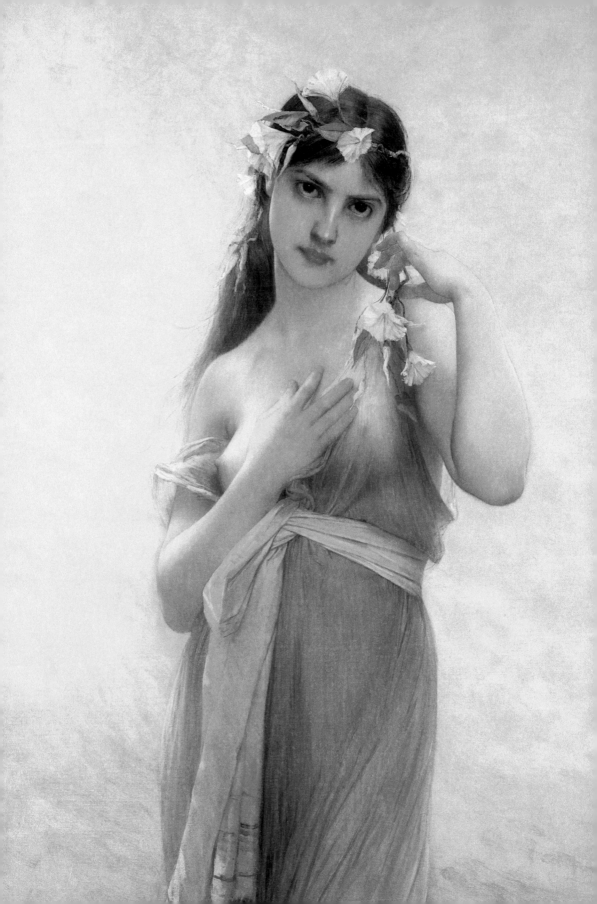

L-SCOPOLAMINE

DATURA

Datura discolor
Datura innoxia
Datura metel

EFFECTS

Profound Visions
Hallucinogenic
Delirium

CULTURAL NAMES

A'neglakya · Ch'óxojilghéi
Indian Apple
Jamestown Weed
Poison Lily · Sacred Thornapple
Tolohuaxihuitl
Xtóhk'uh
Yerba del diablo

USAGE

Inhalation
Edible

COLLOQUIALISMS

Angel's Trumpet
Brugmansia · Devil's Weed
Jimson Weed · Mad Apple
Trumpet Weed

Datura

He who consumes the thorn apple drink believes that he is consorting with spirits and demons.

— ERNST FREIHERR VON BIBRA, *The Narcotic Agents of Pleasure and Man*, 1855

Datura, also known as Thornapple, Devil's Trumpet, Moonflower or Jimson Weed, is a flowering plant in the deadly nightshade family. All species are poisonous, with the plant's flowers and seeds containing psychoactive properties that can cause hallucinations, illness and even death if taken in high doses. Datura grows in various climates and regions around the world and has long been celebrated as both a traditional medicine and a transformative spiritual sacrament. The name "datura" is rooted in an early Sanskrit word, meaning "divine inebriation" and fittingly, the plant has a long history of ritual use in various cultures. Among the indigenous peoples of North and South America, datura is considered a sacred plant, revered for its hallucinogenic qualities, the trances induced when taken considered a method of communicating with the spirit realm. Deadly if ingested in larger amounts, the tradition of eating the weed to achieve a visionary state was most likely relegated only to shamans

who understood the dangers of its toxicity. In the mythologies of the native Chumash of the Western United States, Datura is mentioned in creation stories, as a plant that was said to mark a transition between the spirit and material worlds. Some scholars also believe that datura may have been used by the Delphic oracles in ancient Greece in order to enhance their powers of divination. In the early English settlement of Jamestown in the New World, an incident in which several men were thought to have accidentally eaten datura was subsequently documented in *History and Present State of Virginia*, written by Robert Beverly in 1705. In the book the author describes the men's state after ingesting the weed. "Some of them eat plentifully of it, the Effect of which was a very pleasant Comedy; for they turn'd natural Fools upon it for several Days... A thousand such simple Tricks they play'd, and after Eleven Days, return'd to themselves again, not remembering anything that had pass'd."

(previous page) Jules Joseph Lefebvre · *Morning Glory* · France · 1879 A symbol of innocence, purity and virginity, the white morning glory drapes a semi-nude maiden. Lefebvre often used figurative flowers in his portraits.

Maxwell Ashby Armfield · *Datura in Bronze* England · 1920s Datura, or the Devil's Trumpet, has a hallucinogenic potency yet sometimes deadly chemical effects, making the plant both highly desired and deeply feared.

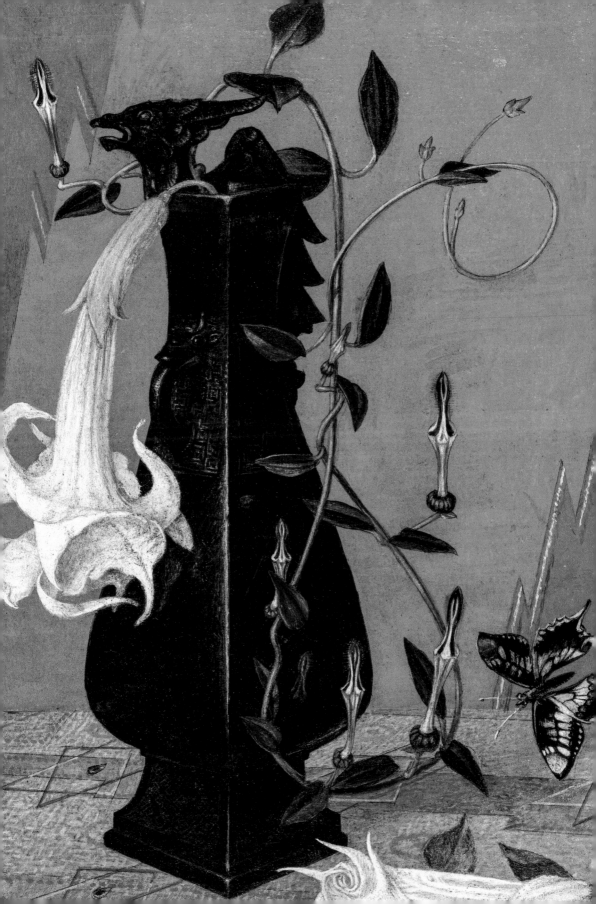

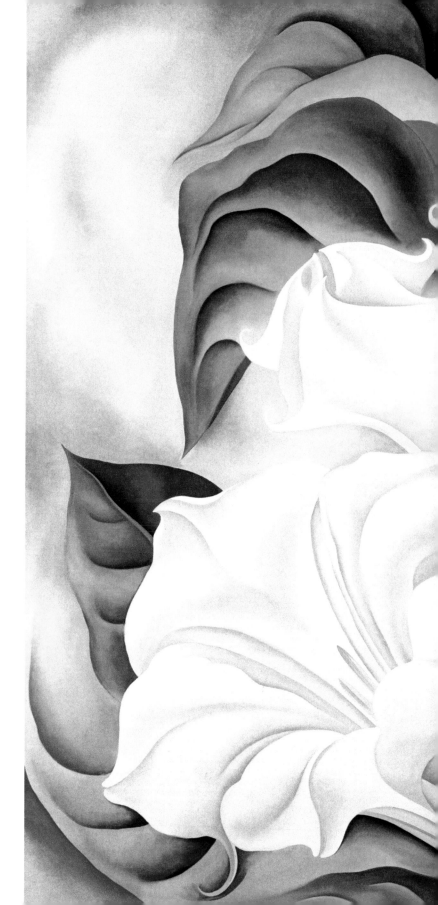

PART IV

Georgia O'Keeffe
Jimson Weed · United
States · 1936–07 Also
known as Datura, or
devil's trumpet, leaves
and seeds get turned
into medicine, but it is
more commonly known
as a hallucinogenic
plant that causes
euphoria. The flower
was a favorite subject of
the famed artist.

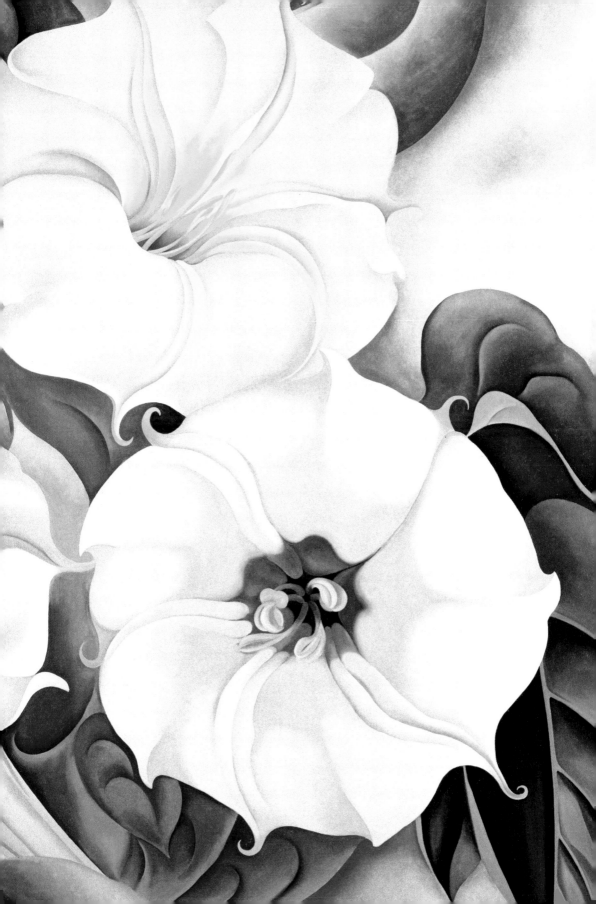

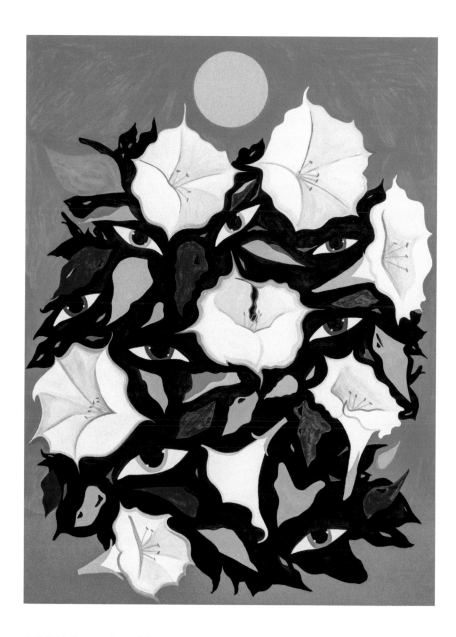

Caris Reid · *Datura in the Moonlight* · United States
2021 The sacred datura flower is captured by the
illustrator Reid, whose work often explores mystical
and esoteric themes.

Olga Volchkova · *Saint Datura* · United States · 2012
In her complex compositions, Volchkova renders
imagined saints which personify plants, some with
purported medicinal properties; as well as poten-
tially toxic botanical examples, such as belladonna
and datura.

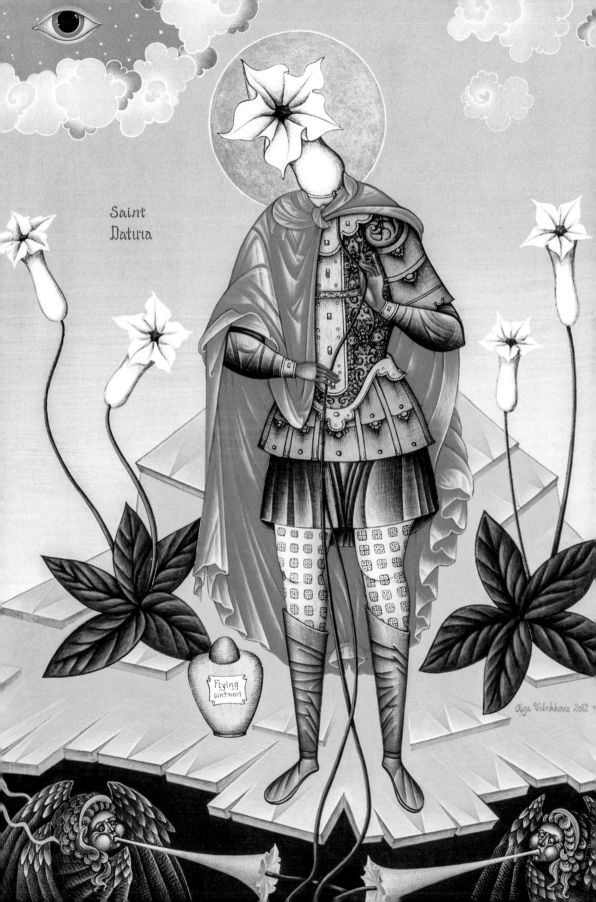

Saint
Datura

Flying
ointment

Olga Volchkova 2012

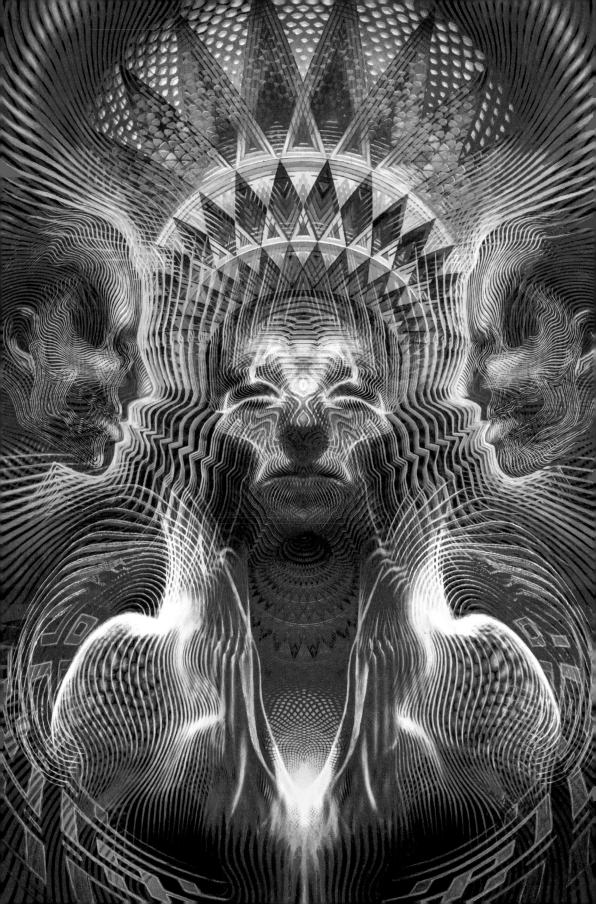

FAMILY

Malpighiaceae

ACTIVE COMPOUNDS

Harmine
Harmaline
Dimethyltryptamine

DIMETHYLTRYPTAMINE

AYAHUASCA

Banisteriopsis caapi
Ilex guayusa
Psychotria viridis

EFFECTS

Euphoria
Spectacular Visions

CULTURAL NAMES

Amarón Wáska
Bejuco de Oro · Iñotaino'
Hapataino' · Kadanytaino'
Nishi · Vine of the Soul

USAGE

Edible
Brewed

COLLOQUIALISMS

Caapi · Curare · DMT
Huasca · Yagé

Ayahuasca

From experience, I came to learn that ayahuasca bestows upon the user knowledge about a variety of topics, not only consciousness and perception, but also leads one to realize what we perceive is an illusion.

— PABLO CESAR AMARINGO SHUÑA, Péruvian folk artist & Shaman, from *Ayahuasca Visions: The Religious Iconography of a Péruvian Shaman*, 1999

Used in ceremony for at least the last thousand years by the indigenous peoples of the Amazon Basin, ayahuasca is a psychoactive brew consisting of two key botanical ingredients, a flowering vine known as Caapi or Yagé and Chacruna, a leafy shrub in the coffee plant family. Both have long been considered sacred "plant teachers" among various South American cultures and when combined their teachings have been said to offer a deep and powerful catharsis. In the language of Quechua, "aya" translates roughly to "spirit" or "soul" and "waska," to vine. The earliest documentation of the medicine's traditional use was recorded by Jesuit missionaries in the 16th century, who recorded accounts of ayahuasca ceremonies in which a shaman or curandero, would consume the drink in ritual for the purposes of divination and communication with the spirit realm.

Use of ayahuasca was traditionally relegated only to the shaman or curandero, who would subsequently translate their experience to the community, with information obtained usually focused on questions concerning hunts, harvest and defining ailments and diagnoses

for the sick. It was not until the 20th century that this plant medicine was first embraced by cultures outside of indigenous societies. The American biologist Richard Evans Schultes, considered one of the founders of modern ethnobotanical studies, was one of the first to study the hallucinogenic qualities of ayahuasca and published extensively on the subject. His early articles and papers, as well as his 1976 publication *Hallucinogenic Plants* and 1979's, *Plants of the Gods: Their Sacred, Healing, and Hallucinogenic Powers*, were largely responsible for igniting an interest around ayahuasca among cultural explorers such as Carlos Castañeda, Aldous Huxley, and the writer William Burroughs. The latter would document his experiments with the plant teacher in a series of letters to fellow Beat poet Allen Ginsberg, published in 1963 as *The Yagé Letters*. In these correspondences, Burroughs described his experience with ayahuasca as "space time travel." "This is the most powerful drug I have ever experienced," he wrote, "That is it produces the most complete derangement of the senses. You see everything from a hallucinated viewpoint. Yagé' is not like anything else."

(previous page) Luke Brown · *Curandero* · Canada 2018 Brown explores the subconscious and psychedelia in much of his work. Inspired in part by the plant medicine traditions of Central and South America, Brownss ode to the indigenous healers and shamans is executed in his visionary style.

Alex Grey · *Ayahuasca Visitation* · United States 2001 As a leader in the modern movement known as Visionary art, Grey explores the subconscious realms through his works, often creating expressive paintings inspired by psychedelic and plant medicine explorations.

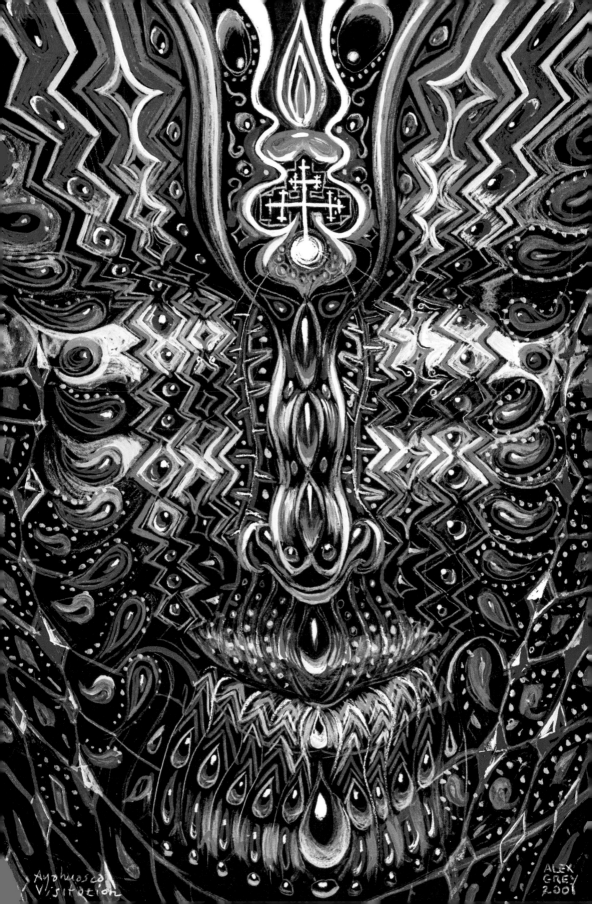

Ayahuasca
Visitation

ALEX
GREY
2001

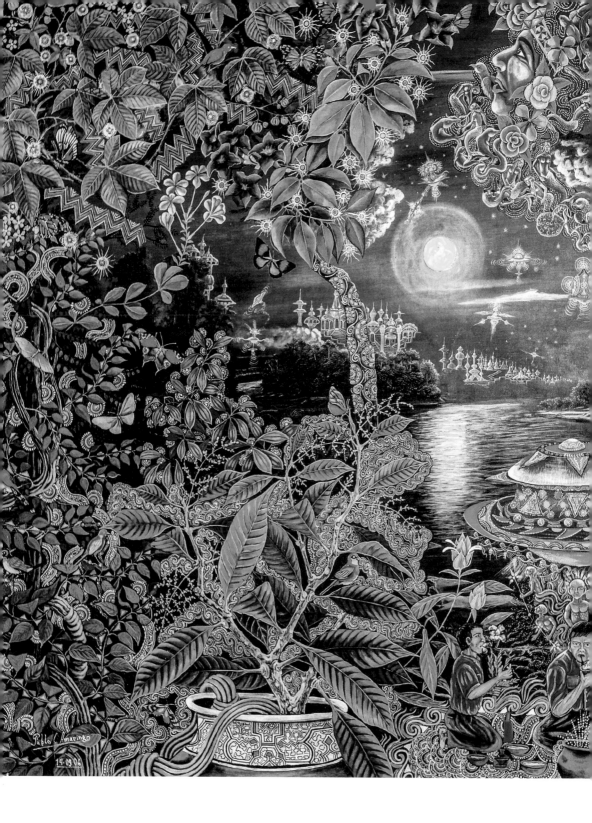

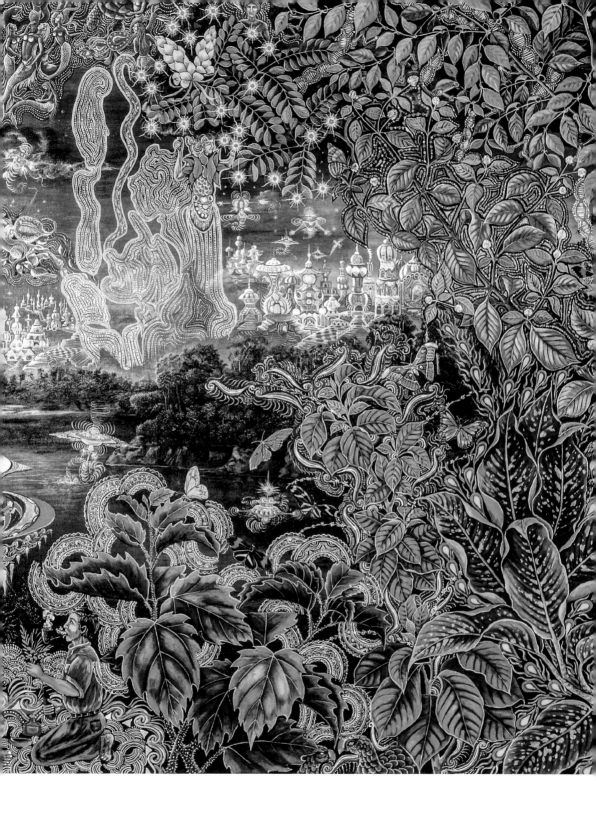

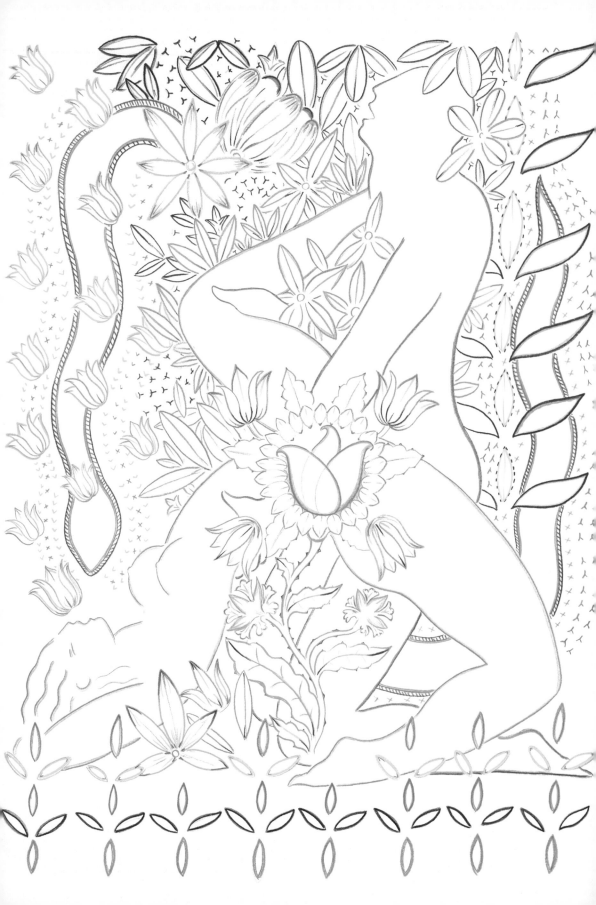

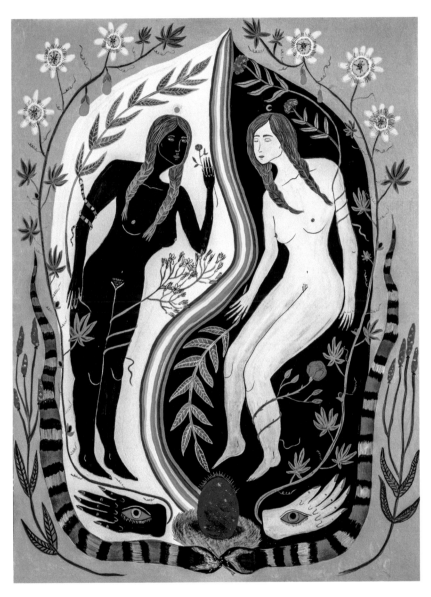

(previous pages)
Pablo Amaringo
Misterio Profundo · Perú
2002 Recognized as
one of the world's
great visionary artists,
Pablo Amaringo was
renowned for his intri-
cate, colorful paintings
inspired by his sha-
manic visions. A master
communicator of the
ayahuasca experience,
Amaringo's art presents
a doorway to the
transcendent worlds of
ayahuasca intended for
contemplation, medita-
tion, and inspiration.

Alphachanneling · *Lovers and Snake* · United States
2016 Inspired in part by explorations into psyche-
delics and plant medicines, the American artist
often imbues their work with overt, exuberant sexu-
ality, carnal love, an act of transcendence and an
expression of enlightenment.

Meagan Boyd / Yinshadowz · *Integrative Magic*
United States · 2020 Plant medicines and psyche-
delia are often subjects explored in the work of the
American artist Boyd who describes herself as a
"painter of microcosmic encapsulations of the sacred
and wild."

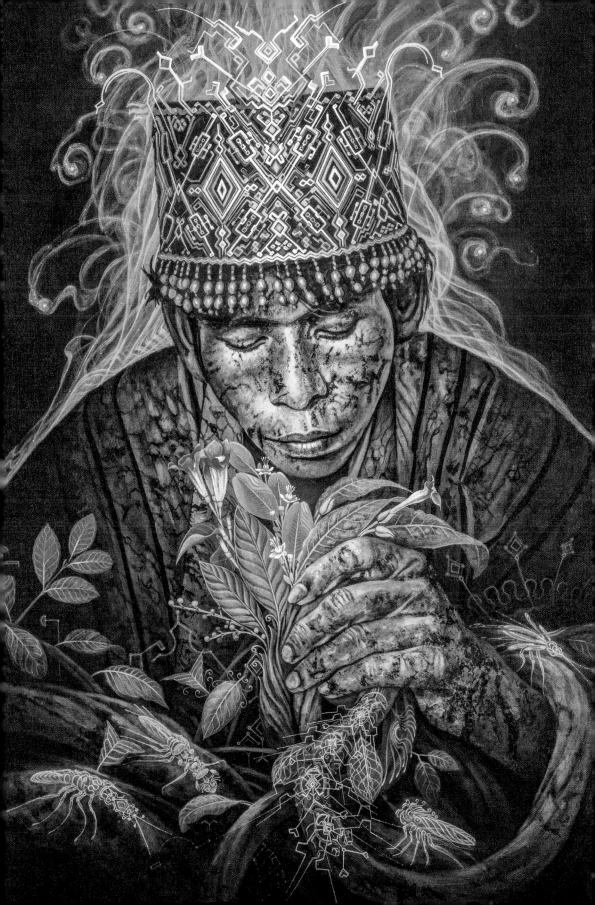

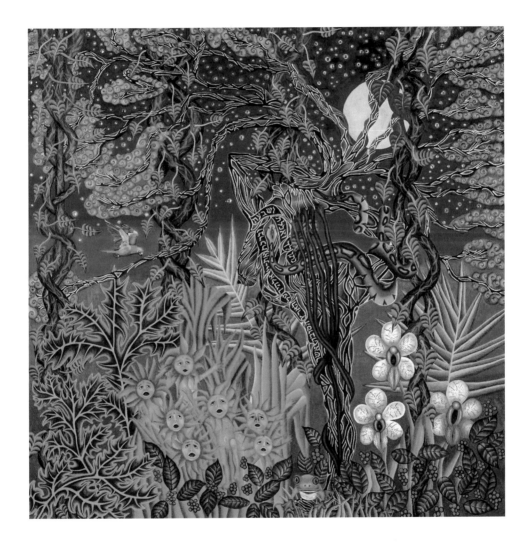

Luis Tamani · *Cuando las plantas cantan* · Perú · 2018
As Tamani explains of his visionary depiction of the ayahuasca plant ceremony, "Plants are magickal beings. And if we know how to remain silent, they give us access to a language never heard before."

Mariela de la Paz · *Gaia Tree* · Chili / United States 2006 In the artist's words, this work was, "Inspired by a full moon night medicine ceremony in the rain forest. All beings and spirits of the jungle appeared and interacted with one another. Gaia tree is represented as a lactating mother nurturing the forest.

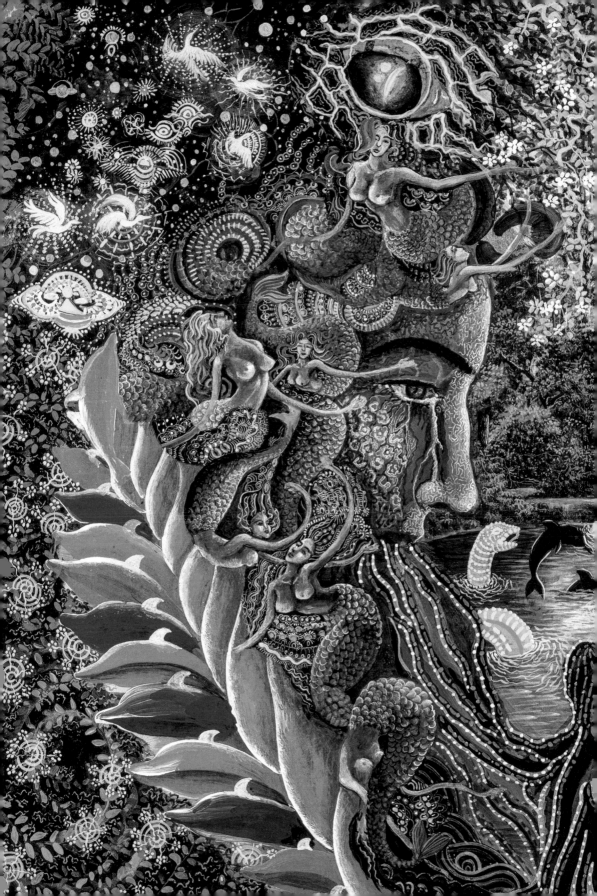

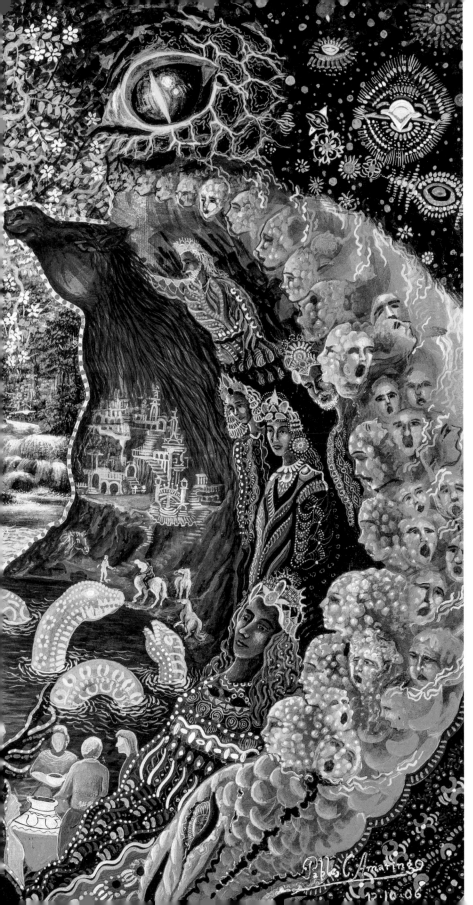

Pablo Amaringo
Llullon Llaqui Supai
Péru · 2006 This work
of visionary shamanic
art represents, accord-
ing to Amaringo,
"the sublime mystery
inherent in the plant
kingdom...When the
spirits walk there, they
do not trample and
crush the vegetation,
they walk lightly, and
we should learn how to
do the same." This work
is featured in the book,
*The Ayahuasca Visions
of Pablo Amaringo* by
Howard G. Charing
and Peter Cloudsley.

UNDER THE INFLUENCE

Art & Psychedelics

Once the artist has had a mystical experience, the task is to integrate the visions and energy of this state into the physical act of making art. . .The artist relies on visionary revelations that point to the spiritual ideal beyond mundane perception. By externalizing these revealed symbols in art objects, the artist provides a crystallized passage back to the mystic visionary state.

— ALEX GREY, Artist, Author, and Founder of the Visionary Art Movement from *The Mission of Art*, 1998

(pg 410)
Casey Jex Smith
Slumber · United States
2020 Growing up in deserts of Utah, Smith's works are often unexpected populated with lush and idyllic scenes in nature, in part due, as the artist explains, "to growing up in a place with very little rain. To escape it you would have to drive up a canyon and hike trails to higher elevations where the landscape would change into a more paradisiacal form. I have always longed for those kinds of landscapes."

The creative manifestation of the psychedelic experience can be seen across time and cultures, from datura flower paintings discovered in prehistoric caves to the Shipibo pottery and fabrics of Péru, their intricate patterns reflecting the lilt of the shaman's song. The ancient worship of corn and sacred cactus is thought to have inspired the vibrant and meticulous handicrafts of the Huichol peoples of Mexico. From mushroom totems carved in stone, and the peyote songs of the Navajo, to poppy flowers wreathing the marble necks of ancient Roman statuary, our shared history is rich in visionary work created either under the influence, or in honor of plant medicine. In the contemporary art world, the term "Psychedelic Art" first emerged in the 1960s. An expansive genre defined by the vivid colors and heightened impressions of a plant-medicine induced "trip." Psychedelic Art expresses itself in a wide variety of media, from sonic explorations and projected light shows, to prints, poetry, and essays. Liberated from the restrictive boundaries of the gallery, Psychedelic Art embraces all mediums, such as the distinctive illustrative style of comic, poster and album covers created by artists like Roger Dean, Rick Griffin, and Peter Max, as well as the wildly imaginative murals crafted by the collective The Fool. Psychedelic Art celebrates a return both to the land and to oneself. Its expressive manifestations range from traditional painting and sculpture to film, and digital composition. The vivid colors, vibrating geometric patterns, and profound conceptual ideas are the hallmark of viewing the universe through the multi-colored lens of the mystic. The genre is not about rendering what is "real" but rather manifesting the visions of the mind, capturing the experiences seen during "the journey." Today, artists continue to create under the influence, across multiple mediums, producing cathartic and mind-bending art using plant medicine as a creative conduit — inner exploration, manifested into inspiring material form.

Pablo Amaringo · *Patinguina Supai* · Perú · 2005
Pablo Amaringo (1938-2009) trained as a curandero in the Amazon, healing himself and others from the age of ten, but retired in 1977 to become a full-time artist. This work features the patiquina, widely used in Péru in baños florales (floral baths) for counteracting brujeria and attracting positive energy. The four varieties of patiquina seen here are verde, blanco, negro and pintado (green, white, black, and mottled), each with its own spirit or guardian which you can see beside each of the plants.

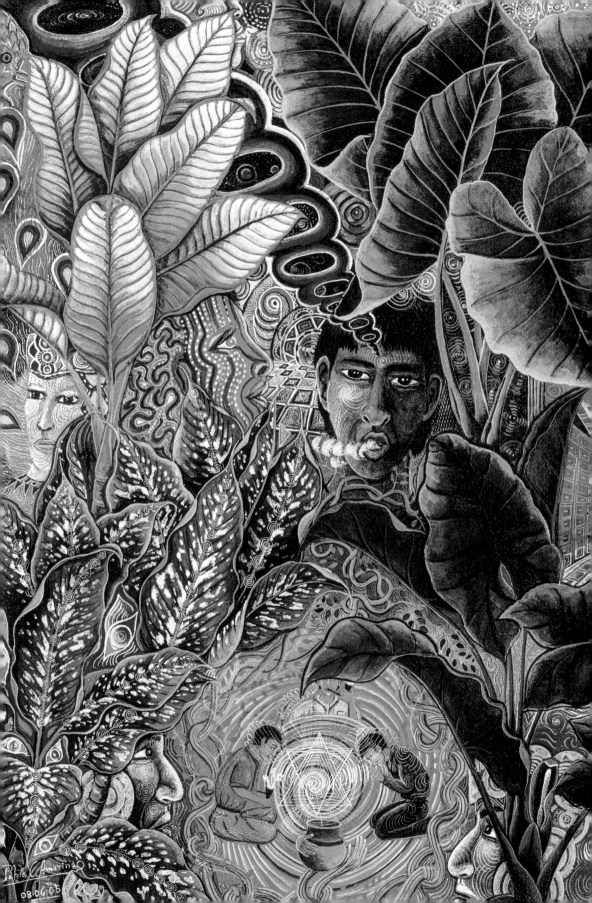

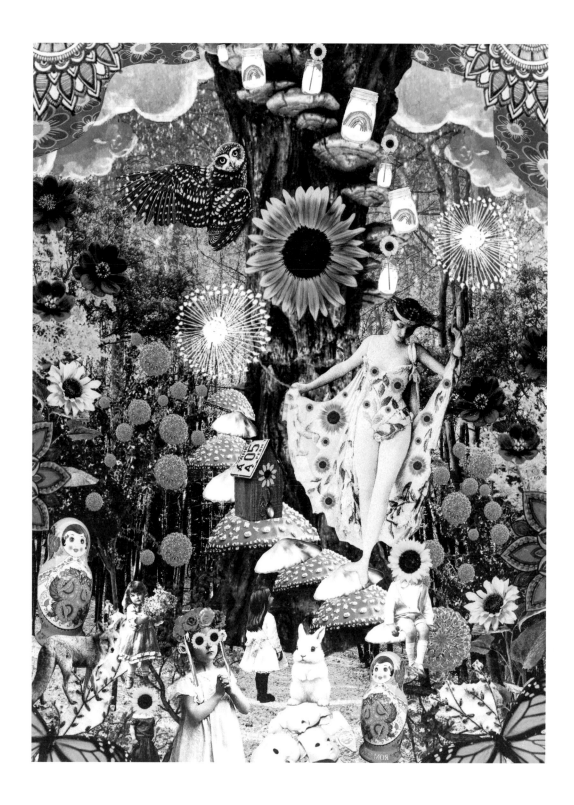

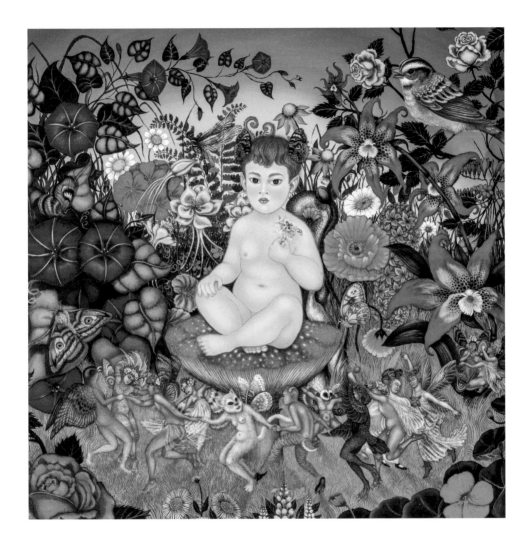

Donna Outtrim / Moonjube · *Soulgathering*
Canada · 2020 Initially inspired by Allen Ginsberg's
poem, *Sunflower Sutra*, Soulgathering evolved, as
the artist explains, "into a celebration of the tran-
scendent bond with nature shared by humankind,
a connection often lost as we grow."

Tino Rodriguez · *Unravel* · United States · 2022
An androgynous child sits atop a mushroom. As the
artist explains, "My work is my search for a spiritual
philosophy that transcends simple duality...I am
fascinated by the complexity of human sexuality,
transformation, longing and transgression."

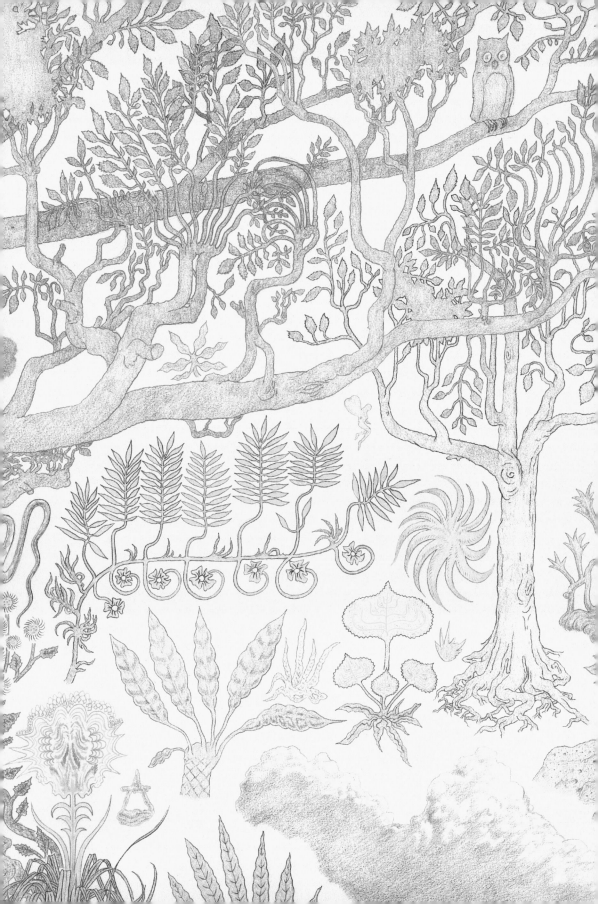

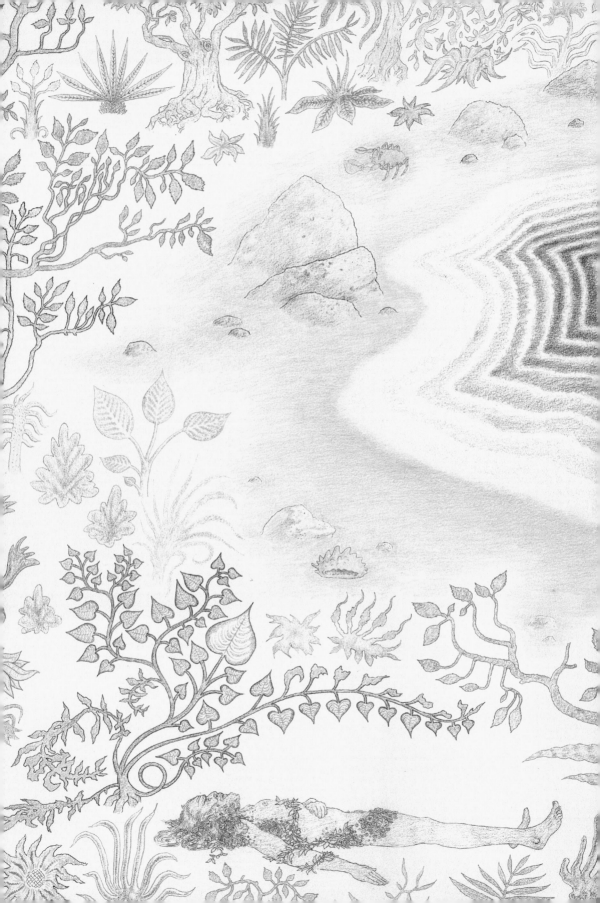

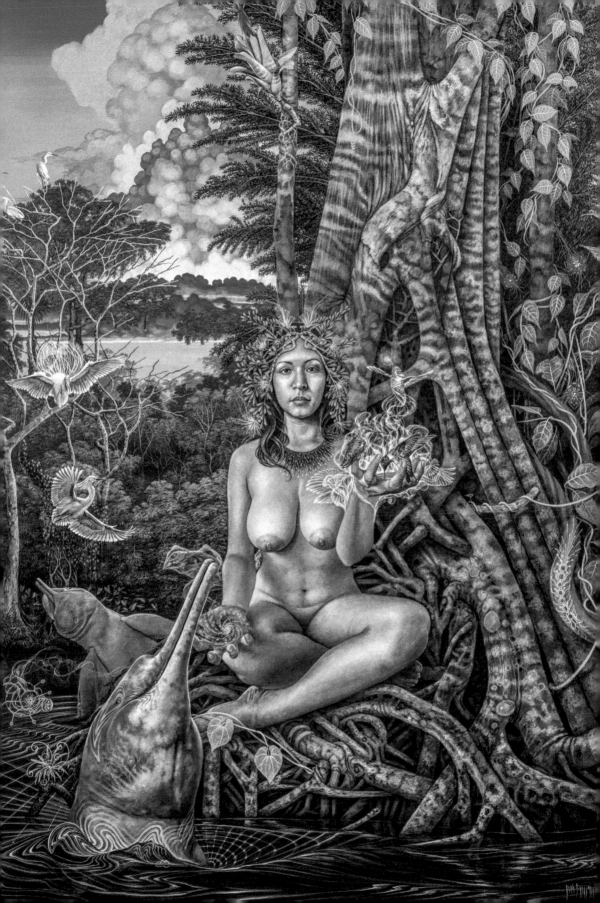

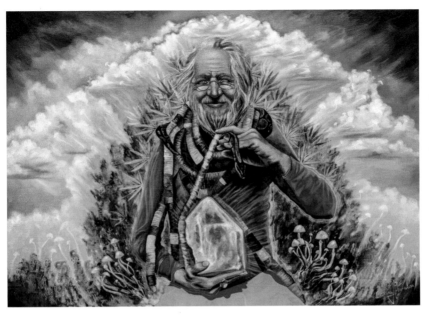

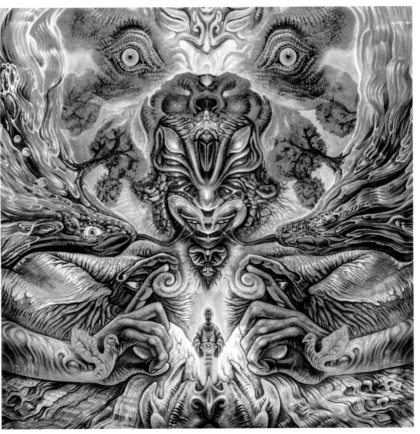

Luis Tamani
Bobinzana · Perú · 2017
The Péruvian artist Tamani often populates his visionary works with what he refers to as "Espíritu de las Plantas" or spirits of the plants. Botanicals, in his paintings are embodied as, "messengers of inspiration. They heal us, teach us, and guide us. "

Helena Arturaleza
Soma, Guardian of Plant Medicine · Netherlands 2019 One in a series of portraits of personal muses, Arturaleza captures Soma, whose mission, the artist explains, "is to bring awareness with marihuana. He dedicated his life to spreading the spirit of marihuana. He works with various plant medicines and in Amsterdam he is known as the Marihuana Guru."

Luke Brown · *Salvia Dalinorum* · Canada 2007 Much of Brown's work explores visions induced by various plant medicines, personal transformative experience expressed through vivid psychedelic art which often anthropomorphizes plants into otherworldly creatures and spirits.

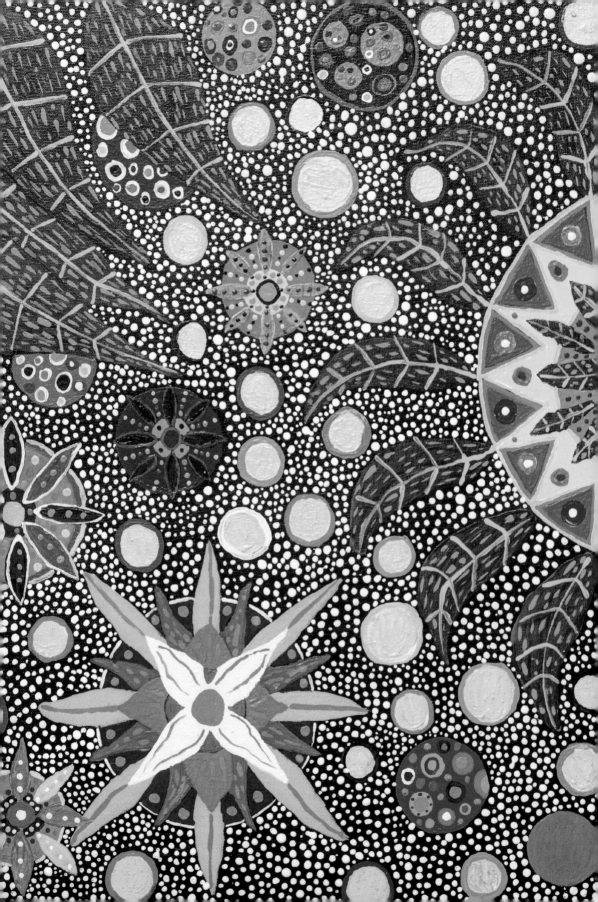

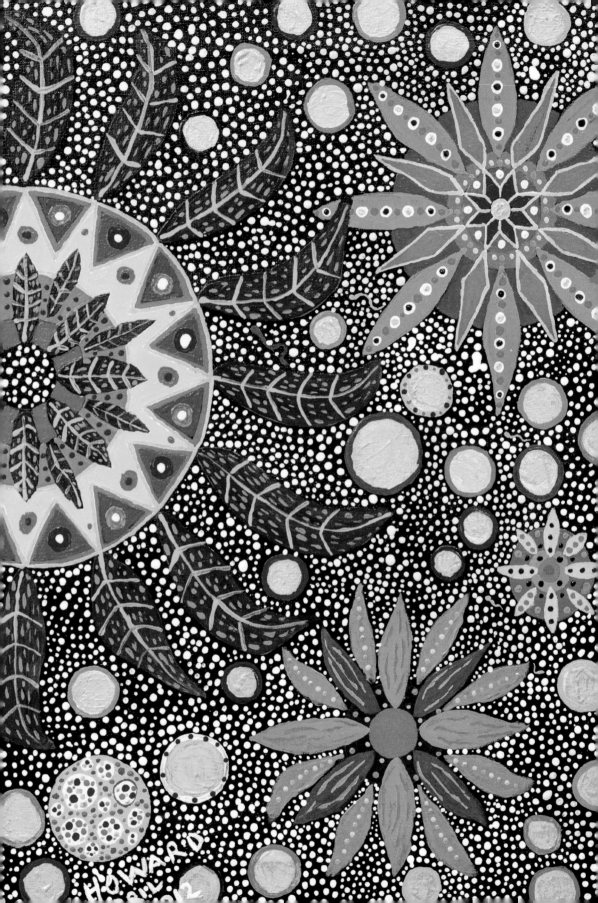

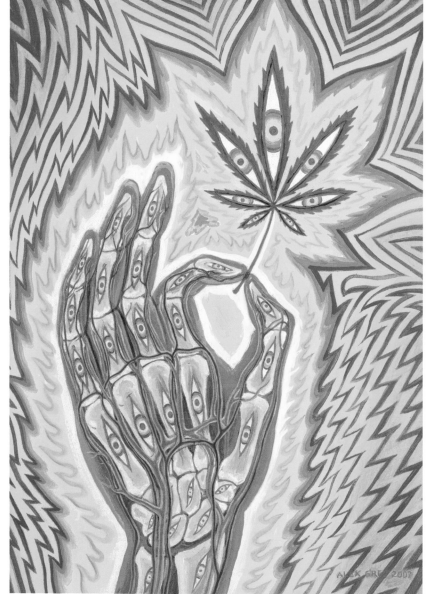

(previous pages)
H.G. Charing
Visionary Ayahuasca painting · England 2012 Charing's artwork and writings are inspired by his experiences working with shamans and elders in the Andes, Amazon Rainforest, and the Philippines, exploring visionary plant medicine traditions.

(following pages)
Daniel Herwitt
Untitled · United States 2020 The artist Daniel Herwitt, sometimes working under the moniker "Sunflower Form" creates hallucinatory botanical dreamscapes that bring an intricately modern approach to the tropes of the Psychedelic Art Movement of the early 1960s.

Alex Grey · *Cannabis Mudra* · United States · 2007 Grey is considered one of the key founders of the Visionary Art movement, his works inspired by sacred geometry, plant medicines and other transformative esoteric practices.

Luke Brown · *Pareidolia* · Canada · 2019 Brown's work often expresses the visions experienced through plant medicine and other psychedelic transformations. This piece began as a live painting collaboration by Brown and fellow artist Jack Lightfoot with Brown completing the painting over 2018 and 2019.

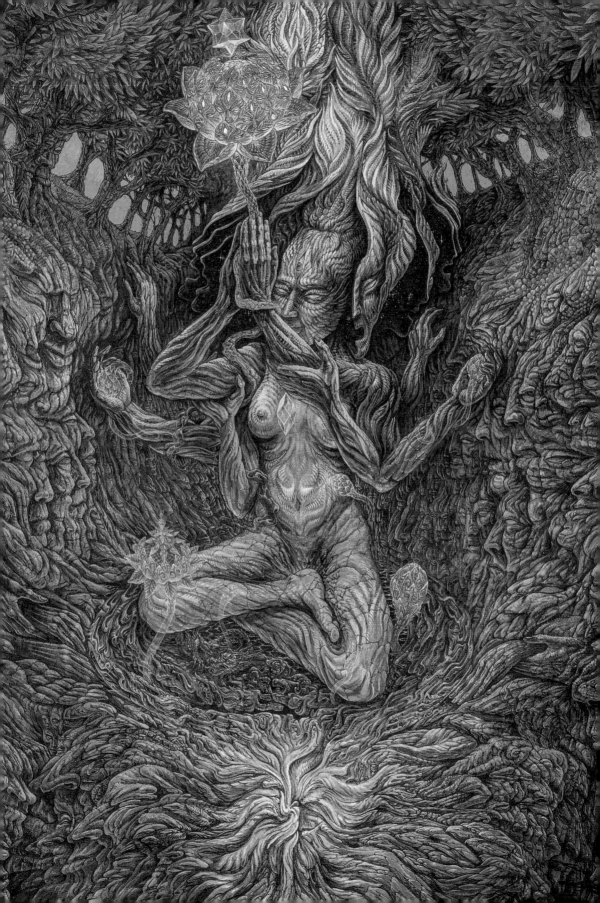

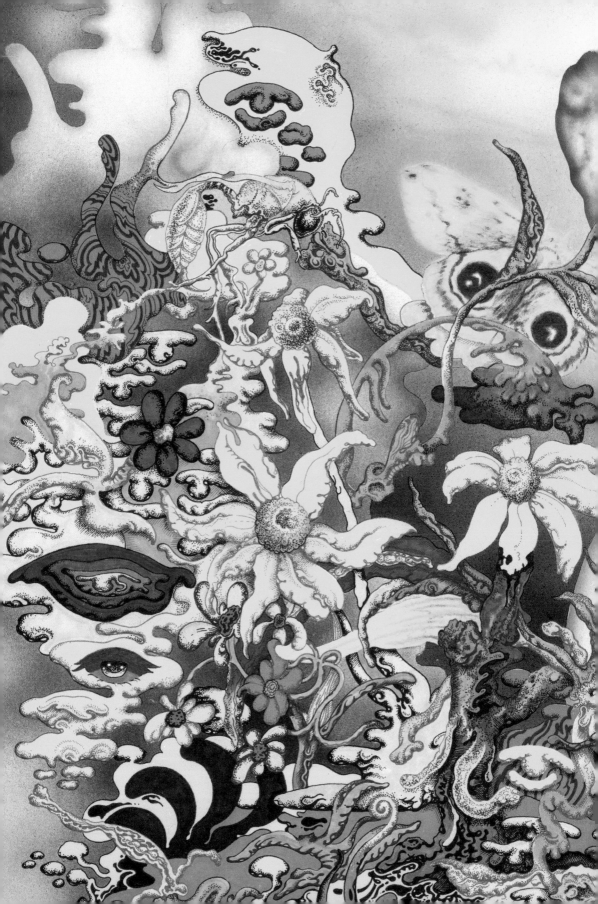

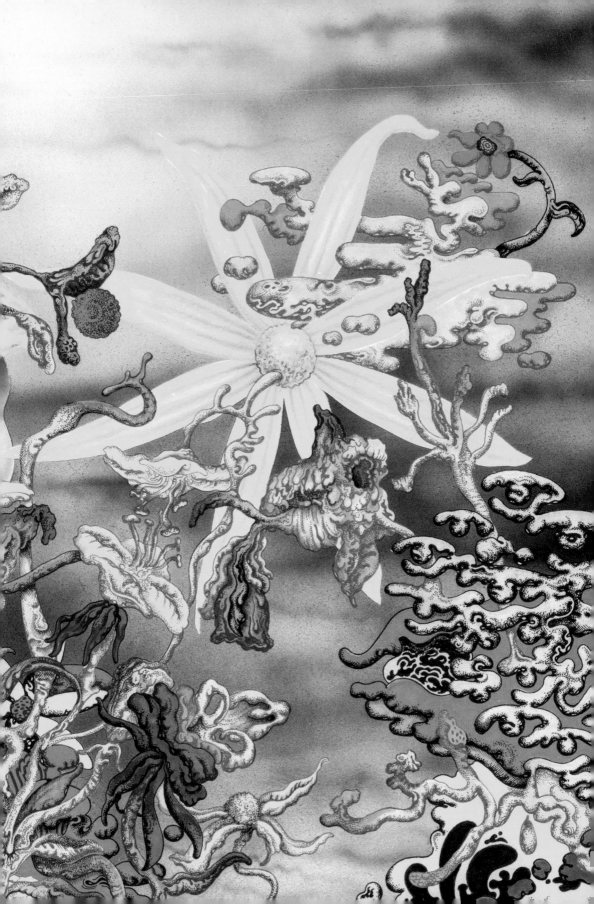

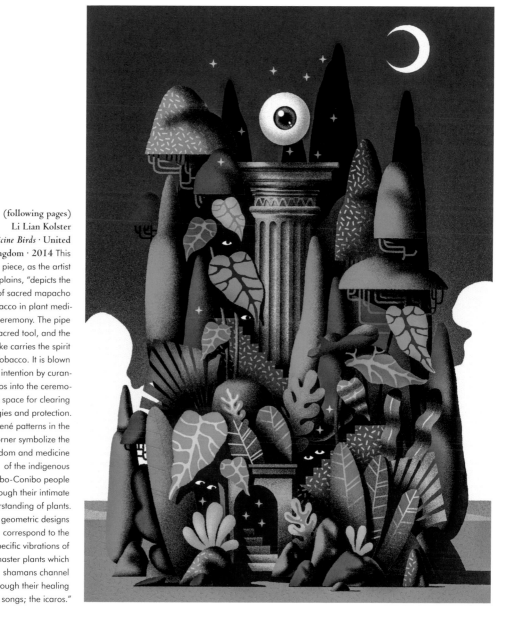

(following pages) Li Lian Kolster *Medicine Birds* · United Kingdom · 2014 This piece, as the artist explains, "depicts the use of sacred mapacho tobacco in plant medicine ceremony. The pipe is a sacred tool, and the smoke carries the spirit of tobacco. It is blown with intention by curanderos into the ceremonial space for clearing energies and protection. The kené patterns in the corner symbolize the wisdom and medicine of the indigenous Shipibo-Conibo people through their intimate understanding of plants. The geometric designs correspond to the specific vibrations of master plants which shamans channel through their healing songs; the icaros."

Matt Löffler · *Astray* · Germany · 2017 According to the artist/illustrator, this work explores themes of centering and enlightenment. As Löffler explains, "The hovering eyeball on top of the pillar represents a watch tower and symbolizes orientation in chaos, which is depicted by the surrounding jungle."

Casey Jex Smith · *Prophet* · United States · 2018 Much of Smith's work is inspired by his experience growing up in Utah and his exposure to the Mormon faith, "…at the center of which is an expanded narrative built around the Garden of Eden…as an elaborate paradise. It's a place I want to be in."

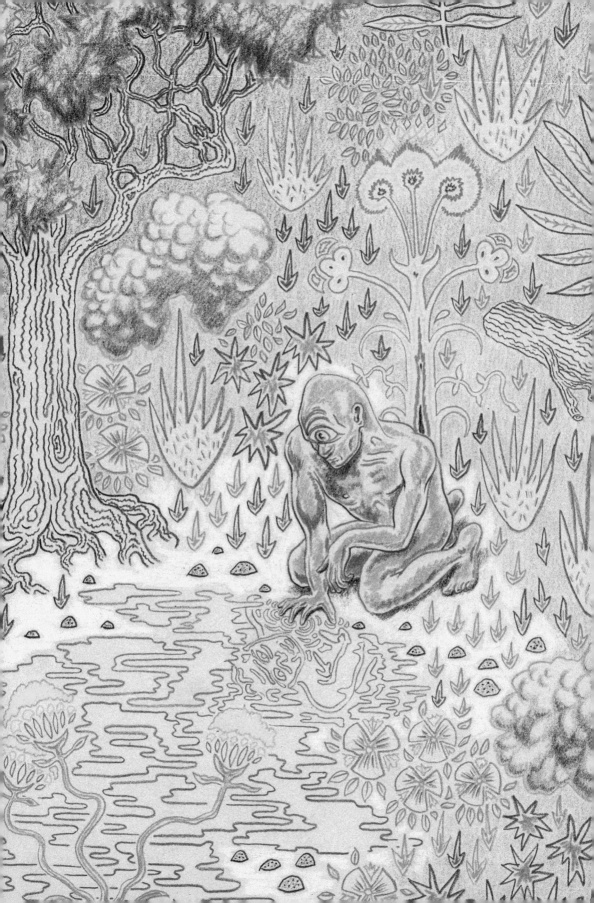

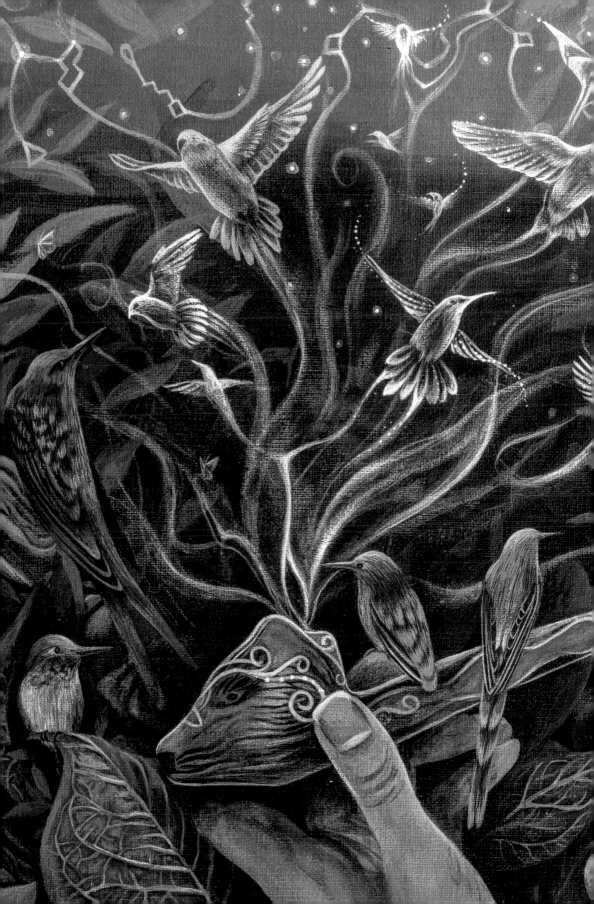

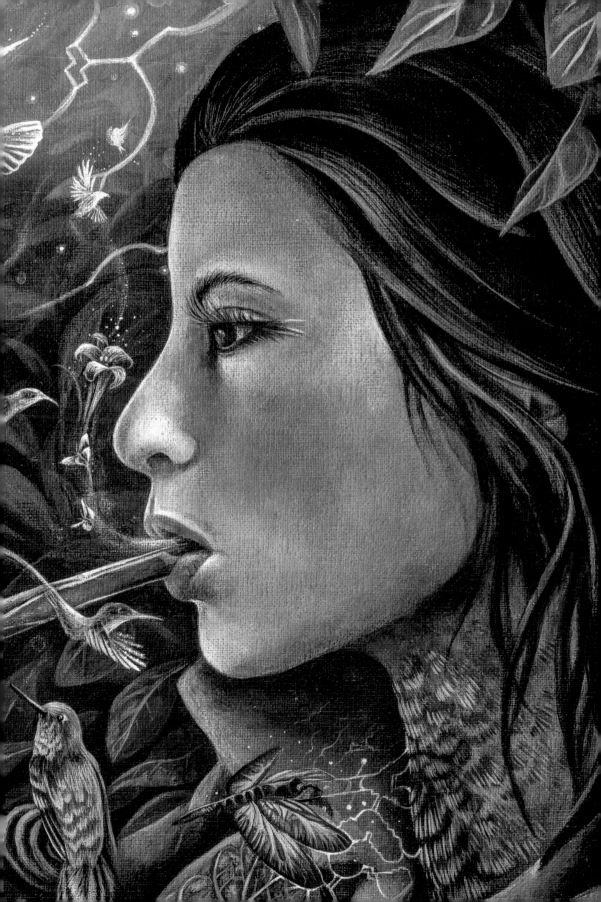

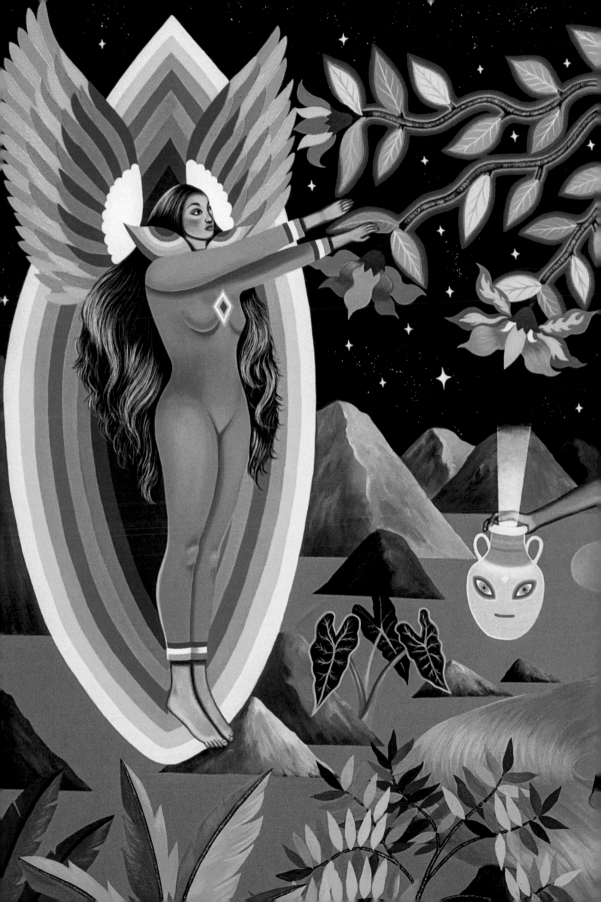

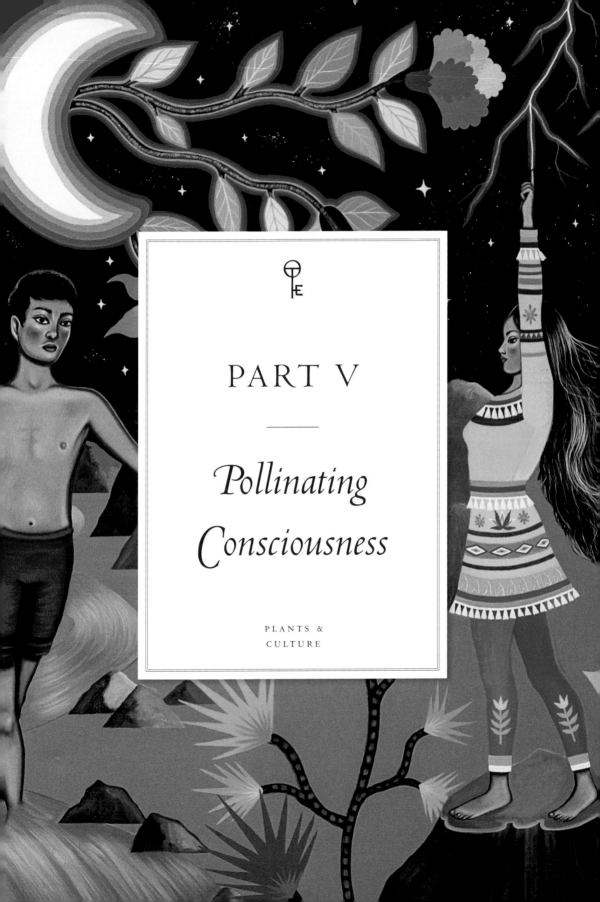

PART V

—

Pollinating Consciousness

PLANTS &
CULTURE

THE BEANSTALK

Plants in Literature

The clearest way into the Universe is through a forest wilderness

— JOHN MUIR, Author, naturalist, and environmental advocate,
from a collection of journal entries written from 1867 to 1911 and later
published as *John of the Mountains: The Unpublished Journals of John Muir*

The entire history of the written word owes a debt to the plant world, first and foremost in the development of paper itself. Ancient Egyptian scrolls were inscribed on the pressed pith of the papyrus, a flowering aquatic plant which still grows, tall and green, along the Nile. Also known as the "paper plant," some of the oldest known writings on papyrus date back to the 4th millennium BCE. Later, in 2nd century China, a process of pressing the pulp of certain trees and plant materials developed, eventually evolving into the paper we know today, now most often manufactured using the cellulose fibers processed from a variety of tree wood as well as grasses and plants such as cotton and hemp.

Early inks were also created from botanical matter often utilizing the soot of burnt wood, a dense charcoal mixed with other materials and minerals. The ancient Mayans documented their histories in a remarkably durable, vibrant blue ink which took its

brilliant indigo hue from the leaves of the South American leafy shrub called Añil. In cultures across the planet, the plant world has enabled us to tell stories in durable, tactile form — allowing our stories to be passed on from one generation to the next.

Nature as setting, symbolic plot point and narrative foundation has also remained a constant in literature and storytelling, perhaps since pine soot ink was first put to pressed papyrus page. Plants and flowers, herbs and trees — all play pivotal roles in our mythic sagas, Biblical parables, Arthurian legends and in indigenous folk tales across cultures. Great writers, past and present, have always looked to the botanical world for inspiration, weaving innumerable references to the natural realm throughout their poetry, plays and prose. Shakespeare, for example, raised in the verdant expanse of the English countryside, wove a leaf green narrative thread through his prolific output

(previous pages) **Paula Duró** · *La Luna* · **Argentina 2017** Duró explores traditional South American folk tales as well as featuring indigenous plants and botanicals in much of her work. As the artist explains, her pieces "combine mystic and visionary arguments that produce a hallucinating experience."

John Tenniel · *Alice Meets the Caterpillar* · **England 1832–39** The mushrooms and flowers tower above small-sized Alice in the famous scene from *Alice in Wonderland*.

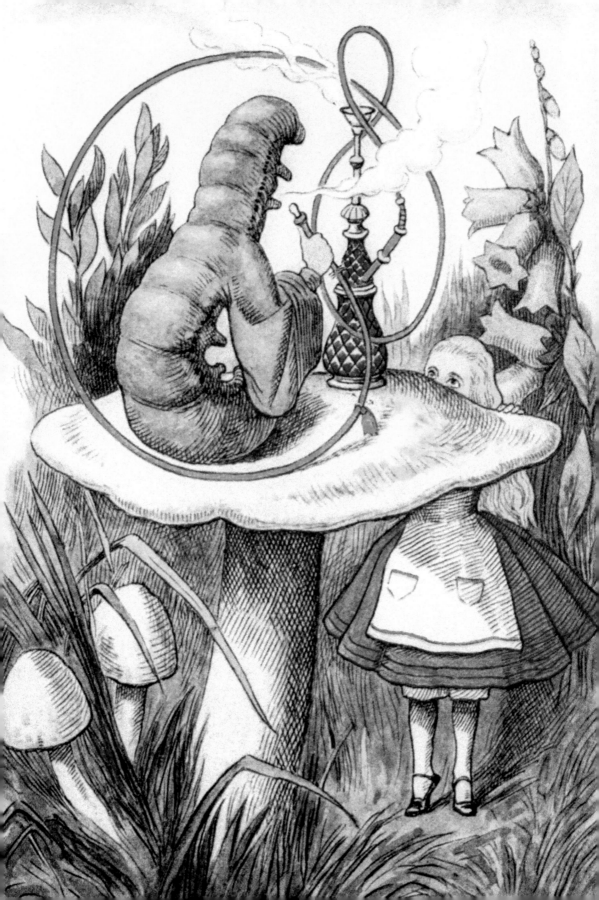

of work, mentioning plants, herbs, and flowers in so many of his writings that his words have since inspired countless gardens planted in his name. In the last century, "Shakespeare Gardens" have become a popular feature of public parks throughout the U.K. and the U.S. — verdant plots planted with all the botanicals mentioned by the Bard within his poems and in the intricate dialogues of his plays, from *Romeo and Juliet's* "a rose by any other name" to Ophelia's lyrical listing of symbolic herbs and flowers

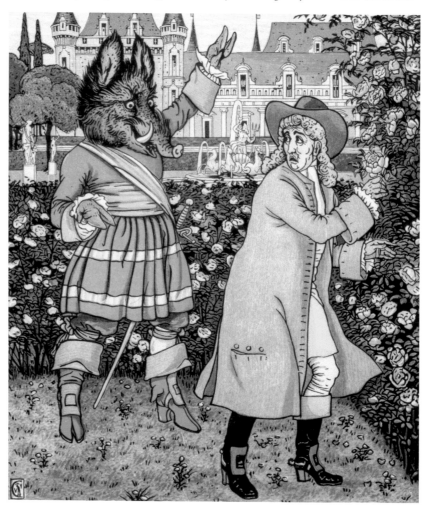

Walter Crane · *Scene from Beauty and the Beast* England · 1901 When the beast catches Belle's father stealing a beloved rose, he imprisons him until Belle is exchanged for his capture. The rose is the symbol of the beast's hope for love.

in her speech with Laertes from *Hamlet*. In 1906, the British illustrator Walter Crane published *Flowers from Shakespeare's Garden: A Posy from the Plays*, celebrating Shakespearean botanicals with a collection of elegant and ornate botanical illustrations. Crane's own creative work often embraced nature as muse, most notably in the images he created to accompany children's literature, as well as in his 1899 publication *Floral Fantasy in an Old English Garden*, which featured Crane's anthropomorphized flower and herb drawings, a surreal and fantastical world of plants transformed into people.

Crane's images also illustrated the famous stories of the Brothers Grimm, his work showcasing the authors' penchant for natural symbolism. In many of the great and enduring Grimm fairy and folk tales, plants, fruits, and trees play a central role, from the Evil Queen's magickal and malevolent poison apple in *Snow White*, to *Cinderella*'s enchanted pumpkin transforming into an ornate carriage, and the menacing and labyrinthine forest in which *Hansel and Gretel* lose their way.

In the 1734 English children's tale, *Jack Spriggins and the Enchanted Bean*, Jack plants his magic seed and is rewarded with a beanstalk that towers high enough to allow him access to the Giant's castle in the clousds. In the famous French story of *La Belle et la Bête*, first published in 1740, it is the illicit plucking of a prized rose that first sets into motion the debt owed by Beauty to the Beast. Plants as gatekeepers into enchanted realms have been present in children's literature throughout the last few centuries, from the magickal allure of poppy fields on the outskirts of Oz's Emerald City, to the caterpillar in Lewis Carroll's *Alice's Adventures in Wonderland*, sitting sage-like atop his mushroom cushion, blowing smoke rings between languorous tokes from his hookah. In the 20th century, Frances Hodgson Burnett's immensely successful 1911 novel, *The Secret Garden*, told the tale of a neglected orphan girl that finds unexpected solace and friendship within a walled and mysterious garden.

In artist and author Shel Silverstein's 1964 children's classic, *The Giving Tree*, a lyrical illustrated narrative traces a boy's lifelong relationship with a kind, generous and inexhaustibly selfless Apple tree. And in Maurice Sendak's *Where the Wild Things Are* (published a year prior) young Max's bedroom is transformed into a verdant jungle island, where nature runs rampant and Max reigns over a world of "wild things." Children's literature is often a world where nature is an inherent piece of the narrative, where grassy fields are soft with sunlight, fairies float like dust motes among the daisies and dandelions and where the woods are dark and full of mystery, a place where adventure awaits.

Poetry, of course, has often placed nature on the highest of literary pedestals, our emotional connection to the Earth the subject of innumerable odes. The 13th century Sufi mystic and poet Rumi often explored the innate connection between the spiritual and natural realm in his work. The traditional Japanese form of haiku often celebrates the botanical world, as in 16th-century poet Bashō's many delicate laments to the beauty of the Cherry tree

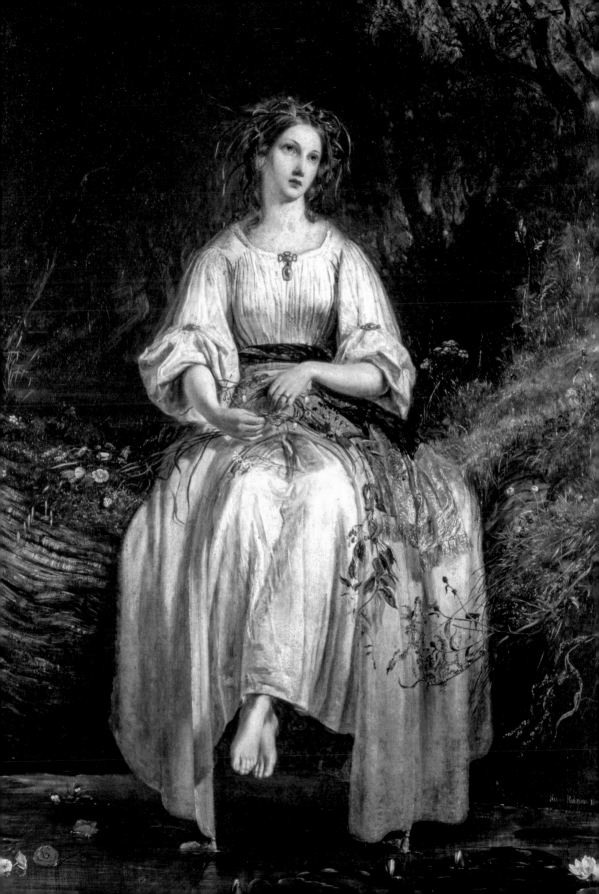

blossom. John Keats, Percy Bysshe Shelley, William Wordsworth, and other English writers of the Romantic Movement of late 18th and early 19th century often populated their work with scenes and symbols drawn from the natural world.

In a spare, sunlit bedroom of mid-1800s New England, the great poet of stillness and solitude, Emily Dickinson, was known to sit, carefully pressing hundreds of flowers and plants into leather bound scrapbooks. These botanical samples were plucked from the world just outside her door and preserved for future creative consultation. Dickinson's communion with nature was intense and profound, a relationship that seems rooted even more deeply than those the poet shared with her family or friends. For Dickinson, nature was an infinite source of inspiration, a well that never ran dry. Another poet enamored with the beauty of botany was the exuberant and impassioned Walt Whitman. While Dickinson approached her muse with ten-der trepidation, Whitman sang of nature with a joyous and primal howl. In his epic collection *Leaves of Grass*, first published in 1855, Whitman celebrates the joys of both the body and the natural world with an unbridled passion, the series of poems a love letter to all things living. In his poem *Song of the Open Road, 6*, Whitman famously states, "Now I see the secret of the making of the best persons. It is to grow in the open air and to eat and sleep with the earth." Later poets such as the Beat revolutionary Allen Ginsberg would take up Whitman's mantle praising "A perfect

beauty of a sunflower!" in his well-known poetic ode, *Sunflower Sutra* published in 1955. In writer and naturalist Diane Ackerman's 1990 book, *A Natural History of the Senses*, the natural world is explored through each – sense, taste, touch, smell, and sight – all in deliriously delicious detail. Ackerman's predecessor, the American naturalist, Transcendentalist, and author Henry David Thoreau famously immortalized his bucolic homestead set on the wooded edge of a shimmering Massachusetts's pond with his groundbreaking; *Walden; or Life in the Woods*. Part memoir and part spiritual and political statement, the book, first published in 1854, documents the two-plus years spent in his small self-built cabin, experimenting with life on the land. As Thoreau writes in the book's opening pages, "I went to the woods because I wished to live deliberately, to front only the essential facts of life, and see if I could not learn what it had to teach, and not, when I came to die, discover that I had not lived."

Thoreau's mentor and friend, the poet Ralph Waldo Emerson, had by then already established the core tenets of the Transcendentalists' dedicated connection with the natural realm in his famous 1836 essay, aptly titled, *Nature*. Controversial in its time, the essay suggests that the divine is an inherent part of the natural world, "In the woods," Emerson writes, "is perpetual youth. Within these plantations of God, a deco-rum and sanctity reign, a perennial festival is dressed, and the guest sees not how he should tire of them in a thousand years. In the woods, we return to reason and faith."

Richard Redgrave · *Ophelia Weaving Her Garlands*
England · 1901 One of the most psychologically insightful characters in *Hamlet*, Ophelia sits prior to her death, poppies at her feet, weaving a ring of grasses for her longing of Hamlet – a woven gar-land symbolizing love, hopelessness, and mourning.

Later, the essayist and adventurer John Muir would again celebrate the majesty of the natural world, his works inspiring the first formations of America's National Park system through colorful, exuberant accounts of his cathartic adventures through California and the Western edge of the United States. In 1968 the writer Edward Abbey would follow Muir's lead with cheerfully misanthropic accounts of his time as a park ranger, in the autobiographical *Desert Solitaire: A Season in the Wilderness.* "Wilderness is not a luxury but a necessity of the human spirit, and as vital to our lives as water and good bread." He continues, "A civilization which destroys what little remains of the wild, the spare, the original, is cutting itself off from its origins and betraying the principle of civilization itself." Abbey's work expands upon the environment and ecologically-centered writings of the

scientist and author Rachel Carson, whose 1962 classic, *Silent Spring* essentially launched the environmental movement in the U.S. and abroad. In 2013, biologist and scholar Robin Wall Kimmerer, released *Braiding Sweetgrass: Indigenous Wisdom, Scientific Knowledge, and the Teachings of Plants,* her work igniting discussions around traditional indigenous methods of caring for the land.

Again and again, nature in all her diversity, captivates writers, offering authors inexhaustible insights, a world of color and light, symbolic cycles of life, death, and rebirth – connections that simultaneously ground the reader and set them free. Through our shared history on Earth, plants have offered us not only the means with which to tell our tales through ink, papyrus, and paper, but also the inspiration that supports so many of our shared narratives. The late poet Mary Oliver who captivated readers with her simple, yet profound statements on nature as means of redemption, often offers thanks in her work for the immense and selfless generosity of the botanical realm. In her 2004 book, *Blue Iris: Poems and Essays,* she writes "And over one more set of hills, along the sea, the last roses have opened their factories of sweetness and are giving it back to the world."

Kate Greenaway · *Cinderella* · England · 19th Century A Victorian imagined Cinderella carries a large pumpkin which will eventually, through magical invocation, change size to carry her.

William Henry Margetson · *Then he climbed quietly down* · England · 1925 The illustration of Jack and The Beanstalk is from *My First Fairy Story Book,* published by Thomas Nelson & Sons.

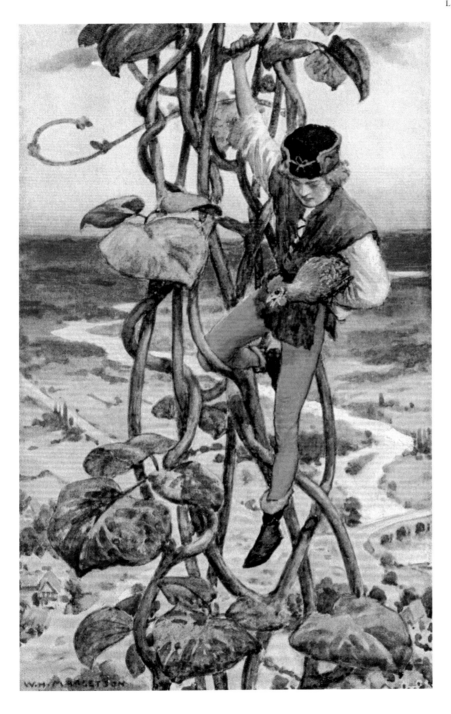

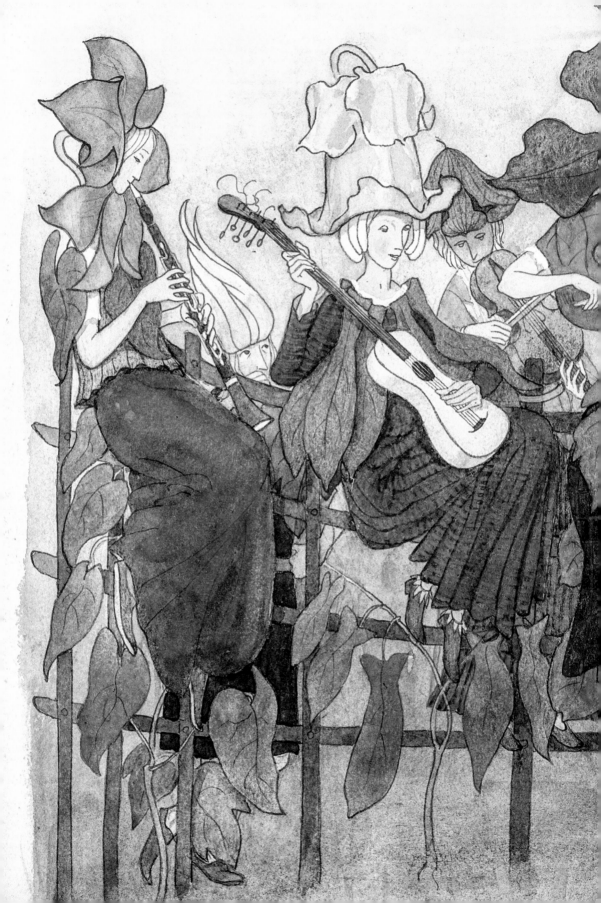

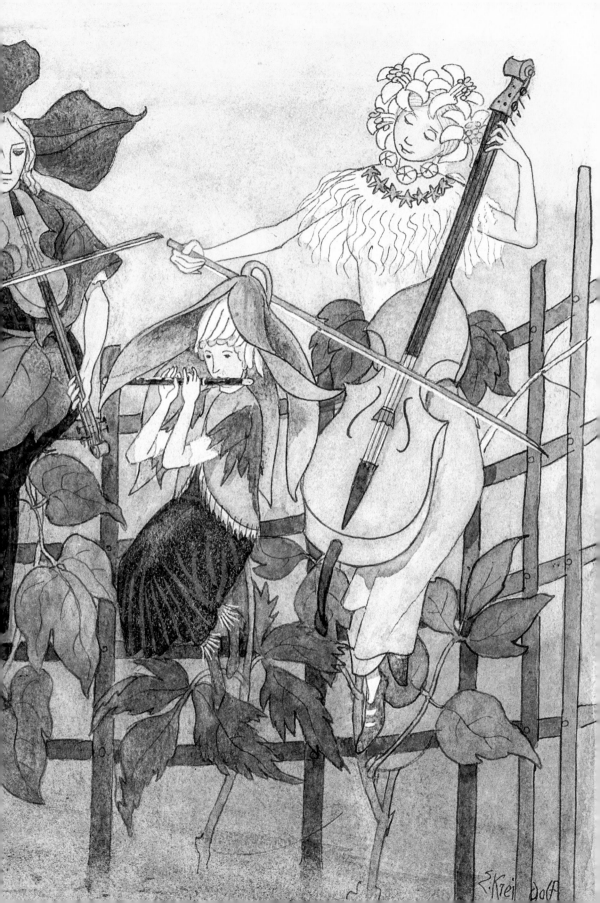

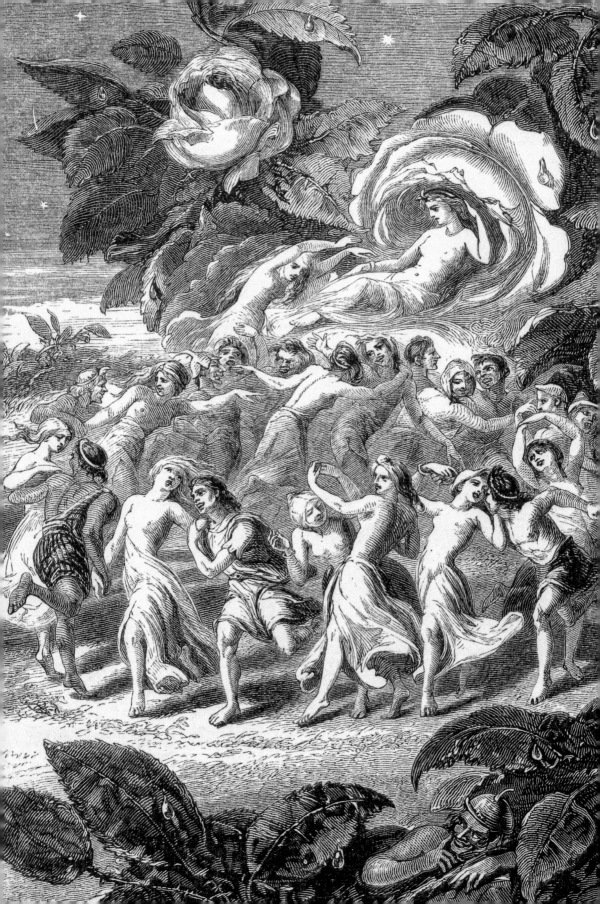

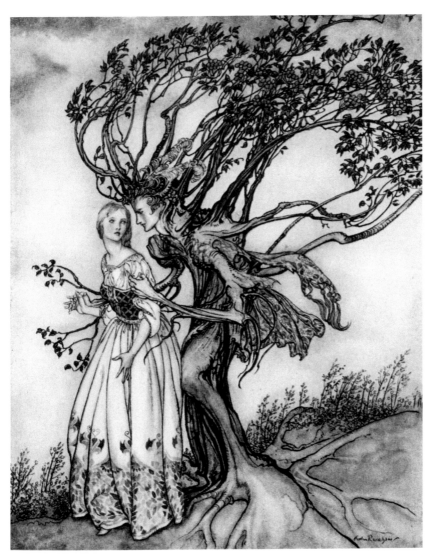

(previous pages)
Ernst Kreidolf
Der Gartentraum
(The Garden Dream)
Switzerland · 1911
The Swiss painter and
children's book illus-
trator is renowned for
his fairy-tale imagery,
much of it incorporating
fantastical floral and
botanicals, whimsical
landscapes populated
by figures bedecked
in flowers and plants,
as in this artwork
for his 1911 book,
Der Gartentraum
(The Garden Dream).

A. B. Frost and Edward G Dalziel · *The Fairy Ring*
England · 1948 The image is from *Midsummer's
Eve: A Fairy Tale of Love* by Anna Maria Hall. Fair-
ies dance in a ring among mystical roses.

Arthur Rackham · *The Old Woman in the Wood*
England · 1917 From the book, *Little Brother and
Little Sister, and Other Tales by The Brothers Grimm,*
a prince, cursed to live as a tree, was released back
into human form by a servant girl, who then
became his princess.

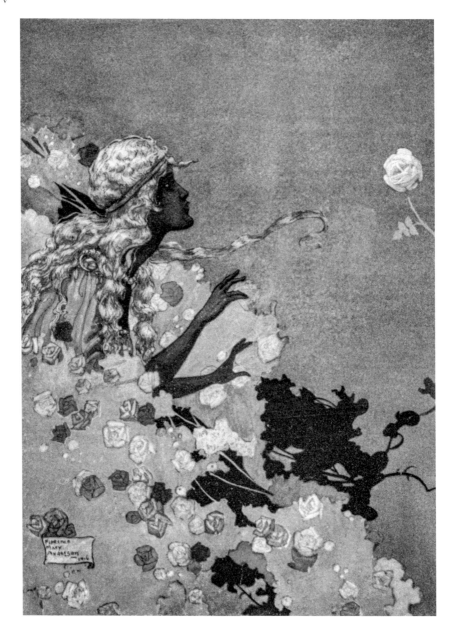

Florence Mary Anderson · *Seeing a beautiful white rose, she stopped to pluck it* · England · 1948 From a Brazilian book of fairy tales, translated into English by Christie T. Young and illustrated by Anderson. In this story, a young princess stops to pick a beautiful white rose, a symbol of purity and innocence.

Harry Clarke · *But there was no voice throughout the vast, illimitable desert* · Ireland · 1923 Art nouveau styled water lilies and other florals along the Zaire River in the desert of Libya are described in Edgar Allen Poe's short story "Silence – a Fable," from the collection, *Tales of Mystery and Imagination*.

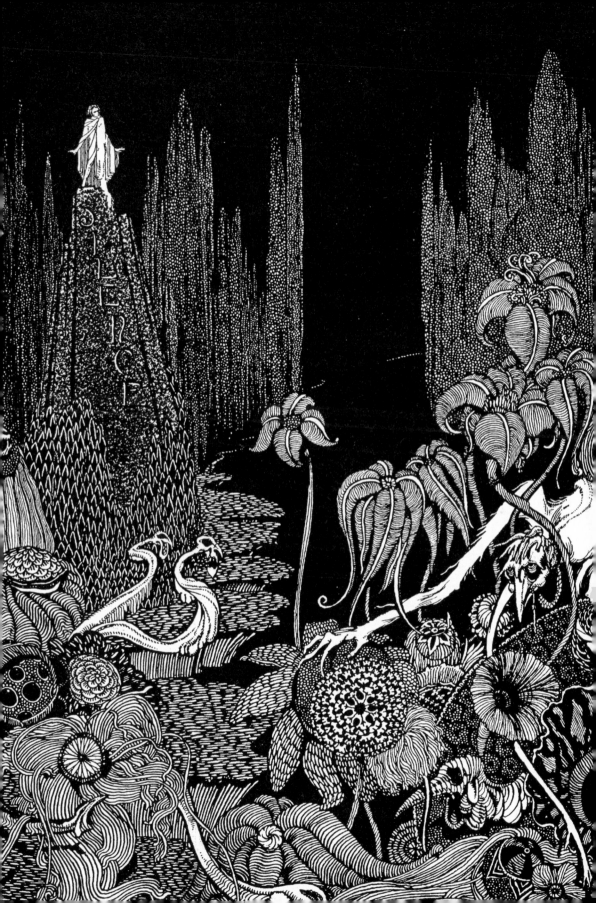

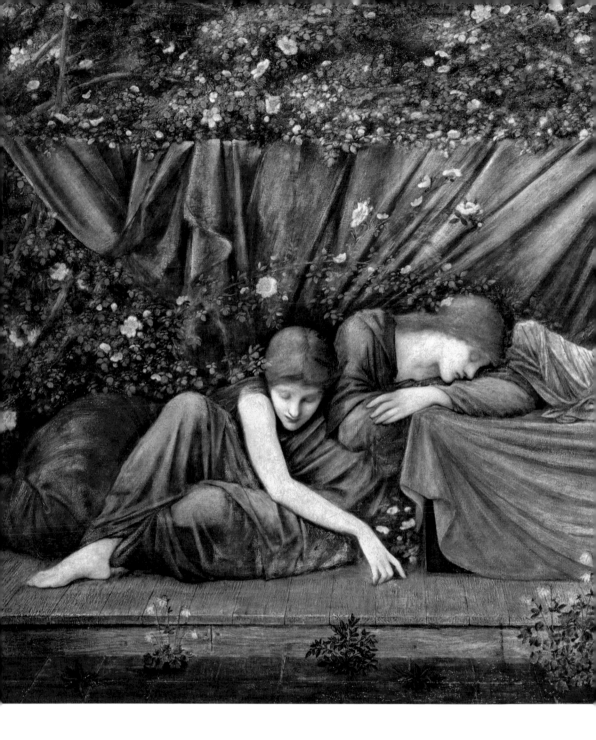

Edward Coley Burne-Jones · *Sleeping Princess*
England · 1874 The origin story of *Sleeping Beauty*
comes from *The Legend of the Briar-Rose*, a
thorned bush that entangles the kingdom where
the enchanted princess awaits her rescue, famously
captured in a series of four paintings.

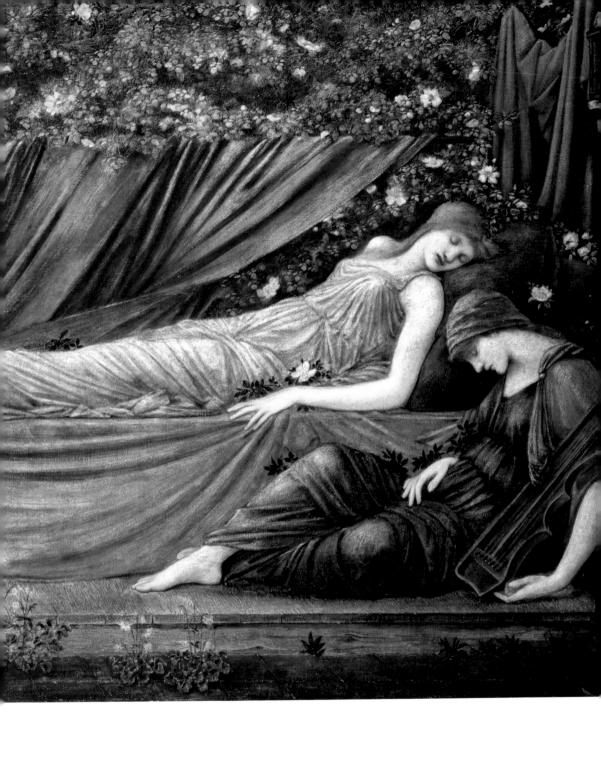

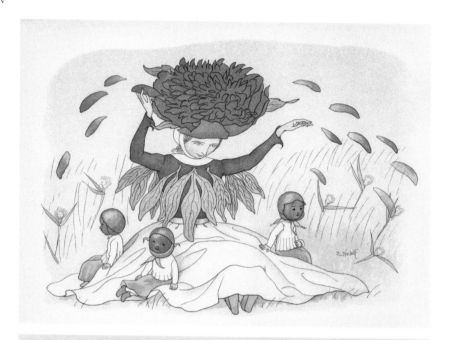

(above) Ernst Kreidolf *Clemantis* · Switzerland 1911 In this interior illustration from the children's book illustrator's 1911 publication *Der Gartentraum (The Garden Dream)*, a narrative populated by Kreidolf's signature flower fairies and botanical sprites.

W. W. Denslow · *The Cowardly Lion, Scarecrow and Tin Man in the Deadly Field of Poppies* · England 1906 As they venture to meet the 'Wizard of Oz,' Frank Baum's characters become lulled to sleep by the poisonous poppies, yet powerfully intoxicating.

Sir John Tenniel · *Painting the Roses Red* · England 1865 In *Alice's Adventures in Wonderland*, the knights must paint the roses from white to red, or the queen will behead them. The symbology suggests that she prefers red for violence and fury, as opposed to white for kindness and purity.

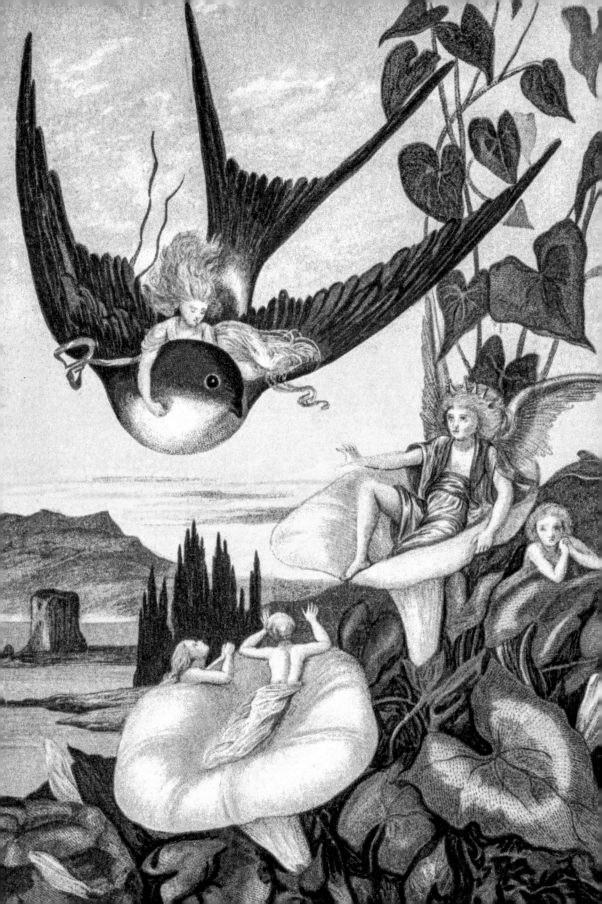

I have been a devotee of nature since I can remember. At a young age I started working with plants and flowers as allies in self-expression. In floristry and garden design I was able to cultivate a deep relationship with the cycles of the seasons and a listening of the plants that has stayed with me. From my early practice of creating poetic expressions in the form of floral designs to now being an herbalist and healer who works intimately with the medicinal and spiritual aspects of nature, it always ties back into our ability to be in a relationship. The cross section or co-creative field between humans and the natural world is now my passion and is where all my inspiration and work stems from. Matching people up with their plant allies is a magical alchemy that I love being a part of. I think in the language of plants and flowers. I see human beings as a part of nature and so a lot of my work and study is around mending and tending to this intimate relationship. How can we cultivate more self-acceptance and heal our wounds so that we can begin to walk more intimately with our own true nature? Co-creative partnership with this planet is the medicine I believe is needed at this time and to achieve that consciousness shift we must recognize our natural place in the web of life. We are not at the center but one strand within the web. We have been living in a non-harmonic way with our environment. This divide has caused a lot of pain for both ourselves and the Earth. It's so vital for our survival that we begin to ground into guidance and build strong intuitive capacities once again so we can have the strength to stand up for what is best for all of life.

— KRISTEN CAISSIE, Herbalist, Florist, Founder of Moon Canyon, 2022

Eleanor Vere Boyle · *Illustration from Thumbelina* Scotland · 1872 Raised in the Scottish countryside, nature was hugely influential to Boyle's work, which often includes flowers and plants, as in this illustration for the story of *Thumbelina* from an 1872 edition of *Hans Christian Andersen's Fairy Tales*.

(previous pages) John Everett Millais · *Ophelia* England · 1851–52 One of the best-known artistic renderings of Shakespeare's Ophelia, who calmly sinks in a river drowning, still holding the symbolic flowers she was known for.

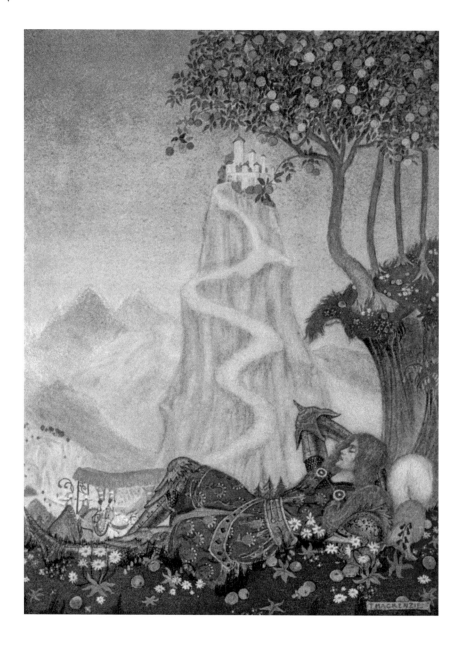

Thomas Mackenzie · *Lancelot Lay Sleeping Under the Apple Tree* · England · 1920 Due to the intensity of traveling in the sun, Lancelot seeks the shade of the famed apple tree under which he falls to sleep and is found by the sorceress Morgan le Fay.

Unknown · *The Seven Dwarves Mourning Snow White* · France · 1911 From the Grimm Brothers fairy tale, Snow White was murdered by a poisoned apple and honored with ample flowers.

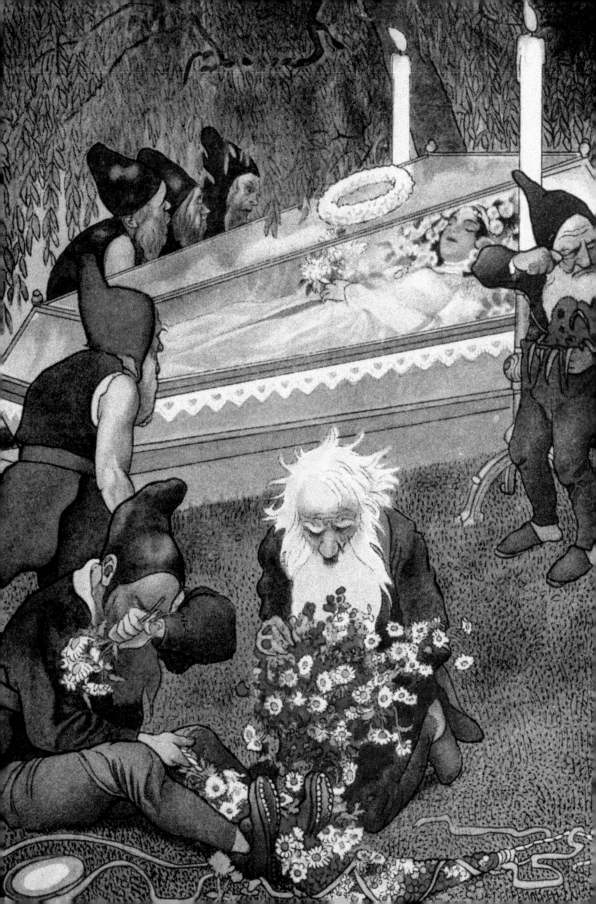

PLANTS AS MUSE

Nature & Contemporary Culture

When you take a flower in your hand and really look at it, it's your world for the moment. I want to give that world to someone else. Most people in the city rush around so they have no time to look at a flower. I want them to see it whether they want to or not.

— GEORGIA O'KEEFFE, from an interview with *The New York Post*, 1946

Plants and nature have been the artists' muse since the earliest cave paintings depicting mushrooms, cactus, and flowers – powdered mineral pigments rubbed onto stone in the flicker of firelight. Nature is inspiration across all mediums and art forms, word to page, ink to canvas, the snap of the shutter. There are certain artists for whom nature was a central and continually evolving motivation to manifest work, artists we immediately align with imagery of flowers or plants, trees, or gardens. Van Gogh's sunflowers, vivid and bright, the artist documenting the natural realm with a vibratory, slightly hallucinogenic immediacy. There is Monet in his garden at Giverny, growing wildflowers beside Roses, crawling vines amid tidy shrubs, a garden painted more than planted, organized with the beautiful cacophony of an artist's palette. There is the Symbolist Paul Gauguin, immersed in his sunlight and Palms, French Polynesian reveries; and the luminous floral explorations of Henri Matisse, once quoted as saying, "There are always flowers for those who want to see them." Centuries prior, in the 1500s, the Italian painter Giuseppe Arcimboldo created

playful detailed paintings by anthropomorphizing plants, fruits and flowers into figures in a series of works that set the natural realm at their center.

Later, the Surrealist Movement would approach nature with the same whimsical eye, playing with size and form, mutating the physical world into multiple dimensions of their own. In Salvador Dalí's visions, a rose hovers immense and sensual over vast plains of dry grass. In Dorothea Tanning's dreamlike imagery, a giant sunflower sprawls down a wide staircase, its green stem wrapped seductively around a young woman's waist. In the early 20th century, the newly invented medium of photography focused the artist's lens on natural subjects. The renowned Ansel Adams approached his photographic documentation of trees with a singular intensity, his images capturing and amplifying their innate majesty and power. His contemporary, Imogen Cunningham photographed botanicals with a gentle, seductive intimacy – a Calla Lily with its feminine curve of white blossom, an agave leaf, large and leathery, its edges

Salvador Dalí · *The Rose* · Spain · 1958 Perhaps the most multi-symbolic flower of them all, the rose gets a subtle surrealist treatment as the star of the floral world.

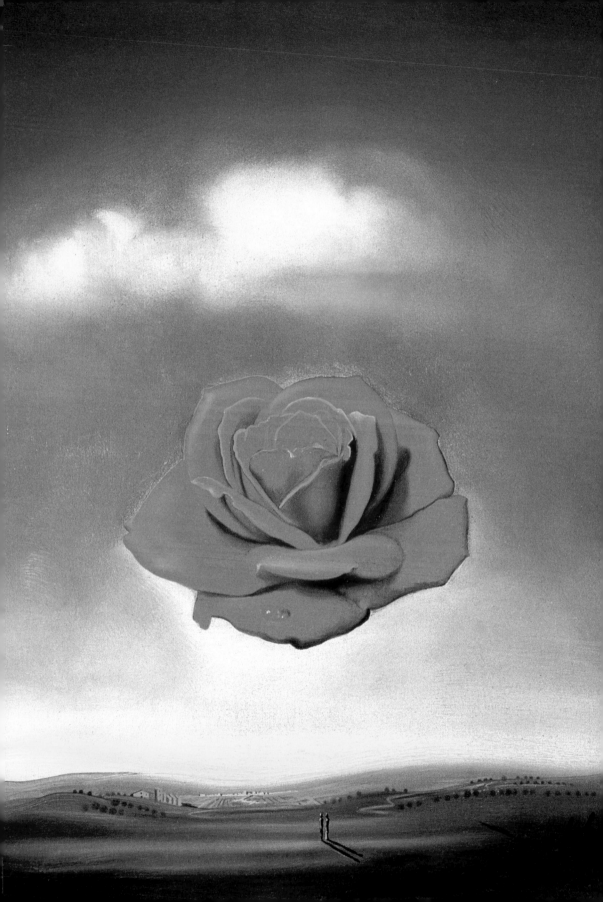

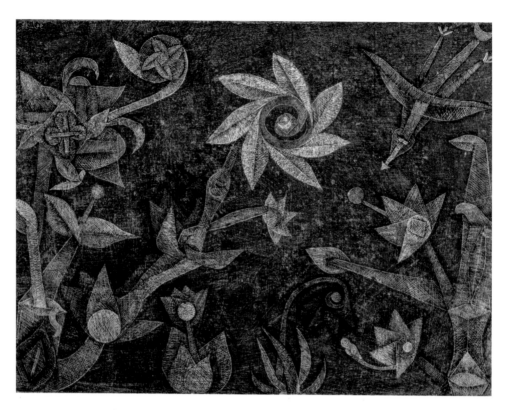

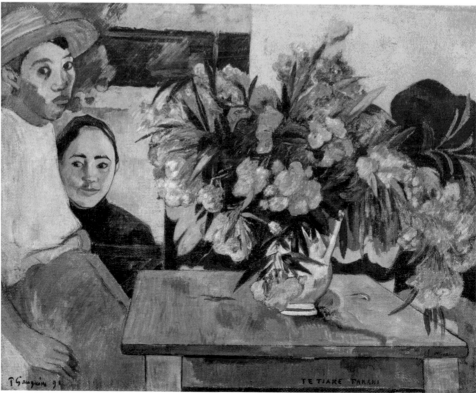

intensely serrated. Edward Weston captured the skin of the common green pepper in lush black and white, the image reminiscent of the smooth, curved back of a woman. Later, the artist Robert Mapplethorpe would bring a similar element of arousal and carnality to his images of plants and flowers, documenting the eroticism of the botanical world with the eye of a lover in longing. Decades earlier, the artist Georgia O'Keeffe would famously state, "My painting is what I have to give back to the world for what the world gives to me." For O'Keeffe, that reciprocal generosity came in the form of lush, fearlessly vivid reflections of the natural world around her, the bleached bones and smooth totemic stones of the New Mexican desert, and flowers — Datura blossom, crimson Poppies, fringe-petaled Iris — all rendered into sensuous, voluptuous imagery, the viewer pulled in close — seduced.

Later Andy Warhol would make nature "Pop," particularly with his 1964 *Flowers*, a series of vibrant floral lithographs. Meanwhile, plants were becoming not only a muse to artists, but visionary medicine as well, with the advent of the Psychedelic Art movement and the creation of artwork under the influence of cannabis, magic mushrooms, peyote cactus and other psychoactive plant compounds. The subsequent effects can be seen across the counterculture works of the era, in popular movies and music and on the gallery walls as well, such as in "Looking for Mushrooms," the 1967 experimental film by the multimedia artist and filmmaker Bruce Conner, and in the groundbreaking works of Marjorie Cameron, specifically her unabashedly feral and sexualized 1961 illustration titled,

"Peyote Vision." The composer John Cage is another example, finding creative inspiration in his mycological studies. The natural world itself would eventually transform into both canvas and medium — most notably in the prolific land art works of Andy Goldsworthy, and in the riotous, oversized, flower-covered sculptures of Jeff Koons, whose 1992 work "Puppy" features a 43-foot-tall depiction of a West Highland Terrier covered by over 60,000 flowering plants. More recently the Japanese artist Azume Makoto has sent floral arrangements into space, set them aflame and encased them in enormous blocks of ice. The incorporation of natural elements into immersive installations, photographs and other mediums has also become a means of activism, serving to elevate and promote platforms for environmental and ecological causes. The South American photographer Sebastião Salgado has continually turned his lens on the vast destruction of the Amazonian rainforest in a quest to raise awareness of climate change and deforestation. His non-profit, Instituto Terra, established in 1998 by Salgado and his partner Lélia, has subsequently planted more than 2.5 million trees in their homeland of Brazil. Another example is the multi-media artist Yoko Ono's creation of the ongoing interactive installation, "Wish Tree" which encourages participants to pen their wishes onto strips of paper which are then hung onto living trees. Describing the core intention of the work, Ono explains, "the hope is that these wishes go out to all corners of the planet and give encouragement, inspiration, and a sense of solidarity in a world now filled with fear and confusion. Let us come together to realize a peaceful world."

Paul Klee · *Crucifers und Spiral Flowers* · Switzerland/Germany · 1922 Influenced by both Cubist and Surrealist schools, Klee created highly individualistic works. This painting of flowers is indicative of his approach, which often combined elements from nature with mathematical geometric forms.

Paul Gauguin · *Te Tiare Farani (Flowers of France)* France · 1891 Gauguin often incorporated nature in his work. Though known for his later career paintings depicting his time in tropical Polynesia, here Gauguin explores the flora of his native homeland of France.

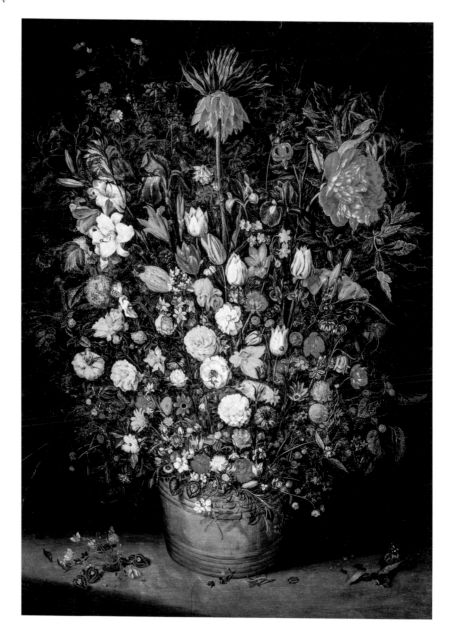

Jan Brueghel The Elder · *Vase with Flowers* · Belgium 1603 One in a series of nature paintings by the Flemish Master of landscapes and floral bouquets, this work is sometimes referred to by the title, "Bouquet of Flowers in an Earthenware Vase."

Giuseppe Arcimboldo · *Flora* · Italy · 1591 The artist's use of flowers and fruits to create symbolic humans is perfectly appropriate for his depiction of Flora, the Roman Goddess of flowers and spring.

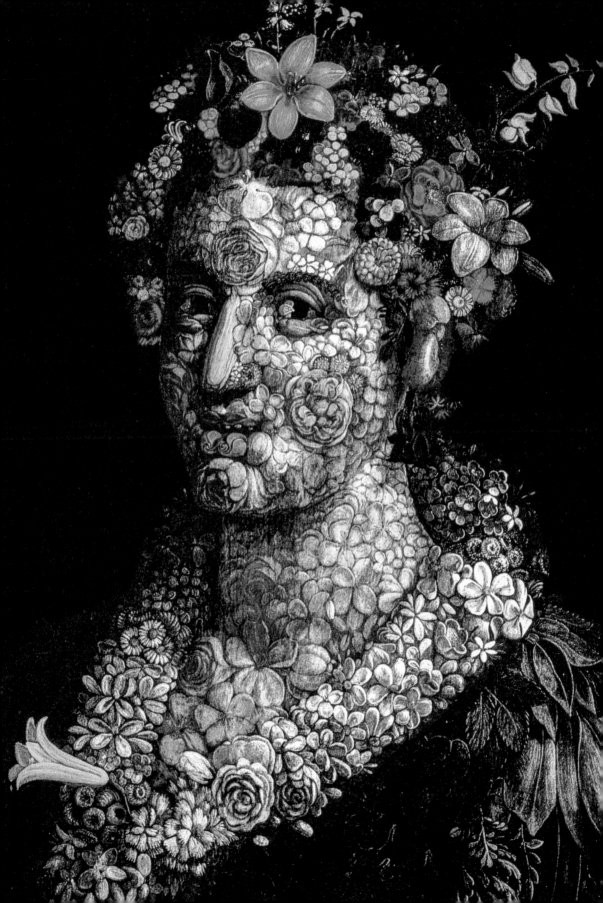

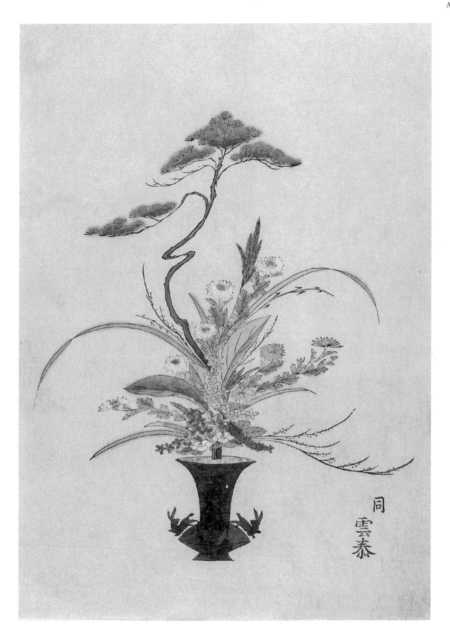

Clara Maria Pope · *The Flowers of Shakespeare*
England · 1835 A watercolor montage of all the
different flowers Shakespeare refers to with famil-
iarity in much of his writing, often using their
folkloric names and alluding to their popular uses.

Takada Anritsubō · *Flower Arrangement* · Japan · 19th
Century Ikenobō is the oldest school of ikebana
flower arranging in Japan. It was founded in the
15th century by Buddhist monks. Ikenobō utilizes the
flower's bud more than the full bloom, for within the
bud is the energy of life's blossoming for the future.

457

Frida Kahlo · *Roots* · Mexico · 1943 The poetic
description of Kahlo's self-portrait is one of sensual
embrace with the vine of Mother Earth herself,
entwined and penetrated – in oneness, as oneness.

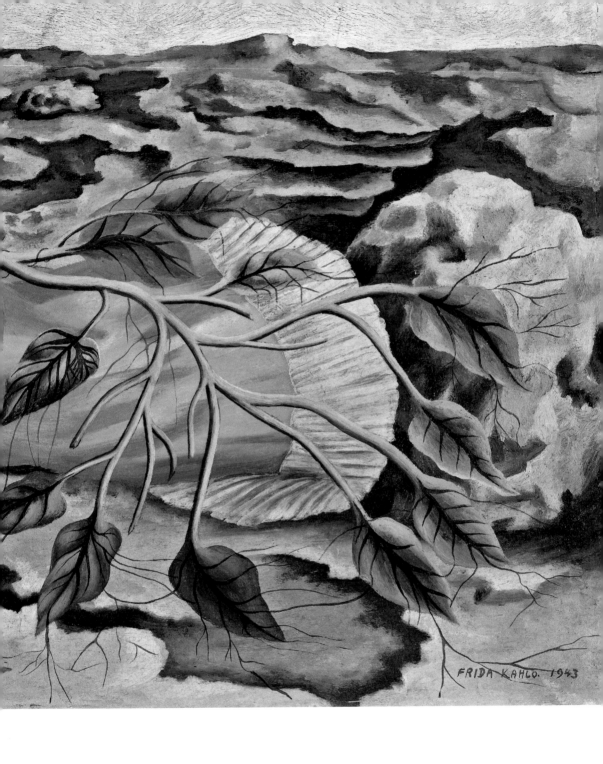

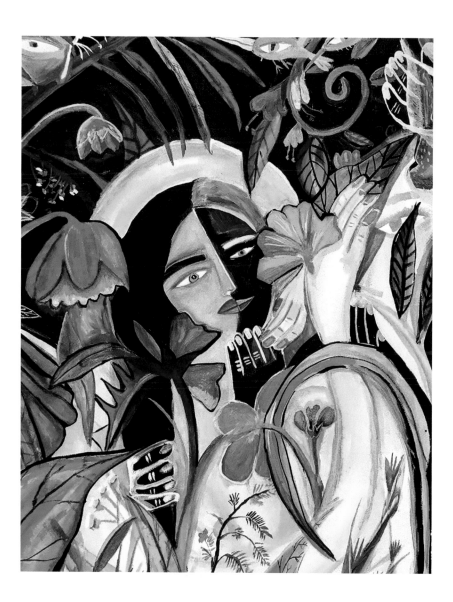

Elena Stonaker · *Juni's Garden* · United States · 2017
The American fine artist and designer Stonaker is
known for her intricate textile work and soft sculp-
ture installations created through myth and nature-
based narratives. Much of her work explores nature
and plant-life through a playful, fantastical lens.

Alphachanneling · *Flower of Life, Underwater*
United States · 2015 The artist's dialogues with
various plant teachers is woven throughout their art-
work. As they explain, "In the same way that a plant
turns towards the sun, I believe my desire turns me
on to that which nourishes me and makes me grow."

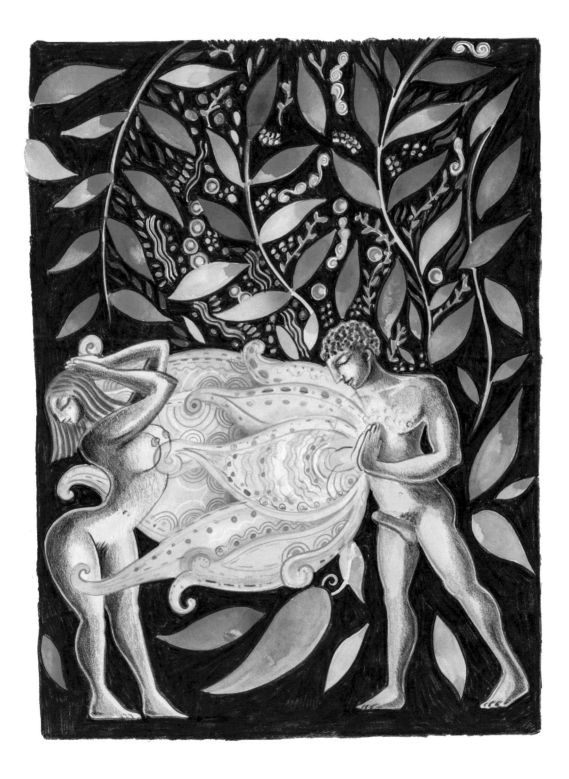

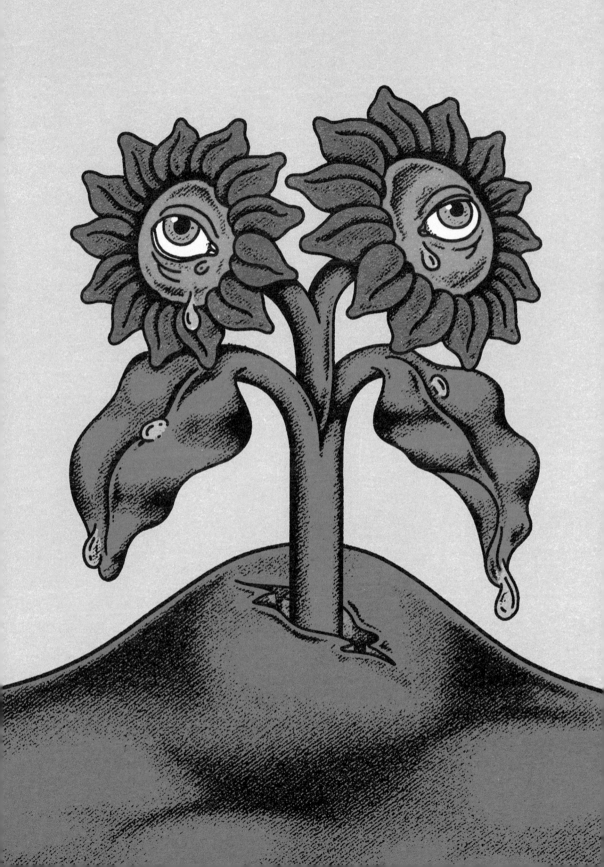

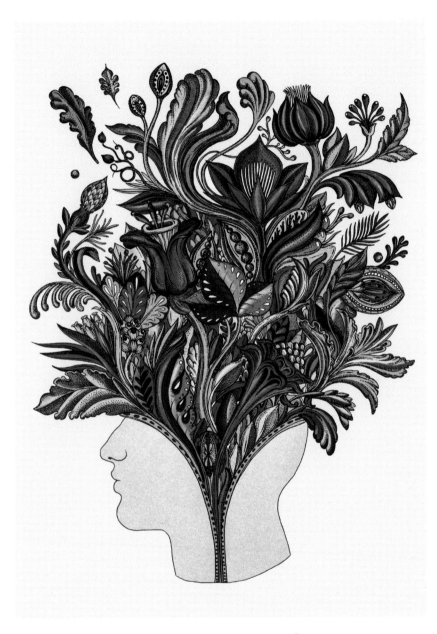

(following and left)
Sarah Stewart · *Willow*
United States · 2022
A muralist and painter, Stewart goes under the moniker Rattlesnakes and Rainbows. This work is part of an ongoing series of illustrations created for an oracle deck featuring plant and botanical symbology. As Stewart explains, "this deck focuses on the energetic healing properties of botanicals, more specifically, flower essences. They are plant spirits that work upon our energetic body to help restore balance and health."

River Cousin · *Heal by Numbers #1* · England 2022 The British illustrator explores gender, transformation, and hallucinogenic enlightenment in his work, often incorporating fantastical elements which push at the boundaries of perception.

Katie Scott · *Foliage* · England · 2017 Scott is known for her vivid and detailed illustrations of plants, flowers, fungi, and other botanicals. As she explains, "I can't imagine a life without flowers and plants… I enjoy looking after them and having a relationship with them."

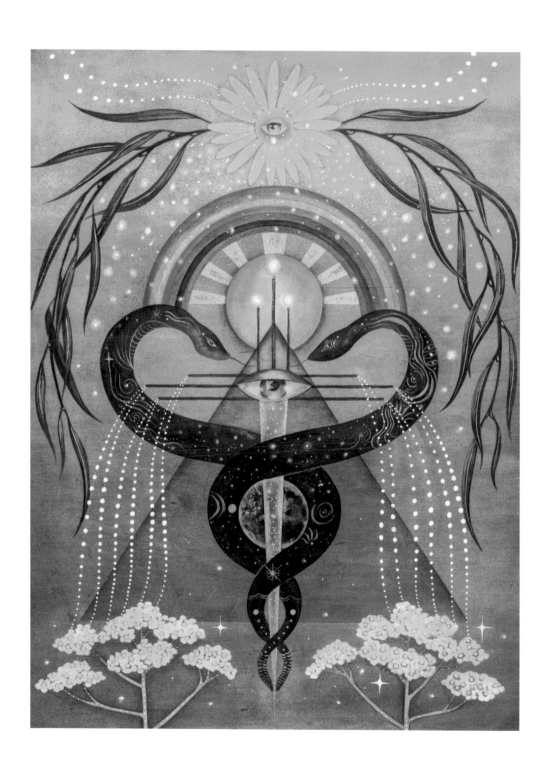

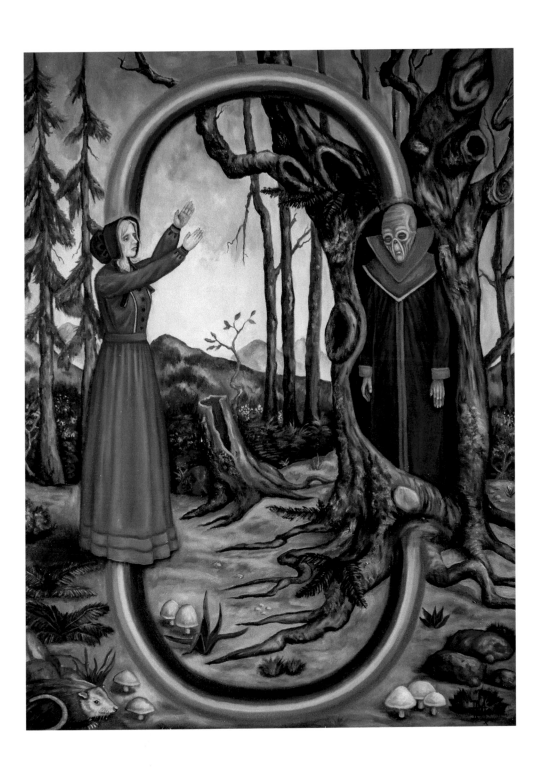

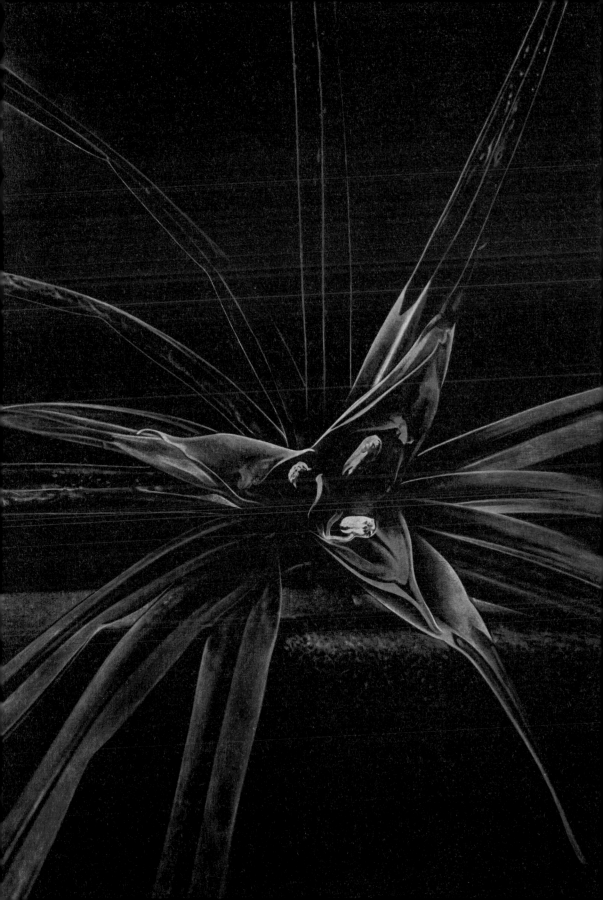

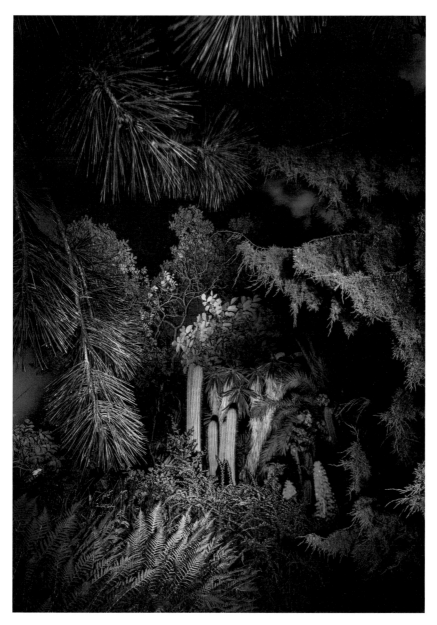

(previous and right)
Mark Rogers · *Energy
Cycle* · **United States
2020** Building mythical
narratives within his
works, often set in
otherworldly natural
landscapes, the artist
documents an ongoing
exploration which, as
they explain, "illustrates
a fictional series of
events and interactions
between various
extraterrestrials and
settlers of the Western
United States. As I
draw in my sketchbooks
to create the concepts
for my paintings, I am
slowly building and
expanding on a western
fantasy world."

Becca Mann · *Pandanus Flower* · **United States
2020** The flora of Mann's native California and
the Pacific are explored in exquisite detail as part
of a series of oil and flashe paintings capturing rare
blooms, botanicals and cacti in the artist's emotive,
intricately realistic style.

Linda Westin · *Illuminated Dendrology – Dimensional
Forest II* ·**Sweden · 2019** One in a series of works
by the Swedish artist that explores nature through
her experience as a neuroscientist using super-reso-
lution fluorescence microscopy. Westin is guided by
"physics, mathematical symbols and rules."

467

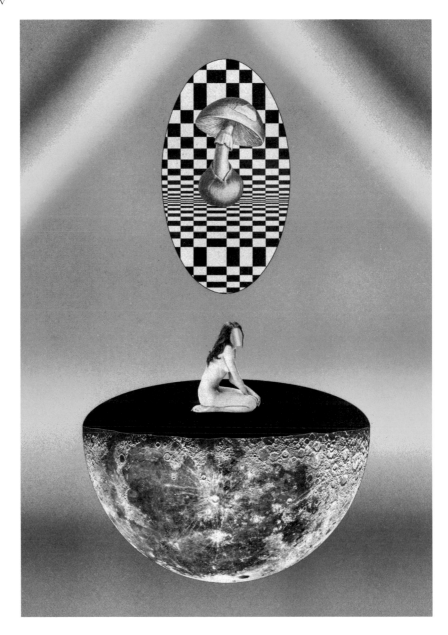

Mariano Peccinetti · *Mushroom* · Argentina · 2021
Working primarily in collage, the artist Peccinetti
creates playful, psychedelic works that celebrate the
magic of fungi.

Javiera Estrada · *The Miami* · United States · 2017
Estrada's work encompasses photography, mixed
media, sculpture, installation, and film. In her work,
the artist often explores what she explains as, "the
complexities of the subconscious mind, dreams,
and the polarities between darkness and light."

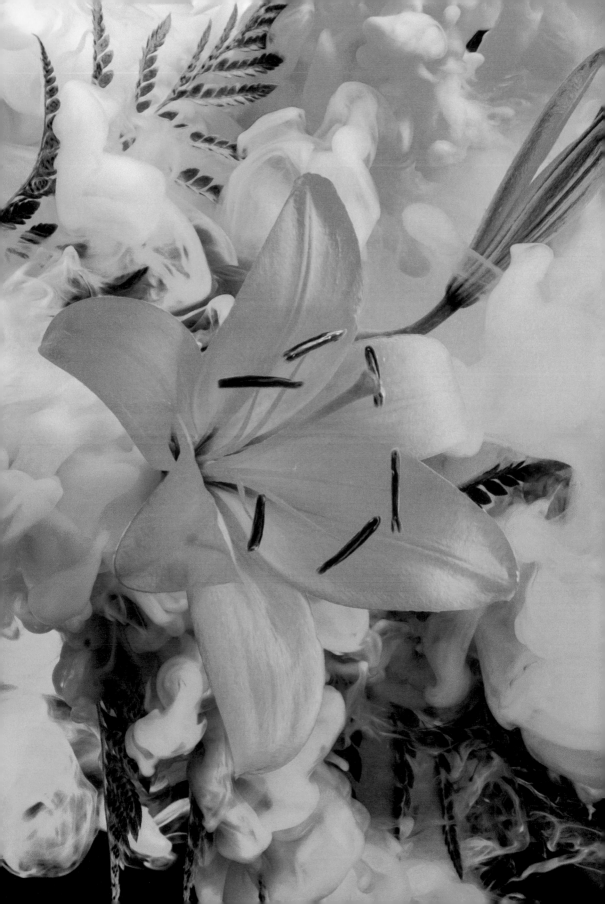

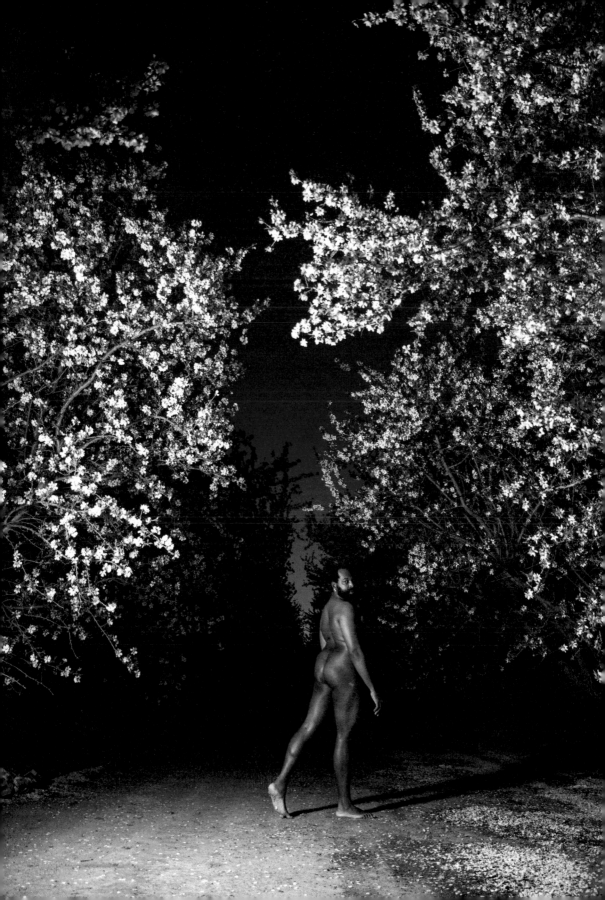

(following pages)
Daniel Herwitt
Untitled · United States
2018 Manifesting fluidly
psychedelic botanical
landscapes, Herwitt,
sometimes working
under the moniker
"Sunflower Form" has
created album art, post-
ers, and other merchan-
dise for musical acts
such as Talking Terps
and the Grateful Dead.

Maurice Harris · *Self Portrait, Almond Orchard*
April · 2021 The florist, performer, and multimedia
artist Harris places their own body at the center of
this expressive and intimate self-portrait captured
at night among rows of almond groves.

Lani Trock · *Monero, the unknowable* · United States
2016 A multi-disciplinary artist based in Los Angeles,
Trock works with audiovisuals, movement, sculpture,
and immersive, installations to facilitate planetary
evolution into biosphere consciousness.

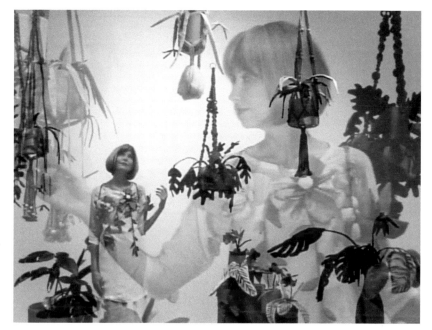

Jade Gordon and Megan Whitmarsh *Barbara* · United States 2019 In this, work in progress video, soft sculpture, and performance piece, the artists explore an ongoing and evolving narrative. As Gordon explains, "The house is the body in dreams. Barbara (Emily Anderson) is a realtor who sees herself as a 'relator.' She is a dancer communicating with flowers. This is a vision of her inner life."

(opposite) Elana Stonaker · *Soft Flower* United States · 2019 Working across multiple mediums, from painting to immersive and interactive art, Stonaker also brings her uniquely whimsical visions to the fabric art and soft sculpture, which often depicts oversized plants, trees, and other wild creatures.

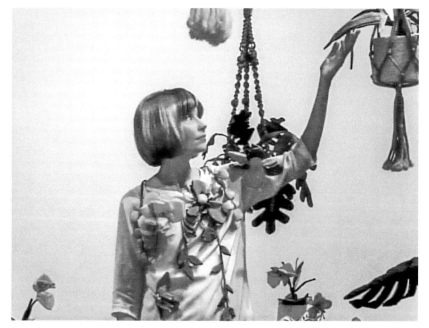

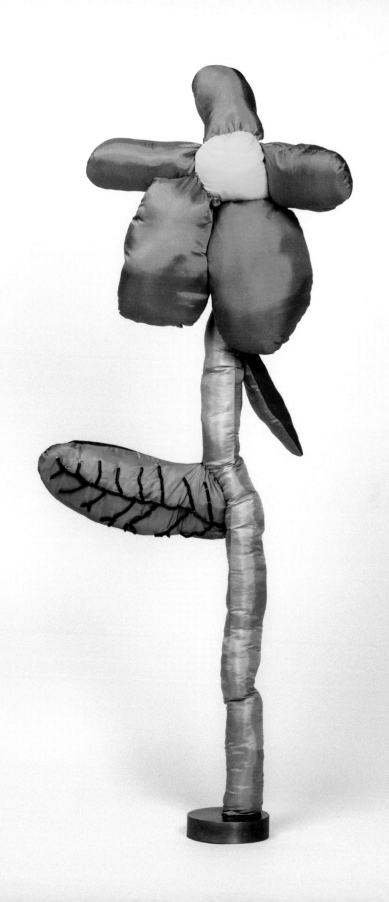

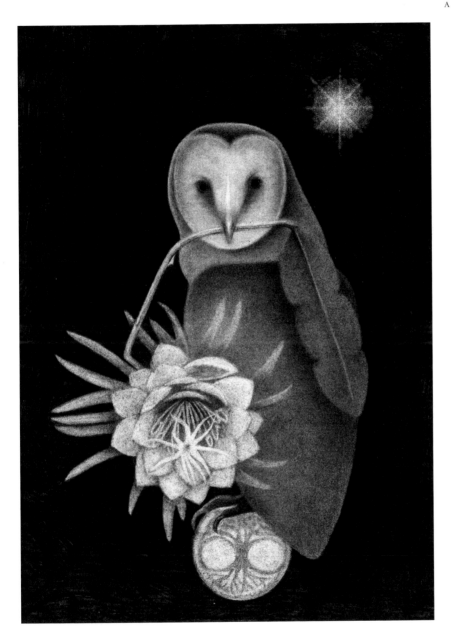

Becca Mann · *Nightblooming Cereus* · United States
2018 The artist explains "The Cereus project is
ongoing and varies in approach. These are contact
prints from a hand-painted negative, made in the
darkroom as a nod to the epiphytic nightbloomers
and night pollinators."

Meagan Donegan · *Owl Bringing Cereus* · United
States · 2021 Donegan's intricately detailed work
explores an enchanted dreamlike realm populated
by mythical animals and botanicals.

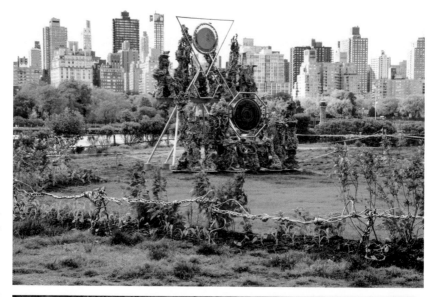

Guadalupe Maravilla
*Disease Throwers (#13 &
#14)* · United States
2021 As part of the
artist's ongoing 'Disease
Thrower' series. The
sculptures feature vari-
ous symbolic elements,
including cast fruits and
vegetables. A medicinal
garden surrounds the
sculptures, and includes
the plantings of corn,
squash, beans – key
crops for Indigenous
communities in the
Americas, along with
roses, tobacco, and
various plants with
healing properties.

Guadalupe Maravilla
*Aerial view of Tripa
Chuca* · United States
2021 Maravilla
expanded upon a game
from his childhood in El
Salvador called, "Tripa
Chuca" where players
simultaneously draw
lines that never touch,
to create a temporary
artwork inside a circular
garden of medicinal
plants.

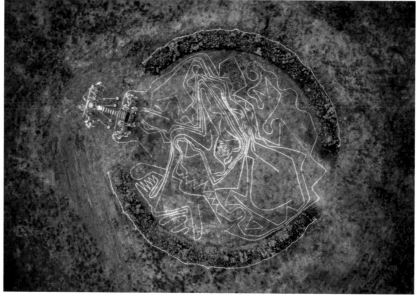

(opposite) Elena Stonaker · *In the Garden* · United
States · 2019 Multimedia artist Stonaker explores
nature, myth, and feminine symbology in her works.
A common setting in many of her pieces is a fantasti-
cal natural realm, where the bodies play in intimate
interaction with the plant and botanical world.

(following pages) Inka Essenhigh · *Rave Scene*
United States · 2022 Essenhigh's detailed and
fantastical paintings express a keen awareness of
nature's beauty and elasticity through seasonal
cycles. In this work flowers are anthropomorphized,
creating a celebratory dance scene.

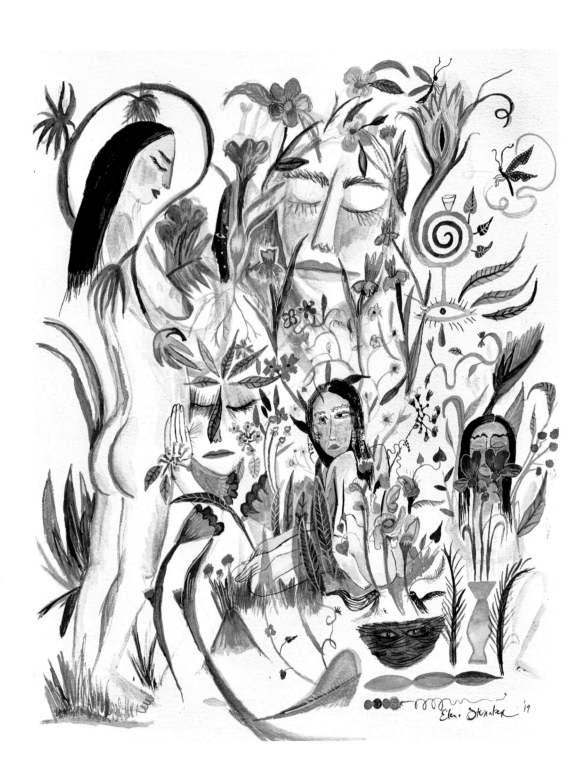

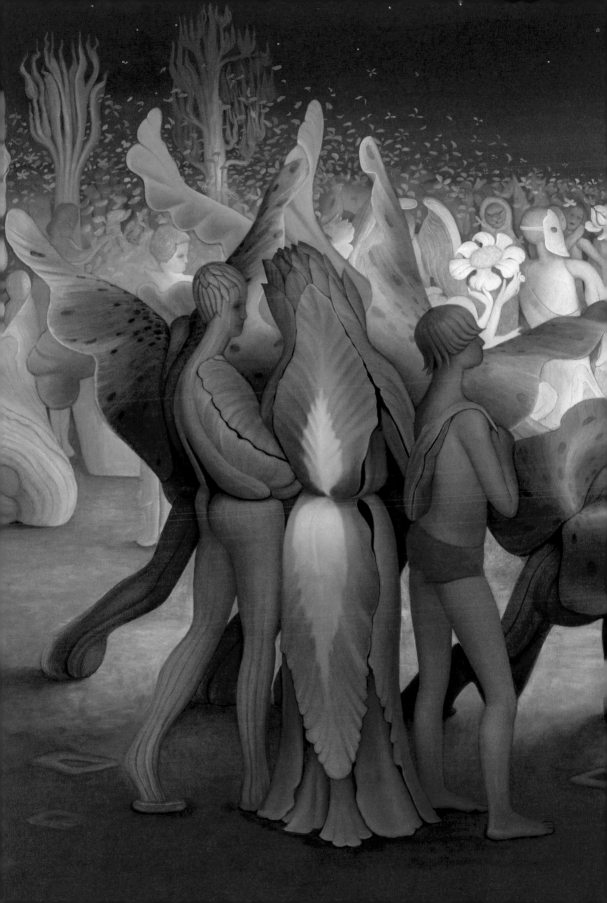

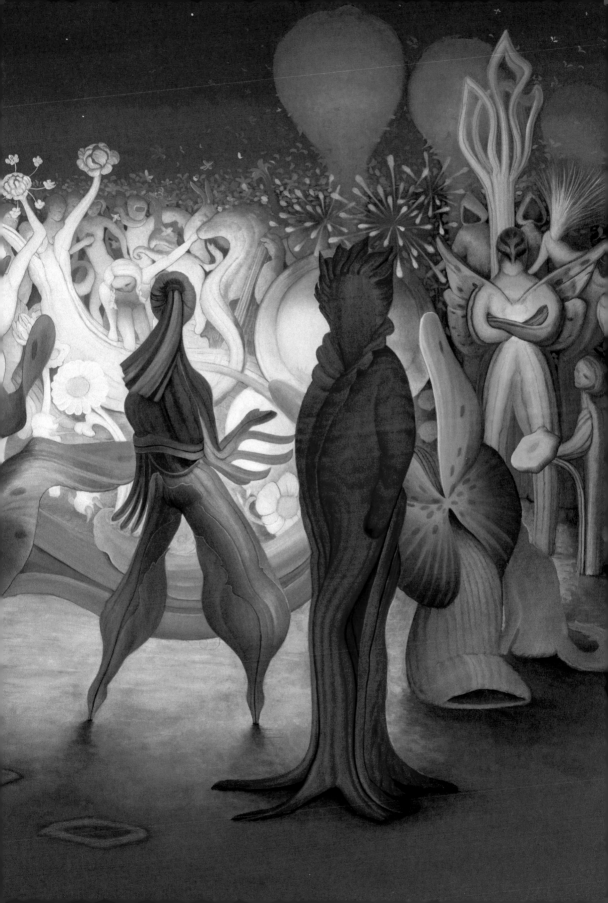

River Cousin · *Love & Fear* · England ·2020 The contemporary illustrator Cousins' work explores, as they explain, "the surreality of childhood, gender and sexuality, non-binary identity as a lens to explore the grey areas, 'in-betweens', wake, and sleep, dark and light, masculine and feminine.

Alphachanneling · *Two Souls — Moment of Recognition* United States · 2016 The American artist's work captures what they describe as, "a mythical world of the Utopian Erotic, a holistic exaltation of sexuality, carnal, explicit, and provocative, but in the most gentle, graceful, and reverential way."

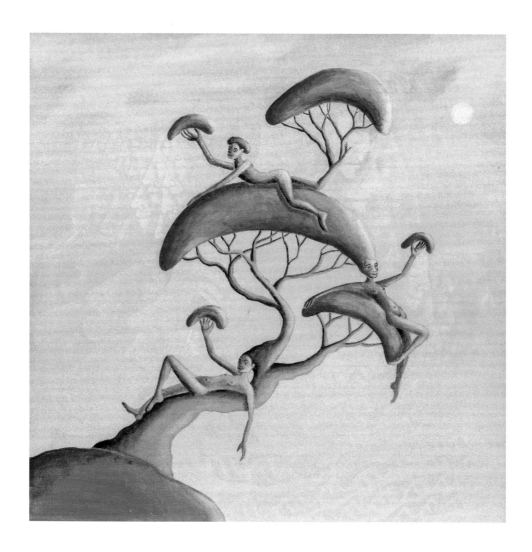

Freyja Dean · *Ostara* · England · 2022 The artist studied Scientific and Natural History illustration, subjects that have influenced her work in various creative fields such as costume design, character design for computer games, album covers and art-works for various medical and science museums.

Marlene Steyn · *The Nudie Branch* · South Africa 2021 The multimedia artist Steyn's tapestry-like paintings work, as the artist explains, "to subvert the medium of painting and draw on a multitude of references: art history, psychoanalysis, mythology and contemporary culture."

Unknown · *Leonor Fini* · France · 1962 The master of surrealist costume, art and set design is photographed at an exhibition in Paris. Her body was often her vehicle for artistic expression, using flowers and feathers as creative clothing.

Javiera Estrada · *Beauty* · United States · 2017 The Mexican American artist works in multiple mediums. Her photography work reflects her search for the spiritual. As she explains, "every piece of art created is a self-portrait, a physical expression of that inner nameless world our soul inhabits."

Rodarte · *Backstage at the SS19 Rodarte Show*
United States · 2019 Backstage detail photo-
graphed by Nina Westervelt of Rodarte's Spring
Summer 2019 Collection, with hair design by Odile
Gilbert and real rose garlands by Joseph Free.

William Lemon · *Morning Ideas, Afternoon Work*
United States · 2022 Part of a series called "Spells
for the Home," the artist created these works as
a way of "inviting the seer to notice the beauty in
details and relationships between things."

(following pages)
Remedios Varo · *Tiforal*
Japan · 1947 In this
fantastical work by
the Spanish Mexican
surrealist, a series of
sculptures resembling
animate creatures,
populate a lush and
utopian garden.

Tyrone Williams · *Untitled* · England · 2017
In his meditative and abstract documentations
of both the man-made and the nature world, the
British photographer Williams, focuses on finding,
as he describes, "beauty in the mundane."

Andie Dinkin · *Marie Antoinette's Hairdo* · United
States · 2021 The American illustrator takes
inspiration from the botanical realm in many of her
works. In this whimsical piece, an expressive hair
style is populated with florals, plants, and other
creatures from the realms of nature.

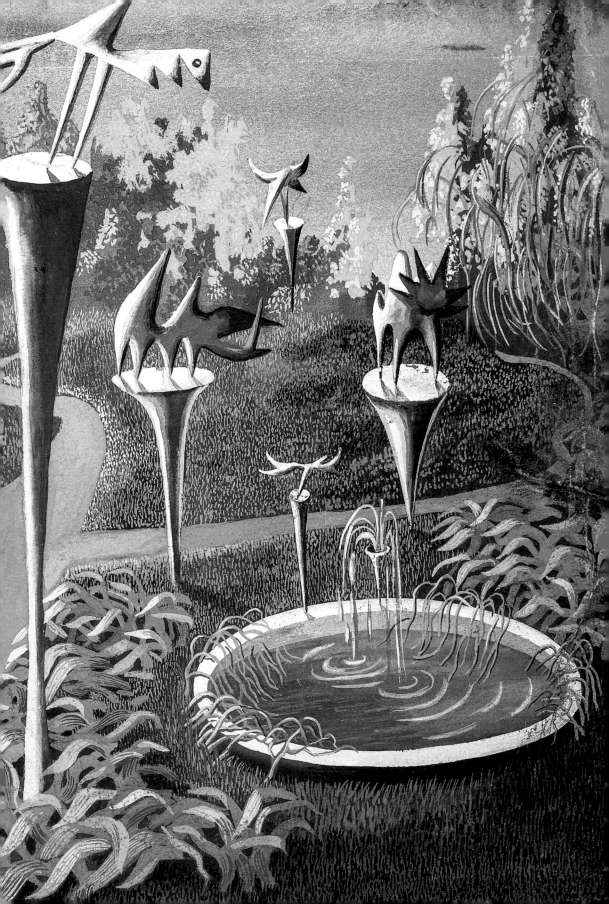

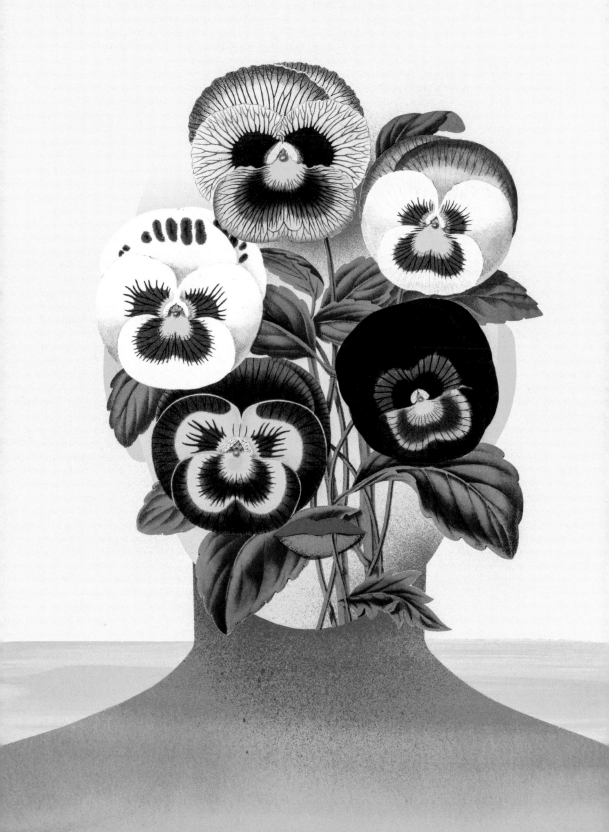

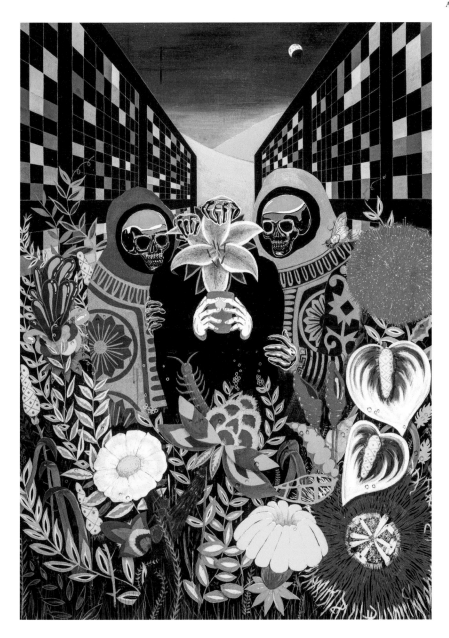

Valero Doval · *Florescence II* · Spain · 2021 One in
his ongoing Florescence Series, this piece exemplifies
what they explain as the common thread that runs
through all their work, "a tendency to look for beauty
in contrast; in the combination of opposing concepts
that mirror the diversity of man and nature."

John Dwyer · *The Text* · United States · 2020
The multimedia artist Dwyer explores themes of
sci-fi, fantasy, nature and future dystopias in his
paintings, films, and musical compositions.

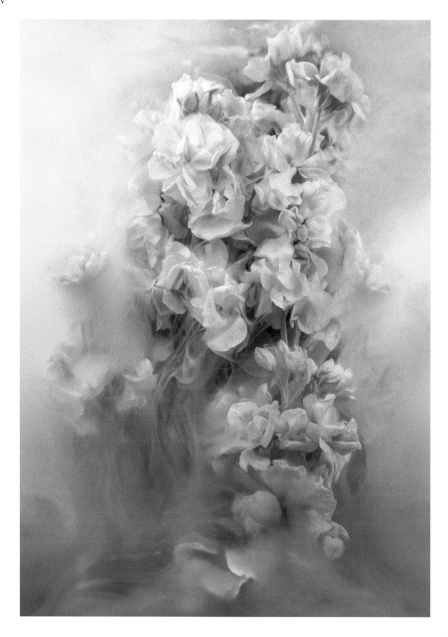

Javiera Estrada · *Butterflies* · United States · 2017
Using photography as her focal medium, the sound
of the camera's click offers Estrada, "the perfect
confluence between the real and the ethereal."

Florence Welch and Autumn de Wilde · *Photography
for Florence + The Machine's 'Dance Fever' album
packaging* · England · 2022 Creative direction and
photography by Autumn de Wilde, with florals by
Rob Hedderwick, hair by Odile Gilbert, and back-
drop painted by Thomasina Smith.

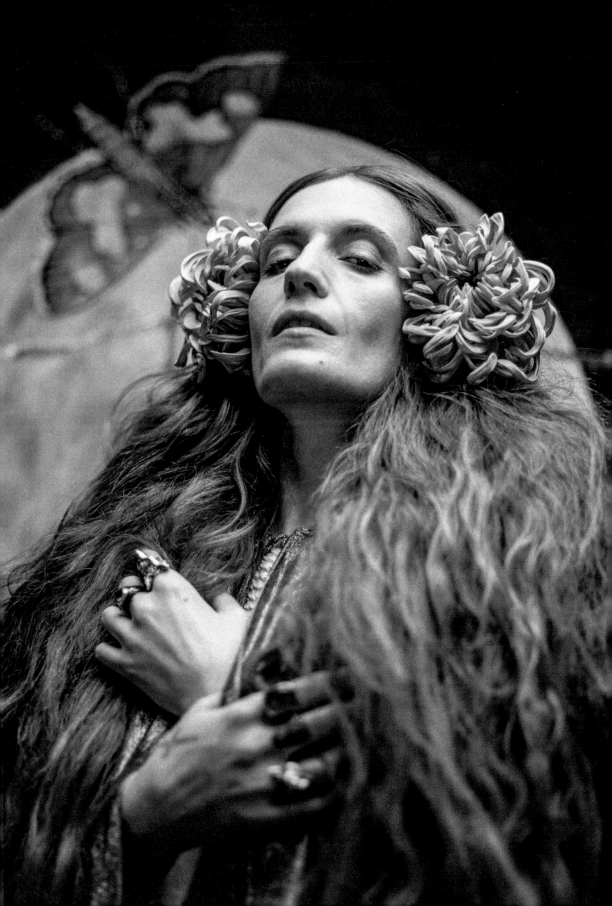

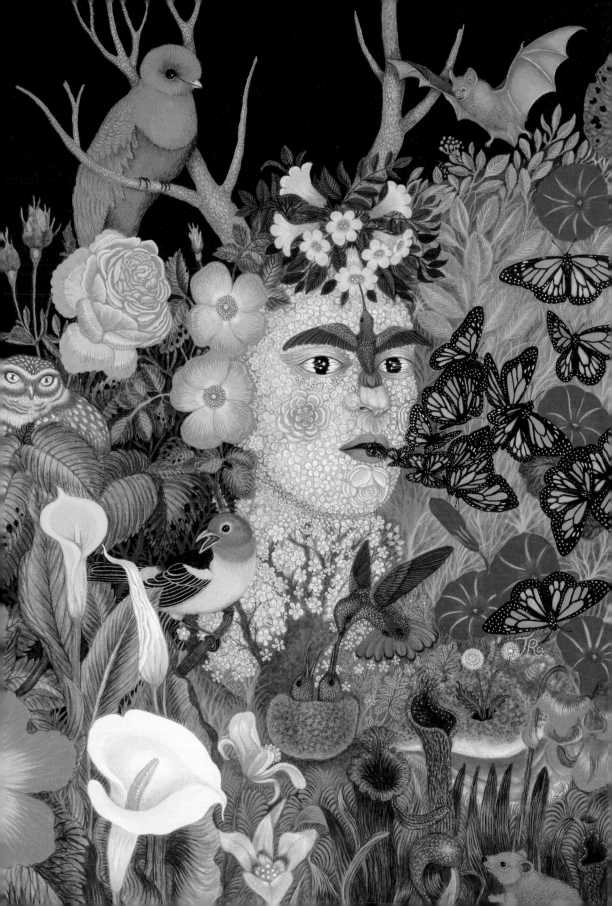

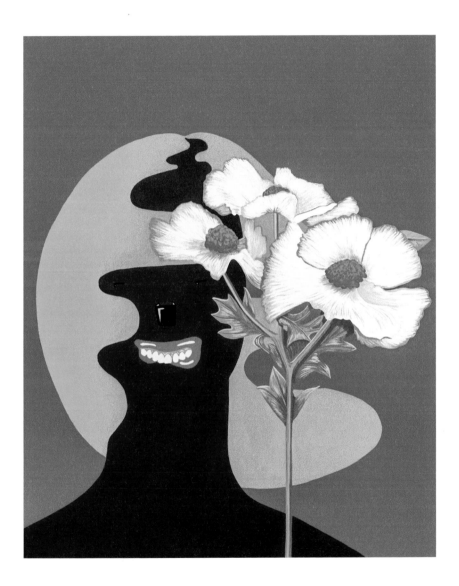

Tino Rodriguez · *World Without End (A botanical portrait of the artist Frida Kahlo)* · United States 2022 The Mexican American painter and illustrator Rodriguez pays homage to the artist Frida Kahlo in this exuberant work integrating vivid florals blooms and botanicals.

Chris Fallon · *Swamp Series, Matilija* · United States · 2020 One in a series of works featuring floral elements integrated with portraiture, Fallon gives detailed attention on the botanicals, intricately expressed flowers and plants juxtaposed with a pop comic illustrative style of faces and figures.

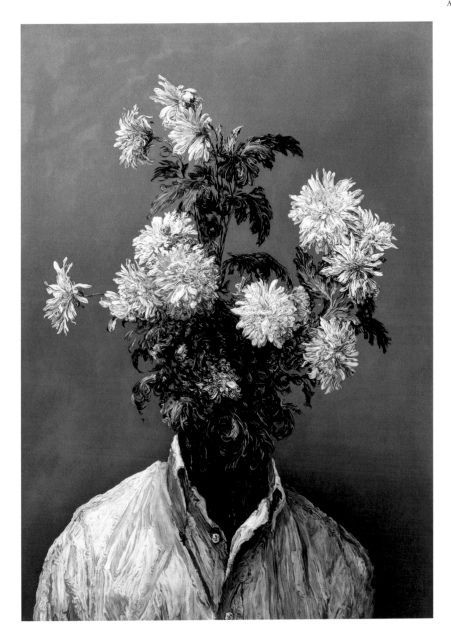

Lani Trock · *Ethereum, Seize the means of production*
United States · **2017** Seeing this universe as an
interconnected, symbiotic organism, Trock's work
envisions new paradigms that embody a cultural
shift from scarcity, commodification, and competition,
to abundance, collaboration and mutual benefit.

Glenn Brown · *Architecture and Morality* · **England**
2004 The British artist Brown is known for the use
of art historical references in his paintings. In this
work a classic botanical work and a portrait are
transformed through color and juxtaposition.

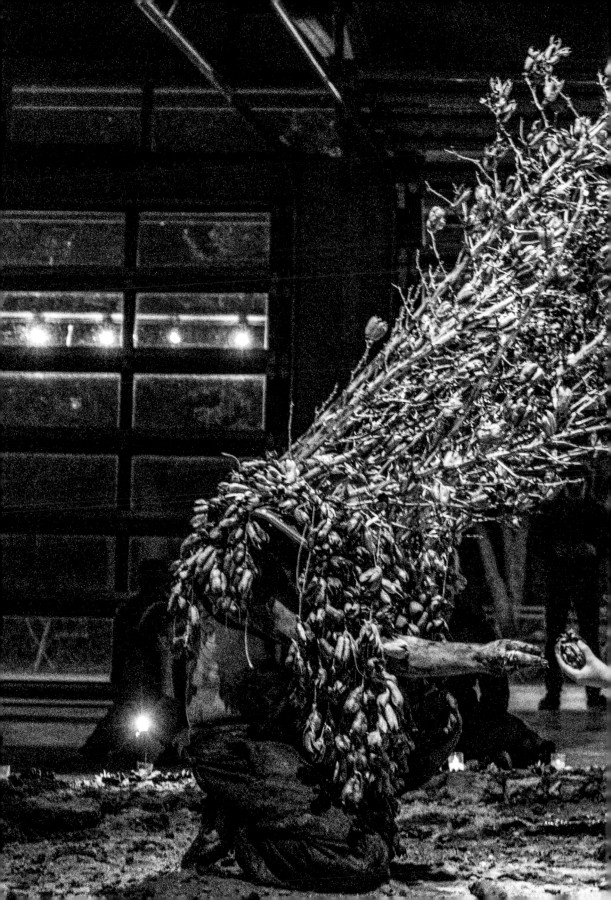

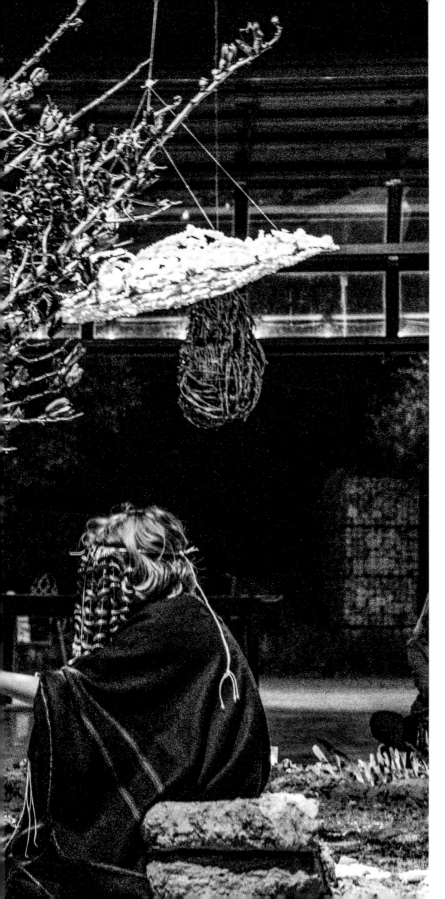

Lucien Shapiro · *Dust, Water, Fire* · United States · 2019 As the artist explains, "Dust, Water, Fire was a ritual performance that took place in Marfa, Texas at The Capri arts space. The performance took place inside a circle made from local adobe bricks and mud. The yucca used for the costume was sourced from the surrounding desert. The performance was held on a full moon, its purpose to release what no longer served each individual participating and creating room for something new to enter. Each of the directions, North, South, East, and West, were marked by sculptures made from local dust and glue. At the center of the circle, sat a figure draped in repurposed bottle caps, representing the future. Above him, an object made of salt protected the participants from outside energies."

Robert Mapplethorpe · *Ken Moody, 1984* · United States · 1984 Mapplethorpe's work often celebrates the beauty of bodies and nature. The eroticism inherent in his famous documentation of flowers and plants is expanded upon in this sensual, intimate portrait.

Lauren Spencer King · *Flower No.3* · United States 2021 Reaching back to art historical traditions such as Dutch still life and botanical illustrations, King represents the vivid and intense complexity of orchids, free from allegory and symbolism.

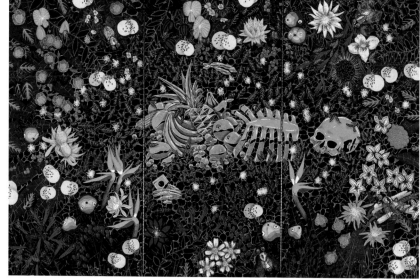

(below) John Dwyer · *The Vegetarian* · United States 2020 Both in his band, the Osees and in his films, animations and artworks, Dwyer envisions dystopian futures influenced by pop culture artifacts such as sci-fi and fantasy illustrations, b-movie camp and musical genres like punk, rock, and experimental jazz.

(above) April Rose · *Naughty by Nature* · United States · 2020 The California-based artist April Rose works under the moniker "Rainbow Kimono" creating kaleidoscopic and fantastical works which explore a fresh, modern psychedelic vision through painting, ceramic design, and fabric art.

Valero Doval · *Visual Arrangement II* · Spain · 2016 Primarily using collage, Doval's work, as the artist explains, "is a declaration of love...where the man-made, the natural, and the spiritual interact in a neutral space, suspended in time – science meets spirit, fear meets joy, and simplicity meets complexity.

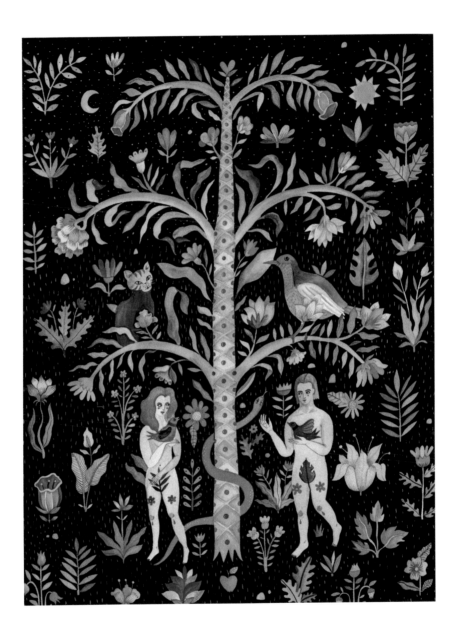

Heliana Rotariu /Aitch · *Adam and Eve* · Romania 2015 Heliana Rotariu, who uses the artist's name Aitch, is a Romanian born multimedia artist working in illustration as well as jewelry and clothing design Here they bring their modern visionary take to the Christian mythology of the Garden of Eden.

Gallardo Gervasio · *Perfume* · Spain · 1976 Having created covers for science fiction and fantasy books, the artist and illustrator Gervasio also brought his surreal eye to the advertising world. Perfume is one in a series of botanical works featured in his 1976 book, *The Fantastic World of Gervasio Gallardo*.

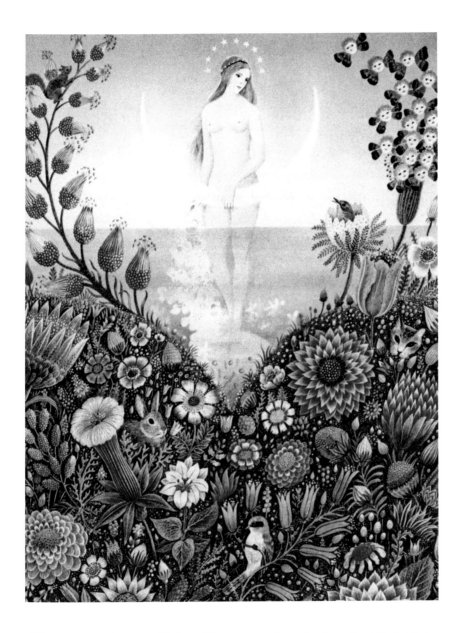

(following pages) Marlene Steyn · *The flower child with hay fever* · South Africa · 2022 Steyn's work explores nature through dreamlike exuberance and fantasy. As the artist explains, their paintings express, "memories of a world outside. But like in memories, like in dreams, these landscapes are somewhat formless, unidentifiable."

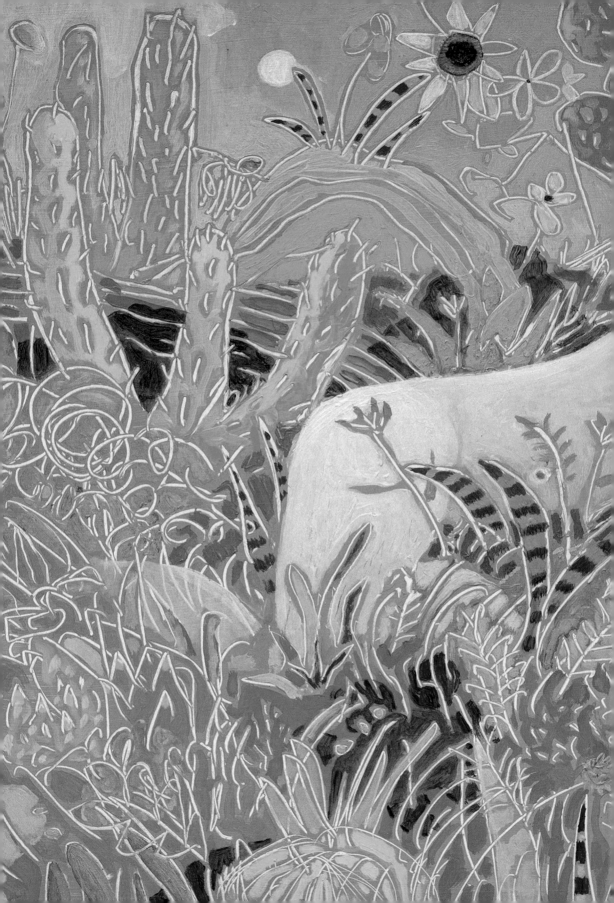

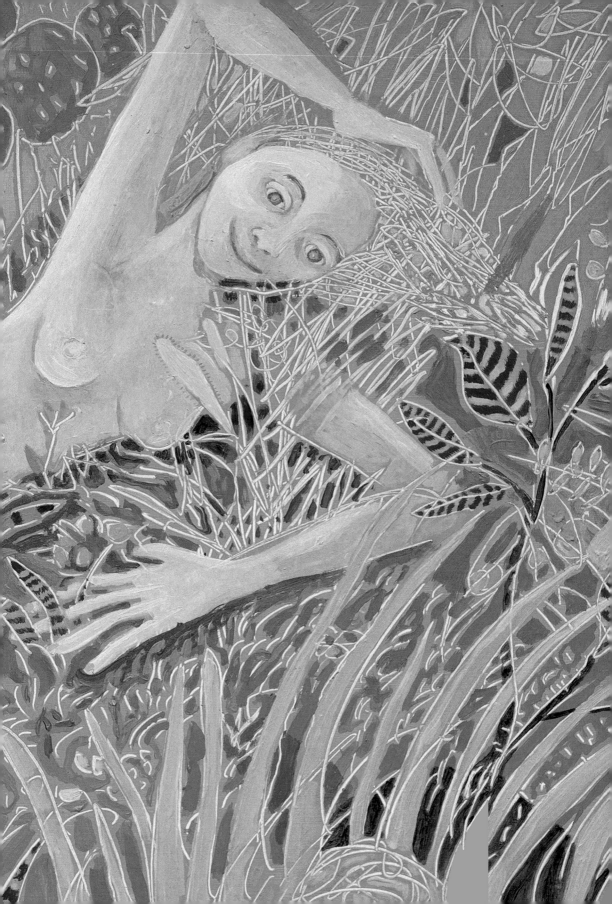

FOR THE SEEKERS

A Final Note on the Library of Esoterica

The Library of Esoterica explores the expansive visual history of the arcane, showcasing artwork birthed through the expressions of a wide variety of traditions and rituals. The intent of this series is to offer inclusive, introductory overviews to these ancient rituals and to explore their complex symbolism objectively, rather than dogmatically.

In doing so, the aspiration is to draw back the veil to reveal a deeper appreciation of these valuable tools of the psyche. Esoteric knowledge offers powerful methods for self-exploration and meditation. These magickal practices have developed over centuries in order to allow for a further understanding of the inner world.

The goal of this series is to present condensed summaries of these ancient systems and from there, encourage readers to further explore the rituals, ceremonies, and sacred philosophies of various global cultures. The task is to inspire readers to seek out knowledge, to study the teachings of scholars past and present, who have dedicated themselves to the development and preservation of these ancient arts.

The hope is that *The Library of Esoterica* emboldens readers to begin their own journey down into the dark halls of the arcane, to pull the dusty tomes from the shelves, to take the timeworn cards from the satchel and spread them across the silks, to look up to the sky and read meaning in the movement of the stars.

As the author, teacher, and archivist Manly P. Hall stated so eloquently in his masterwork, *The Secret Teachings of All Ages*, "To live in the world without becoming aware of the meaning of the world is like wandering about in a great library without touching the books." Later, in this indispensable and exhaustive overview of the world's esoteric teachings, Hall exclaims, "Only transcendental philosophy knows the path. Only the illumined reason can carry the understanding part of man upward to the light. Only philosophy can teach man to be born well, to live well, to die well, and in perfect measure, be born again. Into this band of the elect, those who have chosen the life of knowledge, of virtue, and of utility, the philosophers of the ages invite, YOU."

Johfra Bosschart · *Unicorn* · Netherlands · 1980
A mythical unicorn rears back from a hissing serpent in Bosschart's fantastical vision of Eden, an enchanted realm populated by otherworldly flora and fauna.

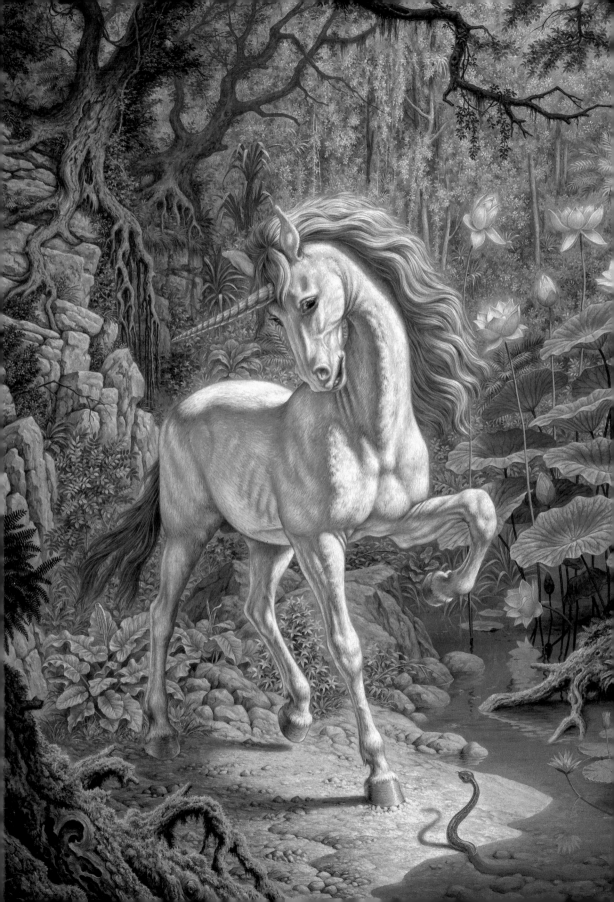

BIBLIOGRAPHY

Bennett, Robin Rose. *Healing Magic: A Green Witch Guidebook to Conscious Living*. Berkeley, CA:
 North Atlantic Books, 2014.
———. *The Gift of Healing Herbs: Plant Medicines and Home Remedies for a Vibrantly Healthy Life*.
 Berkeley, CA: North Atlantic Books, 2014.
Blackwell, Elizabeth. *A Curious Herbal*. London: Nourse, 1751.
Blankespoor, Juliet. *The Healing Garden: Cultivating and Handcrafting Herbal Remedies*. New York, USA:
 HarperCollins, 2022.
Burroughs, William S., Allen Ginsberg, and Oliver Harris. *The Yage Letters*. Great Britain:
 Penguin Books, Limited, 2009.
Carson, Rachel. *Silent Spring*. London: Penguin Books, in association with Hamish Hamilton, 2015.
Darwin, Charles, and George Levine. *The Origin of Species: By Means of Natural Selection*.
 New York: Barnes & Noble, 2004.
Duke, James A. *The Green Pharmacy: The Complete Guide to Healing Herbs, from the World's Leading
 Authority*. Emmaus, PA: Rodale, 2000.
Elk, Black, and John G. Neihardt. *Black Elk Speaks: The Complete Edition*. Lincoln: University of Nebraska
 Press, 2014.
Ellis, Havelock. *Mescal: A New Artificial Paradise*. Washington: Smithsonian Inst., 1898.
Gately, Iain. *Drink: A Cultural History of Alcohol*. New York: Gotham Books, 2009.
George, A. R. *The Epic of Gilgamesh: The Babylonian Epic Poem and Other Texts in Akkadian and Sumerian*.
 London, United Kingdom: Penguin Books, 2020.
Ghalioungui, Paul. *The Ebers Papyrus: A New English Translation, Commentaries and Glossaries*. Cairo:
 Academy of Scientific Research and Technology, 1987.
Hildegard. *Hildegard's Healing Plants: From Her Medieval Classic Physica*. Boston: Beacon Press, 2002.
———. *Physica*. Berlin: de Gruyter, 2010.
Huxley, Aldous. *The Doors of Perception*. New York: Harper Perennial, 2009.
Jarman, Derek, and Olivia Laing. *Modern Nature: The Journals of Derek Jarman, 1989-1990*.
 London: Vintage Classics, 2018.
Jewell, Jennifer. *The Earth in Her Hands: 75 Extraordinary Women Working in the World of Plants*.
 Portland, OR: Timber Press, 2020.
Johnson, Wendy. *Gardening at the Dragon's Gate: At Work in the Wild and Cultivated World*.
 New York: Bantam Books, 2008.
Kimmerer, Robin Wall. *Braiding Sweetgrass: Indigenous Wisdom, Scientific Knowledge, and the Teachings
 of Plants*. Minneapolis: Milkweed, 2020.
Kranz, Lauri, Dean Kuipers, and Yoshihiro Makino. *A Garden Can Be Anywhere: Creating Bountiful and
 Beautiful Edible Gardens*. New York (N.Y.): Abrams, 2019.
Lee, Michele Elizabeth. *Working the Roots: Over 400 Years of Traditional African American Healing*.
 S.l.: Wadastick, 2017.

Li, Shizhen. *Compendium of Materia Medica*. Beijing: Foreign Languages Press, 2003.

McKenna, Terence K. *Food of the Gods: The Search for the Original Tree of Knowledge: A Radical History of Plants, Drugs, and Human Evolution*. London, England: Penguin Random House, 2021.

McKenna, Terence K., and O. N. Oeric. *The Invisible Landscape: Mind, Hallucinogens, and the I Ching*. San Francisco, CA: Harper San Francisco, 1994.

Montgomery, Pam. *Partner Earth: A Spiritual Ecology*. Rochester, VT: Destiny Books, 1997.

———. *Plant Spirit Healing: A Guide to Working with Plant Consciousness*. Rochester, VT: Bear & Co., 2008.

Oss, O. T., and O. N. Oeric. *Psilocybin, Magic Mushroom Grower's Guide: A Handbook for Psilocybin Enthusiasts*. San Francisco, Calif: Quick American Publ, 1991.

Pedanius, Dioscorides, and Max Wellmann. *De Materia Medica*. Berlin: Weidmann, 1958.

Pliny. *Historia Naturalis*. Venice: Bartholomaeus de Zanis, 1489.

Pollan, Michael. *How to Change Your Mind*. Penguin, 2019.

———. *This Is Your Mind on Plants*. Penguin, 2022.

Quincey, Thomas de. *The Confessions of an English Opium-Eater*. London: Dent, 1967.

Redouté, Pierre Joseph, and Hans Walter Lack. *The Book of Flowers = Das Buch Der Blumen = Le Livre Des Fleurs*. Köln: TASCHEN, 2020.

Rose, Karen M. *The Art & Practice of Spiritual Herbalism: Transform, Heal, & Remember with the Power of Plants and Ancestral Medicine*. Beverly, MA: Fair Winds Press, 2022.

Rätsch, Christian. *The Encyclopedia of Psychoactive Plants: Ethnopharmacology and Its Applications*. Rochester, VT: Park Street Press, 2005.

Ruiz, Felicia Cocotzin. *Earth Medicines: Ancestral Wisdom, Healing Recipes, and Wellness Rituals from a Curandera*. Boulder, CO: Roost Books, 2021.

Salmón, Enrique. *Iwígara: American Indian Ethnobotanical Traditions and Science*. Portland, OR: Timber Press, 2020.

Schultes, Richard Evans, Albert Hofmann, and Christian Rätsch. *Plants of the Gods: Their Sacred, Healing and Hallucinogenic Powers*. Rochester, VT: Healing Arts Press, 2006.

Simard, S. *Finding the Mother Tree: Discovering the Wisdom of the Forest*. New York: Vintage Books, a division of Penguin Random House, LLC, 2022.

Stamets, Paul. *Mycelium Running: How Mushrooms Can Help Save the World*. Berkeley, CA: Ten Speed Press, 2005.

Thoreau, Henry David. *Walden*. Dragon Classics, 2020.

Tompkins, Peter, and Christopher Bird. *The Secret Life of Plants*. New York: Harper & Row, 1973.

The Upanishads. Delhi: Motilal Banarsidass, 1965.

Vanderbeck, Paige. *Green Witchcraft: A Practical Guide to Discovering the Magic of Plants, Herbs, Crystals, and Beyond*. Emeryville, CA: Rockridge Press, 2021.

Verinder., Erin. *Plants for the People*. New York: Thames & Hudson, 2020.

Wasson, Robert Gordon, Ruck Carl A P., and Albert Hofmann. *The Road to Eleusis: Unveiling the Sacred of the Mysteries*. New York, NY: Jovanovich, 1978.

Whitman, Walt, and David S. Reynolds. *Walt Whitman's Leaves of Grass*. New York: Oxford University Press, 2005.

———. *Speciman Days*. New York: NAL, 1961.

Williams, Terry Tempest. *The Hour of Land: A Personal Topography of America's National Parks*. Copyright 2016: Sarah Crichton Books/Farrar, Straus and Giroux, 2016.

Wohlleben, Peter. *Hidden Life of Trees: What They Feel, How They Communicate – Discoveries from a Secret World*. Greystone Books, 2018.

IMAGE CREDITS

© AGIP/Bridgeman Images: 486; /akg-images / De Agostini Picture Lib. / A. Dagli Orti: 228; /akg-images / De Agostini Picture Lib. / G. Nimatallah: 73; /akg-images: 13, 70, 452, 196, 131, 286, 545, 287, 143, 73, 228, 146, 150, 133, 231, 293, 194, 141, 152, 102, 89, 304, 300, 452, 142, 455, 436, 443, 33, 442, 439, 448, 438. 446, 285, 286, 312, 49, 161, 83, 188, 125, 239, 72, 226, 13, 199, 97, 249, 140, 316, 86, 147, 324, 90, 326, 296, 289, 280, 53, 211, 232; /© Alex Grey, courtesy of the artist: 145, 148, 331, 375, 397, 416; /Alphachanneling, courtesy of the artist: 46, 251, 266, 400, 461, 482; / Andie Dinkin courtesy of the artist: 491; /Ansel Adams: 123; /April Rose, courtesy of the artist: 506; /© Ariana Papademetropoulos, courtesy of the artist & Deitch Gallery: 7, 158; /Arik Roper, courtesy of the artist: 204, 347; /Arrington de Dionyso, courtesy of the artist: 350-351; /© Aymon de Lestrange/ Bridgeman Images: 335; /Becca Mann, courtesy of the artist: 466, 476; /Biblioteca Estense, Modena, Emilia-Romagna, Italy/Bridgeman Images: 175; / Bibliotheque des Arts Decoratifs, Paris, France G. Dagli Orti /© NPL - DeA Picture Library/Bridgeman Images: 206; /Bibliotheque Nationale, Paris, France/ Bridgeman Images: 198, 449; /Bibliotheque Nationale, Paris, France © Archives Charmet/ Bridgeman Images: 168, 200; /Bibliotheque Publique de Neuchatel, Switzerland © NPL - DeA Picture Library/Bridgeman Images: 151; / Birmingham Museums and Art Gallery/Bridgeman Images: 212; /© Bonhams, London, UK / Bridgeman Images: 381; /Bridgeman Images: 17, 19, 21, 22, 29, 45, 209, 221, 233; /British Library, London, UK © British Library Board. All Rights Reserved/Bridgeman Images: 177; /Burghley House Collection, Lincolnshire, UK © NPL - DeA Picture Library/Bridgeman Images: 239; /Casey Jex Smith, courtesy of the artist: 129, 410, 421; /Chris Fallon courtesy of the artist: 499; /© Christie›s Images/ Bridgeman Images: 59, 77, 118, 163, 165, 227, 242, 244, 236, 256, 259, 299, 386, 389, 432, 451, 490; /Courtesy of Archives, Larousse, Paris, France/ Bridgeman Images: 285(t); /Courtesy of Russell-Cotes. Art Gallery and Museum, Bournemouth, UK © Russell-Cotes Art Gallery / Supported by the National Art Collections Fund/Bridgeman Images: 95; /Courtesy of the TASCHEN Collection: 11, 12, 14, 16, 30, 31, 38-39, 43, 44; /Courtesy of the Trustees of Sir John Soane's Museum, London © Sir John Soane›s Museum /Bridgeman Images: 456; /Daniel Herwitt, courtesy of the artist: 418, 472; /Daniel Meijome, courtesy of the artist: 348, 356; /Darren Romanelli /DRx courtesy of the artist: 373; /Deir el-Medina, Thebes, Egypt/Bridgeman Images: 173; /Donna Outtrim / Moonjube, courtesy of the artist: 408; /Down House, Kent,UK/Bridgeman Images: 25; /Dublin City Gallery, The Hugh Lane, Ireland © Dublin City Gallery the Hugh Lane / Bridgeman Images: 440; /Edward S. Curtis, Edward S. Curtis Collection. Published in: *The North American Indian* / Edward S. Curtis. [Seattle, Wash.]: Edward S. Curtis, 1907-30, v. 19, p. 210: 368; /Elena Stonaker, courtesy of the artist: 157, 268-269, 460, 479; /Ernst Kreidolf, courtesy Ernst Kreidolf-Association: 434, 442; /Ethnographic Collections, University College London, UK © UCL Art Museum,

University College London/Bridgeman Images: 174; /Everett Collection/Bridgeman Images: 337; /First published in the UK in 2016 by Big Picture Press. Illustration copyright © 2016 by Katie Scott, 2022: 154-155; /Florence + The Machine, Ltd., courtesy of the artist: 497; /© Florilegius/Bridgeman Images: 263, 372; /Freya Dean, courtesy of the artist: 484; /Frida Kahlo, © Banco de México Diego Rivera Frida Kahlo Museums Trust / VG Bild-Kunst, Bonn 2022: 458-459; /Gallardo Gervasio, courtesy Lavaty Art Gallery: 509; /Gallerie dell'Accademia, Venice, Italy/ Bridgeman Images: 171; /Gemäldegalerie Alte Meister, Dresden, Germany © Staatliche Kunstsammlungen Dresden /© Staatliche Kunstsammlungen Dresden/Bridgeman Images: 320; /Gemäldegalerie Alte Meister, Kassel, Germany © Museumslandschaft Hessen Kassel / Ute Brunzel/ Bridgeman Images: 319; Georgia O'Keeffe, © Georgia O'Keeffe Museum / VG Bild-Kunst, Bonn 2022: 190-1; /Glenn Brown, courtesy of the artist and Gagosian Gallery: 501; /Guadalupe Maravilla Courtesy the Artist; Socrates Sculpture Park; and PPOW, New York; Image by KMDeco Creative Solutions: Mark DiConzo: 478; /Guadalupe Maravilla Courtesy the Artist; Socrates Sculpture Park; and PPOW, New York; Image by Sara Morgan: 478; /Helena Arturaleza, courtesy of the artist: 413(t); /Heliana Rotariu /Aitch,courtesy of the artist: 508; / Henri Matisse, © Succession H. Matisse / VG Bild-Kunst, Bonn 2022: 264-5; /Heritage Images / Ashmolean Museum, University of Oxford: 82; /Heritage Images / akg-images: 49; /Heritage-Images / Art Media / akg-images: 455; /Howard G. Charing, courtesy of the artist: 415; /Indianapolis Museum of Art at Newfields, USA © Indianapolis Museum of Art / Gift of Eli Lilly and Company/ Bridgeman Images: 390; /Inka Essenhigh, courtesy of the artist: 480-481; /Jade Gordon & Megan Whitmarsh, courtesy of the artists: 473; /Jason Traeger, courtesy of the artist: 270-271; /Javiera Estrada, courtesy of the artist: 468, 487, 496; /Jeaneen Lund, courtesy of the artist: 58; /Johfra Bosschart, courtesy of the Van Soest Collection, © VG Bild-Kunst, Bonn 2022: 103, 301, 513; /John Dwyer, courtesy of the artist: 495, 506; /Joyce Lee, courtesy of the artist: 252, 262; /Katie Scott, courtesy of the artist: 463; /Katie Scott, courtesy of the artist. 'Tree of Plant Life' Illustration taken from *Botanicum*: 154-155; /L., courtesy of the artist: 162; /Lani Trock, courtesy of the artist: 471, 500; /Lauren Spencer King, courtesy of the artist: 504; /© Lefevre Fine Art Ltd., London/Bridgeman Images: 145; /Leonora Carrington, © VG Bild-Kunst, Bonn 2022: 161; /Leonard de Selva © /Bridgeman Images: 362; /Li Lian Kolster, courtesy of the artist: 422-423; /Lieke Romeijn, courtesy of the artist: 9; /Linda Westin, courtesy of the artist: 128, 467; /© Look and Learn / Elgar Collection/Bridgeman Images: 190, 248; /© Look and Learn/Bridgeman Images: 22, 209; /© Luca Tettoni / Bridgeman Images: 197; /Lucien Shapiro, courtesy of the artist: 503; /Luis Tamani, courtesy of the artist: 112, 267, 276, 402, 412; /Luke Brown, courtesy of the artist: 386, 452, 413, 417; /Manchester Art Gallery, UK © Manchester Art Gallery / Bridgeman Images: 80-81, 154; /Mantovani © akg-images / Mantovani: A.R.Mantovani: 102; /Mariano Peccinetti, courtesy of the artist: 142, 144, 468, back cover; /Mariela de la Paz, courtesy of the artist: 167, 378, 403; /Mark Rogers, courtesy of the artist: 465; /Marlene Steyn, courtesy of the artist and SMAC Gallery:136, 485, 510-511; /Matt Loeffler, courtesy of the artist: 420; /Matthew Palladino, courtesy of the artist: 384; /Maurice Harris, courtesy of the artist: 36, 470; /Meagan Boyd, courtesy of the artist: 347, 401; /Meagan Donegan, courtesy of the artist: 108, 477; /© Meret Oppenheim / DACS / © VG Bild-Kunst, Bonn 2022: 142; /Metropolitan Museum of Art, New

York, USA/Bridgeman Images: 230; /Minneapolis Institute of Arts, MN, USA© Minneapolis Institute of Art/Gift of Mr. and Mrs. E.J. Phelps/Bridgeman Images: 237; /Musée de la Vallée, Barcelonnette, Alps de Haute, France © Jean Bernard: 382; /Musee des Beaux-Arts, Mulhouse, France/Bridgeman: 74; /Museo Archeologico Nazionale, Naples, Campania, Italy/Bridgeman: 82; /Museo de Arqueologia, Guatemala Luisa Ricciarini/Bridgeman Images: 78; /Museum Folkwang, Essen, Germany/ Bridgeman Images: 184-185; /Natural History Museum, London, UK© Natural History Museum, London /Bridgeman Images: 182; /Natural History Museum, London, UK© Natural History Museum, London /Bridgeman Images: 20, 360; /Nicole Nadeau, courtesy of the artist: 349; /Nobuyoshi Araki, Taschen Collection: 253; /© NPL – DeA Picture Library/Bridgeman Images: 119; /Pablo Amaringo, featured in the book, *The Ayahuasca Visions of Pablo Amaringo* by Howard G. Charing and Peter Cloudsley: 399, 405, 407; /Palazzo del Te, Mantua, ItalyPhoto © Raffaello Bencini/Bridgeman Images: 98-99; /Paula Duró, courtesy of the artist: 252, 224- 226; /Penny Slinger, Courtesy of the artist. © Penny Slinger. All Rights Reserved, DACS/Artimage 2022, © VG Bild-Kunst, Bonn 2022: 159, 254-255; /© Peter Nahum at The Leicester Galleries, London/ Bridgeman Images: 245; /Peter Palladino/The Agnes Pelton Society/Bridgeman Images: 329; / Philadelphia Museum of Art, Pennsylvania, PA, USA © Philadelphia Museum of Art / Bequest of Mrs. Maurice J. Speiser in memory of Raymond A./ Bridgeman Images: 85; /Picture Alliance/DPA/ Bridgeman Images: 27(b); /Picture Alliance/DPA/ Bridgeman Images: 27(t); /© Christopher Wood Gallery, London, UK/Bridgeman Images: 237(t); /Courtesy of Julian Hartnoll/Bridgeman Images: Regional Art Museum, SimbirskPhoto © Fine Art Images/Bridgeman Images: 272; /Remedios Varo © VG Bild-Kunst, Bonn 2022: 492-3; /René Magritte, © VG Bild-Kunst, Bonn 2022 / Bridgeman: 118, 164: /Rijksmuseum, Amsterdam, The Netherlands/Bridgeman Images: 322; /RIT Libraries and Archives © RIT Libraries and Archives: 27; /River Cousin, courtesy of the artist: 124, 247, 462, 482; /© Rodarte, courtesy of the artists: 488; /Roger Dean, courtesy of the artist: 127-128; / © Photo RMN, Paris – Arnaudet: 28; /© Salvador Dalí, Fundació Gala-Salvador Dalí, VG Bild-Kunst, Bonn 2022 / Bridgeman Images: 451, front cover; /Samuel Colman, courtesy of the artist: 2; /Sarah Stewart, courtesy of the artist: 42, 464; /© Sotheby's / akg-images: 89; /State Hermitage Museum, St. Petersburg, Russia/Bridgeman Images: 217; /The Barnes Foundation, Philadelphia, Pennsylvania, USA © Succession H. Matisse/ DACS 2022/Photo: © The Barnes Foundation/Bridgeman Images: 264; /© The Maas Gallery, London/Bridgeman Images: 29; /The Stapleton Collection/Bridgeman Images: 362(t), 201, 377-378; /The Steven Arnold Museum and Archives: 464; /© Theodora Allen, Courtesy of the artist and Blum & Poe, Los Angeles/New York/ Tokyo Photo: Sam Kahn: 333; /Tino Rodriguez & Virgo Paraiso, courtesy of the artists. Photo credit: Don Felton: 79; /Tino Rodriguez, courtesy of the artist. Photo credit: Don Felton: 409, 498; /Tom Benton, courtesy of the Hunter S. Thompson Trust: 383; /Tuco Amalfi, courtesy of the artist: 60-61, 135, 259-260; /Tyrone Williams courtesy of the artist: 490; /Universal History Archive/UIG/Bridgeman Images: 174, 243(t); /Valero Doval, courtesy of the artist: 41, 55, 494, 406; /Vasko Taskovski, courtesy of the artist: 62, 137; /Walker Art Gallery, National Museums Liverpool© National Museums Liverpool /Bridgeman Images: 223; /© Whitford & Hughes, London, UK/ Bridgeman Images: 364-365; /William Lemon, courtesy of the artist: 165, 489.

For those seeking to explore the history, art and healings traditions of plant and fungi medicines, we encourage you to support the work of all the wonderful artists and interviewees included in this volume. The following is a brief list of individuals and institutions that offer invaluable information through their print and digital media.

INDIVIDUALS · Laura Ash, Kelsey Barrett, Suhaly Bautista-Carolina, Robin Rose Bennett, Mary Blue, Marcus Bridgewater, Kristen Caissie, Rosemary Gladstar, Tiana Griego, Maurice Harris, Shelby Hartman, Christopher Hobbs, Dean Kuipers, Lauri Kranz, Madison Margolin, Hamilton Morris, Alexis Nikole Nelson, Flora Pacha, Michael Pollan, Karen Rose, Paul Stamets, Dr. Jillian Stansbury, Loria Stern, Dr. David Delgado Shorter, Lani Trock, Erin Lovell Verinder, Terry Tempest Williams, Jaguar Womban

WEBSITES / PODCASTS / MEDIA
Anima Mundi, Black Forager, Bloom and Plume, Botanica Cimarron, California School of Herbal Studies, Chestnut School of Herbs, Cultivating Place,

DoubleBlind, Edible Gardens, Fungi Perfecti, Heavy Nettle Gathering, The Herbal Highway, Jennifer Jewell, The Lighthouse Vibration, Mountain Rose Herbs, Moon Canyon Healing, Moon Mother Apothecary, The Plant Lore Agency, The Plant Path, Poppy and Someday, Sacred Vibes Apothecary, The Scarlet Sage Herb Co., Wake Up to Nature, Wild Weeds, Wise Woman Healing Ways, Wooden Spoon Herbs, WombNation Community

INSTITUTIONS · The Alchemist Kitchen, The British Library, California School of Herbal Studies, Creative Folkestone / Prospect Cottage, The Edible Schoolyard Project, The Getty Research Institute, The Huntington Library – Art Museum and Gardens, The Philosophical Research Society, MAPS (Multidisciplinary Association for Psychedelic Studies), Mycological Society of America, The New York Botanical Gardens, Ram Dass / Love Serve Remember Foundation, Royal Botanic Gardens – Kew, Seed Savers Exchange, Sierra Club, Slow Food International, Bakara Wintner and Christian Berry of Everyday Magic, Devany Amber Wolfe of Serpentfire, Madison Young of Open Eye Crystals

Thank you to the artists, authors, publishers, and scholars, kind enough to share in their knowledge and passion with us, and for the generous participation of the various plant practitioners and healers, as well as the ecologists, botanists, herbalists, and farmers who offered wisdom through insightful interviews.

We are endlessly grateful for to all those who have offered support, connections and encouragement throughout this project including; Jennifer Brandt-Taylor, Kristen Caissie of Moon Canyon, Kelly Carmena of the Philosophical Research Society, Grace

Converse, Pam Montgomery, Pam Grossman of Phantasmaphile, Barbara Kramer of Plant Lore, curator Margot Ross, Corey Scholibo of WILE, Dr. David Delgado Shorter, Meg Thompson and Nina Wiener.

And finally, this book would not exist without the talent and dedication of Nic Taylor and Lisa Doran, and the wisdom and encouragement of Kathrin Murr, Marion Boschka, Andy Disl, and Benedikt Taschen.

— LOE SERIES EDITOR,
JESSICA HUNDLEY, 2022

IMPRINT

Edited by Jessica Hundley

Written by Jessica Hundley
Captions by Michelle Mae

Design by Thunderwing

Research & licensing by Lisa Doran

All images and quotations are © Copyright
their respective copyright owner. In case of
any inadvertent errors or omissions in credit,
please contact the publisher. Excerpts featured
throughout the book have been edited from
the publications cited. In some cases, they have
been slightly condensed or edited for clarity.

ISBN 978-3-8365-8564-4
Printed in Slovakia

EACH AND EVERY TASCHEN BOOK
PLANTS A SEED!

TASCHEN is a carbon neutral publisher. Each
year, we offset our annual carbon emissions
with carbon credits at the Instituto Terra, a
reforestation program in Minas Gerais, Brazil,
founded by Lélia and Sebastião Salgado. To
find out more about this ecological partnership,
please check: www.taschen.com/zerocarbon

Inspiration: Unlimited. Carbon footprint: Zero.

To stay informed about TASCHEN and our
upcoming titles, please subscribe to our
free magazine at www.taschen.com/magazine,
follow us on Instagram and Facebook, or
e-mail your questions to contact@taschen.com.

© 2022 TASCHEN GmbH
Hohenzollernring 53, D-50672 Köln
www.taschen.com

(front cover) Salvador Dalí · *The Rose* · Spain · 1958
© Salvador Dalí, Fundació Gala-Salvador Dalí /
VG Bild-Kunst, Bonn 2022; Photo: Bridgeman
Images

(back cover) Mariano Peccinetti · *Mushroom Day*
Argentina · 2020